Canon® EOS Rebel T1i/500D FOR DUMMES®

by Julie Adair King

Author of Digital Photography For Dummies

Canon® EOS Rebel T1i/500D For Dummies® Published by Wiley Publishing, Inc. 111 River Street Hoboken, NJ 07030-5774 www.wiley.com

Copyright © 2009 by Wiley Publishing, Inc., Indianapolis, Indiana

Published by Wiley Publishing, Inc., Indianapolis, Indiana

Published simultaneously in Canada

No part of this publication may be reproduced, stored in a retrieval system or transmitted in any form or by any means, electronic, mechanical, photocopying, recording, scanning or otherwise, except as permitted under Sections 107 or 108 of the 1976 United States Copyright Act, without either the prior written permission of the Publisher, or authorization through payment of the appropriate per-copy fee to the Copyright Clearance Center, 222 Rosewood Drive, Danvers, MA 01923, (978) 750-8400, fax (978) 646-8600. Requests to the Publisher for permission should be addressed to the Permissions Department, John Wiley & Sons, Inc., 111 River Street, Hoboken, NJ 07030, (201) 748-6011, fax (201) 748-6008, or online at http://www.wiley.com/go/permissions.

Trademarks: Wiley, the Wiley Publishing logo, For Dummies, the Dummies Man logo, A Reference for the Rest of Us!, The Dummies Way, Dummies Daily, The Fun and Easy Way, Dummies.com, Making Everything Easier, and related trade dress are trademarks or registered trademarks of John Wiley & Sons, Inc. and/ or its affiliates in the United States and other countries, and may not be used without written permission. Canon is a registered trademark of Canon, Inc. All other trademarks are the property of their respective owners. Wiley Publishing, Inc., is not associated with any product or vendor mentioned in this book.

LIMIT OF LIABILITY/DISCLAIMER OF WARRANTY: THE PUBLISHER AND THE AUTHOR MAKE NO REPRESENTATIONS OR WARRANTIES WITH RESPECT TO THE ACCURACY OR COMPLETENESS OF THE CONTENTS OF THIS WORK AND SPECIFICALLY DISCLAIM ALL WARRANTIES, INCLUDING WITH-OUT LIMITATION WARRANTIES OF FITNESS FOR A PARTICULAR PURPOSE. NO WARRANTY MAY BE CREATED OR EXTENDED BY SALES OR PROMOTIONAL MATERIALS. THE ADVICE AND STRATEGIES CONTAINED HEREIN MAY NOT BE SUITABLE FOR EVERY SITUATION. THIS WORK IS SOLD WITH THE UNDERSTANDING THAT THE PUBLISHER IS NOT ENGAGED IN RENDERING LEGAL, ACCOUNTING, OR OTHER PROFESSIONAL SERVICES. IF PROFESSIONAL ASSISTANCE IS REQUIRED, THE SERVICES OF A COMPETENT PROFESSIONAL PERSON SHOULD BE SOUGHT. NEITHER THE PUBLISHER NOR THE AUTHOR SHALL BE LIABLE FOR DAMAGES ARISING HEREFROM. THE FACT THAT AN ORGANIZA-TION OR WEBSITE IS REFERRED TO IN THIS WORK AS A CITATION AND/OR A POTENTIAL SOURCE OF FURTHER INFORMATION DOES NOT MEAN THAT THE AUTHOR OR THE PUBLISHER ENDORSES THE INFORMATION THE ORGANIZATION OR WEBSITE MAY PROVIDE OR RECOMMENDATIONS IT MAY MAKE. FURTHER, READERS SHOULD BE AWARE THAT INTERNET WEBSITES LISTED IN THIS WORK MAY HAVE CHANGED OR DISAPPEARED BETWEEN WHEN THIS WORK WAS WRITTEN AND WHEN IT IS READ.

For general information on our other products and services, please contact our Customer Care Department within the U.S. at 877-762-2974, outside the U.S. at 317-572-3993, or fax 317-572-4002.

For technical support, please visit www.wiley.com/techsupport.

Wiley also publishes its books in a variety of electronic formats. Some content that appears in print may not be available in electronic books.

Library of Congress Control Number: 2009930927

ISBN: 978-0-470-53389-5

Manufactured in the United States of America

10 9 8 7 6 5 4 3 2

About the Author

Julie Adair King is the author of many books about digital photography and imaging, including the bestselling *Digital Photography For Dummies*. Her most recent titles include *For Dummies* guides to the Canon EOS Digital Rebel XS, XSi/450D, and XTi/400D, *Digital Photography Before & After Makeovers*, *Digital Photo Projects For Dummies, Julie King's Everyday Photoshop For Photographers, Julie King's Everyday Photoshop Elements*, and *Shoot Like a Prol: Digital Photography Techniques*. When not writing, King teaches digital photography at such locations as the Palm Beach Photographic Centre. A graduate of Purdue University, she resides in Indianapolis, Indiana.

Author's Acknowledgments

This book would not have been possible without the many talented professionals at John Wiley & Sons, including Rebecca Senninger, Brian Walls, Teresa Artman, Jen Riggs, Heidi Unger, Steve Hayes, Andy Cummings, and Mary Bednarek.

I am also indebted to technical editor David Hall, whose keen eye and vast experience set me on the right track whenever I mistakenly thought I should go left; to Canon guru Chuck Westfall for always answering all my questions, even the silly ones; and to Scott Heath at Synergy Communications for his help with this book and various other projects.

Thank you all for sharing your time and your expertise — the book would not have been the same without it.

Publisher's Acknowledgments

We're proud of this book; please send us your comments through our online registration form located at http://dummies.custhelp.com. For other comments, please contact our Customer Care Department within the U.S. at 877-762-2974, outside the U.S. at 317-572-3993, or fax 317-572-4002.

Some of the people who helped bring this book to market include the following:

Acquisitions an	nd Editorial
-----------------	--------------

Composition Services

Project Coordinator: Patrick Redmond	
•	
Layout and Graphics: Claudia Bell,	
Reuben W. Davis, Melissa K. Jester, Melissa K. Smith	
Proofreaders: Laura Albert, Debbye Butler	
Indexer: BIM Indexing & Proofreading Services	
Special Help	
Teresa Artman, Jen Riggs, Heidi Unger	

Publishing and Editorial for Technology Dummies

Richard Swadley, Vice President and Executive Group Publisher

Andy Cummings, Vice President and Publisher

Mary Bednarek, Executive Acquisitions Director

Mary C. Corder, Editorial Director

Publishing for Consumer Dummies

Diane Graves Steele, Vice President and Publisher

Composition Services

Debbie Stailey, Director of Composition Services

Contents at a Glance

Introduction 1
Part 1: Fast Track to Super Snaps
Chapter 1: Getting the Lay of the Land
Chapter 2: Taking Great Pictures, Automatically
Chapter 3: Controlling Picture Quality65
Chapter 4: Monitor Matters: Picture Playback, Live View, and Movie Mode
Part 11: Taking Creative Control 129
Chapter 5: Getting Creative with Exposure and Lighting
Chapter 6: Manipulating Focus and Color185
Chapter 7: Putting It All Together
Part 111: Working with Picture Files
Chapter 8: Downloading, Organizing, and Archiving Your Photos
Chapter 9: Printing and Sharing Your Photos273
Part IV: The Part of Tens
Chapter 10: Ten Fast Photo-Editing Tricks
Chapter 11: Ten Special-Purpose Features to Explore on a Rainy Day
Index

Table of Contents

.

000

.....

Introduction	1
A Quick Look at What's Ahead Part I: Fast Track to Super Snaps Part II: Taking Creative Control Part III: Working with Picture Files Part IV: The Part of Tens Icons and Other Stuff to Note	2 3 3 4
About the Software Shown in This Book Practice, Be Patient, and Have Fun!	
Part 1: Fast Track to Super Snaps	
Chapter 1: Getting the Lay of the Land	9
Getting Comfortable with Your Lens	10
Attaching a lens	
Removing a lens	
Using an IS (image stabilizer) lens	13
Shifting from autofocus to manual focus	14
Zooming in and out	15
Adjusting the Viewfinder Focus	15
Working with Memory Cards	17
Exploring External Camera Controls	18
Topside controls	
Back-of-the-body controls	
Front-left buttons	
Viewing and Adjusting Camera Settings	
Ordering from menus	
Using the Shooting Settings display	
Taking advantage of the Quick Control screen	
Decoding viewfinder data	
Checking the Camera Settings display	
Reviewing Basic Setup Options	
Setup Menu 1	
Setup Menu 2	
Setup Menu 3	
Three more customization options	37

Chapter 2: Taking Great Pictures, Automatically	
Getting Good Point-and-Shoot Results	
Exploring Basic Flash Options	
Using Red-Eye Reduction Flash	
Shooting in the Fully Automatic Modes	
Full Auto mode	
Automatic scene modes (a.k.a. Image Zone modes)	
Gaining More Control with Creative Auto	
Changing the Drive Mode	61
Chapter 3: Controlling Picture Quality	
Diagnosing Quality Problems	
Decoding the Quality Options	
Considering Resolution: Large, Medium, or Small?	70
Pixels and print quality	71
Pixels and screen display size	72
Pixels and file size	73
Resolution recommendations	75
Understanding File Type (JPEG or Raw)	76
JPEG: The imaging (and Web) standard	76
Raw (CR2): The purist's choice	79
My take: Choose Fine or Raw	
Chapter 4: Monitor Matters: Picture Playback, Live View,	
and Movie Mode	
Disabling and Adjusting Instant Review	
Viewing Images in Playback Mode	
Viewing multiple images at a time	
Jumping through images	
Rotating vertical pictures	
Zooming in for a closer view	
Viewing Picture Data	
Basic information display modes	
Shooting Information display	
Understanding Histogram display mode	
Deleting Photos	101
Erasing single images	
Erasing all images on your memory card	102
Erasing selected images	105
Protecting Photos	105
Using Your Monitor as a Viewfinder Enabling Live View	107
Taking a shot in Live View mode	
Customizing Live View shooting data	
Using the Quick Control screen in Live View mode	
Displaying an alignment grid	

_____ Table of Contents

Recording Movies	. 117
Changing the information display	
Setting basic recording options	
Shooting your first movie	
Playing movies	

Part 11: Taking Creative Control...... 129

Chapter 5: Getting Creative with Exposure and Lighting	131
Kicking Your Camera into Advanced Gear	132
Introducing the Exposure Trio: Aperture, Shutter Speed, and ISO.	
Understanding exposure-setting side effects	
Doing the exposure balancing act	141
Monitoring Exposure Settings	
Choosing an Exposure Metering Mode	
Setting ISO, f-stop, and Shutter Speed	148
Controlling ISO	148
Adjusting aperture and shutter speed	152
Sorting through Your Camera's Exposure-Correction Tools	155
Overriding autoexposure results with Exposure	
Compensation	
Improving high-contrast shots with Highlight Tone Priority.	158
Experimenting with Auto Lighting Optimization	161
Correcting lens vignetting with Peripheral Illumination	
Correction	
Locking Autoexposure Settings	
Bracketing Exposures Automatically	
Using Flash in Advanced Exposure Modes	
Understanding your camera's approach to flash	171
Adjusting flash power with Flash Exposure Compensation	
Locking the flash exposure	
Exploring more flash options	
Using an external flash unit	183
Chapter 6: Manipulating Focus and Color	185
Reviewing Focus Basics	185
Adjusting Autofocus Performance	
Selecting an autofocus point	
Changing the AF (autofocus) mode	
Autofocusing in Live View and Movie Modes	
Choosing the Live View or Movie mode autofocusing	
method	193
Quick mode autofocusing	195
-	

Canon EOS Rebel T1i/500D For Dummies _____

Using Live mode autofocusing	198
Using Live mode autofocus with face detection	
Manipulating Depth of Field	
Using A-DEP mode	
Checking depth of field	
Controlling Color	
Correcting colors with white balance	
Changing the white balance setting	
Creating a custom white balance setting	
Fine-tuning white balance settings	
Bracketing shots with white balance	
Choosing a Color Space: sRGB vs. Adobe RGB	
Taking a Quick Look at Picture Styles	221
Taking a Quick Look at Ficture Styles	
Chapter 7: Putting It All Together	
Recapping Basic Picture Settings	
Setting Up for Specific Scenes	
Shooting still portraits	
Capturing action	232
Capturing scenic vistas	
Capturing dynamic close-ups	239
Coping with Special Situations	
coping	

Part	111:	Working	with	Picture	Files	24	5
------	------	---------	------	---------	-------	----	---

Chapter 8: Downloading, Organizing, and Archiving	2/17
Your Photos	
Sending Pictures to the Computer	248
Connecting camera and computer	
Starting the transfer process	251
Downloading images with Canon tools	253
Using ZoomBrowser EX/ImageBrowser	
Getting acquainted with the program	
Viewing photos in full-screen mode	
Organizing your photos	
Processing Raw (CR2) Files	
Chapter 9: Printing and Sharing Your Photos	
Avoiding Printing Problems	
Check the pixel count before you print	
Allow for different print proportions	
Get print and monitor colors in sync	
Printing Online or In-Store	

xii

_____ Table of Contents

Printing from ZoomBrowser EX/ImageBrowser	
Preparing Pictures for E-Mail and Online Sharing	
Creating an In-Camera Slide Show	
Viewing Your Photos on a Television	
Part 1V: The Part of Tens	. 299
Chapter 10: Ten Fast Photo-Editing Tricks	301
Removing Red-Eye	
Cropping Your Photo	
Adjusting Color Saturation	
Tweaking Color Balance	
Adjusting Exposure	
Three-point exposure control with the Level Adjustment	
filter	
Gaining more control with the Tone Curve Adjustment	
filter	
Sharpening Focus (Sort Of)	
Shifting to AutoPilot	
Adding Text	
Saving Your Edited Files	
Chapter 11: Ten Special-Purpose Features to Explore	
on a Rainy Day	327
Changing the Function of the Set Button	
Customizing Exposure and Focus Lock Options	
Disabling the AF-Assist Beam	
Enabling Mirror Lockup	
Adding Cleaning Instructions to Images	
Turning Off the Shooting Settings Screen	
Adding Original Decision Data	
Creating Your Very Own Camera Menu	
Tagging Files with Your Copyright Claim	
Getting Free Help and Creative Ideas	
1	2/2
Index	. 343

Canon EOS Rebel T1i/500D For Dummies

xiv

Introduction

n 2003, when Canon introduced the very first under-\$1,000 digital SLR camera, the EOS Digital Rebel/300D, it revolutionized the camera scene. For the first time, photography enthusiasts could enjoy the benefits of digital SLR photography without breaking the bank. And even at the then-unheard-of price, the camera delivered exceptional performance and picture quality, earning it rave reviews and multiple industry awards. No wonder it quickly became a best seller.

That tradition of excellence and value lives on in the EOS Rebel T1i/500D. Like its ancestors, this baby offers the range of advanced controls that experienced photographers demand plus an assortment of tools designed to help beginners to be successful as well. Adding to the fun, this camera also brings a brand new feature to the Rebel line: the option to record short, highdefinition digital movies.

This Rebel is so feature-packed, in fact, that it can be a challenge to sort everything out, especially if you're new to digital photography, SLR photography, or both. For starters, you may not even be sure what SLR means or how it affects your picture taking, let alone have a clue as to all the other techie terms you encounter in your camera manual — resolution, aperture, white balance, format, and so on. And if you're like many people, you may be so overwhelmed by all the controls on your camera that you haven't yet ventured beyond fully automatic picture-taking mode. And that's a shame because it's sort of like buying a Porsche and never actually taking it on the road.

Therein lies the point of *Canon EOS Rebel T1i/500D For Dummies*. Through this book, you can discover not just what each bell and whistle on your camera does, but also when, where, why, and how to put it to best use. Unlike many photography books, this one doesn't require any previous knowledge of photography or digital imaging to make sense of things, either. In classic *For Dummies* style, everything is explained in easy-to-understand language, with lots of illustrations to help clear up any confusion.

In short, what you have in your hands is the paperback version of an in-depth photography workshop tailored specifically to your Canon picture-taking powerhouse. Whether your interests lie in taking family photos, exploring nature and travel photography, or snapping product shots for your business, you'll get the information you need to capture the images you envision.

A Quick Look at What's Ahead

This book is organized into four parts, each devoted to a different aspect of using your camera. Although chapters flow in a sequence that's designed to take you from absolute beginner to experienced user, I also tried to make each chapter as self-standing as possible so that you can explore the topics that interest you in any order you please.

The following sections offer brief previews of each part. If you're eager to find details on a specific topic, the index shows you exactly where to look.

Part 1: Fast Track to Super Snaps

Part I contains four chapters that help you get up and running with your Rebel T1i/500D:

- Chapter 1, "Getting the Lay of the Land," offers a tour of the external controls on your camera, shows you how to navigate camera menus to access internal options, and walks you through initial camera setup and customization steps.
- Chapter 2, "Taking Great Pictures, Automatically," shows you how to get the best results when using the camera's fully automatic exposure modes, including Portrait, Sports, and Landscape modes. It also features the new Creative Auto mode, which makes it easy for you to take a little more artistic control over your photos.
- Chapter 3, "Controlling Picture Quality," introduces you to one setting that's critical whether you shoot in automatic or manual mode: the Quality setting, which affects resolution (pixel count), file format, file size, and picture quality.
- Chapter 4, "Monitor Matters: Picture Playback, Live View, and Movie Mode" explains how to review your pictures on the camera monitor, delete unwanted images, and protect your favorites from accidental erasure. In addition, this chapter introduces you to Live View shooting, in which you can use your monitor as a viewfinder, and explains your camera's movie-recording features.

Part 11: Taking Creative Control

Chapters in this part help you unleash the full creative power of your camera by moving into semiautomatic or manual photography modes.

Chapter 5, "Getting Creative with Exposure and Lighting," covers the all-important topic of exposure, starting with an explanation of three critical exposure controls: aperture, shutter speed, and ISO. This chapter also discusses your camera's advanced exposure modes (P, Tv, Av, M, and A-DEP), explains exposure options such as metering mode and exposure compensation, and offers tips for using the built-in flash.

- Chapter 6, "Manipulating Focus and Color," provides help with controlling those aspects of your pictures. Look here for information about your camera's automatic and manual focusing features as well as details about color controls such as white balance and the Picture Style options.
- Chapter 7, "Putting It All Together," summarizes all the techniques explained in earlier chapters, providing a quick-reference guide to the camera settings and shooting strategies that produce the best results for specific types of pictures: portraits, action shots, landscape scenes, close-ups, and more.

Part 111: Working with Picture Files

This part of the book, as its title implies, discusses the often-confusing aspect of moving your pictures from camera to computer and beyond.

- Chapter 8, "Downloading, Organizing, and Archiving Your Photos," guides you through the process of transferring pictures from your camera memory card to your computer's hard drive or other storage device. Just as important, this chapter explains how to organize and safeguard your photo files.
- Chapter 9, "Printing and Sharing Your Photos," helps you turn your digital files into "hard copies," covering both retail and do-it-yourself printing options. This chapter also explains how to prepare your pictures for online sharing and, for times when you have the neighbors over, how to display your pictures on a television screen.

Part 1V: The Part of Tens

In famous *For Dummies* tradition, the book concludes with two "top ten" lists containing additional bits of information and advice.

- Chapter 10, "Ten Fast Photo-Editing Tricks," shows you how to fix lessthan-perfect images using the free software provided with your camera. You can find out how to remove red-eye, adjust color and exposure, crop your photos, and more.
- Chapter 11, "Ten Special-Purpose Features to Explore on a Rainy Day," presents information about some camera features that, while not found on most "Top Ten Reasons I Bought My Rebel T1i/500D" lists, are nonetheless interesting, useful on occasion, or a bit of both.

Icons and Other Stuff to Note

If this isn't your first *For Dummies* book, you may be familiar with the large, round icons that decorate its margins. If not, here's your very own icondecoder ring:

I apply this icon either to introduce information that's especially worth storing in your brain's long-term memory or to remind you of a fact that may have been displaced from that memory by some other pressing fact.

When you see this icon, look alive. It indicates a potential danger zone that can result in much wailing and teeth-gnashing if ignored.

Lots of information in this book is of a technical nature — digital photography is a technical animal, after all. But if I present a detail that is useful mainly for impressing your technology-geek friends, I mark it with this icon.

A Tip icon flags information that will save you time, effort, money, or some other valuable resource, including your sanity.

Additionally, I need to point out a few other details that will help you use this book:

- Other margin art: Replicas of some of your camera's buttons and onscreen graphics also appear in the margins of some paragraphs and in some tables. I include these to provide a quick reminder of the appearance of the button or option being discussed.
- ✓ Software menu commands: In sections that cover software, a series of words connected by an arrow indicates commands that you choose from the program menus. For example, if a step tells you to "Choose File-⇒Print," click the File menu to unfurl it and then click the Print command on the menu.
- Camera firmware: Firmware is the internal software that controls many of your camera's operations. This book was written using version 1.0.9 of the firmware, which was the most current at the time of publication.

Occasionally, Canon releases firmware updates, and it's a good idea to check the Canon Web site (www.canon.com) periodically to find out whether any updates are available. (Chapter 1 tells you how to determine which firmware version your camera is running.) Firmware updates typically don't carry major feature changes — they're mostly used to solve technical glitches in existing features — but if you do download an update, be sure to read the accompanying description of what it accomplishes so that you can adapt my instructions as necessary.

AFMEMBER

About the Software Shown in This Book

Providing specific instructions for performing photo organizing and editing tasks requires that I feature specific software. In sections that cover file downloading, organizing, printing, and e-mail sharing, I selected Canon EOS Utility along with Canon ZoomBrowser EX (for Windows users) and ImageBrowser (for Mac users). These programs are part of the free software suite that ships with your camera.

Rest assured, though, that the tools used in these programs work very similarly in other programs, so you should be able to easily adapt the steps to whatever software you use. (I recommend that you read your software manual for details, of course.)

Practice, Be Patient, and Have Fun!

To wrap up this preamble, I want to stress that if you initially think that digital photography is too confusing or too technical for you, you're in very good company. *Everyone* finds this stuff a little mind-boggling at first. So take it slowly, experimenting with just one or two new camera settings or techniques at first. Then, each time you go on a photo outing, make it a point to add one or two more shooting skills to your repertoire.

I know that it's hard to believe when you're just starting out, but it really won't be long before everything starts to come together. With some time, patience, and practice, you'll soon wield your camera like a pro, dialing in the necessary settings to capture your creative vision almost instinctively.

So without further ado, I invite you to grab your camera, a cup of whatever it is you prefer to sip while you read, and start exploring the rest of this book. Your Rebel T1i/500D is the perfect partner for your photographic journey, and I thank you for allowing me, through this book, to serve as your tour guide.

Canon EOS Rebel T1i/500D For Dummies _____

6

Part I Fast Track to Super Snaps

This part shows you how to take best advantage of your camera's automatic features and also addresses some basic setup steps, such as adjusting the viewfinder to your eyesight and getting familiar with the camera menus, buttons, and dials. In addition, chapters in this part explain how to obtain the very best picture quality, whether you shoot in an automatic or manual mode, how to review your photos, and how to use your camera's Live View and movie-making features.

Getting the Lay of the Land

In This Chapter

- Attaching and using an SLR lens
- Working with camera memory cards
- Getting acquainted with external camera controls
- Decoding viewfinder and monitor information
- Selecting options from menus
- Using the Shooting Settings and Quick Control displays

M1 31

Customizing basic camera operations

still remember the day that I bought my first SLR film camera. I was excited to finally move up from my point-and-shoot camera, but I was a little anxious, too. My new pride and joy sported several unfamiliar buttons and dials, and the explanations in the camera manual clearly were written for someone with an engineering degree. And there was the whole business of attaching the lens to the camera, an entirely new task for me. I saved my pennies a long time for that camera — what if my inexperience caused me to damage the thing before I even shot my first pictures?

.

You may be feeling similarly insecure if your Rebel T1i/500D is your first SLR, although some of the buttons on the camera back may look familiar if you've previously used a digital point-and-shoot camera. If your Rebel is both your first SLR and first digital camera, you may be doubly intimidated.

Trust me, though, that your camera isn't nearly as complicated as its exterior makes it appear. With a little practice and the help of this chapter, which introduces you to each external control, you'll quickly become as comfortable with your camera's buttons and dials as you are with the ones on your car's dashboard. This chapter also guides you through the process of mounting and using an SLR lens, working with digital memory cards, and navigating your camera's internal menus. Finally, the end of the chapter walks you through options that enable you to customize many aspects of your camera's basic operation.

Before you start exploring this chapter, be sure that you fully charge your camera battery and then install it into the battery chamber on the bottom of the camera. I'm guessing that you already took this step, but if not and you need help, the front part of the camera manual provides details.

Getting Comfortable with Your Lens

One of the biggest differences between a point-and-shoot camera and an SLR *(single-lens reflex)* camera is the lens. With an SLR, you can swap out lenses to suit different photographic needs, going from an extreme close-up lens to a super-long telephoto, for example. Additionally, an SLR lens has a movable focusing ring that gives you the option of focusing manually instead of relying on the camera's autofocus mechanism.

Of course, those added capabilities mean that you need a little background information to take full advantage of your lens. To that end, the next three sections explain the process of attaching, removing, and using this critical part of your camera.

Attaching a lens

Your camera can accept two categories of Canon lenses: those with an EF-S design and those with a plain-old EF design.

The EF stands for *electro focus;* the S, for *short back focus.* And no, you don't need to remember what the abbreviation stands for — just make sure that if you buy a Canon lens other than the one sold with the camera, it carries either the EF or EF-S specification. (The letters are part of the lens name; for example, the kit lens name is EF-S 18-55mm IS, with the IS standing for *image stabilization,* a feature explained later in this chapter.) If you want to buy a non-Canon lens, check the lens manufacturer's Web site to find out which lenses work with the Rebel T1i/500D.

Whatever lens you choose, follow these steps to attach it to the camera body:

- 1. Remove the cap at covers the lens mount on the front of the camera.
- 2. Remove the cap that covers the back of the lens.

3. Locate the proper lens mounting index on the camera body.

A *mounting index* is simply a marker that tells you where to align the lens with the camera body when connecting the two. Your camera has two of these markers, one red and one white, as shown in Figure 1-1.

Which marker you use to align your lens depends on the lens type:

- Canon EF-S lens: The white square is the mounting index.
- *Canon EF lens:* The red dot is the mounting index.

If you buy a non-Canon lens, check the lens manual for help with this step.

4. Align the mounting index on the lens with the correct one on the camera body.

The lens also has a mounting index; Figure 1-2 shows the one that appears on the so-called "kit lens" — the EF-S 18–55mm IS (image stabilizer) zoom lens that Canon sells as a unit with the Rebel T1i/500D. If you buy a different lens, the index marker may be red or some other color, so again, check the lens instruction manual.

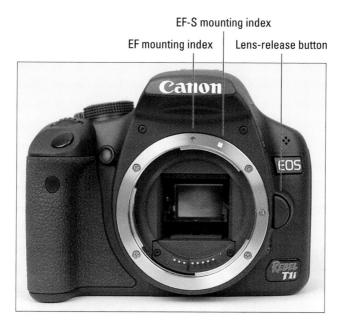

Figure 1-1: Which index marker you should use depends on the lens type.

5. Keeping the mounting indexes aligned, position the lens on the camera's lens mount.

When you do so, grip the lens by its back collar as shown in the figure.

6. Turn the lens in a clockwise direction until the lens clicks into place.

In other words, turn the lens toward the lens-release button (see Figure 1-1), as indicated by the red arrow in Figure 1-2.

Always attach (or switch) lenses in a clean environment to reduce the risk of getting dust, dirt, and other contaminants inside the camera or lens. Changing lenses on a sandy beach, for example, ian't a good idea. For added actact

isn't a good idea. For added safety,

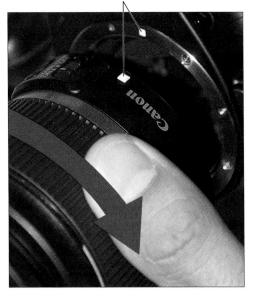

EF-S mounting indexes

Figure 1-2: Place the lens in the lens mount with the mounting indexes aligned.

point the camera body slightly down when performing this maneuver, as shown in the figure. Doing so helps prevent any flotsam in the air from being drawn into the camera by gravity.

Removing a lens

To detach a lens from the camera body, take these steps:

1. Locate the lens-release button on the front of the camera.

I labeled the button in Figure 1-1.

2. Grip the rear collar of the lens.

In other words, hold onto the stationary part of the lens that's closest to the camera body.

3. Press the lens-release button while turning the lens away from the lens-release button.

You should feel the lens release from the mount at this point. Lift the lens off the mount to remove it.

4. Place the rear protective cap onto the back of the lens.

If you aren't putting another lens on the camera, cover the lens mount with the protective cap that came with your camera, too.

Using an 1S (image stabilizer) lens

The 18–55mm lens sold with the Rebel T1i/500D camera offers *image stabilization*. On Canon lenses, this feature is indicated by the initials *IS* in the lens name.

Image stabilization attempts to compensate for small amounts of camera shake that are common when photographers handhold their cameras and use a slow shutter speed, a lens with a long focal length, or both. Camera shake is a problem because it can result in blurry images, even when your focus is dead-on. Although image stabilization can't work miracles, it does enable most people to capture sharper handheld shots in many situations than they otherwise could.

However, when you use a tripod, image stabilization can have detrimental effects because the system may try to adjust for movement that isn't actually occurring. Although this problem shouldn't be an issue with most Canon IS lenses, if you do see blurry images while using a tripod, try setting the Stabilizer switch (shown in Figure 1-3) to Off. You also can save battery power by turning off image stabilization when you use a tripod.

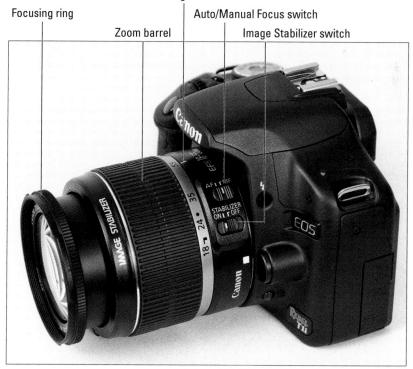

Focal length marker

Figure 1-3: Set the focusing switch to MF before turning the manual focus ring.

If you use a non-Canon lens, the image stabilization feature may go by another name: *anti-shake, vibration compensation,* and so on. In some cases, the manufacturers may recommend that you leave the system turned on or select a special setting when you use a tripod, so be sure to check the lens manual for information.

Whatever type of lens you use, note that image stabilization isn't meant to eliminate the blur that can occur when your subject moves during the exposure. That problem is related to shutter speed, a topic you can explore in Chapter 5. Chapter 6 offers more tips for blur-free shots and explains focal length and its effect on your pictures.

Shifting from autofocus to manual focus

Like any modern camera, yours offers autofocusing capabilities. Your Rebel T1i/500D offers an excellent autofocusing system, which you can find out how to exploit to its best advantage in Chapter 6. With some subjects, how-ever, autofocusing can be slow or impossible, which is why your camera also offers manual focusing.

You make the shift from auto to manual focus as follows:

1. Locate the AF/MF switch on the side of the lens.

This switch sets the focus operation to either auto (AF) or manual (MF). Figure 1-3 shows you the switch as it appears on the Rebel T1i/500D kit lens. The switch should be in a similar location on other Canon lenses. If you use a lens from another manufacturer, check the lens instruction manual.

2. Set the switch to the MF position, as shown in the figure.

3. Look through the viewfinder and twist the focusing ring until your subject comes into focus.

On the kit lens, the focusing ring is at the far end of the lens barrel, as indicated in Figure 1-3. If you use another lens, the focusing ring may be located elsewhere, so check your lens manual.

If you have trouble focusing, you may be too close to your subject; every lens has a minimum focusing distance. (For the kit lens, the minimum close-focus range is about 10 inches; for other lenses, check the specifications in the lens manual.) You also may need to adjust the viewfinder to accommodate your eyesight; see the next section for details.

Some lenses enable you to use autofocusing to set the initial focusing point and then fine-tune focus manually. Check your lens manual for information on how to use this option, if available. (It's not offered on the kit lens.)

Zooming in and out

If you bought a zoom lens, it sports a movable zoom barrel. On the kit lens, the barrel is just behind the focusing ring, as shown in Figure 1-3, but again, the relative positioning of the two components depends on your lens. Whatever the lens model, though, you rotate the lens barrel to zoom.

The numbers around the edge of the zoom barrel, by the way, represent *focal lengths*. I explain focal lengths in Chapter 6. In the meantime, just note that when the lens is mounted on the camera, the number that's aligned with the white focal-length indicator, labeled in Figure 1-3, represents the current focal length. In Figure 1-3, for example, the focal length is 55mm.

Adjusting the Viewfinder Focus

Perched on the top-right edge of the viewfinder is a tiny black knob, labeled in Figure 1-4. Officially known as a *dioptric adjustment control*, this knob enables you to adjust the magnification of the viewfinder to mesh with your eyesight.

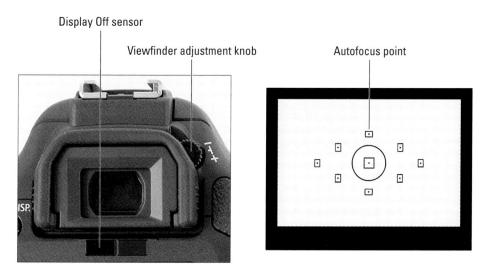

Figure 1-4: Use the little knob to set the viewfinder focus for your eyesight.

Part I: Fast Track to Super Snaps

Adjusting the viewfinder to your eyesight is critical: If you don't, scenes that appear out-of-focus through the viewfinder may actually be sharply focused through the lens, and vice versa.

Follow these steps to adjust your viewfinder:

- 1. Remove the lens cap from the front of the lens.
- 2. Look through the viewfinder and concentrate on the focusing screen shown on the right side of Figure 1-4.

The *focusing screen* is the collective name assigned to the group of nine autofocus points that appears in the viewfinder — the little squares with the dots inside. I labeled one of the little guys in Figure 1-4. (The circle that surrounds the center autofocus point is related to exposure metering, a subject you can explore in Chapter 5.)

3. Rotate the viewfinder adjustment knob until the autofocus points appear to be in focus.

Don't worry about focusing the actual picture now; just pay attention to the sharpness of the autofocus points.

If your eyesight is such that you can't get the autofocus points to appear sharp by using the dioptric adjustment control, you can buy an additional eyepiece adapter. This accessory, which you pop onto the eyepiece, enables further adjustment of the viewfinder display. Prices range from about \$15–\$30 depending on the magnification you need. Look for an adapter called an *E-series dioptric adjustment lens*.

One other note about the viewfinder: See that little black window underneath the viewfinder — the one labeled Display Off sensor in Figure 1-4? When you put your eye up to the viewfinder, the sensor tells the camera to turn off the monitor display, saving you the trouble of doing the job yourself. If the monitor doesn't turn off automatically, the upcoming section "Setup Menu 1" tells you how to fix things; see the information related to the LCD Auto Off feature.

Keep in mind, too, that with the T1i/500D, you can opt to use the monitor instead of the viewfinder to frame and preview your shots. This feature is called *Live View* shooting. Because many of the functions connected with Live View shooting are similar to those you use during picture playback, I cover both uses of your monitor together in Chapter 4. Chapters 5 and 6 spell out some additional details of setting exposure and focus in Live View mode.

Working with Memory Cards

Instead of recording images on film, digital cameras store pictures on *memory cards*. Your Rebel T1i/500D uses a specific type of memory card called an *SD card* (for *Secure Digital*), shown in Figures 1-5 and 1-6. You can also use high-capacity SD cards, which carry the label SDHC. (The high-capacity part just means that you can store more files on these cards than on regular SD cards.)

For movie recording, Canon recommends that you purchase a high-capacity card that carries an SD *speed class* rating of 6 or higher. This number refers to how quickly data can be written to and read from the card. A higher-speed card helps ensure the smoothest movie recording and playback.

Whatever the speed or capacity, safeguarding your memory cards — and the images on them — requires a few precautions:

- Inserting a card: Turn the camera off and then put the card in the card slot with the label facing the back of the camera, as shown in Figure 1-5. Push the card into the slot until it clicks into place.
- ✓ Formatting a card: The first time you use a new memory card, take a few seconds to *format* it by choosing the Format option on Setup Menu 1. This step ensures that the card is properly prepared to record your pictures. See the upcoming section "Setup Menu 1" for details.
- Removing a card: First, check the status of the memory card access light, labeled in Figure 1-5. After making sure that the light is off, indicating that the camera has finished recording

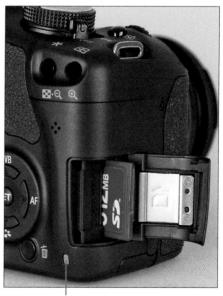

Memory card access light

Figure 1-5: Insert the card with the label facing the camera back.

your most recent photo, turn the camera off. Open the memory card door, as shown in Figure 1-5. Depress the memory card slightly until you hear a little click and then let go. The card should pop halfway out of the slot, enabling you to grab it by the tail and remove it.

- Handling cards: Don't touch the gold contacts on the back of the card. (See the left card in Figure 1-6.) When cards aren't in use, store them in the protective cases they came in or in a memory card wallet. Keep cards away from extreme heat and cold as well.
- Locking cards: The tiny switch on the left side of the card, labeled *lock switch* in Figure 1-6, enables you to lock your card, which prevents any data from being erased or recorded to the card. Press the switch toward the bottom of the card to lock the card contents; press it toward the top of the card to unlock the data.

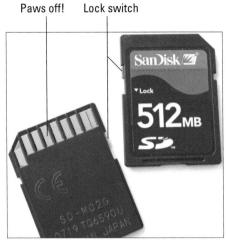

Figure 1-6: Avoid touching the gold contacts on the card.

Exploring External Camera Controls

Scattered across your camera's exterior are a number of buttons, dials, and switches that you use to change picture-taking settings, review and edit your photos, and perform various other operations.

Later chapters discuss all of your camera's functions in detail and provide the exact steps to follow to access those functions. The next three sections provide a basic road map to the external controls plus a quick introduction to each.

Topside controls

Your virtual tour begins on the top-right side of the camera, shown in Figure 1-7.

The items of note here are

On/Off switch: Okay, I'm pretty sure you already figured this one out, but just move the switch to On to fire up the camera and then back to Off to shut it down.

Chapter 1: Getting the Lay of the Land

By default, the camera automatically shuts itself off after 30 seconds of inactivity to save battery power. To wake up the camera, press the shutter button halfway or press the Menu, DISP, or Playback buttons. You can adjust the auto shutdown timing via Setup Menu 1, covered later in this chapter.

✓ Mode dial: Rotate this dial to select an *exposure* mode, which determines whether the camera operates in fully automatic, semi-automatic, or manual exposure mode when you take still pictures. To shoot a movie, you set the dial to Movie mode. Mode dial Red-eye reduction/ self-timer lamp Shutter button Main dial ISO button

Figure 1-7: The tiny pictures on the Mode dial represent special automatic shooting modes.

Canon categorizes the various modes into zones:

- *Image Zone:* The camera offers six Image Zone settings designed to make it easy to automatically capture specific types of scenes Portrait mode for people pics, Sports mode for action shots, and so on. (Chapter 2 explains all six.)
- *Basic Zone:* The Basic Zone category includes the six Image Zone settings plus Full Auto mode and Creative Auto mode, also covered in Chapter 2.
- *Creative Zone:* The Creative Zone category includes the advanced exposure modes, (P, Tv, Av, M, and A-DEP), which I introduce in Chapter 5.

Movie mode is apparently outside the zoning limits, as it stands on its own, with no zone moniker.

If you ask me, keeping track of all these zones is a little confusing, especially because the modes in the Image Zone category are often referred to generically in photography discussions as *creative scene modes* or *creative modes*. So, to keep things a little simpler, I use the generic terms fully automatic exposure modes to refer to all the Basic Zone modes and *advanced exposure modes* to refer to the Creative

Zone modes. For Creative Auto mode, which straddles the line between fully automatic and advanced, I use its full name to avoid inserting my own bit of confusion into the mix.

- ✓ Main dial: Just forward of the Mode dial, you see a black dial that has the official name *Main dial*. You use this dial when selecting many camera settings (specifics are provided throughout the book). In fact, it plays such an important role that you'd think it might have a more auspicious name, but Main dial it is.
- ✓ ISO button: During normal, still photography, this button provides one way to access the camera's ISO speed setting, which determines how sensitive the camera is to light. Chapter 5 details this critical exposure setting. When you're shooting movies, pressing the button instead initiates AE Lock, a feature that locks autoexposure at its current setting. Check out Chapter 4 for details.
- ✓ Shutter button: You probably already understand the function of this button, too. But see Chapter 2 to discover the proper shutter-button-pressing technique you'd be surprised how many people mess up their pictures because they press that button incorrectly.
- ✓ Red-Eye Reduction/Self-Timer Lamp: When you set your flash to Red-Eye Reduction mode, this little lamp emits a brief burst of light prior to the real flash the idea being that your subjects' pupils will constrict in response to the light, thus lessening the chances of red-eye. If you use the camera's self-timer feature, the lamp blinks to provide you with a visual countdown to the moment at which the picture will be recorded. See Chapter 2 for more details about Red-Eye Reduction flash mode and the self-timer function.

Back-of-the-body controls

Traveling over the top of the camera to its back, you encounter a smorgasbord of buttons — 13, in fact, not including the viewfinder adjustment knob, discussed earlier in this chapter. Figure 1-8 gives you a look at the layout of backside controls.

Don't let the abundance of buttons intimidate you. Having all of those external controls actually makes operating your camera easier. On cameras that have only a few buttons, you have to dig through menus to access the camera features, which is a pain. But you can access almost every critical shooting setting on your camera via external buttons, which is much more convenient.

Chapter 1: Getting the Lay of the Land

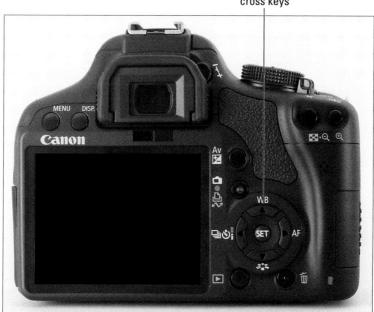

Set button and cross keys

Figure 1-8: Having lots of external buttons makes accessing the camera's functions easier.

Throughout this book, pictures of some of these buttons appear in the margins to help you locate the button being discussed. So even though I provide the official control names in the following list, don't worry about getting all of those straight right now. The list I provide here is just to get you acquainted with the *possibility* of what you can accomplish with all of these features.

Do note, however, that many of the buttons have multiple names because they serve multiple purposes depending on whether you're taking pictures, reviewing images, or performing some other function. In this book, I refer to these buttons by the first label you see in the following list to simplify things. For example, I refer to the AF Point Selection/Magnify button as the AF Point Selection button. Again, though, the margin icons help you know exactly which button I'm describing.

And here's another tip: If the label or icon for a button is blue, it indicates a function related to viewing, printing, or downloading images. Labels that indicate a shooting-related function are white, and the sole red label indicates a button purpose related to Live View and movie shooting.

With that preamble out of the way, journey with me now over the camera back, starting at the top-right corner and working westward (well, assuming that your lens is pointing north, anyway):

✓ AF Point Selection/Magnify button: When you use certain advanced shooting modes, you press this button to specify which of the nine autofocus points you want the camera to use when establishing focus. Chapter 6 tells you more. In Playback, Live View, and Movie mode, you use the button to magnify the image display (thus the plus sign in the button's magnifying glass icon). See Chapter 4 for help with that function.

✓ AE Lock/FE Lock/Index/Reduce button: As you can guess from the official name of this button, it serves many purposes. The first two are related to still-image capture functions: You use the button to lock in the autoexposure (AE) settings and to lock flash exposure (FE). Chapter 5 details both issues. When using Live View and Movie modes, the button serves as the autofocus and autoexposure trigger.

The button also serves two image-viewing functions: It switches the display to Index mode, enabling you to see multiple image thumbnails at once, and it reduces the magnification of images when displayed one at a time. Chapter 4 explains Playback, Live View, and Movie modes.

Exposure Compensation/Aperture button: When you work in M (manual) exposure mode, you press this button and rotate the Main dial to choose the aperture setting, better known as the *fstop*. In the other advanced exposure modes, you instead use the button and dial to apply *Exposure Compensation*, a feature that enables you to adjust the exposure selected by the camera's autoexposure mechanism. Chapter 5 discusses both issues.

- Live View/Movie/Print/Share button: You press this button to shift the camera into Live View mode and, when shooting movies, to start and stop recording. (For the latter, you must first set the Mode dial to Movie mode.) Chapter 4 offers the pertinent details. This button is also involved when you transfer images to your computer or print pictures directly from the camera; check out Chapters 8 and 9 for information about those topics.
- ✓ Set button and cross keys: Figure 1-8 points out the Set button and the four surrounding buttons, known as cross keys. These buttons team up to perform several functions, including choosing options from the camera menus. You use the cross keys to navigate through menus and then press the Set button to select a specific menu setting. You can find out more about ordering from menus later in this chapter.

In this book, the instruction "Press the left cross key" means to press the one that sports the left-pointing arrowhead. "Press the up cross key" means to press the one with the up-pointing arrowhead, and so on. The cross keys and the Set button also have non-menu responsibilities, as follows:

- After displaying the Shooting Settings screen, press the Set button to shift to the Quick Control screen. The Quick Control screen is just one option for adjusting picture-taking settings; get the full story in the upcoming section "Taking Advantage of the Quick Control screen."
- *Press the right cross key to adjust the AF mode.* This option controls the camera's autofocus behavior, as outlined in Chapter 6.
- *Press the left cross key to change the Drive mode.* The Drive mode settings enable you to switch the camera from single-frame shooting to continuous capture or self-timer/remote-control shooting. See Chapter 2 for details.
- *Press the down cross key to change the Picture Style.* Chapter 6 explains Picture Styles, which you can use to adjust color, contrast, and sharpness of your pictures.
- *Press the up cross key to change the White Balance setting.* The White Balance control, explained near the end of Chapter 6, enables you to ensure that your photo colors are accurate and not biased by the color of the light source.

You can customize the function of the Set button; Chapter 11 explains how. But while you're working with this book, stick with the default setup, just described. Otherwise, the instructions I give won't work.

- Playback button: Press this button to switch the camera into picturereview mode. Chapter 4 details playback features.
- Erase button: Sporting a trash can icon, the universal symbol for delete, this button lets you erase pictures from your memory card. Chapter 4 has specifics. In Live View and Movie mode, also covered in Chapter 4, this button is involved in the focusing process.
- Menu button: Press this button to access the camera menus. See the next section for details on navigating menus.
- ✓ DISP button: The Shooting Settings display, covered later in this chapter, appears automatically on the monitor when you turn on the camera. The screen shuts off after a period of inactivity, after which you can bring it back to life by either pressing the DISP button or pressing the shutter button halfway and then releasing it.

But that's just the start of the DISP button's tricks. If the camera menus are displayed, pressing the button takes you to the Camera Settings display, explained in the upcoming section "Viewing and Adjusting Camera Settings." In Playback, Live View, and Movie modes, pressing the button changes the picture-display style, as outlined in Chapter 4.

Front-left buttons

On the front-left side of the camera body, you find three more buttons, all labeled in Figure 1-9. This trio works as follows:

- Flash button: Press this button to bring the camera's built-in flash out of hiding when you use the advanced exposure modes (P, Tv, Av, M, or A-DEP). See Chapter 2 for help with using flash in the other exposure modes and flip to Chapters 5 and 7 for more tips on flash photography.
- Lens-release button: Press this button to disengage the lens from the lens mount so that you can remove it from the camera. See the first part of this chapter for details on mounting and removing lenses.
- ✓ Depth-of-Field Preview button: When you press this button, the image in the viewfinder offers an approximation of the depth of field that will result from your selected aperture setting, or f-stop. Depth of field refers to how much of the scene will be in sharp focus. Chapter 6 provides details on depth of field, which is an important aspect of your picture composition. Chapter 5 explains aperture and other exposure settings.

Flash button Lens-release button

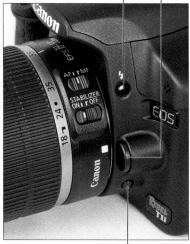

Depth-of-Field Preview button

Figure 1-9: Press the Flash button to bring the built-in flash out of hiding.

Viewing and Adjusting Camera Settings

You've no doubt already deduced that your Rebel T1i/500D is loaded with options. It also gives you several ways to monitor the current settings and to adjust them if needed. The next sections provide just a quick introduction to viewing and changing settings; in later chapters, I explain and illustrate exactly how and where to access individual options. (Note, too, that the information here relates to regular shooting modes — if you switch to Live View or Movie mode, things work differently. You can get the scoop on those two modes in Chapter 4.)

Ordering from menus

You access many of your camera's features via internal menus, which, conveniently enough, appear on the monitor when you press the Menu button, located atop the upper-left corner of the camera back. Features are grouped into nine menus, described briefly in Table 1-1.

In case you didn't notice, the icons that represent the menus are color coded. Shooting Menus 1 and 2 have red icons, as does the Movie menu; Setup Menus 1, 2, and 3 sport yellow icons; the Playback menus have a blue symbol; and the My Menu icon is green. (Chapter 11 explains the My Menu feature, through which you can create your own, custom menu.)

Table 1-1		Rebel T1i/500D Menus	
Symbol	Open This Menu	to Access These Functions	
	Shooting Menu 1	Picture Quality settings, Red-Eye Reduction flash mode, and a few other basic camera settings.	
0:	Shooting Menu 2	Advanced photography options including Exposure Compensation, Metering mode, and custom White Balance. Appears only in P, Tv, Av, M, and A-DEP modes.	
▶.	Playback Menu 1	Rotate, protect, and erase pictures as well as functions related to transferring and printing directly from the camera.	
D :	Playback Menu 2	Additional playback features, including histogram display and image jump.	
٦ť	Setup Menu 1	Memory card formatting plus basic custom- ization options, such as the file-numbering system and auto shutdown timing.	
TT ^s	Setup Menu 2	More customization options, Live View options, and maintenance functions, such as sensor cleaning. Some options available only in advanced exposure modes.	
778	Setup Menu 3	Custom Functions, firmware information, and options for resetting camera functions to factory defaults; menu appears only in P, Tv, Av, M, and A-DEP modes.	
13	My Menu	User-customized menu setup; also available only in advanced exposure modes.	
Ъ.	Movie Menu	Settings related to shooting movies, includ- ing whether sound is recorded. Appears only when Mode dial is set to Movie mode.	

After you press the Menu button, a screen similar to the one shown on the left in Figure 1-10 appears. Along the top of the screen, you see the icons shown in Table 1-1, each representing a menu. (Remember that which icons appear depends on the setting of the Mode dial.)

The highlighted icon marks the active menu; options on that menu automatically appear on the main part of the screen. In the figure, Shooting Menu 1 is active, for example.

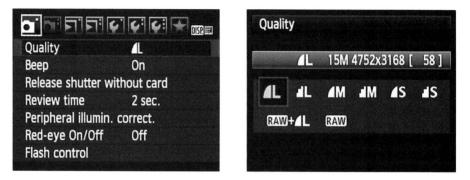

Figure 1-10: Use the cross keys to navigate menus; press Set to access available settings.

Shooting Menu 2, Setup Menu 3, and My Menu appear in the menu display only when you set the Mode dial to one of the advanced exposure modes (P, Tv, Av, M, and A-DEP). Some menu items on Setup Menu 2 are hidden as well in the fully automatic exposure modes. The Movie menu appears only when you set the Mode dial to the Movie setting.

I explain all the important menu options elsewhere in the book; for now, just familiarize yourself with the process of navigating menus and selecting options. After pressing the Menu button to display the menus, use these techniques:

- To select a different menu: Press the right or left cross keys or rotate the Main dial to cycle through the available menus.
- ✓ To select and adjust a function on the current menu: Press the up or down cross key to highlight the feature you want to adjust. On the left side of Figure 1-10, the Quality option is highlighted, for example. Next, press the Set button. Settings available for the selected item then appear either right next to the menu item or on a separate screen, as shown on the right side of the figure. Either way, use the cross keys to highlight your preferred setting and then press Set again to lock in your choice.

Using the Shooting Settings display

Shown in Figure 1-11, the Shooting Settings display contains the most important critical photography settings — aperture, shutter speed, ISO, and the like. Note that the display is relevant only to regular still-photography shooting, though. When you switch to Live View mode or Movie mode, you can choose to see some settings superimposed over your image in the monitor, but the process of adjusting settings and customizing the display is different. (See Chapter 4 for details.)

The types of data shown in the Shooting Settings display depend on the exposure mode you select. The figure shows data that's included when you work in one of the advanced modes, such as Tv (shutter-priority autoexposure). In the fully automatic modes as well as in Creative Auto mode, you see far fewer settings because you can control fewer settings in those modes. The figure does label two key points of data that are helpful in any mode, though: how many more pictures can fit on your memory card at the current settings and the status of the battery. A "full" battery icon like the one in the figure shows that the battery is fully charged. If the icon appears empty, go look for your battery charger.

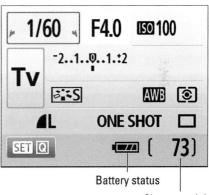

Shots remaining

Figure 1-11: The Shooting Settings display gives you an easy way to monitor current picture settings.

You can use the Shooting Settings display to both view and adjust certain picture-taking settings. Here's what you need to know:

- ✓ Turning on the Shooting Settings display: The display appears briefly when you turn on the camera. After the display shuts off, you can turn it on again by pressing the DISP button or by pressing the shutter button halfway and then releasing it. Or, if menus are on the screen, you can use only the shutter-button technique to go back to the Shooting Settings display. (Pressing the DISP button in that scenario has a different result.)
- Turning off the Shooting Settings display: As soon as you put your eye to the viewfinder, the display turns off automatically, and the viewfinder display becomes active. You can also press DISP to turn the display off if needed. If you use the button to turn off the display, press the button again to bring the display back to life; pressing the shutter button halfway doesn't do the trick.

Adjusting settings: While the Shooting Settings display is active, you can change some shooting settings by rotating the Main dial alone or by using the dial in combination with one of the camera buttons.

For example, in the shutter-priority autoexposure mode (Tv, on the Mode dial), rotating the Main dial changes the shutter speed. And if you press and hold the Exposure Compensation button, the Exposure Compensation meter becomes highlighted, as shown on the left in Figure 1-12, and you can rotate the Main dial to adjust the setting. Release the button to continue shooting.

Notice the tinted background and tiny curved arrows that surround the shutter speed value in Figure 1-11 and the Exposure Compensation meter in Figure 1-12? The tint indicates the active option; the curved arrows remind you to use the Main dial to adjust the setting.

In some cases, the camera displays a screen full of options instead of the curved arrows when you press a control button. Pressing the ISO button in the advanced exposure modes, for example, takes you to the screen you see on the right in Figure 1-12. You can then release the button and either rotate the Main dial or use the cross keys to select the setting you want to use. Press the Set button to lock in your choice and bring back the full Shooting Settings display.

1/60 F4.0 130 100	ISO speed
2101.:2	100
	AUTO 100 200 400 800
L ONE SHOT	1600 3200
SET Q (73)	

Figure 1-12: Pressing a control button either activates the highlighted setting (left) or takes you to a screen of available settings (right).

Taking advantage of the Quick Control screen

New to the Rebel T1i/500D is a feature called the Quick Control screen, which was previously offered only on Canon's higher-end pro cameras. This feature enables you to change certain shooting settings without using the control buttons (ISO button, the Exposure Compensation button, and so on) or menus.

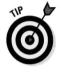

You can use this technique to adjust settings in any exposure mode, but the settings that are accessible depend on the mode you select. To try it out, set the Mode dial to Tv so that what you see on your screen will look like what you see in the upcoming figures. Then follow these steps:

1. Display the Shooting Settings screen.

Either press the shutter button halfway and then release it or press the DISP button.

2. Press the Set button.

The screen now shifts into Quick Control mode, and one of the options on the screen becomes highlighted. The option name also appears at the bottom of the screen, as shown on the left in Figure 1-13. In the figure, the Flash Exposure Compensation setting is selected. (This particular option doesn't appear on the screen until after you enter Quick Control mode *unless* you've previously enabled the function. See Chapter 5 for the full scoop.)

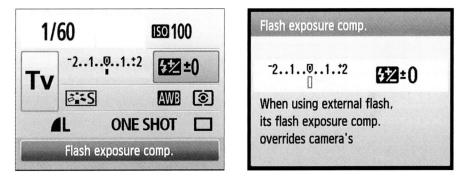

Figure 1-13: Press Set to shift to Quick Control mode; the active option appears highlighted.

3. Press the cross keys to move the highlight over the setting you want to adjust.

Again, the available options depend on the exposure mode, and the figure shows options presented in the Tv (shutter-priority autoexposure) mode.

4. Adjust the setting.

In general, you can use either of these two techniques:

• Rotate the Main dial to scroll through the possible settings.

• Press Set to display a screen that contains all the possible settings. In some cases, the screen contains a brief explanation or note about the option, as shown on the right in Figure 1-13. You then can choose between rotating the Main dial or pressing the cross keys to highlight the setting you want to use. Then press Set again to return to the Quick Control screen.

A few controls require a slightly different approach, but don't worry — I spell out all the needed steps throughout the book.

5. To exit Quick Control mode, press the shutter button halfway and release it.

You're returned to the normal Shooting Settings display.

Decoding viewfinder data

When the camera is turned on, you can view critical exposure settings and a few other pieces of information in the viewfinder. Just put your eye to the viewfinder and press the shutter button halfway to activate the display. (I'm assuming that Live View mode, in which you use the monitor as viewfinder, is disabled, as it is by default. Ditto for Movie mode. See Chapter 4 for details about both.)

The viewfinder data changes depending on what action you're undertaking and what exposure mode you're using. For example, if you set the Mode dial to P (for programmed autoexposure), you see the basic set of data shown in Figure 1-14: shutter speed, f-stop (aperture setting), Exposure Compensation setting, and ISO setting. Additional data is displayed when you enable certain features, such as Flash Exposure Compensation.

Again, I detail each viewfinder readout as I explain your camera options throughout the book. But I want to point out now one often-confused value you may see: The value at the far right end of the viewfinder (9, in the figure) shows you the number of *maximum burst frames*. This number relates to shooting in the Continuous capture mode, where the camera fires off multiple shots in rapid succession as long as you hold down the shutter button. (Chapter 2 has details on this mode.) Note that although the highest number that the viewfinder can display is 9, the actual number of maximum burst frames may be higher. At any rate, you don't really need to pay attention to the number until it starts dropping toward 0, which indicates that the camera's *memory buffer* (its temporary internal data-storage tank) is filling up. If that happens, just give the camera a moment to catch up with your shutter-button finger.

While you're looking through the viewfinder, you can adjust some shooting settings by using the Main dial alone or in conjunction with the function buttons, as you do with the Shooting Settings screen. For example, if you're working in one of the advanced exposure modes (P, Tv, Av, M, or A-DEP) and press the ISO button, all data but the current ISO setting dims, and you can then rotate the Main dial to change the setting. Press the shutter button half-way to return to the normal viewfinder display after changing the setting.

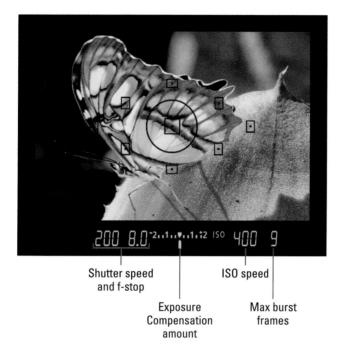

Checking the Camera Settings display

In addition to the Shooting Settings display, you can view a collection of additional settings data via the Camera Settings display, shown in Figure 1-15. This screen is purely an informational tool, however; you can't actually adjust any of the reported settings from this screen.

To display the Camera Settings screen, first display the camera menus by pressing the Menu button. Then press the DISP button.

Figure 1-15 shows the settings that you can monitor when shooting in the advanced exposure modes. Again, that's P, Tv, Av, M, and A-DEP. Here are the details you can glean from the display, with settings listed in the order they appear on the screen.

- Freespace: This value indicates how much storage space is left on your camera memory card. How many pictures you can fit into that space depends on the Quality setting you select. Chapter 3 explains this issue.
- ✓ Color Space: This value tells you whether the camera is capturing images in the sRGB or Adobe RGB color space, an advanced option that you can investigate in Chapter 6.

Freespace	392 MB
Color space	sRGB
WB SHIFT/BKT	0,0/±0
Live View show	ot. Enable
,⁺⊑+ Enable	⊚ Off
^z 1 min.	🙃 0n 🖸 💻
•))) On	C Enable
	04/29/2009 15:05:35

Figure 1-15: Press the DISP button when the menus are active to view this screen.

- ✓ White Balance Shift/Bracketing: Add this to the list of advanced color options covered in Chapter 6.
- Live View Shooting: Chapter 4 details this feature, which enables you to use your monitor instead of the viewfinder to compose your shots.
- Auto Sensor Cleaning and Red-Eye Reduction flash mode: (These two functions share a line in the screen.) See "Setup Menu 2," later in this chapter, for more about automatic sensor cleaning; check out Chapter 2 for information about Red-Eye Reduction flash mode.
- Auto Power Off and Auto Rotate: For information on these two settings, which also live together on the display, see the upcoming section, "Setup Menu 1."
- ✓ Beep and LCD Auto Off: The first setting determines whether the camera beeps after certain operations; you can adjust the setting via Shooting Menu 1, as explained later in this chapter. The second setting, covered in the section "Setup Menu 1," controls whether the Shooting Settings display turns off automatically when you put your eye to the viewfinder.
- ✓ Date/Time: The section "Setup Menu 2" also explains how to adjust the date and time.

In the fully automatic and Creative Auto exposure modes, the Color Space, White Balance Shift/Bracketing, and Live View Shooting status information doesn't appear in the Camera Settings display because you can't use those features in those exposure modes.

Of course, with the exception of the free card space value, you also can simply go to the menu that contains the option in question to check its status. The Camera Settings display just gives you a quick way to monitor some of the critical functions without hunting through menus.

Reviewing Basic Setup Options

One of the many advantages of investing in the Rebel T1i/500D is that you can customize its performance to suit the way *you* like to shoot. Later chapters explain options related to actual picture taking, such as those that affect flash behavior and autofocusing. The rest of this chapter details options related to initial camera setup, explaining how to accomplish such things as setting the date and time, setting up the camera's file-numbering system, and adjusting monitor brightness.

Setup Menu 1

At the risk of being labeled conventional, I suggest that you start your camera customization by opening Setup Menu 1, shown in Figure 1-16.

Here's a quick rundown of each menu item:

- Auto Power Off: To help save battery power, your camera automatically powers down after a certain period of inactivity. By default, the shutdown happens after 30 seconds, but you can change the shutdown delay to 1, 2, 4, 8, or 15 minutes. Or you can disable auto shutdown altogether by selecting the Off setting.
- File Numbering: This option controls how the camera names your picture files.
 - *Continuous:* This is the default; the camera numbers your files sequentially, from 0001 to 9999, and places all images in the same folder. The initial folder name is 100Canon; when you reach image 9999, the camera creates a new folder, named 101Canon, for your next 9,999 photos. This numbering sequence is retained even if you change memory cards, which helps to ensure that you don't wind up with multiple images that have the same filename.
 - *Auto Reset:* If you switch to this option, the camera restarts file numbering at 0001 each time you put in a different memory card. I discourage the use of this option, for the reason already stated.

- Whichever option you choose, beware one gotcha: If you swap out memory cards and the new card already contains images, the camera may pick up numbering from the last image on the new card, which throws a monkey wrench into things. To avoid this problem, format the new card before putting it into the camera. (See the upcoming Format bullet point for details.)
- *Manual Reset:* Select this setting if you want the camera to begin a new numbering sequence, starting at 0001, for your next shot. The camera then returns to whichever mode you previously used (Continuous or Auto Reset).

Part I: Fast Track to Super Snaps

Auto Rotate: If you enable this feature, your picture files include a piece of data that indicates whether the camera was oriented in the vertical or horizontal position when you shot the frame. Then, when you view the picture on the camera monitor or on your computer, the image is automatically rotated to the correct orientation.

To automatically rotate images both in the camera monitor and on your computer monitor, stick with the default setting. In the

Auto power off	30 sec.
File numbering	Continuous
Auto rotate	0n 🖸 💻
Format	
LCD auto off	Enable
Screen color	1

Figure 1-16: Options on Setup Menu 1 deal mainly with basic camera behavior.

menu, this setting is represented by On followed by a camera icon and a monitor icon, as shown in Figure 1-16. If you want the rotation to occur just on your computer and not on the camera, select the second On setting, which is marked with the computer monitor symbol but not the camera symbol. To disable rotation for both devices, choose the Off setting.

Note, though, that the camera may record the wrong orientation data for pictures that you take with the camera pointing directly up or down. Also, whether your computer can read the rotation data in the picture file depends on the software you use; the programs bundled with the camera can perform the auto rotation.

Format: The first time you insert a new memory card, use this option to *format* the card, a maintenance function that wipes out any existing data on the card and prepares it for use by the camera.

WARNING!

If you previously used your card in another device, such as a digital music player, be sure to copy those files to your computer before you format the card. You lose *all* data on the card when you format it, not just picture files.

When you choose the Format option from the menu, you can opt to perform a normal card formatting process or a *low-level* formatting. The latter gives your memory card a deeper level of cleansing than ordinary formatting and thus takes longer to perform. Normally, a regular formatting will do.

LCD Auto Off: When the Enable setting is selected, as it is by default, the camera automatically turns off the camera monitor if the Shooting Settings screen is displayed and you put your eye up to the camera view-finder. (The little sensor underneath the viewfinder notes the presence of your eye and signals the camera to turn off the monitor.) You can

deactivate this feature by choosing the Disable setting if you prefer. The monitor is one of the biggest battery drains on the camera, however, so in my opinion, the auto shutoff feature is a good thing.

The eye-detection thing only works when the Shooting Settings screen is active. So if the monitor is displaying menus or the Quick Control screen, press the shutter button halfway and release it to return to the Shooting Settings display. You then can either press DISP or put your eye to the viewfinder to turn off the monitor.

✓ Screen Color: If you don't like the default color scheme of the Shooting Settings display, which is the one used for the screens shown in this book, you can choose from three other schemes via this menu option.

Setup Menu 2

Setup Menu 2, shown in Figure 1-17, offers an additional batch of customization options:

LCD Brightness: This option enables you to make the camera monitor brighter or darker. After highlighting the option on the menu, as shown in Figure 1-17, press Set to display a screen similar to what you see in Figure 1-18. The camera displays a picture from your memory card; if the card is empty, you see a black box instead. Press the right and left cross keys to adjust the brightness setting. Press Set to finish the job and return to the menu.

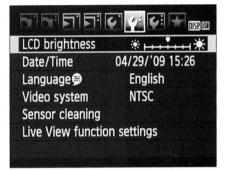

Figure 1-17: Setup Menu 2 offers more ways to customize basic operations.

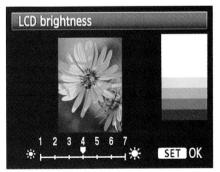

If you take this step, keep in mind that what you see on the display may not be an accurate rendition of the actual exposure of your image. Crank up the monitor brightness, for example, and an underexposed photo may look just fine. So I recommend that you keep the brightness at the default setting, which places the brightness marker at dead

center on the little brightness scale, as shown in Figure 1-18. As an alternative, you can gauge exposure by displaying a tool called the *histogram*, explained in Chapter 4, when reviewing your images.

Date/Time: When you turn on your camera for the very first time, it automatically displays this option and asks you to set the date and time.

Keeping the date/time accurate is important because that information is recorded as part of the image file. In your photo browser, you can then see when you shot an image and, equally handy, search for images by the date they were taken. Chapter 8 shows you where to locate the date/ time data when browsing your picture files.

- Language: This option determines the language of any text displayed on the camera monitor. Screens in this book display the English language, but I find it entertaining on occasion to hand my camera to a friend after changing the language to, say, Swedish. I'm a real yokester, yah?
- Video System: This option is related to viewing your images and movies on a television, a topic I cover in Chapter 9. Select NTSC if you live in North America or other countries that adhere to the NTSC video standard; select PAL for playback in areas that follow that code of video conduct.
- Sensor Cleaning: Highlight this option and press Set to access some options related to the camera's internal sensor-cleaning mechanism. These work like so:
 - *Auto Cleaning:* By default, the camera's sensor-cleaning mechanism activates each time you turn the camera on and off. This process helps keep the image sensor which is the part of the camera that captures the image free of dust and other particles that can mar your photos. You can disable this option, but I can't imagine why you would choose to do so.
 - *Clean Now:* Select this option and press Set to initiate a cleaning cycle.
 - *Clean Manually:* In the advanced exposure modes (P, Tv, Av, M, and A-DEP), you can access this third option, which prepares the camera for manual cleaning of the sensor. I don't recommend this practice; sensors are delicate, and you're really better off taking the camera to a good service center for cleaning.
- Live View Functions: This part of the menu also is available only in the advanced exposure modes. As the name implies, options here relate to Live View shooting, in which you can preview your shots in the monitor. Chapter 4 explains your options.

Setup Menu 3

Setup Menu 3, shown in Figure 1-19, contains the following offerings, which you can access only in the advanced exposure modes. Again, those modes are P, Tv, Av, M, and A-DEP. Chapter 5 introduces you to each mode.

- ✓ Custom Functions: Selecting this option opens the door to customizing 13 camera functions, known as *Custom Functions* in Canon lingo. These functions either relate to advanced exposure options or are otherwise designed for people with some photography experience. Check the index to find out where to locate details about the various functions.
- Clear Settings: Via this menu option, you can restore the default shooting settings. You also can reset all the Custom

Figure 1-19: To display Setup Menu 3, you must set the Mode dial to an advanced exposure mode.

Functions settings to their defaults through this option. Additionally, if you use the provided EOS Utility software to automatically add copyright information to all your picture files — a topic you can explore in Chapter 11 — you can clear the copyright notice.

✓ Firmware Ver.: This screen tells you the version number of the camera firmware (internal operating software). At the time of publication, the current firmware version was 1.0.9.

Keeping your camera firmware up-to-date is important, so visit the Canon Web site (www.canon.com) regularly to find out whether your camera sports the latest version. Follow the instructions given on the Web site to download and install updated firmware if needed.

Three more customization options

Shooting Menu 1, shown in Figure 1-20, offers two more basic setup options — at least, these options fall into that category if you share my logic, which some may consider a frightening prospect.

At any rate, these two options work as follows:

- Beep: By default, your camera beeps after certain operations, such as after it sets focus when you use autofocusing. If you're doing top-secret surveillance and need the camera to hush up, set this option to Off.
- Release Shutter without Card: Setting this option to Disable prevents shutter-button release when no memory card is in the camera. If you turn the option on, you can take a picture and then review the results for a few seconds in the camera monitor.

Quality	A L
Веер	On
Release shutter wi	thout card
Review time	2 sec.
Peripheral illumin.	correct.
Red-eye On/Off	Off
Flash control	

Figure 1-20: You can silence the camera via Shooting Menu 1.

The image isn't stored anywhere, however; it's temporary.

If you're wondering about the point of this option, it's designed for use in camera stores, enabling salespeople to demonstrate cameras without having to keep a memory card in every model. Unless that feature somehow suits your purposes, keep this option set to Disable.

Adding a final level of customization choices, the My Menu feature does just what its name implies: You can create a personalized menu that contains up to six functions from the existing menus. Then, instead of hunting through all the other menus to find settings that you use frequently, you can access the settings quickly just by displaying My Menu. Chapter 11 shows you how to take advantage of this feature, which I happen to love a lot. Unfortunately, you can take advantage of My Menu only in the advanced exposure modes (P, Tv, Av, M, and A-DEP).

Why does this camera have two names?

You may notice that your camera manual, as well as this book, refers to your camera by two different names— EOS Rebel T1i and EOS 500D. What gives? The answer is that Canon assigns different names to a single camera model depending on the part of the world where it's sold.

The *EOS* part, by the way, stands for Electro Optical System, the core technology used in

Canon's autofocus SLR (single-lens reflex) cameras. According to Canon, the proper pronunciation is *ee-ohs*, which is also how you pronounce the name *Eos*, the goddess of dawn in Greek mythology.

With apologies to the goddess, I save a little room in this book by shortening the camera name to simply Rebel T1i/500D, which is already long enough.

Taking Great Pictures, Automatically

In This Chapter

- Shooting your first pictures
- Setting focus and exposure automatically
- Using flash in automatic exposure modes
- Getting better results by using the automatic scene modes
- Gaining more control with Creative Auto mode
- Changing from single-frame to continuous shooting
- Switching the camera to Self-Timer or Remote-Control mode

A re you old enough to remember the Certs television commercials from the 1960s and '70s? "It's a candy mint!" declared one actor. "It's a breath mint!" argued another. Then a narrator declared the debate a tie and spoke the famous catchphrase: "It's two, two, two mints in one!"

Well, that's sort of how I see the Rebel T1i/500D. On one hand, it provides a full range of powerful controls, offering just about every feature a serious photographer could want. On the other, it also offers fully automated exposure modes that enable people with absolutely no experience to capture beautiful images. "It's a sophisticated photographic too!!" "It's as simple as 'point and shoot'!" "It's two, two, two cameras in one!"

Now, my guess is that you bought this book for help with your camera's advanced side, so that's what other chapters cover. This chapter, however, is devoted to your camera's point-and-shoot side, explaining how to get the best results from the fully automatic exposure modes. You can also find details about the new Creative Auto mode in this chapter. Sort of like "fully automatic plus," this mode handles most duties for you but enables you to control a few aspects of your pictures, such as whether flash is used and whether the background is softly focused or as sharp as your subject.

Getting Good Point-and-Shoot Results

Your camera offers several automatic, point-and-shoot exposure modes, all of which I explain later in this chapter. But in any of those modes, the key to good photos is to follow a specific picture-taking technique.

To try it out, set the Mode dial on top of the camera to Full Auto, as shown in the left image in Figure 2-1. Then set the focusing switch on the lens to the AF (autofocus) position, as shown in the right image in Figure 2-1. (The figure features the lens that is bundled with the Rebel T1i/500D. If you own a different lens, the switch may look and operate differently; check your lens manual for details.)

Auto/Manual Focus switch

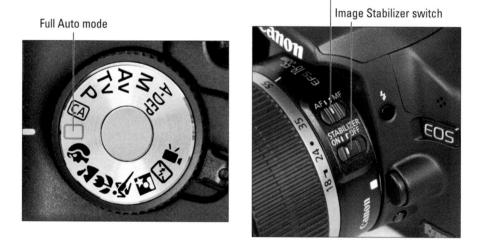

Figure 2-1: Choose these settings for fully automatic exposure and focus.

Unless you are using a tripod, also set the Stabilizer switch to the On setting, as shown in Figure 2-1. This setting turns on the Image Stabilizer feature, which is designed to produce sharper images by compensating for camera movement that can occur when you handhold the camera. Again, if you use a lens other than the kit lens, check your lens manual for details about using its stabilization feature, if provided.

Your camera is now set up to work in the most automatic of automatic modes. Follow these steps to take the picture:

1. Looking through the viewfinder, frame the image so that your subject appears under an autofocus point.

The *autofocus points* are those nine tiny rectangles clustered in the center of the viewfinder, as shown in Figure 2-2.

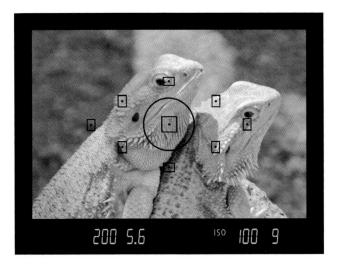

Figure 2-2: The tiny rectangles in the viewfinder indicate autofocus points.

2. Press and hold the shutter button halfway down.

The camera's autofocus and autoexposure meters begin to do their thing. In dim light, the flash may pop up if the camera thinks additional light is needed. Additionally, the flash may emit an *AF-assist beam*, a few rapid pulses of light designed to help the autofocusing mechanism find its target. (The *AF* stands for autofocus.)

At the same time, the autoexposure meter analyzes the light and selects initial aperture (f-stop) and shutter speed settings, which are two critical exposure controls. These two settings appear in the viewfinder; in Figure 2-2, the shutter speed is 1/200 second and the f-stop is f/5.6. You also see the current ISO setting and the maximum burst rate. (Chapter 5 details shutter speed, f-stops, and ISO; see Chapter 1 for information about the maximum burst rate.)

When focus is established, the camera beeps at you, assuming that you didn't silence its voice via Shooting Menu 1, as discussed at the end of Chapter 1. Additionally, the focus indicator in the viewfinder lights, as shown in Figure 2-3, and the dot inside an autofocus point briefly turns red. That red dot indicates which autofocus point the camera used to establish focus. Sometimes multiple dots turn red, as in Figure 2-3, which simply tells you that all the objects within those autofocus areas are now in focus. The autoexposure meter continues monitoring the light up to the time you take the picture, so the f-stop and shutter speed values in the viewfinder may change if the light shifts.

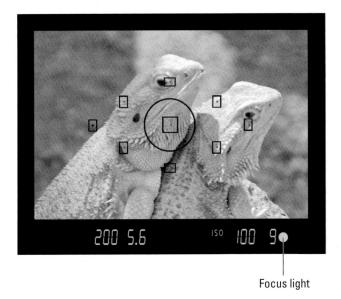

Figure 2-3: The green light indicates that the camera has locked focus.

NRRNING!

3. Press the shutter button the rest of the way down to record the image.

While the camera sends the image data to the camera memory card, the memory card access lamp lights, as shown in Figure 2-4. Don't turn off the camera or remove the memory card while the lamp is lit, or you may damage both camera and card.

When the recording process is finished, the picture appears briefly on the camera monitor. By default, the review period is two seconds. See Chapter 4 to find out how to adjust or disable the instant review and how to switch to Playback mode and take a longer look at your image. I need to add a couple important notes about this process, especially related to Step 2:

Solving autofocus problems:

When you shoot in the fully automatic modes as well as in Creative Auto mode, the camera typically focuses on the closest object. If the camera insists on selecting an autofocus point that isn't appropriate for your subject, the easiest solution is to switch to manual focusing and be done with it. Chapter 1 shows you how. Or you can use the advanced exposure modes, which enable you to select a specific autofocus point. Chapter 6 explains that option plus a few other tips for getting good autofocus results.

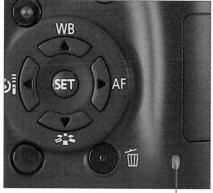

Memory card access light

Figure 2-4: The card access lamp lights while the camera sends the picture data to the card.

Shooting moving subjects: If the focus indicator doesn't light but

you hear a continuous series of beeps, the camera detected motion in the scene and shifted to an autofocusing mode called AI Servo. (The AI stands for *artificial intelligence*.) In this mode, the camera focuses continually after you press the shutter button halfway to try to maintain focus on the subject. As long as you keep the subject within one of the autofocus points, focus should be correct. However, continuous autofocusing is possible only in the Full Auto, Flash Off, Creative Auto, and Sports modes. In the other fully automatic modes, focus is locked when you press the shutter button halfway. See Chapter 6 for more tips about this and other autofocus modes.

- ✓ Locking exposure: By default, pressing the shutter button halfway does not lock exposure along with focus. Your camera instead continues metering and adjusting exposure until you fully press the shutter button. If you want to lock exposure, you must use an advanced exposure mode and rely on the AE (autoexposure) Lock button. You also can simply switch the camera's Mode dial to M, which shifts the camera to manual exposure mode, and then set your desired exposure settings (aperture, shutter speed, and ISO). Chapter 5 discusses these and other exposure issues.
- Changing the Drive mode setting: In most of the automatic exposure modes, your camera automatically sets the Drive mode to Single, which records a single image with each press of the shutter button. But in Portrait and Sports modes, the camera instead selects Continuous mode, which records pictures as long as you hold down the shutter

button. Creative Auto gives you the choice of both Drive modes. And you can also set the Drive mode to a Self-Timer or Remote Control setting for any exposure mode. See the end of this chapter for details.

✓ Shooting in Live View mode: You can't use Live View mode, which enables you to frame your image using the camera monitor instead of the viewfinder, in the fully automatic modes or the Creative Auto mode. If you want to take advantage of Live View, you must switch to an advanced exposure mode (P, Tv, Av, M, or A-DEP). See Chapter 5 for details on those modes; Chapter 4 provides a primer on Live View shooting.

More focus factors to consider

When you focus the lens, in either autofocus or manual focus mode, you determine only the point of sharpest focus. The distance to which the sharp-focus zone extends from that point what photographers call the *depth of field* depends in part on the *aperture setting*, or *f-stop*, which is an exposure control. Some of your camera's fully automatic exposure modes are designed to choose aperture settings that produce a certain depth of field.

The Portrait setting, for example, uses an aperture setting that shortens the depth of field so that background objects are softly focused an artistic choice that most people prefer for portraits. On the flip side of the coin, the Landscape setting selects an aperture that produces a large depth of field so that both foreground and background objects appear sharp.

Another exposure-related control, *shutter speed*, plays a focus role when you photograph moving objects. Moving objects appear blurry at slow shutter speeds; at fast shutter speeds, they appear sharply focused. On your camera, the Sports shooting mode automatically selects a high shutter speed to help you "stop" action, producing blur-free shots of the subject.

A fast shutter speed can also help safeguard against allover blurring that results when the camera is moved during the exposure. The faster the shutter speed, the shorter the exposure time, which reduces the time that you need to keep the camera absolutely still. If you're using the Rebel T1i/500D kit lens, you can also improve your odds of shake-free shots by enabling the Image Stabilizer (IS) feature (set the Stabilizer switch on the lens to the On position). For a very slow shutter speed, using a tripod is the best way to avoid camera shake.

Creative Auto mode, explained later in this chapter, gives you a little input over f-stop. But in this mode or any of the fully auto modes, the range of f-stops and shutter speeds the camera can select depends on the lighting conditions. When you're shooting at night, for example, the camera may not be able to select a shutter speed fast enough to stop action even in Sports mode.

If you want more control over focus and depth of field, you need to switch to an advanced exposure mode. Chapters 5 and 6 show you how to use those modes and explain all these concepts fully.

Exploring Basic Flash Options

Your built-in flash has three basic modes of operation, which are represented by the icons shown in the margin:

Auto flash: The camera decides when to fire the flash, basing its decision on the lighting conditions.

✓ On: The flash fires regardless of the lighting conditions. You may hear this flash mode referred to as *force* flash, because the camera is forced to trigger the flash even if its exposure brain says there's plenty of ambient light. It's sometimes also called *fill* flash because it's designed to fill in shadows that can occur even in bright light.

Off: The flash does not fire, no way, no how.

As with most everything else on your camera, which settings are available to you depends on the exposure mode you choose. Here's how things shake out:

- ✓ Full Auto, Portrait, Close-Up, and Night Portrait: In these modes, Auto flash is used; you cannot control whether the flash fires. However, you can set the flash to Red-Eye Reduction flash mode if you want. See the next section for the pros and cons of Red-Eye Reduction flash.
- Landscape, Sports, and Flash Off exposure modes: Flash is disabled.

- Disabling flash in the Flash Off mode makes sense, of course. But why no flash in Sports and Landscape mode, you ask? Well, Sports mode is designed to enable you to capture moving subjects, and the flash can make that more difficult because it needs time to recycle between shots. On top of that, the maximum shutter speed that's possible with the built-in flash is 1/200 second, which often isn't fast enough to ensure a blur-free subject. Finally, action photos usually aren't taken at a range close enough for the flash to reach the subject, which is also the reason why flash is disabled for Landscape mode.
- Creative Auto: In this mode, you can choose from all three flash settings, and you can enable Red-Eye Reduction flash as well. See the upcoming section "Gaining More Control with Creative Auto" for details on how to select the flash mode you want to use.
- P, Tv, Av, M, and A-DEP: In these modes, you don't actually choose a flash mode. Instead, you simply press the Flash button on the side of the camera to pop up the built-in flash when you want that extra burst of light and close the flash unit when you want to go flash free. You also have access to some advanced flash options, such as Flash Exposure Compensation, which enables you to vary the flash intensity. See Chapter 5 for the complete story on using flash in these exposure modes.

Part I: Fast Track to Super Snaps

The viewfinder displays the following symbols to alert you to the flash status:

- Flash On: A little lightning bolt like the one you see in the highlighted area of Figure 2-5 tells you that the flash is enabled.
- Flash Recycling: If you see the word *Busy* along with the lightning bolt, as shown in Figure 2-5, the flash needs a few moments to recharge. When the flash is ready to go, the *Busy* message disappears.

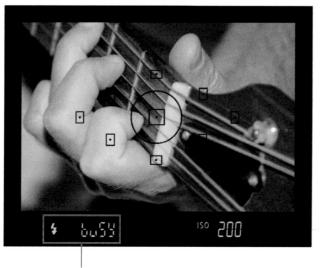

Flash status indicators

Figure 2-5: A Busy signal means that the flash is recharging.

Using Red-Eye Reduction Flash

For any exposure mode that permits flash, you can enable a feature called *Red-Eye Reduction*. When you turn on this feature, the Red-Eye Reduction lamp on the front of the camera lights up when you press the shutter button halfway. The purpose of this light is to attempt to shrink the subject's pupils, which helps reduce the chances of red-eye. The flash itself fires when you press the shutter button the rest of the way.

To enable Red-Eye Reduction, head for Shooting Menu 1. Select Red-Eye On/Off, as shown on the left in Figure 2-6, and press the Set button to display the second screen in the figure. Highlight On and press Set again. To turn off Red-Eye Reduction, just return to the menu and set the option to Off.

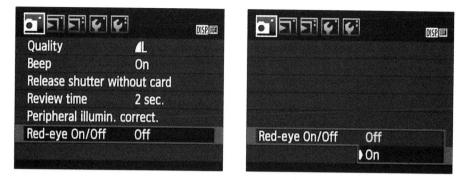

Figure 2-6: Turn Red-Eye Reduction flash mode on and off via Shooting Menu 1.

The viewfinder and Shooting Settings display don't offer any indication that Red-Eye Reduction is enabled. But you can check the setting by pressing the Menu button and then the DISP button. The Camera Settings display appears; look for the little eyeball icon and the word On or Off, as shown in Figure 2-7.

Freespace	392 MB
Color space	sRGB
WB SHIFT/BKT	0,0/±0
Live View shoot.	Enable
.t⊡+Enable <	⊙ Off
💑 1 min. 🕠	ô. On 🖸 💻
•))) On	🗇 Enable
04/2	9/2009 15:05:35

After you press the shutter button halfway in Red-Eye Reduction flash mode, a row of vertical bars appears in the center of the viewfinder display, just to the left of the ISO value. A few instants later, the bars turn off one by

Figure 2-7: You can check the Red-Eye Reduction status in the Camera Settings screen as well as in the menu.

one. For best results, wait until all the bars are off to take the picture. (The delay gives the subject's pupils time to constrict in response to the Red-Eye Reduction lamp.)

Shooting in the Fully Automatic Modes

You can choose from seven fully automatic exposure modes, highlighted in Figure 2-8. The next sections provide details on each mode.

As you explore these modes — or any exposure mode, for that matter — remember that you can use manual or autofocus as you see fit. If you opt for autofocus, the camera locks the autofocus point differently depending on the exposure mode, however.

Red-eye reduction status

Full Auto mode

In Full Auto mode, represented on the Mode dial by the rectangle you see in the margin, the camera selects all settings based on the scene that it detects in front of the lens. Your only job is to lock in focus, using the twostage autofocus technique I outline at the beginning of the chapter, or by setting the lens to manual focus mode and using the focus ring on the lens, as explained in Chapter 1.

Full Auto mode is great for casual, quick snapshooting. But keep these limitations in mind:

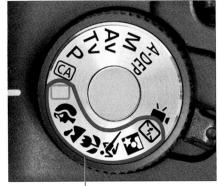

Fully automatic exposure modes

Figure 2-8: Set the dial to the exposure mode you want to use.

Picture Style: Full Auto mode

records your photo using the Standard Picture Style setting. The aim of this mode is to produce a crisp, vivid image. You can get more details about how Picture Styles affect your photos in Chapter 6.

- Drive mode: The camera selects the Single setting automatically, so you record one image for every press of the shutter button. For information on how to change the setting to a Self-Timer or Remote Control mode, see the last section in this chapter.
- Flash: Auto flash is used. That is, the camera fires the flash automatically if the available light is too dim to otherwise expose the picture. You can enable Red-Eye Reduction mode; see the preceding section for details.
- Autofocusing: In most cases, the camera focuses the closest object that falls under one of the autofocus points. To focus on a different area, the easiest option is to switch to manual focusing.

If you stick with autofocus, note that the camera adjusts its autofocusing behavior depending on whether it thinks you're shooting a still or moving subject. For still subjects, the camera locks focus when you press the shutter halfway. But if the camera senses motion, it continually adjusts focus from the time you press the shutter button halfway. You must reframe your shot as necessary to keep the subject within one of the nine autofocus points to ensure sharp focus. See Chapter 6 for additional information on getting good autofocus results.

- ✓ Color: Color decisions are also handled for you automatically. Normally, the camera's color brain does a good job of rendering the scene, but if you do want to tweak color, you must switch to an advanced exposure mode. You can then manipulate color via the White Balance controls and Picture Style options, all covered in Chapter 6.
- **Exposure:** You also give up total control over exposure to the camera. Chapter 5 shows you what you're missing.
- Quality: You can choose any Quality setting. Chapter 3 discusses this setting, which determines both the image resolution, or pixel count, and the file format (JPEG or Raw).

I decided not to include an example of a photo taken in Full Auto mode because, frankly, the results that this setting create vary widely depending on the available light and how well the camera detects whether you're trying to shoot a portrait, landscape, action shot, or whatever. But the bottom line is that Full Auto is a one-size-fits-all approach that may not take best advantage of your camera's capabilities. So if you want to more consistently take great pictures instead of good ones, I encourage you to explore the exposure, focus, and color information found in Part II so that you can abandon this exposure mode in favor of ones that put more photographic decisions in your hands.

Automatic scene modes (a.k.a. Image Zone modes)

In Full Auto mode, the camera tries to figure out what type of picture you want to take by assessing what it sees through the lens. If you don't want to rely on the camera to make that judgment, your camera offers six other fully automatic modes that are specifically designed for taking popular categories of pictures. For example, most people prefer portraits that have softly focused backgrounds. So in Portrait mode, the camera selects settings that can produce that type of background.

These six automatic modes — the ones represented by the little pictographs highlighted in Figure 2-8 — are officially known as Image Zone modes in Canon lingo and in your camera manual. For reasons I state in Chapter 1, I avoid using the whole "zone" moniker system in this book and instead refer to the six Image Zone modes as *fully automatic scene modes*. But if you should seek information about these modes elsewhere, whether online or in your manual, be sure to search for the topic under its official name.

Whatever you call them, all six modes share a couple of limitations — or benefits, depending on how you look at things:

- Color: As with Full Auto mode, you can't tweak color. Some modes manipulate colors in ways that you may or may not appreciate, and you're stuck if you have a color cast problem.
- Exposure: The camera makes all exposure decisions, too, including whether the flash fires or not.

In the next sections, you can read about the unique features of each of the scene modes.

Portrait mode

Portrait mode attempts to select an aperture (f-stop) setting that results in a short depth of field, which blurs the background and puts the visual emphasis on your subject. Figure 2-9 offers an example. Keep in mind, though, that the short depth of field produced by Portrait mode may result in softer focus on objects set in front of your subject, not just those behind it. Either way, the extent to which the depth of field is reduced depends on the current lighting conditions (which affect the range of f-stops the camera can use), the distance between your subject and those foreground or background objects, and a couple of other factors that I discuss in Chapter 6.

Figure 2-9: Portrait setting produces a softly focused background.

Along with favoring an f-stop that produces a shorter depth of field, the camera selects these settings in Portrait mode:

- Picture Style: Logically enough, the camera automatically sets the Picture Style option to Portrait. As detailed in Chapter 6, this Picture Style results in a slightly less sharp image, the idea being to keep skin texture nice and soft. Colors are also adjusted subtly to enhance skin tones.
- ✓ Drive mode: Contrary to what you may expect, the Drive mode is set to Continuous, which means that the camera records a series of images in rapid succession as long as you hold down the shutter button. This technique can come in especially handy if your portrait subject can't be counted on to remain still for very long — a toddler or pet, for example.

Should you want to include yourself in the portrait, you can switch the Drive mode setting to a Self-Timer or Remote Control mode. See the end of this chapter for details.

Flash: Auto flash is used; the camera decides whether you need flash or not. For outdoor portraits, this can pose a problem: A flash generally improves outdoor portraits, and if the ambient light is very bright, the camera doesn't give you access to the flash. For an illustration of the difference a flash can make, see Chapter 7. That chapter also contains tips on using flash in nighttime and indoor portraits.

Although you can't control whether the flash fires, you can choose to enable or disable Red-Eye Reduction flash, explained a little earlier in this chapter.

Autofocusing: Portrait mode employs the One-Shot AF (autofocus) mode. This is one of three AF modes available on your camera, all detailed in Chapter 6. In One-Shot mode, the camera locks focus when you press the shutter button halfway. Typically, the camera locks focus on the closest object that falls under one of the nine autofocus points. If your subject moves out of the selected autofocus point, the camera doesn't adjust focus to compensate.

Landscape mode

Whereas Portrait mode aims for a very shallow depth of field (small zone of sharp focus), Landscape mode, which is designed for capturing scenic vistas, city skylines, and other large-scale subjects, produces a large depth of field. As a result, objects both close to the camera and at a distance appear sharply focused, as shown in Figure 2-10.

Like Portrait mode, Landscape mode achieves the greater depth of field by manipulating the exposure settings specifically, the aperture, or f-stop setting. So the extent to which the camera can succeed in keeping everything in sharp focus depends on the available light. To fully understand this issue, see Chapters 5 and 6. And in the meantime, know that you also can extend depth of field by zooming out, if you're using a zoom lens, and moving farther from your subject.

As for other camera settings, Landscape mode results in the following options:

Picture Style: The camera automatically sets the Picture Style option to Landscape, which produces a sharper image, with well-defined "edges" — the borders between areas of contrast or color change. The Picture Style setting also produces more vivid blues and greens, which is what most people prefer from their landscape photos. You can read more about Picture Styles in Chapter 6.

Figure 2-10: Landscape mode produces a large zone of sharp focus and intensifies blues and greens.

- Drive mode: The camera selects the Single option, which records one image for each press of the shutter button. As with the other scene modes, you can switch to a Self-Timer or Remote Control setting by following the steps laid out at the end of this chapter.
- Flash: The built-in flash is disabled, which is typically no big deal: Because of its limited range, a built-in flash is of little use when shooting most landscapes anyway.
- ✓ Autofocusing: The AF (autofocus) mode is set to One-Shot, which means that focus is locked when you press the shutter button halfway. (See Chapter 6 for details.) Focus usually is set on the nearest object that falls under one of the nine autofocus points, but remember that because of the large depth of field that the Landscape mode produces, both far and near objects may appear equally sharp, depending on their distance from the lens.

Close-Up mode

Switching to Close-Up mode doesn't enable you to focus at a closer distance to your subject than normal as it does on some non-SLR cameras. The close-focusing capabilities of your camera depend entirely on the lens you use.

But choosing Close-Up mode does tell the camera to try to select an aperture (f-stop) setting that results in a short depth of field, which blurs background objects so that they don't compete for attention with your main subject. I used this setting to capture the orchid in Figure 2-11, for example. As with Portrait mode, though, how much the background blurs varies depending on the distance between your subject and the background as well as on the lighting conditions (which determine the range of f-stops that will produce a good exposure), your camera-to-subject distance, and the lens focal length. (Chapter 6 explains all these issues.)

Figure 2-11: Close-Up mode also produces short depth of field.

Other settings selected for you in Close-Up mode are as follows:

Picture Style: Close-Up mode uses the Standard picture style, just like Full Auto. The resulting image features crisp edges and vivid colors.

- Drive mode: The Drive mode is set to Single, so you record one photo each time you fully press the shutter button. However, you can select a Self-Timer or Remote Control mode if needed.
- Flash: Flash is set to Auto, so the camera decides whether the picture needs the extra pop of light from the built-in flash. For times when the camera enables the flash, you have the option of using Red-Eye Reduction mode.

Whether or not you enable Red-Eye Reduction, watch your subject-tocamera distance if you're shooting a living subject; a burst of flash light at close range can be damaging to the subject's eyes. A better choice in this scenario is to switch to the Creative Auto mode, which lets you disable the flash as well as request a shallow depth of field.

✓ Autofocusing: The AF mode is set to One-Shot mode; again, that simply means that when you press the shutter button halfway, the camera locks focus, usually on the nearest object that falls under one of the nine autofocus points.

See Chapter 6 for more details about AF modes and other focusing issues. Chapter 7 offers additional tips on close-up photography.

Sports mode

Sports mode results in a number of settings that can help you photograph moving subjects, such as the soccer player in Figure 2-12. First, the camera selects a fast shutter speed, which is needed to "stop motion." Shutter speed is an exposure control that you can explore in Chapter 5.

Also, keep these Sports mode settings in mind:

- Picture Style: The camera automatically sets the Picture Style option to Standard, which is designed to produce sharp images with bold colors.
- ✓ Drive mode: To enable rapid-fire image capture, the Drive mode is set to Continuous. This mode enables you to record multiple frames with a single press of the shutter button. You also have the option of switching to a Self-Timer or Remote Control mode. Check out the end of this chapter for details on Drive mode settings.
- Flash: Flash is disabled, which can be a problem in low-light situations, but it also enables you to shoot successive images more quickly because the flash needs a brief period to recycle between shots. In addition, disabling the flash permits a faster shutter speed; when the flash is on, the maximum shutter speed is 1/200 second. (See Chapter 5 for details about flash and shutter speeds.)

Autofocusing: The AF mode is set to AI Servo. In this mode, the camera establishes focus initially when you press the shutter button halfway. But if the subject moves, the camera attempts to refocus.

For this feature to work correctly, you must adjust framing so that your subject remains within one of the autofocus points. You may find it easier to simply switch to manual focusing and twist the focusing ring as needed to track the subject's movement yourself.

Figure 2-12: To capture moving subjects without blur, try Sports mode.

The other critical thing to understand about Sports mode is that whether the camera can select a shutter speed fast enough to stop motion depends on the available light and the speed of the subject itself. In dim lighting, a subject that's moving at a rapid pace may appear blurry even when photographed in Sports mode.

To fully understand shutter speed, visit Chapter 5. And for more tips on action photography, check out Chapter 7.

Night Portrait mode

As its name implies, Night Portrait mode is designed to deliver a betterlooking portrait at night (or in any dimly lit environment). It does so by combining flash with a slow shutter speed. That slow shutter speed produces a longer exposure time, which enables the camera to rely more on ambient light and less on the flash to expose the picture. The result is a brighter background and softer, more even lighting.

I cover the issue of using a slow shutter speed in detail in Chapter 5; Chapter 7 has some additional nighttime photography tips. For now, the important thing to know is that the slower shutter speed means that you probably need a tripod. If you try to handhold the camera, you run the risk of moving the camera during the long exposure, resulting in a blurry image. Enabling the Image Stabilizer (IS) feature of your lens, if available, can help, but for night-time shooting, even that may not permit successful handheld shooting. Your subjects also must stay perfectly still during the exposure, which can also be a challenge.

If you do try Night Portrait mode, be aware of these other settings that are automatically selected by the camera:

- Picture Style: The Standard setting, designed to deliver sharp, bold photos, is selected. See Chapter 6 for more about Picture Styles.
- Drive mode: The default setting is Single, but you also can choose a Self-Timer or Remote Control mode. Check out the end of this chapter for details.
- Flash: Flash is enabled when the camera thinks more light is needed which, assuming that you're actually shooting at night, should be most of the time. You can set the flash to Red-Eye Reduction mode if you prefer. See the section "Using Red-Eye Reduction Flash," earlier in this chapter, for details.
- ✓ Autofocusing: The AF mode is set to One-Shot, which locks focus when you depress the shutter button halfway.

Flash Off mode

\$

The Flash Off mode delivers the same results as Full Auto mode but ensures that the flash doesn't fire, even in dim lighting. This mode provides an easy way to ensure that you don't break the rules when shooting in locations that don't permit flash: museums, churches, and so on. But it can also come in handy any time you prefer not to use flash. See Chapters 5 and 7 for information about flash photography.

Gaining More Control with Creative Auto

Creative Auto mode might be better named "Full Auto Plus." This mode is set up initially to work the same way as Full Auto, explained earlier in this chapter. But if you don't like the results you get, you can make the following adjustments for your next shot:

- Enable or disable the flash.
- Make the picture brighter or darker.
- Soften or sharpen the apparent focus of the picture background.
- Select from four Picture Styles, which affect the color and sharpness of the image. One of the four options creates a black-and-white photo.

Although it's great for beginners to have an easy way to have a little more input on their pictures, Creative Auto still doesn't give you anywhere near the level of creative control you get in the advanced exposure modes. For example, you can decide whether you want the flash to fire in Creative Auto mode, but you can't adjust flash power or change the way the camera calculates the flash exposure, as you can in the P, Tv, Av, M, and A-DEP modes. That said, if you're feeling overwhelmed by all the new stuff that comes with digital SLR photography and you're not ready to dive into the more advanced exposure modes covered in Chapters 5 and 6, then by all means, Creative Auto is a better choice than the other modes covered in this chapter. Here's how to use it:

1. Set the Mode dial on top of the camera to the CA setting.

The Creative Auto version of the Shooting Settings screen, shown in Figure 2-13, appears on the monitor. (If you don't see the screen, press the DISP button or press the shutter button halfway and then release it.) The six settings you can adjust in this mode are labeled in the figure.

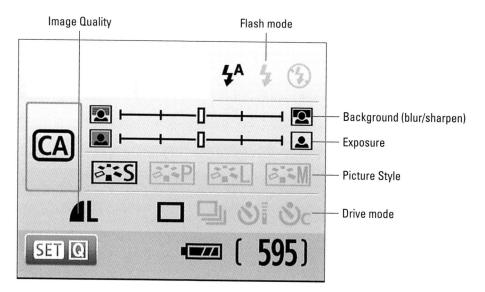

Figure 2-13: In Creative Auto mode, the Shooting Settings screen displays these controls.

2. Press Set.

Pressing Set shifts the screen into Quick Control mode. One of the six adjustable settings is highlighted, and a text label appears at the bottom of the screen to remind you what the highlighted setting does. In Figure 2-14, for example, the Flash setting is highlighted.

- 3. Press the cross keys to move the highlight over the setting you want to adjust.
- 4. Adjust the highlighted setting by rotating the Main dial.

See the upcoming list for some advice about each of the options.

For the Quality and Drive mode options, you also can press Set to display a screen containing all possible settings. After you get to the options screen, rotate the Main dial or use the right and left cross keys to highlight the setting you want to use. Then press Set to return to the Ouick Control screen.

- 5. To adjust another setting, press the cross keys to highlight it.
- 6. After you select all the settings you want to change, press the shutter button halfway and release it.

The monitor returns to the normal Shooting Settings display, and you're ready to take your picture.

Now for the promised explanations of how the six Creative Auto options work:

- Flash: You can choose from three flash settings, which are represented on the Shooting Settings screen by the icons you see in the margin:
 - *Auto:* The camera fires the flash automatically if it thinks extra light is needed to expose the picture.
 - *On:* The flash fires regardless of the ambient light.
 - Off: The flash does not fire.

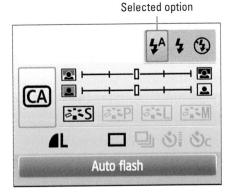

Figure 2-14: Press Set to enter Quick Control mode and adjust the Creative Auto options.

of MEMBER

For the Auto and On settings, you can use the Red-Eye Reduction flash feature. See "Exploring Basic Flash Options" and "Using Red-Eye Reduction Flash," earlier in this chapter, for more information about flash photography.

Background (blur/sharpen): The topmost of the two slider bars on the Creative Auto screen gives you some control over *depth of field*, or the distance over which objects in the scene remain sharply focused.

Unfortunately, this feature doesn't play nice with the flash. If you set the flash mode to On, the bar becomes dimmed and out of your reach. Ditto if you set the flash mode to Auto and the camera sees a need for flash.

Assuming that the flash doesn't get in your way, move the little indicator on the bar to the left to shorten depth of field, which makes distant objects appear blurrier. (Remember, after highlighting the bar, you just rotate the Main dial to move the indicator.) Shift the indicator to the right to make distant objects appear sharper.

The camera creates this shift in depth of field by adjusting the aperture setting (f-stop). A lower f-stop number produces a more shallow depth of field, for a blurrier background; a higher f-stop setting produces a greater depth of field, for a sharper background. However, because aperture also plays a critical role in exposure, the range of f-stops the camera can choose — and, therefore, the extent of focus shift you can achieve with this setting — depends on the available light. The camera gives priority to getting a good exposure, assuming that you'd prefer a well-exposed photo to one that has the background blur you want but is too dark or too light. Understand, too, that when the aperture changes, the camera also must change the shutter speed, ISO (light sensitivity setting), or both to maintain a good exposure.

You can view the shutter speed and aperture settings that the camera has in mind by pressing the shutter button halfway, which kicks the autoexposure system into gear. The shutter speed and f-stop then appear in the areas labeled in Figure 2-15. In the left half of the figure, you see the settings the camera chose with the Background slider indicator at the center position. When I moved the slider to the left, the camera selected a lower f-stop, as shown in the second screen in the figure. That lower f-stop decreases depth of field, blurring the background more. But it also lets more light into the camera, so the shutter speed (exposure time) increased to compensate. In some cases, the camera may also adjust ISO (light sensitivity) to improve exposure.

At very slow shutter speeds, camera shake can blur the image. A blinking shutter speed value alerts you to the potential for this problem; put your camera on a tripod to avoid the risk of camera shake. Also remember that moving objects appear blurry at slow shutter speeds.

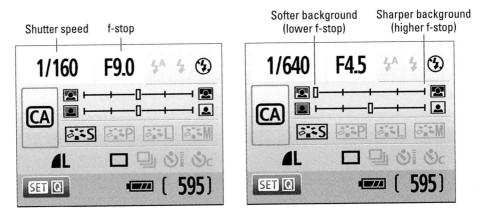

Figure 2-15: Changing the background blur setting affects both aperture and shutter speed.

To find out more about depth of field, aperture, shutter speed, ISO, and exposure, start with the sidebar "More Focus Factors to Consider," earlier in this chapter, then see Chapters 5 and 6 for the complete story.

Exposure: If your picture is underexposed, select this second slider and then move the indicator bar to the right before your next shot. Move the slider to the left to reduce the brightness of your next shot. To produce the exposure shift, the camera may adjust aperture, shutter speed, ISO, or all three.

Again, if the shutter speed blinks after you adjust the Exposure slider, it means that the camera had to select a slow shutter speed and is suggesting that you use a tripod to avoid camera shake.

- Picture Styles: Picture Styles apply certain adjustments to color, sharpness, and contrast to your pictures. You can select from four Picture Styles in Creative Auto mode: Standard, Portrait, Landscape, and Monochrome (black and white). To see examples of each style and learn more about how your picture will be affected, check out the end of Chapter 6.
- Drive mode: You can choose from all but one of the Drive mode options, explained in the next section. The 2-Second Self-Timer mode is off limits, as it is in the fully automatic exposure modes.
- Quality: You get access to the full range of Quality options. Chapter 3 helps you understand these settings.

Changing the Drive Mode

The Drive mode enables you to tell the camera what to do when you press the shutter button: record a single frame, a series of frames, or record one or more shots after a short delay.

Your camera offers the following Drive mode settings, which are represented by the symbols you see in the margin:

- ✓ Single: This setting, which is the default for Creative Auto and all fully automatic modes except Portrait and Sports, records a single image each time you press the shutter button. In other words, this is normalphotography mode.
- Continuous: Sometimes known as *burst mode*, this setting records a continuous series of images as long as you hold down the shutter button. On the Rebel T1i/500D, you can capture just about 3.4 shots per second. Obviously, this mode is great for capturing fast-paced subjects, which is why it's the default setting for Sports mode. It's also selected for Portrait mode, which is a great benefit if your subject is the fidgety type.

Keep in mind that some camera functions can slow down the continuous capture rate. For example, when you use flash or enable the High ISO Noise Reduction feature (explained in Chapter 5), you typically can't achieve the highest burst rate. The speed of your memory card also plays a role in how fast the camera can capture images. In other words, consider 3.4 shots per second a best-case scenario.

✓ Self-Timer/Remote Control: Want to put yourself in the picture? Select this mode and then press the shutter button and run into the frame. You have about 10 seconds to get yourself in place and pose before the image is recorded.

I also often use the self-timer function when I want to avoid any possibility of camera shake. The mere motion of pressing the shutter button can cause slight camera movement, which can blur an image. So I put the camera on a tripod and then activate the self-timer function. This enables "hands-free" — and therefore motion-free — picture taking.

As another alternative, you can purchase one of the optional remotecontrol units sold by Canon. You can opt for either a wireless unit or one that plugs into the remote-control terminal on the left side of the camera. Either way, set the Drive mode to the Self-Timer/Remote Control option when you want to trigger the shutter release button with the remote control.

Part I: Fast Track to Super Snaps

2-Second Self-Timer: This mode works just like the regular self-timer mode, but the capture happens just two seconds after you fully press the shutter button. Unfortunately, this mode isn't available to you in the fully automatic exposure modes or Creative Auto mode; you can choose this option only in P, Tv, Av, M, or A-DEP modes.

()2

 Self-Timer Continuous: With this option, the camera waits 10 seconds after you press the shutter button and then captures a continuous series of images. You can record as many as 10 continuous images.

To check the current Drive mode, display the Shooting Settings screen. The Drive mode icon appears in the area labeled in Figure 2-16.

If you want to use a different mode, you have two options:

Use the Quick Control screen.

First, display the Shooting Settings screen; either press the DISP button or press the shutter button halfway and then release it. Now press Set to shift to Ouick Control mode and use the

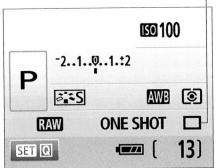

Figure 2-16: The icon that appears here represents the Drive mode.

cross keys to highlight the Drive mode icon, as shown on the left in Figure 2-17. The name of the current setting appears at the bottom of the screen. Rotate the Main dial to cycle through the available Drive mode options.

As an alternative, highlight the Drive mode icon and then press Set. You then see a screen showing all the possible settings, as shown on the right in Figure 2-17. Press the right or left cross key or rotate the Main dial to highlight your Drive mode of choice. For the Self-Timer Continuous mode, press the up or down cross key to set the number of continuous shots you want the camera to capture, as shown in the figure. Finally, press the Set button to lock in the setting. (This second method is the only way to adjust the frame-count for the Self-Timer Continuous option.)

Again, you can access all five Drive mode options *only* in the advanced exposure modes (P, Tv, Av, M, and A-DEP). In Creative Auto mode, you lose the 2-Second Self-Timer mode. And in all the fully auto modes, you see only the default Drive mode — either Single or Continuous — plus the Self-Timer/Remote Control and the Self-Timer Continuous options.

Press the left cross key. It's marked by three little Drive mode icons to help you remember its function. After you press the cross key, you see the screen shown on the right in Figure 2-17. Highlight your choice and press Set. Again, you can press the up or down cross key to change the number of frames to be captured in the Self-Timer Continuous mode.

Your selected Drive mode remains in force until you change it or switch to an exposure mode for which the selected Drive mode isn't available.

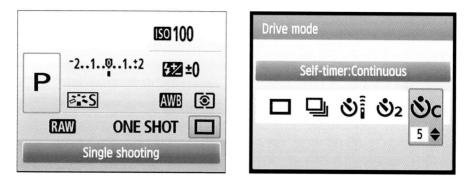

Figure 2-17: You can access all of these Drive options only in advanced exposure modes.

Part I: Fast Track to Super Snaps _____

Controlling Picture Quality

3

In This Chapter

- Reviewing factors that lead to poor photo quality
- Exploring resolution, pixels, and ppi
- Calculating the right resolution for traditional print sizes

- Understanding the tradeoff between picture quality and file size
- Deciding on the best file format: JPEG or Raw?
- Picking the right JPEG quality level

A lmost every review of the Rebel T1i/500D contains glowing reports about the camera's top-notch picture quality. As you've no doubt discovered for yourself, those claims are true, too: This baby can create large, beautiful images.

Getting the maximum output from your camera, however, depends on choosing the right capture settings. Chief among them, and the topic of this chapter, is the appropriately named Quality setting. This critical control determines two important aspects of your pictures: *resolution*, or pixel count; and *file format*, which refers to the type of computer file the camera uses to store your picture data.

Resolution and file format both play a large role in the quality of your photos, so selecting from the eight Quality settings on your camera is an important decision. Why not just dial in the setting that produces the maximum quality level and be done with it? Well, that's the right choice for some photographers. But because choosing that maximum setting has some disadvantages, you may find that stepping down a notch or two on the quality scale is a better option, at least for some pictures. To help you figure out which Quality setting meets your needs, this chapter explains exactly how resolution and file format affect your pictures. Just in case you're having quality problems related to other issues, though, the first section of the chapter provides a handy quality-defect diagnosis guide.

Diagnosing Quality Problems

When I use the term *picture quality*, I'm not talking about the composition, exposure, or other traditional characteristics of a photograph. Instead, I'm referring to how finely the image is rendered in the digital sense.

Figure 3-1 illustrates the concept: The first example is a high-quality image, with clear details and smooth color transitions. The other examples show five common digital-image defects.

High quality

Pixelation

JPEG artifacts

Noise

Color cast

Lens/sensor dirt

Figure 3-1: Refer to this symptom guide to determine the cause of poor image quality.

Each of these defects is related to a different issue, and only two are affected by the Quality setting. So if you aren't happy with your image quality, first compare your photos to those in the figure to properly diagnose the problem. Then try these remedies:

- Pixelation: When an image doesn't have enough *pixels* (the colored tiles used to create digital images), details aren't clear, and curved and diagonal lines appear jagged. The fix is to increase image resolution, which you do via the Quality setting. See the upcoming section, "Considering Resolution: Large, Medium, or Small?" for details.
- ✓ JPEG artifacts: The "parquet tile" texture and random color defects that mar the third image in Figure 3-1 can occur in photos captured in the JPEG (*jay-peg*) file format, which is why these flaws are referred to as JPEG artifacts. This defect is also related to the Quality setting; see the "Understanding File Type (JPEG or Raw)" section, later in this chapter, to find out more.
- Noise: This defect gives your image a speckled look, as shown in the lower-left example in Figure 3-1. Noise is most often related to a very long exposure time (that is, a very slow shutter speed) or to an exposure control called ISO, which you can explore in Chapter 5. To adjust shutter speed or ISO, you must switch to one of the advanced exposure modes (P, Tv, Av, M, or A-DEP).
- Color cast: If your colors are seriously out of whack, as shown in the lower-middle example in the figure, try adjusting the camera's White Balance setting. Chapter 6 covers this control and other color issues. Note, though, that you also must use an advanced exposure mode to adjust white balance.
- Lens/sensor dirt: A dirty lens is the first possible cause of the kind of defects you see in the last example in the figure. If cleaning your lens doesn't solve the problem, dust or dirt may have made its way onto the camera's image sensor. See the sidebar "Maintaining a pristine view," elsewhere in this chapter, for information on safe lens and sensor cleaning.

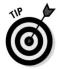

When diagnosing image problems, you may want to open the photos in your photo software and zoom in for a close-up inspection. Some defects, especially pixelation and JPEG artifacts, have a similar appearance until you see them at a magnified view.

I should also tell you that I used a little digital enhancement to exaggerate the flaws in my example images to make the symptoms easier to see. With the exception of an unwanted color cast or a big blob of lens or sensor dirt, these defects may not even be noticeable unless you print or view your image at a very large size. And the subject matter of your image may camouflage some flaws; most people probably wouldn't detect a little JPEG artifacting in a photograph of a densely wooded forest, for example.

In other words, don't consider Figure 3-1 as an indication that your Rebel is suspect in the image quality department. First, *any* digital camera can produce these defects under the right circumstances. Second, by following the guidelines in this chapter and the others mentioned in the preceding list, you can resolve any quality issues that you may encounter.

Decoding the Quality Options

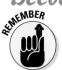

Your camera's Quality setting determines both the image resolution and file format of the pictures you shoot. To access the control, you can go two routes:

- ✓ Quick Control screen: After displaying the Shooting Settings screen, press Set to shift to Quick Control mode and use the cross keys to highlight the Quality icon, as shown on the left screen in Figure 3-2. You can then rotate the Main dial to cycle through the available Quality settings. Or, if you prefer, press Set to display the screen shown on the right in the figure, which contains all the possible Quality options. This time, use either the Main dial or the right or left cross key to highlight the setting you want to use. Press Set to wrap things up.
- Shooting Menu 1: Press the Menu button and then display Shooting Menu 1, shown on the left in Figure 3-3. Highlight Quality and press the Set button to display the screen you see on the right in the figure. Use the right or left cross key to highlight the option you want to use and then press Set.

Figure 3-2: You can change the Quality setting in seconds by using the Quick Control screen.

Chapter 3: Controlling Picture Quality

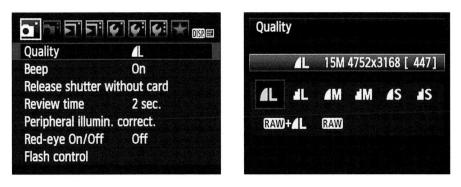

Figure 3-3: You also can select the Quality option via Shooting Menu 1.

If you're new to digital photography, the Quality settings won't make much sense to you until you read the rest of this chapter, which explains format and resolution in detail. But even if you are schooled in those topics, you may need some help deciphering the way that the settings are represented on your camera. As you can see from Figures 3-2 and 3-3, the options are presented in rather cryptic fashion, so here's your decoder ring:

At the bottom of the Quick Settings screen, you see three bits of information about the currently selected Quality setting: the resolution, or total pixel count (measured in megapixels), the horizontal and vertical pixel count, and the number of subsequent shots you can fit on your current memory card if you select that Quality setting. I labeled the different values in Figure 3-2. The next section explains pixels and megapixels, if you're new to the game.

✓ This same informational bar appears at the top of the screen that appears when you change the setting via Shooting Menu 1 or press Set after highlighting the Quality option on the Quick Settings screen. (See the right screens in Figures 3-2 and 3-3.) The next two rows of both screens show icons representing the eight Quality settings.

✓ Settings on the middle row of these screens capture images in the JPEG (*jay-peg*) file format. The little arc-like icons represent the level of JPEG *compression*, which affects picture quality and file size. You get two JPEG options: Fine and Normal. The smooth arcs represent the Fine setting; the jagged arcs represent the Normal setting. Check out the upcoming section "JPEG: The imaging (and Web) standard" for details.

41

✓ Within the JPEG category, you can choose from three resolution settings, represented by L, M, and S (*large, medium*, and *small*). See the next section for information that will help you select the right resolution.

✓ The Quality settings in the third row enable you to capture images in the Raw file format. All Raw files are created at the Large resolution setting, giving you the maximum pixel count. One of the two Raw settings also records a JPEG Fine version of the image, also at the maximum resolution. The upcoming section "Raw (CR2): The purist's choice" explains the benefits and downsides to using the Raw format.

Which Quality option is best depends on several factors including how you plan to use your pictures and how much time you care to spend processing your images on your computer. The rest of this chapter explains these and other issues related to the Quality settings.

Considering Resolution: Large, Medium, or Small?

To decide upon a Quality setting, the first decision you need to make is how many *pixels* you want your image to contain. Pixels are the little square tiles from which all digital images are made; the word *pixel* is short for *picture element*. You can see some pixels close up in the right image in Figure 3-4, which shows a greatly magnified view of the eye area in the left image.

Figure 3-4: Pixels are the building blocks of digital photos.

The number of pixels in an image is referred to as *resolution*. Your camera offers you three resolution levels, which are assigned the generic labels Large, Medium, and Small and are represented on the list of Quality settings by the initials L, M, and S. Table 3-1 shows you the pixel count that results from each option. (If you select Raw as your Quality setting, images are always captured at the Large resolution value.)

Table 3-1	The Resolution Side of the Quality Settings		
Symbol	Setting	Pixel Count	
L	Large	4752 x 3168 (15.1 MP)	
Μ	Medium	3456 x 2304 (8 MP)	
S	Small	2352 x 1568 (3.7 MP)	

In the table, the first pair of numbers shown for each setting represents the image *pixel dimensions* — that is, the number of horizontal pixels and the number of vertical pixels. The values in parentheses indicate the total resolution, which you get by multiplying the horizontal and vertical pixel values. This number is usually stated in *megapixels*, or MP for short. The camera displays the resolution value using only one letter M, however (refer to Figures 3-2 and 3-3). Either way, one megapixel equals 1 million pixels. (I rounded off the megapixel values in the table.)

To figure out how many pixels are enough, you need to understand how resolution affects print quality, display size, and file size. The next sections explain these issues, as well as a few other resolution factoids.

Pixels and print quality

When mulling over resolution options, your first consideration is how large you want to print your photos, because pixel count determines the size at which you can produce a high-quality print. If you don't have enough pixels, your prints may exhibit the defects you see in the pixelation example in Figure 3-1, or worse, you may be able to see the individual pixels, as in the right example in Figure 3-4.

Depending on your photo printer, you typically need anywhere from 200 to 300 pixels per linear inch, or *ppi*, of the print. To produce an 8×10 print at 200 ppi, for example, you need a pixel count of 1600×2000 .

Table 3-2 lists the pixel counts needed to produce traditional print sizes at 200 ppi and 300 ppi. Again, the optimum ppi varies depending on the printer — some printers prefer even more than 300 ppi — so check your manual or ask the photo technician at the lab that makes your prints. (And note that ppi is *not* the same thing as *dpi*, which is a measurement of printer resolution. *Dpi* refers to how many dots of color the printer can lay down per inch; most printers use multiple dots to reproduce one pixel.)

Table 3-2	Pixel Requirements for Traditional Print Sizes		
Print Size	Pixels for 200 ppi	Pixels for 300 ppi	
4 x 6 inches	800 x 1200	1200 x 1800	
5 x 7 inches	1000 x 1400	1500 x 2100	
8 x 10 inches	1600 x 2000	2400 x 3000	
11 x 14 inches	2200 x 2800	3300 x 4200	

Even though many photo-editing programs enable you to add pixels to an existing image, doing so isn't a good idea. For reasons I won't bore you with, adding pixels — known as *resampling* — doesn't enable you to successfully enlarge your photo. In fact, resampling typically makes matters worse. The printing discussion at the start of Chapter 9 includes some example images that illustrate this issue.

Pixels and screen display size

Resolution doesn't affect the quality of images viewed on a monitor, television, or other screen device the way it does on printed photos. Instead, it determines the *size* at which the image appears.

This issue is one of the most misunderstood aspects of digital photography, so I explain it thoroughly in Chapter 9. For now, just know that you need *way* fewer pixels for onscreen photos than you do for printed photos. For example, Figure 3-5 shows a 450-x-300-pixel image that I attached to an e-mail message.

For e-mail images, I usually stick with a maximum horizontal pixel count of 450 and a maximum vertical size of 400 pixels, depending on whether the picture is oriented horizontally, as in the figure, or vertically. If your image is much larger, the recipient may not be able to view the entire picture without scrolling the display.

In short, even if you use one of the Small Quality settings on your Rebel T1i/500D, which produce images that contain 2352 x 1568 pixels, you'll have more than enough pixels for most onscreen uses. The only exception might

be an image that you want to display via a digital projector that has a very high screen resolution. Again, Chapter 9 details this issue and shows you how to prepare your pictures for online sharing.

Figure 3-5: A 450-x-300-pixel image is plenty large for sharing via e-mail.

Pixels and file size

Every additional pixel increases the amount of data required to create a digital picture file. So a higher-resolution image has a larger file size than a lowresolution image.

Large files present several problems:

- ✓ You can store fewer images on your memory card, on your computer's hard drive, and on removable storage media such as a CD-ROM.
- The camera needs more time to process and store the image data on the memory card after you press the shutter button. This extra time can hamper fast-action shooting.
- ✓ When you share photos online, larger files take longer to upload and download.
- ✓ When you edit your photos in your photo software, your computer needs more resources and time to process large files.

To sum up, the tradeoff for a high-resolution image is a large file size. But note that file format, which is the other half of the Quality equation on your Canon, also affects file size. See the upcoming section "Understanding File Type (JPEG or Raw)" for more on that topic. The upcoming sidebar "How many pictures fit on my memory card?" provides details on the file-storage issue.

How many pictures fit on my memory card?

That question is one of the first asked by new camera owners — and it's an important one because you don't want to run out of space on your memory card just as the perfect photographic subject presents itself.

As explained in the discussions in this chapter, image resolution (pixel count) and file format (JPEG or Raw) together contribute to the size of the picture file which, in turn, determines how many photos fit in a given amount of camera memory. The table below shows you the approximate size of the files, in megabytes (MB), that are generated at each of the possible resolution/ format combinations on your Rebel T1i/500D. (The actual file size of any image also depends on other factors, such as the subject, ISO setting, and Picture Style setting.) In the Image Capacity column, you see approximately how many pictures you can store at the setting on a 2GB (gigabyte) memory card.

Symbol	Quality Setting	File Size	lmage Capacity
4 L	Large/Fine	5.0MB	370
al L	Large/Normal	2.5MB	740
A M	Medium/Fine	3.0MB	610
M h	Medium/Normal	1.6MB	1,190
	Small/Fine	1.7MB	1,080
l S	Small/Normal	0.9MB	2,030
RAW+	Raw+Large/Fine	25.2MB*	72
RAW	Raw	20.2MB	90

Resolution recommendations

As you can see, resolution is a bit of a sticky wicket. What if you aren't sure how large you want to print your images? What if you want to print your photos *and* share them online?

I take the "better safe than sorry" route, which leads to the following recommendations about whether to choose Large, Medium, or Small when you select a Quality setting:

✓ Always shoot at a resolution suitable for print. You then can create a low-resolution copy of the image in your photo editor for use online. Chapter 9 shows you how.

Again, you *can't* go in the opposite direction, adding pixels to a low-resolution original in your photo editor to create a good, large print. Even with the very best software, adding pixels doesn't improve the print quality of a low-resolution image.

- ✓ For everyday snapshots, the Medium setting (8 MP) is probably sufficient. I find 15.1 MP, which is what you get from the Large setting, to be overkill for most casual snapshots, which means that you're creating huge files for no good reason. So I stick with Medium unless I'm shooting critical images.
- ✓ Jump to Large (15.1 MP) if you plan to crop your photos or make huge prints. Always use the maximum resolution if you think you may want to crop your photo and enlarge the remaining image. For example, when I shot the left photo in Figure 3-6, I wanted to fill the frame with the butterfly, but I couldn't do so without getting so close that I risked scaring it away. So I kept my distance and took the picture at the Large setting, which enabled me to crop the photo and still have enough pixels left to produce a great print, as you see in the right image.
- Reduce resolution if shooting speed is paramount. If you're shooting action and the shot-to-shot capture time is slower than you'd like that is, the camera takes too long after you take one shot before it lets you take another dialing down the resolution may help. Lower resolution produces smaller files, and the smaller the file, the less time the camera needs to record the image to your memory card. Also see Chapter 7 for other tips on action photography.

Part I: Fast Track to Super Snaps

Figure 3-6: Capture images that you plan to crop and enlarge at the highest possible resolution (Large).

Understanding File Type (JPEG or Raw)

In addition to establishing the resolution of your photos, the Quality setting determines the *file format*. The file format simply refers to the type of image file that the camera produces.

Your Rebel offers two file formats, JPEG and Raw, with a couple variations of each. The next sections explain the pros and cons of each setting.

Don't confuse *file format* with the Format option on Setup Menu 1. That option erases all data on your memory card; see Chapter 1 for details.

JPEG: The imaging (and Web) standard

Pronounced *jay-peg*, this format is the default setting on your camera, as it is for most digital cameras. JPEG is popular for two main reasons:

Immediate usability: JPEG is a longtime standard format for digital photos. All Web browsers and e-mail programs can display JPEG files, so you can share them online immediately after you shoot them. You also can get JPEG photos printed at any retail outlet, whether it's an online or local printer. Additionally, any program that has photo capabilities, from photo-editing programs to word-processing programs, can handle your files. Small files: JPEG files are smaller than Raw files. And smaller files means that your pictures consume less room on your camera memory card and in your computer's storage tank.

The downside — you knew there had to be one — is that JPEG creates smaller files by applying *lossy compression*. This process actually throws away some image data. Too much compression leads to the defects you see in the JPEG Artifacts example in Figure 3-1, near the start of this chapter.

On your camera, the amount of compression that is applied depends on whether you choose a Quality setting that carries the label Fine or Normal. The difference between the two breaks down as follows:

- Fine: At this setting, represented by the symbol you see in the margin, very little compression is applied, so you shouldn't see many compression artifacts, if any.
- Normal: Switch to Normal, and the compression amount rises, as does the chance of seeing some artifacting. Notice the jaggedy-ness of the Normal icon, shown in the margin? That's your reminder that all may not be "smooth" sailing when you choose a Normal setting.

Note, though, that even the Normal setting doesn't result in anywhere near the level of artifacting that you see in my example in Figure 3-1. Again, that example is exaggerated to help you recognize artifacting defects and understand how they differ from other image-quality issues.

In fact, if you keep your image print or display size small, you aren't likely to notice a great deal of quality difference between the Fine and Normal compression levels. The differences become apparent only when you greatly enlarge a photo.

Take a look at Figure 3-7, for example, which shows the same subject captured at the Large/Fine and Large/Normal settings, along with the respective file sizes that each option produces. I captured each image at the same resolution so that file type is the only variable. To my eye, at least, there's no clear-cut difference in quality when the photos are printed at this size. However, in Figure 3-8, which shows a greatly enlarged view of a portion of one of the playing cards — the red K from the King of Hearts card — you can detect the impact of the greater compression level applied at the Normal setting.

Understand something important about these examples: At this magnification, you can see some pixelation as well as some compression artifacts. The ragged edge of the letter K is because of pixelation, so that aspect of the photo is the same for both the Normal and Fine examples. The splotchiness between the edges of the letter as well as in the white background is the compression defect. And here, the Fine example exhibits less of that particular defect than the Normal example.

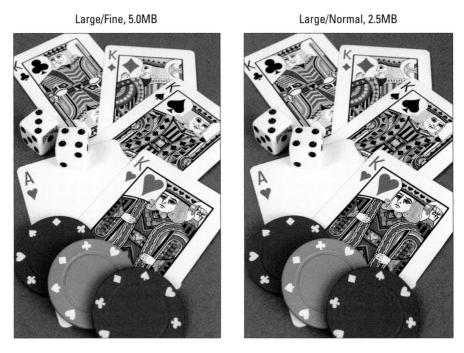

Figure 3-7: When the print or display size is small, detecting any difference in quality between the Fine and Normal examples is difficult.

Figure 3-8: Greatly enlarging an image brings compression defects into view.

Given that the differences between Fine and Normal aren't all that easy to spot until you really enlarge the photo, is it okay to shift to Normal and enjoy the benefits of smaller files? Well, only you can decide what level of quality your pictures demand. For me, the added file sizes produced by the Fine setting aren't a huge concern, given that the prices of memory cards are so low right now that it's easy to stock up on as many as I need. Long-term

78

storage is more of an issue; the larger your files, the faster you fill your computer's hard drive and the more DVDs or CDs you need for archiving purposes. But in the end, I'm willing to take the storage hit in exchange for the lower compression level of the Fine setting. You never know when a casual snapshot is going to be so great that you want to print or display it large enough that even minor quality loss becomes a concern. And of all the defects that you can correct in a photo editor, artifacting is one of the hardest to remove. So I stick with Fine if I shoot in the JPEG format.

I suggest that you do your own test shots, however, carefully inspect the results in your photo editor, and make your own judgment about what level of artifacting you can accept. Artifacting is often much easier to spot when you view images onscreen. It's difficult to reproduce artifacting here in print because the print process obscures some of the tiny defects caused by compression.

If you don't want *any* risk of artifacting, bypass JPEG altogether and change the file type to Raw (CR2). Or consider your other option, which is to record two versions of each file, one Raw and one JPEG. The next section offers details.

Whichever format you select, be aware of one more important rule for preserving the original image quality: If you retouch pictures in your photo software, don't save the altered images in the JPEG format. Every time you alter and save an image in the JPEG format, you apply another round of lossy compression. And with enough editing, saving, and compressing, you *can* eventually get to the level of image degradation shown in the JPEG example in Figure 3-1, at the start of this chapter. (Simply opening and closing the file does no harm.)

Always save your edited photos in a nondestructive format. TIFF, pronounced *tiff*, is a good choice and is a file-saving option available in most photo-editing programs. Should you want to share the edited image online, create a JPEG copy of the TIFF file when you finish making all your changes. That way, you always retain one copy of the photo at the original quality captured by the camera. You can read more about TIFF in Chapter 8, in the section related to processing Raw images. Chapter 9 explains how to create a JPEG copy of a photo for online sharing.

Raw (CR2): The purist's choice

The other picture-file type that you can create on your Rebel is *Camera Raw*, or just *Raw* (as in uncooked) for short.

Each manufacturer has its own flavor of Raw files; Canon's are called CR2 files (or, on some older cameras, CRW). If you use a Windows computer, you see that three-letter designation at the end of your picture filenames.

Raw is popular with advanced, very demanding photographers, for two reasons:

- ✓ Greater creative control: With JPEG, internal camera software tweaks your images, adjusting color, exposure, and sharpness as needed to produce the results that Canon believes its customers prefer. With Raw, the camera simply records the original, unprocessed image data. The photographer then copies the image file to the computer and uses special software known as a *raw converter* to produce the actual image, making decisions about color, exposure, and so on at that point. The upshot is that "shooting Raw" enables you, not the camera, to have the final say on the visual characteristics of your image.
- ✓ Higher bit depth: Bit depth is a measure of how many distinct color values an image file can contain. JPEG files restricts you to 8 bits each for the red, blue, and green color components, or *channels*, that make up a digital image, for a total of 24 bits. That translates to roughly 16.7 million possible colors. On the Rebel T1i/500D, a Raw file delivers a higher bit count, collecting 14 bits per channel. (Chapter 6 provides more information about the red-green-blue makeup of digital images.)

Although jumping from 8 to 14 bits sounds like a huge difference, you may not really ever notice any difference in your photos — that 8-bit palette of 16.7 million values is more than enough for superb images. Where having the extra bits can come in handy is if you really need to adjust exposure, contrast, or color after the shot in your photo-editing program. In cases where you apply extreme adjustments, having the extra original bits sometimes helps avoid a problem known as *banding* or *posterization*, which creates abrupt color breaks where you should see smooth, seamless transitions. (A higher bit depth doesn't always prevent the problem, however, so don't expect miracles.)

Best picture quality: Because Raw doesn't apply the destructive compression associated with JPEG, you don't run the risk of the artifacting that can occur with JPEG.

But of course, as with most things in life, Raw isn't without its disadvantages. To wit:

✓ You can't do much with your pictures until you process them in a Raw converter. You can't share them online, for example, or put them into a text document or multimedia presentation. You can print them immediately if you use the Canon-provided software, but most other photo programs require you to convert the Raw files to a standard format first. Ditto for retail photo printing. So when you shoot Raw, you add to the time you must spend in front of the computer instead of behind the camera lens. Chapter 8 shows you how to process your Raw files using your Canon software.

Raw files are larger than JPEGs. Unlike JPEG, Raw doesn't apply lossy compression to shrink files. In addition, Raw files are always captured at the maximum resolution available on your camera, even if you don't really need all those pixels. For both reasons, Raw files are significantly larger than JPEGs, so they take up more room on your memory card and on your computer's hard drive or other picture-storage device.

Whether the upside of Raw outweighs the down is a decision that you need to ponder based on your photographic needs, your schedule, and your computer-comfort level. But before you make up your mind, compare the Large/Fine JPEG image in Figure 3-8 with its Raw counterpart, shown in Figure 3-9. I included the enlarged area from the JPEG Fine example here to make it easier to compare it with the Raw version. Yes, you can detect some subtle quality differences in the enlarged view, but most people would be hard pressed to distinguish between the two otherwise. And JPEG certainly wins out in terms of convenience, time savings, and smaller file size. (Note that during the Raw conversion process, I tried to use settings that kept the Raw image as close as possible to its JPEG cousin in all aspects but quality. But any variations in exposure, color, and contrast are a result of the conversion process, not of the format per se.)

Figure 3-9: The difference between Raw and Large/Fine images typically is noticeable only when images are greatly enlarged.

Part I: Fast Track to Super Snaps

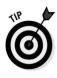

That said, I *do* shoot in the Raw format when I'm dealing with tricky lighting because doing so gives me more control over the final image exposure. For example, if you use a capable Raw converter, you can specify how bright you want the brightest areas of your photo to appear and how dark you prefer your deepest shadows. With JPEG, the camera makes those decisions, which can limit your flexibility if you try to adjust exposure in your photo editor later. And the extra bits in a Raw file offer an additional safety net because I usually can push the exposure adjustments a little further in my photo editor if necessary without introducing banding.

I also go Raw if I know that I'm going to want huge prints of a subject. But keep in mind: I'm a photography geek, I have all the requisite software, and I don't really have much else to do with my time than process scads of Raw images.

If you do decide to try Raw shooting, you can select from the following two Quality options:

- **RAW:** This setting produces a single Raw file at the maximum resolution (15.1 megapixels).
- RAW+Large/Fine: This setting produces two files: the standard Raw file plus a JPEG file captured at the Large/Fine setting. At first glance, this option sounds great: You can share the JPEG online or get prints made and then process your Raw files when you have time.

The problem is that, like the Raw file, the JPEG image is captured at the maximum pixel count — which is *too* large for onscreen viewing. That means that you have to edit the JPEG file anyway to trim down the pixel count before online sharing, although you can produce great prints right away. In addition, creating two files for every image eats up substantially more memory card space. I leave it up to you to decide whether the pluses outweigh the minuses.

My take: Choose Fine or Raw

At this point, you may be finding all this technical goop a bit much — I recognize that panicked look in your eyes — so allow me to simplify things for you. Until you have time or energy to completely digest all the ramifications of JPEG versus Raw, here's a quick summary of my thoughts on the matter:

- If you require the absolute best image quality and have the time and interest to do the Raw conversion process, shoot Raw. See Chapter 8 for more information on the conversion process.
- If great photo quality is good enough for you, you don't have wads of spare time, or you aren't that comfortable with the computer, stick with one of the Fine settings (Large/Fine, Medium/Fine, or Small/Fine).

- If you want to enjoy the best of both worlds, consider Raw+Large/Fine assuming, of course, that you have an abundance of space on your memory card and your hard drive. Otherwise, creating two files for every photo on a regular basis isn't really practical.
- Select JPEG Normal if you're not shooting pictures that demand the highest quality level and you won't be printing or displaying the photos at large sizes. The smaller file sizes also makes JPEG Normal the way to go if you're running seriously low on memory card space during a shoot.
- ✓ Finally, remember that the format and resolution together determine the ultimate picture quality. So be sure that you select the Quality setting that offers both the appropriate number of pixels and format for how you plan to use your image. If you capture an image at the Small/Normal setting, for example, and then print the photo at a large size, the combination of a lower pixel count and a higher level of JPEG compression may produce a disappointing picture quality.

Maintaining a pristine view

Often lost in discussions of digital photo defects — compression artifacts, pixelation, and the like — is the impact of plain-old dust and dirt on picture quality. But no matter what camera settings you use, you aren't going to achieve great picture quality with a dirty lens. So make it a practice to clean your lens on a regular basis, using one of the specialized cloths and cleaning solutions made expressly for that purpose.

If you continue to notice random blobs or hairlike defects in your images (refer to the last example in Figure 3-1), you probably have a dirty *image sensor.* That's the part of your camera that does the actual image capture — the digital equivalent of a film negative, if you will. By default, your camera performs an internal sensor cleaning every time you turn it on and off; you can also run the cleaning process at any time you want by opening Setup Menu 2, choosing the Sensor Cleaning option, and then selecting Clean Now.

Especially if you frequently change lenses in a dirty environment, however, this internal cleaning mechanism may not be able to fully remove all specks from the sensor. In that case, you need a more thorough cleaning, which is done by actually opening up the camera and using special sensor-cleaning tools. You can do this job yourself, but . . . I don't recommend it. An image sensor is pretty delicate, and you can easily damage it or other parts of your camera if you aren't careful. Instead, find a local camera store that offers this service. In my area (central Indiana), sensor cleaning costs about \$30 to \$50. If you bought your camera at a traditional camera store, the store may even provide free sensor cleaning as a way to keep your business.

One more cleaning tip: Never — and I mean never — try to clean any part of your camera using a can of compressed air. Doing so can not only damage the interior of your camera, blowing dust or dirt into areas where it can't be removed, but also, it can crack the monitor.

Part I: Fast Track to Super Snaps _____

Monitor Matters: Picture Playback, Live View, and Movie Mode

In This Chapter

- Exploring picture playback functions
- Deciphering the picture information displays
- Understanding histograms
- Deleting bad pictures and protecting great ones
- Using your monitor as a viewfinder in Live View mode
- Recording movies

ithout question, my favorite thing about digital photography is being able to view my pictures the instant after I shoot them. No more guessing whether I captured the image I wanted or need to try again; no more wasting money on developing and printing pictures that stink. In fact, this feature alone was reason enough for me to turn my back forever on my closetful of film photography hardware.

Of course, with the Rebel T1i/500D, you can use the monitor not only to review your photos, but also to *preview* them. That is, if you turn on the Live View feature, you can use the monitor instead of the view-finder to compose your shots. And not just still shots: You can record short digital movies, too, complete with sound.

Because all these functions involve some of the same buttons, bells, and whistles, I cover them together in this chapter. Additionally, this chapter explains how to delete pictures that you don't like and protect the ones you love from accidental erasure. (Be sure also to visit Chapter 9, which covers some additional ways to view your images, including how to create in-camera slide shows and display your photos and movies on a television.)

Disabling and Adjusting Instant Review

After you take a picture, it automatically appears briefly on the camera monitor. By default, the instant-review period lasts just two seconds. But you can customize this behavior via the Review Time option on Shooting Menu 1, as shown in Figure 4-1.

6. 6: 6: 🕶 DISB		
۵	planting of the state of the second se	
On		
vithout card		Off
2 sec.	Review time	2 sec.
. correct.		4 sec.
Off		8 sec.
		Hold
	S On vithout card 2 sec. . correct.	S On vithout card 2 sec. . correct.

Figure 4-1: You can extend or disable automatic picture review.

Your choices are as follows:

- ✓ Select one of three specific review periods: 2, 4, or 8 seconds.
- Select Off to disable the automatic instant review altogether. Turning off the monitor saves battery power, so keep this option in mind if the battery is running low. You can still view your pictures by pressing the Playback button. See the next section for details.
- Select Hold to display the current image indefinitely or at least until the camera automatically shuts off to save power. (See the Chapter 1 section about Setup Menu 1 to find out about the auto shutdown feature.)

Viewing Images in Playback Mode

To switch your camera to Playback mode and view the images on your memory card, take these steps:

1. Press the Playback button, shown in Figure 4-2 and in the margin.

At the default settings, the camera displays a single picture at a time, with a row of picture data at the top of the frame, as shown in Figure 4-2. You can also display multiple images at a time; the next section tells all.

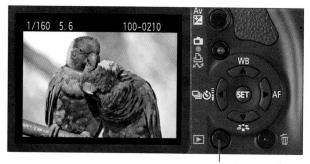

Playback button

Figure 4-2: The default Playback mode displays one picture at a time, with minimal picture data.

To find out how to interpret the picture data and specify what data you want to see, see the upcoming section "Viewing Picture Data."

2. Press the right or left cross key to scroll through your pictures.

- Press the right cross key to view images starting with the oldest one on the card.
- Press the left cross key to view images in reverse order, starting with the most recent picture.

Just keep pressing either key to browse through all of your images.

3. To return to picture-taking mode, press the Playback button or press the shutter button halfway.

The camera exits Playback mode and the Shooting Settings display appears on the monitor. Chapter 1 introduces you to that display.

Viewing multiple images at a time

If you want to quickly review and compare several photos, you can set the camera to Index display mode and view thumbnails of either four or nine images at a time, as shown in Figure 4-3. Just press the AE Lock button, found on the upper-right corner of the camera back and shown in the margin. Press once to display four thumbnails at a time; press again to display nine thumbnails.

Note the little blue checkerboard and magnifying glass icons under the button — they're reminders of the function the button serves in Playback mode. The checkerboard indicates the Index function, and the minus sign in the magnifying glass tells you that pressing the button reduces the size of the image thumbnail. (The silver label above the button indicates a function related to picture taking.)

Figure 4-3: You can view four or nine thumbnails at once.

Remember these factoids about navigating and viewing your photo collection in Index display mode:

- A highlight box surrounds the selected image. For example, in the left screen in Figure 4-3, the upper-right photo is selected.
- Use the cross keys to select a different image. Press the up cross key to shift the selection box up, the right cross key to move it right, and so on.
- Rotate the Main dial to scroll through screens of thumbnails. Rotate right to shift to the next screen; rotate left to go back one screen.

Press the AF Point Selection button to reduce the number of thumbnails. This button lives right next door to the AE Lock button. It, too, has a blue magnifying glass icon, this time with a plus sign in the center to indicate that pressing the button enlarges the thumbnail size. Press once to go from nine thumbnails to four; press again to go from four thumbnails to singe-image view, filling the screen with the selected image. To return to Index display mode, press the AE Lock button again.

Jumping through images

If your memory card contains scads of images, here's a trick you'll love: By using the Jump feature, you can rotate the Main dial to leapfrog through pictures instead of pressing the right or left cross key a bazillion times to get to the picture you want to see. You also can search for the first image shot on a specific date or tell the camera to display only movies or only still shots.

Set up your initial Jump mode by displaying Playback Menu 2 and highlighting Image Jump, as shown on the left in Figure 4-4. (The little symbol at the end of the option name represents the Main dial, in case you care.)

		lmage jump w/m	
Histogram Slide show	Brightness		
lmage jump w/m	10 images	1 image	Date
	3	10 images	Movies
		100 images	Stills
		별 영상은 것은 것은 가지 않는 것이다. 별 영상은 것은 것은 것이 있는 것이 같이다.	

Figure 4-4: You can specify a Jump mode from Playback Menu 2.

Press Set to display the right screen in Figure 4-4, where you can see all six jump-mode settings. They work as follows:

- ✓ 1 Image: This option, in effect, disables jumping, restricting you to browsing pictures one at a time. So what's the point? It's provided to enable you to scroll through pictures using the Main dial instead of the right and left cross keys if you prefer.
- ✓ 10 Images: Select this option to advance 10 images at a time.
- ✓ 100 Images: Select this option to advance 100 images at a time.
- Date: If your card contains images shot on different dates, you can jump between dates with this option. For example, if you're looking at the first of 30 pictures taken on June 1, you can jump past all the others from that day to the first image taken on, say, June 5.
- Movies: Does your memory card contain both still photos and movies? If you want to view only the movie files, select this option. Then you can rotate the Main dial to jump from one movie to the next without seeing any still photos.
- ✓ Stills: This one is the opposite of the Movies option: Your movie files are hidden from view when you use the Main dial to scroll through your photos. You scroll one picture at a time, just as when you use the 1 Image option.

Select the Jump mode you want to use and press Set. Then take these steps to jump through your photos:

ANEMBER

2. Set the camera to display a single photo.

You can use jumping only when viewing a single photo at a time because the Main dial serves another function in Index playback. To get out of Index mode, press the AF Point Selection button (the one marked with the blue "zoom out" magnifying glass) until you see only one image on the monitor.

3. Rotate the Main dial.

The camera jumps to the next image. How many images you advance, and whether you see movies as well as still photos, depends on the Jump mode you select.

1/50

13

If you select any Jump setting but 1 Image, a *jump bar* appears at the bottom of the monitor, as shown in Figure 4-5, indicating the current Jump setting. If you want to view the bar in 1 Image mode, press the up cross key.

After the bar appears, you can

100-2305

Figure 4-5: You also can press the up cross key to cycle through the Jump mode options.

change the Jump setting without having to return to Playback Menu 2. Instead, just press the up or down cross key to cycle through the six Jump settings. Rotate the Main dial to start jumping again.

4. To exit Jump mode, press the right or left cross key.

Now you're back to regular Playback mode, in which each press of the right or left cross key advances through your pictures one at a time. You can return to your selected Jump mode by rotating the Main dial at any time.

Rotating vertical pictures

When you take a picture, the camera can record the image *orientation* — whether you held the camera normally, creating a horizontally oriented image, or turned the camera on its side to shoot a vertically oriented photo. This bit of data is simply added into the picture file. Then when you view the

picture, the camera reads the data and rotates the image so that it appears upright in the monitor, as shown on the left in Figure 4-6. The image is also rotated automatically when you view it in the photo software that shipped with your camera.

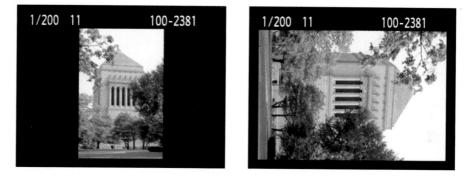

Figure 4-6: You can display vertically oriented pictures in their upright position (left) or sideways (right).

Official photo lingo uses the term *portrait orientation* to refer to vertically oriented pictures and *landscape orientation* to refer to horizontally oriented pictures.

By default, automatic picture rotation is enabled for you. If you want to turn it off, you can do so through the Auto Rotate option on Setup Menu 1, as shown in Figure 4-7. You also can specify that you want the picture to be rotated just on your computer monitor by choosing the second of the two On settings (the one that doesn't sport the little camera icon).

নানারারা		การาธาร	
Auto power off File numbering	30 sec. Continuous		
Auto rotate	On 🖸 💻	Auto rotate) On 🗖 💻
Format			On
LCD auto off	Enable		Off
Screen color	1		

Figure 4-7: Go to Setup Menu 1 to disable or adjust automatic image rotation.

If you turn off automatic rotation, you can rotate images during playback by taking these steps:

1. Display Playback Menu 1 and highlight Rotate, as shown in Figure 4-8.

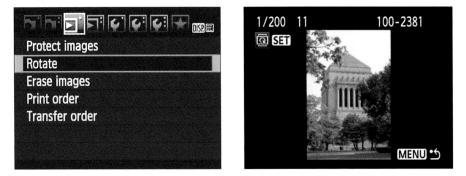

Figure 4-8: You also can rotate individual images from Playback Menu 1.

2. Press the Set button.

An image appears on the monitor, as shown on the right in Figure 4-8.

3. Navigate to the photo that you want to rotate.

If you're viewing pictures one at a time, just press the right and left cross keys to scroll to the photo that needs rotating. In Index display mode, press the cross keys to put the highlight box around the photo.

4. Press the Set button to rotate the image.

Press once to rotate the image 90 degrees; press again to rotate 270 degrees; and once more to return to 0 degrees.

- 5. Repeat Steps 3 and 4 to rotate additional photos.
- 6. Press Menu to exit Rotate mode and return to Playback Menu 1.

These steps apply only to still photos; you can't rotate movies during playback. See the section "Recording movies," later in this chapter, for more about movie playback.

Zooming in for a closer view

By pressing the AF Point Selection button, posing here in the margin, you can more closely inspect a portion of a photo. This feature is especially handy for checking small details, such as whether anyone's eyes are closed in a group portrait. As with image rotating, zooming works only for still photos and only when you're displaying photos one at a time. So if you're viewing pictures in Index display mode, press the AF Point Selection button as many times as needed to display a single image on the monitor. Then use these techniques to adjust the image magnification:

- Zoom in. Press and hold the AF Point Selection button until you reach the magnification you want. You can enlarge the image up to ten times its normal display size.
- ✓ View another part of the picture. Whenever the image is magnified, a little thumbnail representing the entire image appears in the lower-right corner of the monitor, as shown in Figure 4-9. The white box indicates the area of the image that's visible. In the figure, for example, you see the

top-central portion of the lorikeet photo that first chirped onto the scene in Figure 4-2.

Use the cross keys to scroll the display to view a different portion of the image.

✓ View more images at the same magnification. Here's an especially neat trick: While the display is zoomed, you can rotate the Main dial to display the same area of the next photo at the same magnification. So, for example, if you shot that group portrait several times, you can easily check each one for shuteye problems.

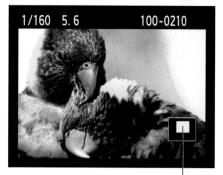

Magnified area

Figure 4-9: Press the cross keys to scroll the display of the magnified image.

- **Zoom out.** To zoom out to a reduced magnification, press the AE Lock button. Continue holding the button down until you reach the magnification you want.
- Return to full-frame view. When you're ready to return to the normal magnification level, you don't need to keep pressing the AE Lock button until you're zoomed out all the way. Instead, press the Playback button, which quickly returns you to the full-frame view.

Viewing Picture Data

When you review still photos, you can press the DISP button to change the type and amount of shooting data that appears with the photo in the monitor. The next several sections offer a guide to the data-display options, starting with the most basic and working up to the most complex. See the upcoming

section "Recording Movies" for information about what's displayed during movie playback.

Basic information display modes

In the simplest display mode, officially called Single Image display, your photo appears as shown in Figure 4-10.

Along the top of the screen, you see the following bits of information, labeled in the figure:

- Shutter speed and f-stop (aperture): Chapter 5 explains these two exposure settings.
- ✓ Exposure Compensation value: This option, also detailed in Chapter 5, enables you to produce a brighter or darker image than the camera's autoexposure meter thinks appropriate. If you applied exposure compensation when you take a picture, the compensation amount appears to the right of the f-stop during playback. Otherwise, this area of the display is empty.

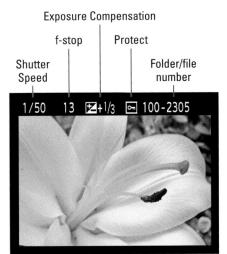

Figure 4-10: The most basic Playback mode displays your image with minimal shooting information.

Protect: Using the Protect feature, described later in this chapter, you can "lock" an image to prevent it from being erased when you use the camera's Erase function. (Formatting the memory card *does* delete the picture, however, so use caution.) If you protect the photo, a little key icon appears next to the Exposure Compensation value.

Folder number and last four digits of file number: See Chapter 1 for information about how the camera assigns folder and file numbers.

From Single Image mode, press the DISP button again to shift to a mode called Single Image Plus Quality.

Now you get two additional pieces of information, as shown in Figure 4-11:

Image number/total images: This pair of values shows you the current image number and the total number of images on the memory card. For example, in Figure 4-11, you see picture 16 out of 38. (Don't confuse the image number with the actual file number; again, the last four digits of the file number appear in the top-right corner of the display, along with the folder number.)

Quality setting: This setting, covered in Chapter 3, determines the image resolution (pixel count) and file format (JPEG or Raw).

The Quality symbols shown during playback are the same ones used to indicate the Quality setting on the camera menus and Shooting Settings screen. Figure 4-11 shows the symbol that represents the Large/Fine setting. Chapter 3 has a chart to help you decode the other symbols.

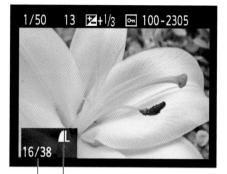

Quality setting

Image number/ total images

Figure 4-11: Press DISP again to add Quality setting information to the basic display.

To view additional details about the settings you used to take a picture, switch to Shooting Information display mode or Histogram display mode. The next sections explain how to interpret the data that appears in these two modes.

Shooting Information display

In the Shooting Information display mode, the camera presents a thumbnail of your image along with scads of shooting data, as shown in Figure 4-12. To get to this screen, first display your photo in full-frame view. The Shooting Information display isn't available in Index display (when four or nine thumbnails are displayed at a time). Then press the DISP button as many times as needed to cycle through the four information-display options until you see the one shown in the figure.

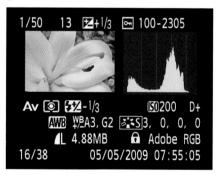

Figure 4-12: You can view more data in Shooting Information Playback mode.

The chartlike thingy on the right side

of the screen is an exposure-evaluation tool known as a *histogram*. You get schooled in the art of reading histograms in the next section.

If any areas of the image thumbnail are blinking, you don't need a histogram to know that you may have an exposure problem. Those blinking spots indicate pixels that are completely white. An abundance of blinking spots can indicate a problem known as *blown* or *clipped highlights*, where areas that should contain a range of light shades are so overexposed that they are instead a solid blob of white. Depending on where in the image those areas occur, you may or may not want to retake the photo. For example, if someone's face contains the blinking spots, you should take steps to correct the problem. But if the blinking occurs in, say, a bright window behind the subject, and the subject looks fine, you may choose to just ignore the alert.

To sort out the maze of other data, it helps to break the display down into five rows of information — the row along the top of the screen and the four rows that appear under the image thumbnail and histogram, as follows:

- Row 1 data: Here you see the same data that appears in the two basic display modes, explained in the preceding section.
- Row 2 data: Shift your attention now to the row of symbols just underneath the thumbnail and histogram. Labeled in Figure 4-13, these symbols indicate the following:

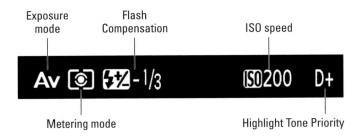

Figure 4-13: This row contains additional exposure information.

- *Exposure mode:* This symbol indicates which of the camera's exposure modes you used Full Auto, Av (aperture-priority auto-exposure), Portrait, and so on. The symbols mirror what you see on the camera Mode dial. You can find details about all the modes in Chapters 2 and 5.
- *Metering mode:* This symbol represents the metering mode, which determines which part of the frame the camera uses when calculating exposure. Chapter 5 explains.
- *Flash Compensation amount:* Here you can see whether you adjusted flash power using the Flash Compensation feature, detailed in Chapter 5.

- *ISO speed:* Chapter 5 also explains this option, which controls the light sensitivity of the camera's image sensor.
- *Highlight Tone Priority:* If you enabled this exposure feature for the shot, you see the little D+ symbol. See Chapter 5 to find out how Highlight Tone Priority affects your photos.
- Row 3 data: Information on this row of the display, labeled in Figure 4-14, mostly relates to color settings. Here's the scoop:

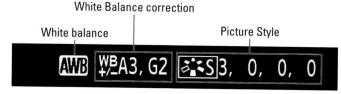

Figure 4-14: Look to this row for details about advanced color settings.

- *White Balance setting:* Chapter 6 has details on this option, which helps ensure accurate photo colors. The setting shown in the figure, AWB, stands for Auto White Balance. See the table in Chapter 6 for a look at the symbols representing other White Balance settings.
- *White Balance correction:* This collection of data tells you whether you applied any adjustment to the White Balance setting you used. Chapter 6 explains this advanced color option.
- *Picture Style:* Notice that the symbol shown here looks similar to the one on the bottom cross key on the camera back. You can use that cross key to access Picture Styles, which enable you to tweak image color, contrast, and sharpness. In the playback display, you see the same symbol plus a letter that indicates the Picture Style you used for the photo. The *S* in Figure 4-14 represents the Standard Picture Style, for example. The values to the right relate to four characteristics that you can adjust for each Picture Style. Chapter 6 explains how each Picture Style affects your image.
- Row 4 data: Shown at the top of Figure 4-15, this row tells you the following tidbits of information:
 - *Quality and file size:* For details on the Quality setting and its affect on file size and picture quality, see Chapter 3. File size is shown in megabytes (MB).

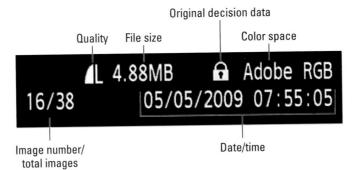

Figure 4-15: The bottom two rows of the display offer this data.

- Original Decision Data: The Rebel T1i/500D enables you to tag an image file with a code that indicates that the image is original meaning that it hasn't been altered in a photo program or otherwise tampered with after it was captured. To check the code, you need a separate product called the Original Data Verification Kit, which retails for about \$700, unfortunately. If you do enable the feature on the camera, which I explain how to do in Chapter 11, a lock icon appears in this area of the playback screen.
- *Color space:* Your camera can capture images in two *color spaces*, sRGB and Adobe RGB. A *color space* is a definition of the spectrum of colors that an image can contain. You can change color spaces only in advanced exposure modes; Chapter 6 has details about how and why to do so.
- Row 5 data: Wrapping up the smorgasbord of shooting data, the bottom row of the playback screen holds two more pieces of information, as shown in Figure 4-15:
 - *Image number/total images recorded:* Again, this pair of numbers indicates the current image number with respect to the total number of images on the current memory card.
 - *Date and time:* These values show you the exact moment that the image was recorded. Of course, you must first set the camera date and time, as Chapter 1 explains.

One note about Figures 4-12 through 4-15: I included all possible symbols, values, and other shooting data just for the purposes of illustration. If any of the data items don't appear on your monitor, it simply means that the feature wasn't enabled when you captured the photo.

Chapter 4: Monitor Matters: Picture Playback, Live View, and Movie Mode

Understanding Histogram display mode

A variation of the Shooting Information display, Histogram display offers the data you see in Figure 4-16. Again, you get the thumbnail view of your image,

but this time some of the extensive shooting data is replaced by a second histogram.

The next two sections explain what information you can glean from the histograms. See the preceding sections for a map to the other shooting data on the screen.

As with the Shooting Information display, this one is only available when you're viewing photos one at a time. If your monitor is showing four or nine thumbnails, press the AF Point Selection button to get to full-frame view. Then press DISP as needed to get to the Histogram display. RGB Histogram

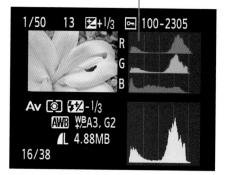

Figure 4-16: Histogram display mode replaces some shooting data with an RGB histogram.

Interpreting a brightness histogram

One of the most difficult photo problems to correct in a photo-editing program is known as *blown highlights* in some circles and *clipped highlights* in others. In plain English, both terms mean that *highlights* — the brightest areas of the image — are so overexposed that areas that should include a variety of light shades are instead totally white. For example, in a cloud image, pixels that should be light to very light gray become white because of overexposure, resulting in a loss of detail in those clouds.

In Shooting Information display mode, areas that fall into this category blink in the image thumbnail. This warning is a great feature because simply viewing the image on the camera monitor isn't always a reliable way to gauge exposure. The relative brightness of the monitor and the ambient light in which you view it affect the appearance of the image onscreen.

For a detailed analysis of the image exposure, check the *Brightness histogram*, which is a little graph that indicates the distribution of shadows, highlights, and *midtones* (areas of medium brightness) in your image, as shown in Figure 4-17. Photographers use the term *tonal range* to describe this aspect of their pictures. The Brightness histogram appears to the right of the image thumbnail in Shooting Information display mode and in the lower-right corner in Histogram display mode.

-1-

 \odot

The horizontal axis of the graph represents the possible picture brightness values, from the darkest shadows on the left to the brightest highlights on the right. And the vertical axis shows you how many pixels fall at a particular brightness value. A spike indicates a heavy concentration of pixels. For example, in Figure 4-17, which shows the histogram for the lily image in Figure 4-16, the histogram indicates a broad range of brightness values, but with the majority of pixels falling between medium and maximum brightness.

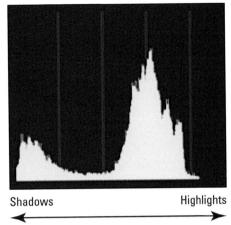

Keep in mind that there is no one "perfect" histogram that you should try to achieve. Instead, you need to interpret the histogram with respect

Figure 4-17: The Brightness histogram indicates the tonal range of your image.

to the amount of shadows, highlights, and midtones that comprise your subject. For example, the histogram in Figures 4-16 and 4-17 makes sense for this particular image because the subject contains mostly light colors, with only a few dark ones. Pay attention, however, if you see a very high concentration of pixels at the far right or left end of the histogram, which can indicate a seriously overexposed or underexposed image, respectively.

Reading an RGB histogram

When you view your images in Histogram display mode, you see two histograms: the Brightness histogram, covered in the preceding section, and an RGB histogram, shown in Figure 4-18.

To make sense of the RGB histogram, you first need to know that digital images are called RGB images because they are created out of three primary colors of light: red, green, and blue. The RGB histogram shows you the brightness values for each of those primary colors.

By checking the brightness levels of the individual color components. sometimes referred to as color channels, you can assess the picture's

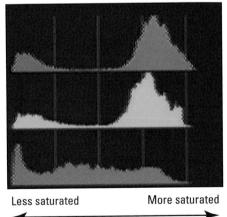

Figure 4-18: The RGB histogram can indicate problems with color saturation.

color saturation levels. If most of the pixels for one or more channels are clustered toward the right end of the histogram, colors may be oversaturated, which destroys detail. On the flip side, a heavy concentration of pixels at the left end of the histogram indicates an image that may be undersaturated.

A savvy RGB histogram reader can also spot color balance issues by looking at the pixel values. But frankly, color balance problems are fairly easy to notice just by looking at the image on the camera monitor. And understanding how to translate the histogram data for this purpose requires more knowledge about RGB color theory than I have room to present in this book.

If you are a fan of RGB histograms, however, you may be interested in another possibility: You can swap the standard Brightness histogram that appears in Shooting Information playback mode with the RGB histogram. Just visit Playback Menu 2, highlight the Histogram option, as shown on the left in Figure 4-19, and press the Set button to display the right screen in the figure. Select RGB instead of Brightness and press the Set button again.

Histogram	Brightness	Histogram	Brightness
Slide show			▶ RGB
lmage jump w/m	10 images		

Figure 4-19: You can change the histogram type that appears in Shooting Information display mode.

For information about manipulating color, see Chapter 6.

Deleting Photos

When you spot a clunker during your picture review, you can erase it from your memory card in a couple of ways, as outlined in the next three sections.

Erasing single images

To delete photos one at a time, take these steps:

1. Select the image that you want to delete.

If you are viewing images in single-frame mode, just display the image on the monitor. In Index display mode, use the cross keys to move the highlight box over the image thumbnail.

2. Press the Erase button, shown in the margin here.

The words Cancel and Erase appear at the bottom of the screen, as shown in Figure 4-20.

3. Press the right cross key to highlight Erase and then press the Set button.

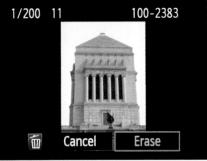

Figure 4-20: Highlight Erase and press Set to delete the current image.

Your picture is zapped into digital oblivion.

If you accidentally erase a picture, don't panic — you may be able to restore it by using data-restoration software. One memory card manufacturer, SanDisk, even provides this type of software free with some of its memory cards. You also can buy stand-alone programs such as MediaRecover (\$30, www.mediarecover.com) or Lexar Image Rescue (also \$30, www.lexar.com). But to have a chance at recovering deleted data, you must not take any more pictures or perform any other operations on your camera while the current memory card is in it. If you do, you may overwrite the erased picture data for good and eliminate the possibility of recovering the image.

Erasing all images on your memory card

To dump all pictures on the memory card, take this approach:

- 1. Display Playback Menu 1 and highlight Erase Images, as shown on the left in Figure 4-21.
- 2. Press the Set button to display the right screen in Figure 4-21.
- 3. Highlight All Images on Card and press the Set button.

After you press Set, you see a confirmation screen asking whether you really want to delete all of your pictures.

	mErase images
Protect images	Select and erase images
Rotate	All images on card
Erase images	
Print order	
Transfer order	
	Menu ·5

Figure 4-21: Use the Erase option on Playback Menu 1 to delete multiple images quickly.

4. Select OK and press Set to go ahead and dump the photos.

Note, though, that pictures that you have protected, a step discussed two sections from now, are left intact.

5. Press Menu to return to Playback Menu 1.

Or press the shutter button halfway to return to shooting pictures.

Erasing selected images

If you want to erase many, but not all, images on your memory card, you can save time by using this deleting option:

1. On Playback Menu 1, highlight Erase Images, as shown on the left in Figure 4-22, and press Set.

You see the main Erase Images screen, shown on the right in Figure 4-22.

	🗑 🗑 Erase images
Protect images	Select and eras
Rotate	All images on c
Erase images	
Print order	
Transfer order	

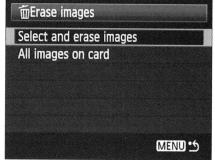

Figure 4-22: You can delete multiple selected images at once.

2. Highlight Select and Erase Images and press the Set button.

You see the current image in the monitor. At the top of the screen, a little check box appears, as shown on the left in Figure 4-23.

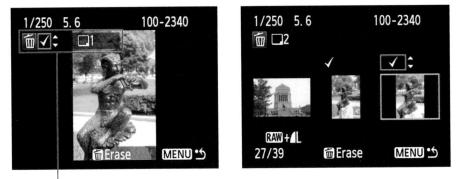

Marked for deletion

Figure 4-23: Use the up and down cross keys to check the box for images you want to delete.

3. Press the up or down cross key to put a check mark in the box and tag the image for deletion.

If you change your mind, press the cross key again to remove the check mark.

- 4. Press the left or right cross keys to view the next image.
- 5. Keep repeating Steps 3 and 4 until you mark all of the images that you want to trash.

If you don't need to inspect each image closely, you can display up to three thumbnails per screen, as shown in the right image in Figure 4-23. Just press the AE Lock button, shown in the margin, to shift into this display. Again, just use the up and down cross keys to mark images for deletion, and use the right and left cross keys to advance through your images.

To return to full-frame view, press the AF Point Selection button, shown in the margin. And if you need an even closer look, keep pressing the button to switch from full-frame view to a magnified view. Use the techniques outlined earlier in this chapter, in the section "Zooming in for a closer view," to adjust the magnification power and scroll the display to view other areas of the image.

6. Press the Erase button.

You see a confirmation screen asking whether you really want to get rid of the selected images.

ALMEMBER

Deleting versus formatting: What's the diff?

In Chapter 1, I introduce you to the Format command, which lives on Setup Menu 1 and erases everything on your memory card. What's the difference between erasing photos by formatting and by using the Erase Images option on Playback Menu 1 to delete all your pictures?

Well, in terms of pictures taken with your Rebel, none. But if you happen to have stored other data on the card, such as a music file or a picture taken on another type of camera, you need to format the card to erase everything on it. You can't view those files on the monitor, so you can't use the Erase Images feature to get rid of them.

One final — and important — note: Although using the Protect feature (explained elsewhere in this chapter) prevents the Erase function from erasing a picture, formatting erases all pictures, protected or not. Formatting also ensures that the card is properly prepared to store any new images you may take.

7. Highlight OK and press Set.

The selected images are deleted, and you return to the Erase Images menu.

8. Press Menu to return to Playback Menu 1.

Or, to continue shooting, press the shutter button halfway.

Protecting Photos

You can protect pictures from accidental erasure by giving them *protected status*. After you take this step, the camera doesn't allow you to delete a picture from your memory card, whether you press the Erase button or use the Erase Images option on Playback Menu 1.

Formatting your memory card, however, *does* erase even protected pictures. See the sidebar elsewhere in this chapter for more about formatting.

The picture protection feature is especially handy if you share a camera with other people. You can protect pictures so that those other people know that they shouldn't delete your super-great images to make room on the memory card for their stupid, badly photographed ones. (This step isn't foolproof, though, because anyone can remove the protected status from an image.)

Perhaps more importantly, when you protect a picture, it shows up as a "read-only" file when you transfer it to a computer. Files that have that read-only status can't be altered. Again, anyone with some computer savvy can remove the status, but this feature can keep casual users from messing around with your images after you've downloaded them to your system.

Of course, you have to know how to remove the read-only status if you plan to edit your photo in your photo software. (Hint: In Canon ZoomBrowser EX, the free Windows-based software that ships with your camera, you can do this by clicking the image thumbnail and choosing File Protect. That command toggles image protection on and off. In ImageBrowser, the Mac version of the Canon software, set the thumbnail display to List Mode and click the photo thumbnail. Then choose File Get Info and then click the Lock box to toggle file protection on and off. See Chapter 8 for help with using these programs.)

Anyway, protecting a picture on the camera is easy. Just take these steps:

1. Display Playback Menu 1 and highlight Protect Images, as shown on the left in Figure 4-24.

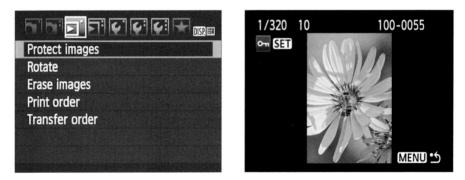

Figure 4-24: Apply Protect status to prevent accidental erasure of important images.

2. Press Set.

An image appears on the monitor, along with a little key icon in the upper-left corner, as shown on the right in Figure 4-24.

3. Navigate to the picture that you want to protect.

Just press the right or left cross key to scroll through your pictures.

4. Press Set to lock the picture.

Now a key icon appears with the data at the top of the screen, as shown in Figure 4-25.

- 5. To lock more pictures, repeat Steps 3 and 4.
- 6. Press the Menu button to exit the protection process.

To remove picture protection while the picture card is still in the camera, follow these same steps. When you display the locked picture, just press Set to turn the protection off. The little key icon disappears from the top of the screen to let you know that the picture is no longer protected.

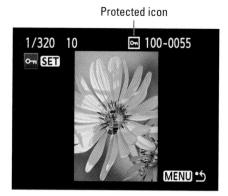

Figure 4-25: The key icon indicates that the picture is protected.

Using Your Monitor as a Viewfinder

If you've used a compact, point-and-shoot digital camera, you may be used to composing your pictures on the camera monitor rather than by looking through the viewfinder. In fact, many compact cameras no longer even offer a viewfinder, which is a real shame, in my opinion. Why? Because when you use the monitor to frame the image, you must hold the camera away from your body, a shooting posture that increases the likelihood of blurry images caused by camera shake. When you use the viewfinder, you can brace the camera against your face, creating a much steadier shooting stance.

Because of some design complexities that I won't bore you with, most digital SLR cameras do not enable you to preview shots on the monitor. Your T1i/500D, however, does offer that feature, known as *Live View*. But using your monitor as a viewfinder on your camera isn't quite as simple as when you use a point-and-shoot, non-SLR model — again, the difference is because of the more involved design of an SLR camera.

Here are the important points to know before you experiment with Live View shooting:

- Live View is available only in advanced exposure modes. That is, you must set the Mode dial to P, Tv, Av, M, or A-DEP mode.
- Manual focusing is recommended. You can use autofocusing, but manual focusing usually offers faster, more precise results. If you want to try autofocusing anyway, Chapter 6 tells you what you need to know.
- Enabling the Auto Lighting Optimizer function may produce an overexposed photo. For best exposure results, disable the option. Visit Setup Menu 3 and set Custom Function 7 to the Off setting. (Chapter 5

explains Auto Lighting Optimizer in more detail; Chapter 11 discusses more Custom Functions.)

- Some functions are disabled or limited in Live View mode. Here's the list of affected features:
 - *Flash:* Flash Exposure lock, covered in Chapter 5, is disabled. Additionally, non-Canon flash units will not work in Live View mode. And here's one more quirk: When you take a flash shot in Live View mode, the camera's shutter sound leads you to believe that two shots have been recorded; in reality, though, only one photo is captured.
 - *A-DEP mode:* This mode functions the same as P (programmed autoexposure), meaning that it no longer tries to achieve a depth of field that keeps all objects in the frame in sharp focus. Chapter 5 explains more about these two modes; Chapter 6 details depth of field and its creative impact on your pictures.
 - *Continuous shooting:* You can use the Continuous Drive mode, introduced in Chapter 2, but the camera will use the exposure settings chosen for the first frame for all the images. And as with flash shots, you hear two shutter sounds for the first frame in your continuous sequence.
 - *Metering mode:* You cannot use Center-Weighted Average, Partial, or Spot exposure metering; the camera always uses Evaluative metering in Live View mode. Chapter 5 explains metering modes.
- * ● ≅:۹
- *AE Lock:* During normal photography, pressing the AE Lock button (shown in the margin) locks the current autoexposure settings. So, for example, if you set exposure on your subject, apply AE Lock, and then reframe the shot, the camera doesn't adjust exposure for the new framing. But during Live View shooting, the AE Lock button is used to initiate autofocusing. So you have to use a little workaround: Open Setup Menu 3, select Custom Functions, and then set Custom Function 10 to option 1, AE lock/AF. At this setting, pressing the shutter button halfway locks the autoexposure settings until you take the picture. The AE Lock button then initiates autofocus both during Live View shooting and normal photography.

To find out more about locking exposure when you're not using Live View mode, check out Chapter 5; Chapter 11 covers the AE Lock Custom Function in detail. I *don't* recommend that you change the setting while you're learning the camera, however, because the buttons won't function as they're described in this book if you do.

- Mirror Lock-Up and Set button functions: You can't enable mirror lock-up (Custom Function 9) in Live View mode. Also, any custom settings that you apply to the Set button (Custom Function 11) don't work in Live View mode. Instead, the Set button switches the Live View display into Quick Control mode, as it does during regular shooting, so that you can adjust certain picture settings easily.
- ✓ You must be extra careful to keep the camera steady. Just as with a point-and-shoot camera, holding the camera out in front of you to capture the image can cause slight camera shake that can blur your image. But with an SLR, the risk is greater because of the added weight of the camera and lens. And if you use a so-called *long lens* a telephoto or zoom lens that extends to a long focal length the potential for camera shake is compounded. So for best results, mount the camera on a tripod when you use Live View.

✓ Using Live View for an extended period can reduce picture quality and harm your camera. When you work in Live View mode, the camera's innards heat up more than usual, and that extra heat can create the right electronic conditions for *noise*, a defect that gives your pictures a speckled look. (Chapter 5 offers more information.) Perhaps more critically, the increased temperatures can damage the camera.

If the symbol shown in the margin appears on the monitor, the camera is warning you that it's getting too hot. If you continue shooting and the temperature continues to increase, the camera will automatically shut off to prevent further damage. But don't let things get to that point: Your pictures will probably be noisy and you risk permanently harming the camera. So when you see the symbol, turn the camera off or at least exit Live View mode for a few minutes. You can then return to Live View mode and capture the image. Keep in mind that in extremely warm environments, you may not be able to use Live View mode for very long before the system shuts down.

Aiming the lens at the sun or other bright lights also can damage the camera. Of course, you can cause problems doing this even during normal shooting, but the potential risk increases when you use Live View. You not only can harm the camera's internal components but also the monitor.

Live View also has the same two other disadvantages that you get when you frame with the monitor on a point-and-shoot camera:

- Any time you use the camera monitor, whether it's for composing a shot or reviewing your images, you put extra strain on the battery. So keep an eye on the battery status icon to avoid running out of juice at a critical moment.
- The monitor display can wash out in bright sunlight. You may find it difficult to compose outdoor shots in Live View mode.

This laundry list of caveats doesn't mean that I'm advising you not to use Live View, however — just that you shouldn't envision it as a full-time alternative to your viewfinder. Rather, think of it as a special-purpose tool that can help in shooting situations where framing with the viewfinder is cumbersome.

I find Live View most helpful for still life, tabletop photography, especially in cases that require a lot of careful arrangement of the scene. For example, I have a shooting table that's about waist high. Normally, I put my camera on a tripod, come up with an initial layout of the objects I want to photograph, set up my lights, and then check the scene through the viewfinder. Then there's a period of refining the object placement, the lighting, and so on. If I'm shooting from a high angle, requiring a camera position above the table and pointing downward, I have to stand on my tiptoes or get a stepladder to check things out through the viewfinder between each compositional or lighting change. At lower angles, where the camera is tabletop height or below, I have to either bend over or kneel to look through the viewfinder, causing no end of later aches in my back and knees. With Live View, I can alleviate much of that bothersome routine (and pain) because I can usually see how things look in the monitor no matter the camera position.

With that lengthy preamble out of the way, the next few sections show you how to enable Live View and briefly introduce the process of Live View shooting. Also see Chapter 5 for details about monitoring and adjusting exposure in Live View mode; check out Chapter 6 for Live View autofocusing options.

Enabling Live View

Before you can use Live View, you must take these steps:

1. Set the Mode dial to P, Tv, Av, M, or A-DEP.

You can use Live View only in these exposure modes. Chapter 5 explains them all; for now, choose P (programmed autoexposure) if you're not familiar with the other modes and you want to experiment with Live View.

- 2. Press the Menu button and display Setup Menu 2.
- 3. Highlight Live View Function Settings, as shown on the left in Figure 4-26.
- 4. Press the Set button.

You see the screen shown on the right in Figure 4-26.

5. Highlight Live View Shoot and press the Set button.

Now you see the screen shown in Figure 4-27.

LCD brightness	*	Live View shoot.	Disable
Date/Time	05/09/'09 07:10	Grid display	Off
Language	English	Metering timer	16 sec.
Video system	NTSC	AF mode	Live mode
Sensor cleaning			
Live View function	on settings		

Figure 4-26: You must enable Live View through Setup Menu 2.

6. Select Enable and press Set.

The Live View Function Settings screen reappears

7. Adjust the metering timing (optional).

When you press the shutter button halfway, the camera's exposure meter comes to life and displays the current aperture and shutter speed on the monitor. By default, the exposure meter and the display turn off after 16 seconds of inactivity to conserve battery power. You can adjust this timing through the

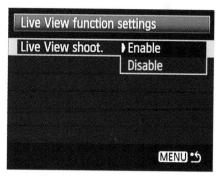

Figure 4-27: Highlight Enable and press the Set button.

Metering Timer option, shown on the right in Figure 4-26. Highlight the option, press Set, and then select a time option. Your choices range from 4 seconds to 30 minutes. Press Set once more after making your selection. Chapter 5 explains aperture, shutter speed, and other exposure matters in detail.

8. Press the Menu button to return to Setup Menu 2.

You're now ready for Live View shooting; see the next section for help taking your first picture.

Taking a shot in Live View mode

After you enable Live View through Setup Menu 2, follow these steps to take a picture.

1. Check the setting on the Mode dial on top of the camera.

Remember, you must set the dial to P, Tv, Av, M, or A-DEP to use Live View.

2. Set the focus switch on your lens to MF (for manual focus).

For reasons explained in the preceding introduction to Live View shooting, I (and Canon) recommend manual focusing. If you want to use autofocus, Chapter 6 spells out how to do so. For now, just keep in mind that when autofocusing is enabled, the screen you see on your monitor will look a little different from those you see in this chapter.

If you use a lens other than the kit lens sold with the Rebel T1i/500D, the switch that shifts you to manual focus may sport a label other than MF. Consult the lens manual for specifics.

3. If the camera is mounted on a tripod, turn off the Image Stabilizer feature.

Image stabilization isn't necessary when you shoot with a tripod. And because it consumes extra battery power, turning it off is a good idea for Live View tripod shooting with most lenses. However, check your lens manual just to be sure: Some lens manufacturers vary in their recommendations on this issue.

4. Press the Live View button to switch from normal viewfinder operation to the Live View preview.

Now your scene appears in the monitor, as shown in Figure 4-28. (If nothing happens when you press the button, you need to return to the preceding section and follow the steps to enable Live View.)

Four different display options are available during Live View shooting, so don't panic if your screen contains either more onscreen data than the one in the figure or no data at all. The next section explains the display options and how to interpret everything you see. For now, just press the DISP button to cycle through the display modes.

- 5. Frame the shot as desired.
- 6. Press the cross keys to move the focusing frame over the spot where you want to focus.

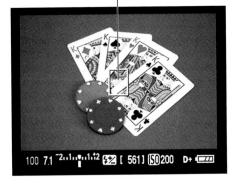

Figure 4-28: Place the center square over the point where you want to establish focus.

The *focusing frame* is that rectangle in the center of the screen, labeled in Figure 4-28.

To put the focusing frame smack in the middle of the screen, press the Erase button (the one that sports the trash can symbol).

7. Turn the focusing ring to set initial focus.

On the kit lens, the focusing ring is at the far end of the lens. (See Chapter 1 if you need help.)

:: • •

8. To magnify the view and verify focus, press the AF Point Selection button (optional).

By pressing the button, you magnify the area within the focusing frame. Your first press of the button magnifies the view by 5, as shown on the left in Figure 4-29. The second press zooms to 10 times magnification, as shown on the right. Press again to return to the normal view.

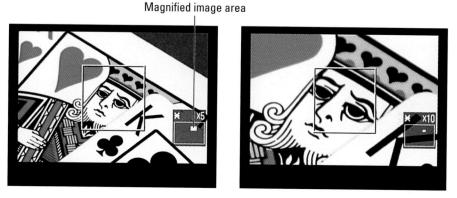

Figure 4-29: Magnify the preview to double-check focus.

In the lower-right corner of the monitor, you see a label showing the current magnification level. Underneath that label, the box inside the small rectangle indicates the portion of the overall frame that's currently visible. If needed, you can reposition the focusing frame to check another part of the image by using the cross keys.

If focus passes inspection, move on; if not, keep adjusting the focusing ring until things look good.

9. Press the shutter button halfway to initiate exposure metering.

If needed, you can adjust exposure by using the options covered in Chapter 5, keeping in mind the restrictions pointed out at the start of the Live View discussion. (For example, you can't select a metering mode other than Evaluative.)

10. Press the shutter button fully to take the shot.

You see your just-captured image on the monitor for a few seconds before the Live View preview returns.

11. To exit the Live View preview, press the Live View button.

You return to the standard Shooting Settings screen. You can then return to framing your images through the viewfinder.

Note that turning the monitor preview off via the Live View button does not officially disable Live View functionality; you must revisit the Live View Shoot option on Setup Menu 2 to do that.

Customizing Live View shooting data

When you first use Live View mode, you see your subject and the basic shot settings shown in Figure 4-28. From that screen, you can press DISP to display a second assortment of settings. A third press of the button adds a brightness histogram into the mix, and a fourth hides all shooting data, leaving just your image and the focusing frame on the screen. Press DISP again to return to the default display.

Figure 4-30 serves as your road map to the maxed-out data display; the following list gives you the guided tour:

- ✓ Data along the bottom of the screen is similar to what you normally see in the viewfinder display. With the exception of the Shots Remaining value and Battery status symbol, these settings relate to exposure issues you can explore in Chapter 5. The Flash Compensation and Highlight Tone Priority symbols appear only if you enable those features.
- The Autofocus mode symbol appears regardless of whether you have your lens set to manual or autofocus. The symbol tells you which of the three possible Autofocus options is selected; Chapter 6 discusses the options and explains Live View autofocusing.
- Some of the other symbols on the left side of the screen are the same as when you view shooting information in Playback mode. I discuss this topic earlier in the chapter; here's a quick reminder:
 - *Picture Style:* Chapter 6 details Picture Styles, which affect picture color, contrast, and sharpness. The symbol you see in Figure 4-30 represents the Standard style.
 - *White Balance:* The initials AWB, shown in the figure, represent Auto White Balance. To see what icons for other settings look like and find out what white balance does in the first place, visit Chapter 6.

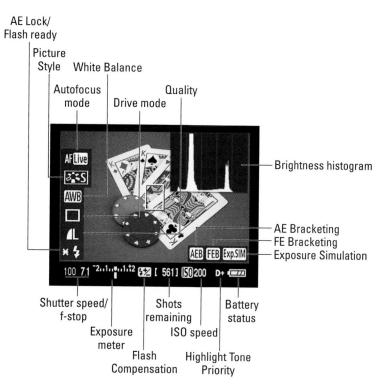

- *Drive mode:* The icon you see in the figure represents the Single Drive mode, in which you capture one image for each press of the shutter button. See the end of Chapter 2 for information about other Drive modes.
- *Quality:* This icon tells you the selected Quality setting, which Chapter 3 explains. The symbol shown in the figure represents the Large/Fine Quality setting.
- *AE* (*autoexposure*) *lock and flash status:* The asterisk tells you that autoexposure lock is in force; a steady flash symbol tells you that the flash is ready to fire. Neither symbol appears if you don't use these features, both of which you can read about in Chapter 5.

Symbols in the lower-right corner indicate the following:

• *AEB and FEB:* The first symbol appears when you enable automatic exposure bracketing (AEB), an exposure tool I cover in Chapter 5. The second symbol stands for flash exposure bracketing (FEB), a function that's possible only when you shoot with a compatible Canon Speedlite external flash; see the flash unit's manual for help with this option.

- *Exp.SIM*: This symbol, which stands for *Exposure Simulation*, indicates whether the image brightness you see on the monitor is simulating the actual exposure that you will record. If the symbol blinks or is dimmed, the camera can't provide an accurate exposure preview, which can occur if the ambient light is either very bright or very dim. Exposure Simulation is also disabled when you use flash in Live View mode.
- ✓ The brightness histogram is another tool you can use to gauge whether your current settings will produce a good exposure. See the section "Interpreting a brightness histogram," earlier in this chapter, to find out how to make sense of what you see. When you use flash, however, the histogram is dimmed (and what you can see isn't accurate because it doesn't reflect the exposure as it will be when the flash is used).

Using the Quick Control screen in Live View mode

Chapter 1 explains how you can use the Quick Control screen to adjust certain camera settings. In Live View mode, you can use the Quick Control method to adjust the Picture Style, White Balance, Drive mode, and Quality settings. If you opt for Live View autofocusing, you also can adjust the autofocusing mode. (Chapter 6 explains autofocusing.)

To use this feature, press the Set button to activate the strip of icons on the left side of the screen. Then use the cross keys to highlight the option you want to adjust. Text appears at the bottom of the screen to show you the current setting. For example, in Figure 4-31, the Quality option is highlighted; the text label shows the Large/Fine setting is selected and the values that represent that setting: total megapixels, horizontal and vertical pixel count, and the number of shots that will fit on the memory card at this setting. (See Chapter 3 for the full story on the Quality setting and how to interpret the data you see in the figure.)

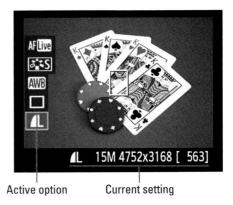

Figure 4-31: Press Set to use the Live View version of the Quick Control screen.

After you highlight an icon on the left side of the screen, rotate the Main dial to cycle through the available settings. Press Set again to return to the normal Live View display and take the picture.

To adjust other picture-taking settings, you can use the standard menu or button/dial operations. For example, to adjust ISO, press the ISO button and rotate the Main dial.

Displaying an alignment grid

When you're doing the kind of work for which Live View is best suited, such as taking product shots or capturing other still-life subjects, the exact placement of objects in the frame can sometimes be important. To assist you in that regard, the camera can display a grid on the monitor, as shown in Figure 4-32.

To set the grid display, visit Setup Menu 2, highlight Live View Function Settings, and press the Set button. Then highlight Grid Display, as shown on the left in Figure 4-33, press the Set button, highlight Grid 1 or Grid 2, as

Figure 4-32: For help aligning objects in the frame, display the grid.

shown on the right in the figure, and press Set again. Grid 1 gives you the loosely spaced gridlines shown in Figure 4-32; for a tighter grid, choose Grid 2. Repeat the menu process and choose Off to lose the grid.

Live View function Live View shoot.		Live View function	on settings
Grid display	Enable Off	Grid display	Off
Metering timer AF mode	16 sec. Live mode		● Grid 1 ## Grid 2 ###
	MENU •5		MENU *5

Figure 4-33: Enable the grid via the Live View Function Settings option on Setup Menu 2.

Recording Movies

Your camera offers a first for the Digital Rebel line: the ability to record digital movies. Although you experience a few more limitations recording live action with the Tli/500D than with a real video camera, it's a fun option to have onboard nonetheless.

Before I give you the specifics, here's the broad overview of movie making:

Movie quality: You can record movies at three different quality levels. The setting you choose determines the frame size and aspect ratio of the movie: 1920 x 1080, known as *Full High-Definition*; 1280 x 720, which qualifies as plain ol' High Def; and 640 x 480, which gives you standard definition. The two higher-quality settings produce movies that have a 16:0 aspect ratio, which is found on many new TV sets and computer monitors. The 640 x 480 setting delivers a 4:3 format, which fits old monitors and TVs like the ones in my house.

The higher the Quality setting, the larger the size of the file needed to store the movie. At the highest setting, you can fit about 12 minutes of movie on a 4GB memory card; drop the setting to 640 x 480, and you can double the length of the movie. The Quality setting also determines the frame rate, explained next.

- Frame rate: The *frame rate* determines the smoothness of the playback. At the top Quality setting, the frame rate is 20 frames per second (fps). At the other two settings, the frame rate is 30 fps, which is the standard frame rate for television-quality video. In other words, movies shot at the super-duper high-def mode may play a little choppier than those at the two lower-quality settings.
- Maximum file size: The maximum file size for a movie is 4GB, regardless of the capacity of your memory card. When you reach that 4GB limit, the camera automatically stops recording. You can always start a new recording, however, and you can join the segments in a movie-editing program later if you want.
- Sound recording: You can record sound or shoot a silent movie. If you enable sound, note the position of the microphone: It's the little four-holed area on the front of the camera, just above the EOS label, as shown in Figure 4-34. Make sure that you don't inadvertently cover up the microphone with your finger. And keep in mind that anything you say will be picked up by the mic along with any other audio present in the scene. I'm notorious for muttering various comments and "actor" instructions during my movies; I'm sure that one day film students everywhere will write papers about this aspect of my oeuvre.
- Video format: Movies are created in the MOV format, which means you

Microphone

Figure 4-34: These tiny holes lead to the camera's internal microphone.

can play them on your computer with most movie-playback programs. If you want to view your movies on a TV, you can connect the camera to the TV, as explained in Chapter 9. Or if you have the necessary computer software, you can convert the MOV file to a format that a standard DVD player can recognize and then burn the converted file to a DVD. You also can edit your movie in a program that can work with MOV files.

Still picture capture: You can snap a still shot during a movie recording session. See the upcoming section "Shooting your first movie" for details.

So far, so good. None of the aforementioned details is terribly unusual or complicated. Where things get a little tricky for the would-be filmmaker are in the areas of focus and exposure:

✓ Focus: As with regular Live View photography, you can use autofocusing to establish initial focus on your subject before you begin recording. You can choose from the same three autofocusing options available for Live View shooting, which I explain in Chapter 6. But after recording begins, the autofocus system lays down for a nap — it doesn't automatically adjust to keep your subject in focus. You can initiate autofocusing again during the recording, but the focus mechanism tends to "hunt" for the focus point, going in and out of focus until it locks onto something. So unless you're recording a static subject — say, a guitar player sitting on a stool or a speaker at a lectern — opt for manual focusing. You can then adjust focus manually any time during the recording.

If you plan to zoom in and out, practice before the big event. It's a bit of a challenge to zoom and focus at the same time, especially while holding the camera in front of you so that you can see the monitor. (A tripod makes the maneuver slightly easier.)

✓ Exposure: The camera automatically sets exposure based on the light throughout the entire scene. However, you can apply Exposure Compensation, which gives you some control over the autoexposure result, and you can apply AE Lock (autoexposure lock) to force the camera to stick with a certain set of exposure settings even if the light in the scene changes. See the next section to find out how to use these two features during movie recording.

Finally, all the precautions mentioned earlier in this chapter related to Live View — including the information about the camera's internal temperature apply to movie recording as well. (Flip to the first part of the section "Using Your Monitor as a Viewfinder" for details.)

With those bits and pieces of information in mind, the rest of this chapter explains how to set up, record, and play movies.

Changing the information display

After you set the Mode dial to Movie mode, the viewfinder turns off, and you see your scene on the monitor. Initially, the screen looks like the one you see in Figure 4-35. The same focusing frame you get in Live View mode appears, and the bottom of the screen shows the exposure meter, battery status icon, and shots remaining value. If you press the shutter button halfway to engage the autoexposure meter, you also see the camera's selected aperture (f-stop) and shutter speed, as shown in the figure.

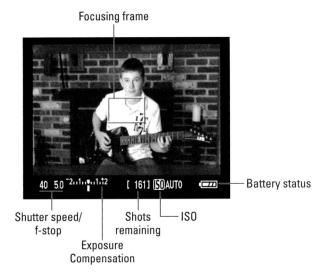

Figure 4-35: The default Movie display contains only a few pieces of shooting data plus the focusing frame.

As with Live View mode, you can press the DISP button to change the display mode. But this time, you get only three options: You can display the limited data shown in Figure 4-35, opt for the expanded data readout shown in Figure 4-36, or hide all data, leaving just the focusing frame.

A couple of items in these two figures warrant a little further explanation:

The shutter speed, ISO, and shots remaining values relate only to any still shots that you may capture during a recording session. (See the upcoming section "Shooting your first movie" for details on that trick.) For movie recording, the camera controls the aperture and ISO settings for you, and shutter speed is irrelevant.

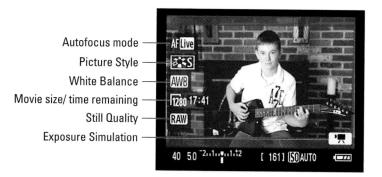

Figure 4-36: Press DISP to reveal these additional shooting options.

- The Picture Style and White Balance options work as they do for normal photography. Picture Style affects color, contrast, and sharpness; White Balance enables you to deal with lighting conditions that may create an unwanted tint or color cast. Chapter 6 explains both features.
- ✓ The exposure meter works as it does when you take still pictures in the P, Tv, Av, or A-DEP modes, which is to say that it indicates the amount of Exposure Compensation that's applied. This feature enables you to request that the camera adjust the brightness of your next recording. It will also affect any still shots that you take. If the little white bar under the meter is at the center position, as in the figures, no compensation has been applied. See the section "Shooting your first movie" for help with this setting.
- The Movie Size/Time Remaining value shows you the recording size you selected along with the length of the movie that will fit on your memory card if you stick with that size.
- The Still Quality setting indicates the Quality option that will be used if you take a still photo. Chapter 3 explains the Quality option, which controls resolution and format (JPEG or Raw).
- ✓ The Exposure Simulation icon works the same way as in Live View mode, although the little symbol is different. If it appears white, as in the figure, you can expect your movie to be about as bright as what you see in the monitor. In very dim or very bright light, the monitor may not be able to provide an accurate representation of the movie brightness and lets you know by dimming the Exposure Simulation symbol. The movie will still record at the best exposure settings the camera can select, however.

Setting basic recording options

Before you begin shooting your first movie, it's a good idea to review the basic recording settings. You adjust some settings via the Movie menu; for others, you can either visit menus or, for faster results, use the Quick Control method.

The next three sections provide some details on the recording settings; Table 4-1 offers a quick reminder of where you can find the various movie settings.

Table 4-1	Basic Movie Recording Options	
To Adjust This Option	Head for This Menu or Screen	
Movie size	Quick Control screen or Movie menu	
Sound recording	Movie menu	
Autofocus mode	Quick Control screen or Movie menu	
Picture Style	Quick Control screen or Shooting Menu 2	
Still Picture Quality	Quick Control screen or Shooting Menu 1	

Reviewing options on the Movie menu

The Movie menu contains several recording options, including the one that enables or disables sound. Before vou can access the Movie menu, shown in Figure 4-37, you must set the camera's Mode dial to the Movie setting. After your image appears on the monitor, press the Menu button and then find your way to the Movie menu.

Here's a rundown of the menu options:

Grid display: As with Live View shooting, you can display two different styles of grids to help keep

Grid display	Off
Metering timer	16 sec.
Movie rec. size	1280x720
AF mode	Live mode
Sound recording	On
Remote control	Disable

Figure 4-37: Turn sound recording on or off via the Movie menu.

your shots aligned properly. Choose Grid 1 for a loosely spaced grid (refer to Figure 4-32); choose Grid 2 for a more tightly spaced grid. For no grid, leave the option set to the default, Off.

Metering timer: This option works exactly as it does for regular Live View shooting. To recap: When you press the shutter button halfway, the exposure meter comes to life, and the camera then establishes the autoexposure settings needed to produce a good exposure. To save battery power, the meter goes to sleep after 16 seconds, but you can

request a shorter or longer delay through the Metering Timer menu option. (See Chapter 5 for a thorough explanation of the meter and exposure in general.)

- ✓ Movie Rec. Size: Use this option to specify the movie quality setting. See the preceding section for details that will help you choose.
- ✓ AF Mode: If you decide to try autofocusing, you can choose from three different autofocus methods. Chapter 6 spells out how these options work. (Again, though, manual focusing is recommended.)
- Sound Recording: Set this option to On if you want the camera to record sound. You can't adjust the recording volume or attach an external microphone, unfortunately.
- Remote control: If you want to use the optional remote control unit to start and stop recording by, set this menu option to On. (For the RC-1 remote unit, you also must set the timing switch to the 2-second delay to use it for movie recording.)

You also can adjust the recording size and AF mode through the Quick Control screen, which I find to be faster than going through the Movie menu. See the next section for details.

Adjusting settings through the Quick Control screen

As you can during Live View shooting, you can adjust some movie-recording settings by using the Quick Control technique. Follow these steps to use this method of adjusting recording settings:

1. Press Set to enter Quick Control mode.

You see a column of control icons running down the left side of the screen. One of the icons is highlighted, as shown in Figure 4-37, and the bottom of the screen tells you the current setting for that option. In Figure 4-38, the White Balance setting is highlighted, for example, and Auto White Balance is in force.

2. Press the up or down cross keys to highlight the icon that represents the option you want to change.

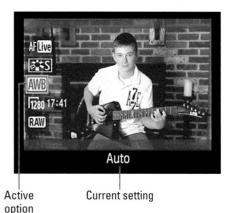

Figure 4-38: Press Set to shift to Quick Control mode and then use the Main dial to adjust the highlighted option.

As a reminder, from top to bottom, the icons enable you to adjust these settings:

- Autofocus mode
- Picture Style
- White Balance
- Movie size
- Still picture quality

The earlier section "Changing the information display" provides some insight on these settings.

- 3. Rotate the Main dial to change the setting.
- 4. Press Set again to exit Quick Control mode and return to the normal display.

Shooting your first movie

When you're ready to try your hand at movie making, take these steps:

1. Set the Mode dial to the Movie setting.

As soon as you select Movie mode, you can preview your shot on the monitor. You also see various bits of recording data on the screen; remember, you can press the DISP button to cycle through the different data display modes if you want more or less screen clutter.

2. Review and select the movie Quality, sound recording, and other options as explained in the preceding sections.

If the Quality setting appears red, your memory card doesn't have sufficient free space to store your movie. You can try lowering the Quality setting; if that doesn't work, you need to free some card space by deleting pictures. (Refer to Figure 4-36 for a look at the icon that represents the Quality setting; again, you may need to press the DISP button to get to this display mode.)

- 3. Compose your shot.
- 4. Set focus.

As in Live View mode, manual focusing is the best way to go, for all the reasons covered earlier in this chapter. So set the lens switch to MF and twist the focusing ring on the lens to bring your subject into focus.

To double-check focus, you can use the same techniques as in Live View mode:

- Use the cross keys to move the focusing frame over the area you want to inspect. Then press the AF Point Selection button once to zoom to a 5-times magnification; press again to zoom to 10 times magnification. Press the button once more to return to normal magnification.
- To return the focusing frame to dead center of the screen, press the Erase button.

5. Apply Exposure Compensation if desired.

You don't really have much control over exposure during movie recording; the camera automatically sets all exposure options for you. However, you can tell the camera that you think that it's over- or underexposing your movie and request that your next recording be a little darker or lighter.

To apply this exposure shift, set the display to one of the two modes that reveals the exposure meter at the bottom of the screen. (Press DISP to change the display mode.) Then press and hold the Exposure Compensation button, shown in the margin. Rotate the dial to move the bar under the meter to the right for a brighter picture; move the indicator left for a darker picture. Release the Exposure Compensation button when you finish.

6. Press the Live View button to start recording.

A red "recording" symbol appears on the monitor, as shown in Figure 4-39.

In the full-data display mode — the one where all the setting icons appear on the left side of the screen — all the icons except the movie recording Quality symbol disappear, as shown in the figure. Next to the icon, you no longer see the length of the recording that will fit on your memory card. Instead, the value represents the elapsed recording time.

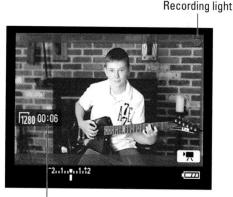

Elapsed time

Figure 4-39: The red dot indicates that you're recording.

7. To stop recording, press the Live View button.

That's all there is to the basic movie-shooting process. But I need to point out a few additional details - some minor, some not:

Using AE Lock: Normally, the camera adjusts exposure during the recording as needed. If you prefer to lock in the exposure settings, you can do so through AE (autoexposure) Lock. But during movie recording, you initiate AE Lock by pressing the ISO button rather than the AE Lock button. After you begin recording, press and release the button. To cancel AE Lock, press the AF Point Selection button.

Snapping a still photo during movie recording: You can interrupt your recording to take a still photo without actually exiting Movie mode. Just press the shutter button as usual to take the shot. The camera records the still photo as a regular image file, using the same Picture Style and White Balance setting you set for your movie. The Still Quality setting determines the picture resolution and file format.

Here are a few drawbacks to capturing a still photo in Movie recording mode:

- If you're shooting a movie at one of the two highest size settings, which capture a movie in the 16:9 aspect ratio, the area included in your still photo is different from what's in the movie shots. All still photos have an aspect ratio of 3:2, so you gain some image area at the top and bottom and lose it from the sides. If the movie size is set to 640 x 480, the capture area is the same for the still photo and the recording.
- You can't use flash, and you're limited to the single Drive mode, recording one shot with each press of the shutter button. (Chapter 2 explains Drive modes.)
- Perhaps most important, your movie will contain a still frame at the point you took the photo; the frame lasts about one second.

ARNING

Using the right memory

cards: I mention this tip in Chapter 1, but it's important enough to repeat: For the best movie recording and playback performance, use memory cards that have a speed rating of 6 or higher. And keep an eve out for the little data recording indicator you see in Figure 4-40. The indicator shows you how much movie data the camera has in its buffer — a temporary data storage tank — awaiting transfer to the memory card.

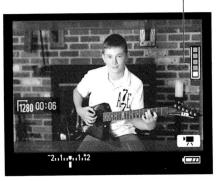

Data-transfer alert

Figure 4-40: If the recording progress indicator keeps hitting the limit, buy a faster memory card. If the indicator level reaches the top, the camera will stop recording new data so that it can finish sending the existing data to the card. You can also try reducing the movie size setting to improve the transfer speed.

- ✓ Turning off Image Stabilization: If possible, turn off Image Stabilization to save battery power. On the kit lens, set the Stabilizer switch to the Off position.
- ✓ Paying attention to camera temperature: As in Live View mode, the camera's internal temperature may increase significantly during movie recording, especially if you're shooting in hot weather. The little thermometer symbol on the screen is your cue to stop recording and turn off the camera to allow it to cool. If you ignore the warning, the camera will stop recording and prevent you from doing any more shooting until it cools.

Playing movies

Chapter 9 explains how to connect your camera to a television set for bigscreen movie playback. To view your movies on the camera monitor, follow these steps:

1. Press the Playback button and then locate the movie file.

When reviewing pictures in full-frame view, you can spot a movie file by looking for the little movie camera icon in the top-left corner of the screen, as shown in Figure 4-41.

In Index playback, you see little "film sprocket" holes along the left edges of movie files. You can't play movies in Index mode, so use the cross keys to highlight the file you want to view and press the AF Point Selection button to get to full-frame view.

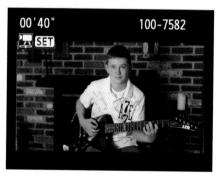

Figure 4-41: The little movie camera symbol tells you you're looking at a movie file.

2. Press the Set button.

Now you see a strip of playback controls at the bottom of the screen, as shown in Figure 4-42.

3. Use the cross keys to highlight the Play button and then press Set.

The control strip disappears and your movie begins playing.

4. To adjust the volume, rotate the Time elapsed Main dial.

Note the little white wheel in the volume display area of the screen — that icon reminds you to use the Main dial to adjust a setting. Rotating the dial controls only the camera speaker's volume; if you connect the camera to a TV, control the volume on the TV instead.

During playback, you can pause the movie and redisplay the control strip at any time by pressing Set. Here's a look at what the various controls do:

Play in slow motion: Highlight the Slow Motion button and press Set. Press the right cross key to increase the slow motion speed; press the left cross key

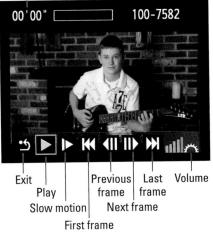

Figure 4-42: To "press" a playback control button, highlight it and press Set.

to reduce it. (A little scale appears in the top-right corner of the screen to indicate where the current setting falls within the range of available slow motion speeds.) To exit slow motion playback, press Set. The control strip reappears; highlight the Play button and press Set to view the movie at normal speed.

- Display the first/last frame of the movie: Highlight the respective frame button, labeled in the figure, and press Set.
- Display the previous frame: Highlight the Previous button and press Set. Each press of the button takes you back a single frame.
- Display the next frame: Highlight the Next Frame button and press Set. Press repeatedly to keep advancing frame by frame.
- Fast forward or rewind: Highlight the Next Frame button and hold down the Set button to fast forward (although "fast" is a relative term here). Highlight the Previous Frame button and hold down Set to rewind.
- **Exit movie playback:** Highlight the Exit symbol and press Set.

Part II Taking Creative Control

s nice as it is to be able to set your camera to automatic mode and let it handle most of the photographic decisions, I encourage you to also explore the advanced exposure modes (P, Tv, Av, M, and A-DEP). In these modes, you can make your own decisions about the exposure, focus, and color characteristics of your photo, which is key to capturing an image as you see it in your mind's eye. And don't think that you have to be a genius or spend years to be successful — adding just a few simple techniques to your photographic repertoire can make a huge difference in how happy you are with the pictures you take.

The first two chapters in this part explain everything you need to know to do just that, providing some necessary photography fundamentals and details about using the advanced exposure modes. Following that, Chapter 7 helps you draw together all the information presented earlier in the book, summarizing the best camera settings and other tactics to use when capturing portraits, action shots, landscapes, and close-up shots.

Getting Creative with Exposure and Lighting

In This Chapter

Exploring advanced exposure modes: P, Tv, Av, M, or A-DEP?

- Understanding the basics of exposure
- ▶ Getting a grip on aperture, shutter speed, and ISO
- Choosing an exposure metering mode
- > Tweaking autoexposure with exposure compensation
- Solving tough exposure problems
- > Using flash in the advanced exposure modes
- Adjusting flash output

By using the simple exposure modes covered in Chapter 2, you can take great pictures with your Rebel T1i/500D. But to really exploit your camera's capabilities — and, more important, to exploit *your* creative capabilities — you need to explore your camera's five advanced exposure modes, represented on the Mode dial by the letters P, Tv, Av, M, and A-DEP.

This chapter explains everything you need to know to start taking advantage of these five modes. First, you get an introduction to three critical exposure controls, *aperture, shutter speed*, and *ISO*. Adjusting these settings enables you to not only fine-tune image exposure but also affect other aspects of your image, such as *depth of field* (the zone of sharp focus) and motion blur. In addition, this chapter

explains other advanced exposure features, such as exposure compensation and metering modes, and discusses the flash options available to you in the advanced exposure modes.

If you're worried that this stuff is too complicated for you, by the way, don't be. Even in these advanced exposure modes, the camera provides you with enough feedback that you're never truly flying without a net. Between the in-camera support and the information in this chapter, you can easily master aperture, shutter speed, and all the other exposure features — an important step in making the shift from picture-taker to photographer.

Kicking Your Camera into Advanced Gear

In the Creative Auto mode, covered in Chapter 2, you can affect picture brightness and depth of field to some extent by using the Exposure and Background sliders. But you don't have full control over either aspect of your images, and you don't have any access to some camera options that can help you solve tough exposure problems.

The moral of the story is that if you want to take full advantage of your camera's exposure tools, set the Mode dial to one of the five exposure modes highlighted in Figure 5-1: P, Tv, Av, M, or A-DEP.

Each of these modes offers a different level of control over two critical exposure settings, aperture and shutter speed. Later in this chapter, I explain these controls fully, but here's a quick Advanced exposure modes

introduction:

- P (programmed autoexposure): In this mode, the camera selects both the aperture and shutter speed for you, but you can choose from different combinations of the two.
- Tv (shutter-priority autoexposure): In this mode, you select a shutter speed, and the camera chooses the aperture setting that produces a good exposure.

Why Tv? Well, shutter speed controls exposure time; Tv stands for time value.

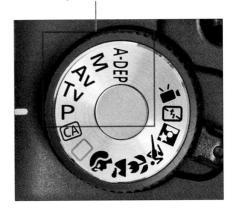

Figure 5-1: To fully control exposure and other picture properties, choose one of these exposure modes.

- ✓ Av (aperture-priority autoexposure): The opposite of shutter-priority autoexposure, this mode asks you to select the aperture setting thus *Av*, for *aperture value*. The camera then selects the appropriate shutter speed to properly expose the picture.
- ✓ A-DEP (auto depth of field): Depth of field refers to the extent to which objects at a distance from your subject appear sharply focused. One way to control depth of field is to adjust the aperture setting. In A-DEP mode, the camera assesses the distance between the lens and major objects in the frame and tries to choose an aperture setting that keeps all those objects within the zone of sharp focus. Then the camera sets the shutter speed appropriate for the aperture it selected.

Although this mode is a nice feature for photographers not yet schooled in manipulating depth of field, it provides the least amount of photographic control of all the advanced exposure modes because you're stuck with whatever aperture and shutter speed the camera selects. In addition, when you use flash or enable Live View shooting, you lose the automatic depth-of-field feature, and A-DEP mode works just like P mode — but without giving you the benefit of being able to select from different combinations of aperture and shutter speed. So after you digest the depth-of-field discussion in Chapter 6, I suggest that you practice using Av mode instead, where you can select the aperture yourself.

✓ M (manual exposure): In this mode, you specify both shutter speed and aperture. But even in M mode, the camera assists you by displaying a meter that tells you whether your exposure settings are on target.

Again, I realize that the descriptions of these modes won't make much sense to you if you aren't schooled in the basics of exposure. To that end, the next several sections provide a quick lesson in this critical photography subject.

Introducing the Exposure Trio: Aperture, Shutter Speed, and ISO

Any photograph, whether taken with a film or digital camera, is created by focusing light through a lens onto a light-sensitive recording medium. In a film camera, the film negative serves as that medium; in a digital camera, it's the image sensor, which is an array of light-responsive computer chips.

Between the lens and the sensor are two barriers, the *aperture* and *shutter*, which together control how much light makes its way to the sensor. The actual design and arrangement of the aperture, shutter, and sensor vary depending on the camera, but Figure 5-2 offers an illustration of the basic concept.

The aperture and shutter, along with a third feature, *ISO*, determine *exposure* — what most of us would describe as the picture's overall brightness and contrast. This three-part exposure formula works as follows:

Aperture (controls amount) of light): The aperture is an adjustable hole in a diaphragm set just behind the lens. By changing the size of the aperture, you control the size of the light beam that can enter the camera. Aperture settings are stated as *f-stop numbers*, or simply *f-stops*, and are expressed with the letter *f* followed by a number: f/2, f/5.6, f/16, and so on. The lower the f-stop number, the larger the aperture, as illustrated by Figure 5-3.

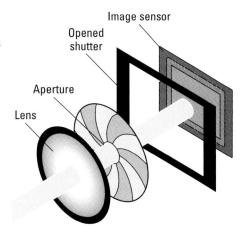

The range of possible f-stops depends on your lens and, if you use a zoom lens, on the Figure 5-2: The aperture size and shutter speed determine how much light strikes the image sensor.

zoom position (focal length) of the lens. For the kit lens sold with the Rebel T1i/500D, you can select apertures from f/3.5–f/22 when zoomed all the way out to the shortest focal length (18mm). When you zoom in to the maximum focal length (55mm), the aperture range is f/5.6–f/36. (See Chapter 6 for a discussion of focal lengths.)

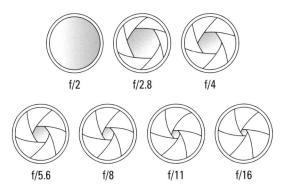

Figure 5-3: The smaller the f-stop number, the larger the aperture.

Shutter speed (controls duration of light): Set behind the aperture, the shutter works something like, er, the shutters on a window. When you aren't taking pictures, the camera's shutter stays closed, preventing light from striking the image sensor. When you press the shutter button, the shutter opens briefly to allow light that passes through the aperture to hit the image sensor.

The length of time that the shutter is open is the shutter speed and is measured in seconds: 1/60 second, 1/250 second, 2 seconds, and so on. Shutter speeds on the Rebel T1i/500D range from 30 seconds to 1/4000 second when you shoot without flash. Should you want a shutter speed longer than 30 seconds, manual exposure mode also provides a feature called bulb exposure. At this setting, the shutter stays open indefinitely as long as you press the shutter button.

If you use the built-in flash, the fastest available shutter speed is 1/200second; the slowest ranges from 1/60 second to 30 seconds, depending on the exposure mode. See the section "Understanding your camera's approach to flash," later in this chapter, for details.

ISO (controls light sensitivity): ISO, which is a digital function rather than a mechanical structure on the camera, enables you to adjust how responsive the image sensor is to light. The term ISO is a holdover from film days, when an international standards organization rated each film stock according to light sensitivity: ISO 100, ISO 200, ISO 400, ISO 800, and so on. Film or digital, a higher ISO rating means greater light sensitivity, which means that less light is needed to produce the image, enabling you to use a smaller aperture, faster shutter speed, or both.

On your camera, you can select ISO settings ranging from 100 to a whopping 12800 when you shoot in the advanced exposure modes. (You're restricted to an ISO range of 200 to 3200, however, if you enable the Highlight Tone Priority function, which you can explore later in this chapter.) For the fully automatic modes, you're limited to ISO speeds from 100 to 1600, and the camera chooses the setting for you automatically. (Highlight Tone Priority isn't available in those modes.)

ATMEMBER

Distilled to its essence, the image-exposure formula is this simple:

- Aperture and shutter speed together determine the quantity of light that strikes the image sensor.
- ✓ ISO determines how much the sensor reacts to that light.

The tricky part of the equation is that aperture, shutter speed, and ISO settings affect your pictures in ways that go beyond exposure. You need to be aware of these side effects, explained in the next section, to determine which combination of the three exposure settings will work best for your picture.

Understanding exposure-setting side effects

You can create the same exposure with different combinations of aperture, shutter speed, and ISO, which Figure 5-4 illustrates. Although the figure shows only two variations of settings, your choices are pretty much endless — you're limited only by the aperture range the lens allows and the shutter speeds and ISO settings the camera offers.

f/5.6, 1/125 second, ISO 200

f/13, 1/25 second, ISO 200

Figure 5-4: Aperture and shutter speed affect depth of field and motion blur.

But the settings you select affect your image beyond exposure, as follows:

Aperture affects depth of field. The aperture setting, or f-stop, affects *depth of field*, or the distance over which sharp focus is maintained. I introduce this concept in Chapter 2, but here's a quick recap: With a shallow depth of field, your subject appears more sharply focused than faraway objects; with a large depth of field, the sharp-focus zone spreads over a greater distance.

When you reduce the aperture size — or *stop down the aperture*, in photo lingo — by choosing a higher f-stop number, you increase depth of field. For example, notice that the background in the left image in Figure 5-4, taken at f/13, appears sharper than the right image, taken at f/5.6. Aperture is just one contributor to depth of field, however; see Chapter 6 for the complete story.

Shutter speed affects motion blur.

At a slow shutter speed, moving objects appear blurry, whereas a fast shutter speed captures motion cleanly. Compare the fountain spray in the photos in Figure 5-4, for example. At a shutter speed of 1/25 second (left photo), the water blurs, giving it a misty look. At 1/125 second (right photo), the droplets appear more sharply focused. How high a shutter speed you need to freeze action depends on the speed of your subject.

If your picture suffers from overall image blur like you see in Figure 5-5, where even stationary objects appear out of focus, the camera moved during the exposure which is always a danger when you handhold the camera at slow shutter speeds. The longer the exposure time, the longer you have to hold the camera still to avoid the blur caused by camera shake. f/29, 1/5 second, ISO 200

Figure 5-5: Slow shutter speeds increase the risk of all-over blur caused by camera shake.

How slow is too slow? It depends on your physical capabilities and

your lens. For reasons that are too technical to get into, camera shake affects your picture more when you shoot with a lens that has a long focal length. For example, you may be able to use a much slower shutter speed when you shoot with a lens that has a maximum focal length of 55mm, like the kit lens, than if you switch to a 200mm telephoto lens. My abilities vary depending on the day and my caffeine intake; I was able to snap the first example in Figure 5-4 at 1/25 second, but frankly, that was a lucky accident. At the 1/5 second shutter speed used in Figure 5-5, camera shake was almost inevitable.

The best idea is to do your own tests to see where your handholding limit lies. Start with a slow shutter speed — say, in the 1/40 second neighborhood, and then click off multiple shots, increasing the shutter speed for each picture. If you have a zoom lens, run the test first at the minimum focal length (widest angle) and then zoom to the maximum focal length for another series of shots. Then it's simply a matter of comparing the images in your photo-editing program. (You may not be able to accurately judge the amount of blur on the camera monitor.) Check out Chapter 8 to find out how to see each picture's shutter speed when you view your images.

138

Putting the f (stop) in focus

One way to remember the relationship between f-stop and depth of field, or the distance over which focus remains sharp, is simply to think of the *f* as *focus*: The higher the *f*-stop number, the larger the zone of sharp *focus*. Please *don't* share this tip with photography elites, who will roll their eyes and inform you that the *f* in *f-stop* most certainly does *not* stand for focus but for the ratio between the aperture size and lens focal length — as if *that's* helpful to know if you aren't an optical engineer. (Chapter 6 explains focal length, which *is* helpful to know.)

To avoid the issue altogether, the best answer is to use a tripod or otherwise steady the camera. If you do need to handhold — and let's face it, no one can carry a tripod *all* the time — improve your odds of a sharp photo by turning on image stabilization, if your lens offers it. (On the kit lens, turn the Stabilizer switch on the side of the lens to On to enable this feature.) See Chapter 6 for tips on solving other focus problems and Chapter 7 for more help with action photography.

ISO affects image noise. When you select a higher ISO setting, making the image sensor more reactive to light, you risk a defect called *noise*. Noise looks like sprinkles of sand and is similar in appearance to film grain, a defect that often mars pictures taken with high ISO film.

Ideally, you should always use the lowest ISO setting on your camera — ISO 100 — to ensure top image quality. But sometimes, the lighting conditions simply don't permit you to do so and still use the aperture and shutter speeds you need.

For example, consider the floral close-ups in Figure 5-6. For this shot, I wanted the background to be blurry but I also wanted the petals to be about as sharp as the stamen and the pistil (the spindly things that protrude from the center of the flower). An f-stop of f/13 produced the depth of field I wanted. But because it was early morning and the light was still pretty dim, I needed a shutter speed of 1/25 second to expose the picture at that f-stop when ISO was set to 100. I usually can't handhold the camera successfully at that slow of a shutter speed, and that was certainly the case on this day. Additionally, a very light breeze was blowing, causing just the slightest flutter of the flower. Those two challenges combined to produce the blurry photo on the left. To fix the problem, I raised the ISO to 400, which enabled me to use a shutter speed of 1/80 second, which was within my handholding comfort zone and also enough to compensate for the breeze.

ISO 400, f/13, 1/80 second

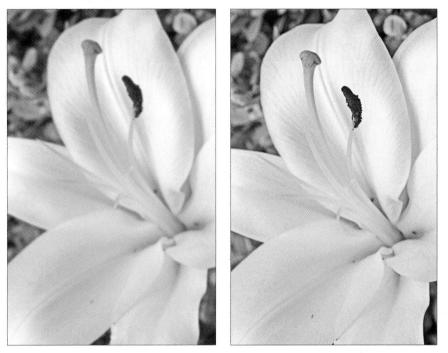

ISO 100, f/13, 1/25 second

Fortunately, you usually don't encounter serious noise with the Rebel T1i/500D until you really crank up the ISO. It's difficult to detect any noise in the ISO 400 image in Figure 5-6, for example. In fact, you may get away with the next step up, ISO 800, if you keep the print or display size of the picture small. As with other image defects, noise becomes more apparent when you enlarge the photo. Noise also is more problematic in areas of flat color.

Just to give you a better look at how ISO affects noise, Figure 5-7 offers magnified views of an area of my lily photo captured at each of the camera's ISO settings. (The two highest settings are disabled by default, and this example makes it clear why — the noise level clearly makes these ultra-high ISO settings "emergency only" options.)

One more important note about noise: A long exposure time — say, 1 second or more — also can produce this defect. Your camera offers built-in noise-reduction filters that aim to compensate for both high ISO noise and long-exposure noise; see the sidebar "Dampening noise"

elsewhere in this chapter for details, including why they aren't necessarily the best solution to the problem. For my example shot, both noise-reduction filters were turned off.

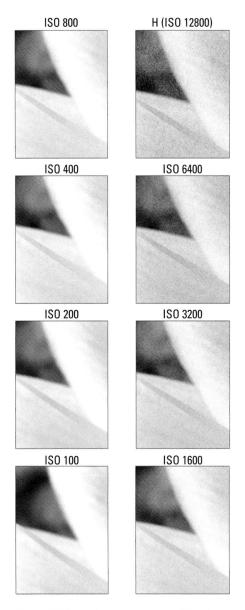

Figure 5-7: Noise becomes more visible when you enlarge your images.

Long story short, understanding how aperture, shutter speed, and ISO affect your image enables you to have much more creative input over the look of your photographs — and, in the case of ISO, to also control the quality of your images. (Chapter 3 discusses other factors that affect image quality.)

Doing the exposure balancing act

When you change any of the three exposure settings — aperture, shutter speed, and ISO — one or both of the others must also shift to maintain the same image brightness.

Say you're shooting a soccer game, for example, and you notice that although the overall exposure looks great, the players appear slightly blurry at the current shutter speed. If you raise the shutter speed, you have to compensate with either a larger aperture, to allow in more light during the shorter exposure, or a higher ISO setting, to make the camera more sensitive to the light. Which way should you go? Well, it depends on whether you prefer the shorter depth of field that comes with a larger aperture or the increased risk of noise that accompanies a higher ISO. Of course, you can also adjust both settings if you choose to get the exposure results you need.

All photographers have their own approaches to finding the right combination of aperture, shutter speed, and ISO, and you'll no doubt develop your own system when you become more practiced at using the advanced exposure modes. In the meantime, here's how I handle things:

- ✓ I always use the lowest possible ISO setting unless the lighting conditions are so poor that I can't use the aperture and shutter speed I want without raising the ISO.
- If my subject is moving (or might move, as with a squiggly toddler or excited dog), I give shutter speed the next highest priority in my exposure decision. I might choose a fast shutter speed to ensure a blur-free photo or, on the flip side, select a slow shutter to intentionally blur that moving object, an effect that can create a heightened sense of motion. When shooting waterfalls, for example, I sometimes use a slow shutter to give the water that blurry, romantic look.
- ✓ For images of non-moving subjects, I make aperture a priority over shutter speed, setting the aperture according to the depth of field I have in mind. For portraits, for example, I use a wide-open aperture (low f-stop number) so that I get a short depth of field, creating a nice, soft background for my subject.

Keeping all this straight is a little overwhelming at first, but the more you work with your camera, the more the whole exposure equation will make sense to you. You can find tips for choosing exposure settings for specific types of pictures in Chapter 7; keep moving through this chapter for details on how to monitor and adjust aperture, shutter speed, and ISO settings.

Monitoring Exposure Settings

When you press the shutter button halfway, the current f-stop, shutter speed, and ISO speed appear in the viewfinder display, as shown in Figure 5-8. Or, if you're looking at the Shooting Settings display, the settings appear as shown in Figure 5-9. In Live View mode, the exposure data appears at the bottom of the monitor and takes a form similar to what you see in the viewfinder. (The upcoming sidebar provides information about other exposure-related aspects of shooting in Live View mode, which I introduce in Chapter 4.)

In the viewfinder and on the monitor in Live View mode, shutter speeds are presented as whole numbers, even if the shutter speed is set to a fraction of a second. For example, for a shutter speed of 1/1000 second, you see just the number 1000 in the display, as shown in Figure 5-8. When the shutter speed slows to 1 second or more, you see quote marks after the number in both displays — 1" indicates a shutter speed of 1 second, 4" means 4 seconds, and so on.

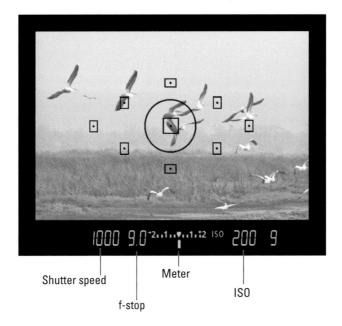

Figure 5-8: The shutter speed, f-stop, and ISO speed appear in the viewfinder.

The viewfinder, Shooting Settings display, and Live View display also offer an *exposure meter*, labeled in Figures 5-8 and 5-9. This little graphic serves two different purposes, depending on which of the advanced exposure modes you're using:

In manual exposure (M) mode, the meter acts in its traditional role, which is to indicate whether your settings will properly expose the image. Figure 5-10 gives you three examples. When the exposure indicator aligns with the center point, as in the middle example, the current settings will produce a proper exposure. If the indicator moves to the left of center, toward the minus side of the scale. as in the left example in the figure, the camera is alerting you that the image will be underexposed. If the indicator

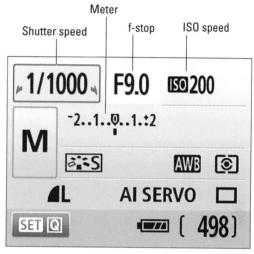

Figure 5-9: You also can view the settings in the Shooting Settings display.

moves to the right of center, as in the right example, the image will be overexposed. The farther the indicator moves toward the plus or minus sign, the greater the potential exposure problem.

✓ In the other modes (P, Tv, Av, and A-DEP), the meter displays the current Exposure Compensation setting. Exposure Compensation is a feature that enables you to tell the camera to produce a brighter or darker exposure than its autoexposure brain thinks is correct. When the exposure indicator is at 0, as in Figures 5-8 and 5-9, no compensation is being applied. See the upcoming section "Overriding autoexposure results with Exposure Compensation" for details.

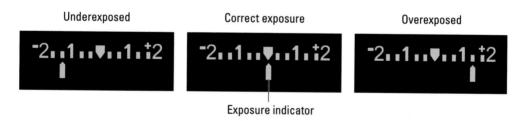

Figure 5-10: In manual exposure (M) mode, the meter indicates whether exposure settings are on target.

Because the meter is designated as an exposure compensation guide when you shoot in the P, Tv, Av, and A-DEP modes, the camera alerts you to exposure problems in those modes as follows:

- ✓ Av mode (aperture-priority autoexposure): The shutter speed value blinks to let you know that the camera can't select a shutter speed that will produce a good exposure at the aperture you selected. You need to choose a different f-stop or adjust ISO.
- ✓ Tv mode (shutter-priority autoexposure): The aperture value blinks instead of the shutter speed. That's your notification that the camera can't open or stop down the aperture enough to expose the image at your selected shutter speed. Your options are to change the shutter speed or ISO.
- P mode (programmed autoexposure): In P mode, both the aperture and shutter speed values blink if the camera can't select a combination that will properly expose the image. Your only recourse is to either adjust the lighting or change the ISO setting.
- ✓ A-DEP mode (auto depth of field): Either the aperture or the shutter speed value may blink. If the shutter speed value blinks 30" (for 30 seconds) or 4000 (for 1/4000 second), the light is too dark or too bright, respectively, for the camera to expose the image properly at any combination of aperture and shutter speed. To compensate for dim lighting, you can raise the ISO or add flash. In too-bright light, lower the ISO if possible — otherwise, find a way to shade or relocate the subject.

If the aperture setting blinks, the exposure will be okay, but the f-stop won't produce the depth of field needed to keep everything in the frame in sharp focus. (See Chapter 6 for complete details on depth of field and the A-DEP mode.)

Keep in mind that the camera's take on exposure may not always be the one you want to follow. First, the camera bases its exposure decisions on the current exposure *metering mode*. As covered next, you can choose four different metering modes, and each one calculates exposure on a different area of the frame. Second, you may want to purposely choose exposure settings that leave parts of the image very dark or parts very light for creative reasons. In other words, the meter and the blinking alerts are guides, not dictators.

Choosing an Exposure Metering Mode

The *metering mode* determines which part of the frame the camera analyzes to calculate the proper exposure. Your Rebel T1i/500D offers four metering modes, described in the following list and represented in the Shooting Settings display by the icons you see in the margins. However, you can access all four modes only in the advanced exposure modes (P, Tv, Av, M, and A-DEP), and only during regular, through-the-viewfinder shooting. In Live View mode, as well as in the fully automatic exposure modes, you're restricted to the first of the four modes, Evaluative metering.

Chapter 5: Getting Creative with Exposure and Lighting

Evaluative metering: The camera analyzes the entire frame and then selects an exposure that's designed to produce a balanced exposure.

Partial metering: The camera bases exposure only on the light that falls in the center 9 percent of the frame. The left image in Figure 5-11 provides a rough approximation of the area that factors into the exposure equation.

•

✓ Spot metering: This mode works like Partial metering but uses a smaller region of the frame to calculate exposure. For Spot metering, exposure is based on just the center 4 percent of the frame, as indicated by the illustration on the right in Figure 5-11.

Center-Weighted Average metering: The camera bases exposure on the entire frame but puts extra emphasis — or *weight* — on the center.

Exposure and Live View shooting

Your camera's Live View mode, detailed at the end of Chapter 4, enables you to use your monitor instead of the viewfinder to compose your images. If you do switch to Live View mode, keep these exposure-related tips in mind:

- Your camera strap sports a little rubber viewfinder cover that you should place over the viewfinder when you're shooting in Live View mode. Otherwise, light can seep in through the viewfinder and affect exposure.
- Several exposure functions described in this chapter are disabled in Live View mode. You can't use flash exposure lock; you're limited to Evaluative metering mode; and you can apply AE Lock (autoexposure lock) only by assigning that function to the shutter button, via Custom Function 10 (Chapter 11 has details). In addition, the A-DEP exposure mode works the same as P mode during Live View shooting.
- A non-Canon external flash won't fire in Live View mode.

- Image noise may increase if you engage Live View shooting for a long period because Live View heats up the camera more than usual; you can help matters by composing the shot, powering off the camera for a few minutes, and then turning the camera back on to take the picture.
- You can display certain exposure settings as well as a histogram along with your image in the monitor. Chapter 4 tells you how and explains histograms.
- If the Exposure Simulation symbol on the monitor is white, the image brightness will be approximately the same as what you see on the monitor. But if the symbol blinks or is dimmed, don't rely on the monitor for an exposure preview. In extreme lighting conditions, the camera may not be able to simulate exposure properly. And if you use flash, Exposure Simulation is automatically disabled.

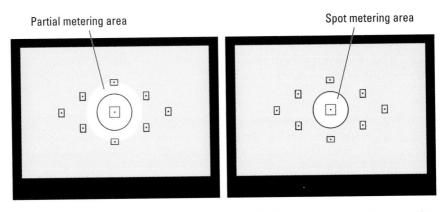

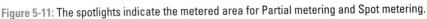

In most cases, Evaluative metering does a good job of calculating exposure. But it can get thrown off when a dark subject is set against a bright background or vice versa. For example, in the left image in Figure 5-12, the amount of bright background caused the camera to select an exposure that left the statue too dark. So I switched to Partial metering, which properly exposed the statue. (Spot metering would produce a similar result with this particular subject.)

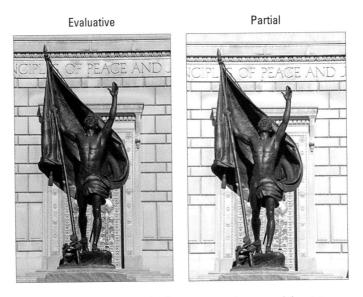

Figure 5-12: In Evaluative mode, the camera underexposed the statue; switching to Partial metering produced a better result.

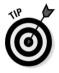

Of course, if your background is very bright and the subject is very dark, the exposure that does the best job on the subject typically overexposes the background. You may be able to reclaim some of the lost highlights by turning on Highlight Tone Priority, a Custom Function explored later in this chapter.

Use either of these two options to change the metering mode:

- ✓ Quick Control screen: First, display the Shooting Settings screen by pressing the shutter button halfway and then releasing it. Then press Set to shift into Quick Control mode and use the cross keys to highlight the Metering mode icon, as shown on the left in Figure 5-13. The selected setting appears in the label at the bottom of the screen. Rotate the Main dial to cycle through the four modes or press Set to display a list of all four modes, as shown on the right in the figure. If you go the second route, use the cross keys or Main dial to highlight the icon for the mode you want to use and then press Set to lock in your decision.
- Shooting Menu 2: Display Shooting Menu 2, highlight Metering mode, as shown on the left in Figure 5-14, and press Set. You then see the screen shown on the right. Highlight your choice and press Set again to return to the menu.

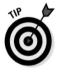

In theory, the best practice is to check the metering mode before each shot and choose the mode that best matches your exposure goals. But in practice, that's a pain, not just in terms of having to adjust yet one more capture setting but also in terms of having to *remember* to adjust one more capture setting.

Current setting

Figure 5-13: You can quickly adjust the Metering mode via the Quick Control screen.

Expo.comp./AEB	-21 <u>0</u> 1.:2	Metering mode
Metering mode	©	Evaluative metering
Custom WB		Province of the second s
WB SHIFT/BKT	0,0/±0	
Color space	sRGB	
Picture Style	Standard	
Dust Delete Data		

Figure 5-14: You also can access the Metering mode on Shooting Menu 2.

So here's my advice: Until you're really comfortable with all the other controls on your camera, just stick with the default setting, which is Evaluative metering. That mode produces good results in most situations, and, after all, you can see in the monitor whether you disagree with how the camera metered or exposed the image and simply reshoot after adjusting the exposure settings to your liking. This option, in my mind, makes the whole metering mode issue a lot less critical than it is when you shoot with film.

The one scenario that might warrant an exception to this advice is if you want to capture a series of images of a subject that's significantly darker or brighter than its background, as in my examples. Then, switching to Partial, Spot, or Center-Weighted Average metering may save you the time of having to adjust the exposure for each image.

Setting 150, f-stop, and Shutter Speed

If you want to control ISO, aperture (f-stop), or shutter speed, set the camera to one of the five advanced exposure modes: P, Tv, Av, M, or A-DEP. Then check out the next several sections to find the exact steps to follow in each of these modes.

Controlling 150

To recap the ISO information presented at the start of this chapter: Your camera's ISO setting controls how sensitive the image sensor is to light. At higher ISO values, you need less light to expose an image.

Remember the downside to raising ISO, however: The higher the ISO, the greater the possibility of noisy images. See Figure 5-7 for a reminder of what that defect looks like.

In the fully automatic exposure modes, the camera selects an ISO from 100 to 1600, depending on the available light and whether you use flash. You have no control over ISO in those exposure modes.

In the advanced exposure modes, you have the following ISO choices:

- ✓ Let the camera choose (Auto ISO). You can still rely on the camera to adjust ISO for you in the advanced exposure modes if you prefer. As it does when you shoot in the fully automatic exposure modes, the camera chooses an ISO setting from 100 to 1600, depending on the available light and whether you use flash. However, if you set the Mode dial to M, for manual exposure mode, ISO is always set to 400. (That's a good thing because when you want firm control over exposure, you don't want the camera adjusting light sensitivity behind your back.)
- Select a specific ISO setting. Normally, you can choose ISO 100, 200, 400, 800, 1600, or 3200. A Custom Function called ISO Expansion enables you to push the ISO to 6400 or yet one step higher, to a setting simply labeled H (for super-duper High, I suppose), which Canon says is equivalent to ISO 12800. Figure 5-7 shows that the H and ISO 6400 settings are also equivalent to a pretty noisy photo, which is likely the reason why these two settings aren't available by default.

To expand the ISO range, go to Setup Menu 3, highlight Custom Functions, and press Set. Use the cross keys to bring up Custom Function 2, as shown on the left in Figure 5-15. (The function number appears in the top-right corner of the screen.) Press Set to activate the options, as shown on the right. Highlight On and press Set again.

Figure 5-15: Custom Function 2 enables you to push the available ISO range to 12800.

A little aside about Custom Functions may be of help here. They're grouped into four categories that are assigned Roman numerals, as in Custom Function I, II, and so on. The category number appears in the top-left corner of the screen. Group I, of which ISO Expansion is a member, contains Custom Functions related to exposure. Knowing the group number isn't important; just don't confuse that number with the actual number of the individual Custom Function, which lives in the upper-right corner.

150

One more complication to note: Another of the exposure-related Custom Functions, Highlight Tone Priority, affects the range of available ISO settings. If you enable that feature, you lose the option of using ISO 100 as well as the two expanded ISO settings (6400 and H, or 12800). Highlight Tone Priority is covered later in this chapter.

You can view the ISO setting in the upper-right corner of the Shooting Settings screen, as shown on the left in Figure 5-16. You can also monitor the ISO in the viewfinder display and in the Live View display.

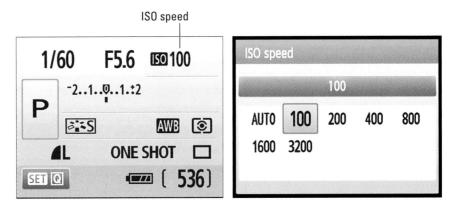

Figure 5-16: Press the ISO button on top of the camera to access the ISO setting.

To adjust the setting, you have the following two options:

- Press the ISO button. It's located just behind the Main dial, on top of the camera. After you press the button, you see the screen shown on the right in Figure 5-16. Use the cross keys or rotate the Main dial to highlight your choice and then press Set.
- ✓ Use the Quick Control screen. After displaying the Shooting Settings screen, press Set to shift to Quick Control mode and then highlight the ISO setting. Then either rotate the Main dial to cycle through the available ISO settings or press Set to display the same screen you see on the right in Figure 5-16. If you take the second approach, highlight your ISO setting and press Set again.

Dampening noise

Noise, the digital defect that gives your pictures a speckled look (refer to Figure 5-7), can occur for two reasons: a long exposure time and a high ISO setting.

The Rebel T1i/500D offers two noise-removal filters, one to address each cause of noise. Both filters are provided through Custom Functions, which means that you can control whether and how they are applied only in the advanced exposure modes.

To control long-exposure noise reduction, visit Setup Menu 3, select Custom Functions, press Set, and then use the right or left cross key to select Custom Function 4, as shown in the left figure. Press Set to access the options, highlight your choice, and then press Set again. The three settings work as follows:

- Off: No noise reduction is applied. This is the default setting.
- Auto: Noise reduction is applied when you use a shutter speed of 1 second or longer, but only if the camera detects the type of noise that's caused by long exposures.
- On: Noise reduction is always applied at exposures of 1 second or longer. (Note: Canon suggests that this setting may actually result in more noise than either Off or Auto when the ISO setting is 1600 or higher.)

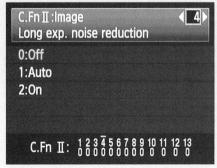

For high ISO noise removal, move to Custom Function 5. This filter offers four settings, as shown in the right figure:

- Standard: The default setting
- Low: Applies a little noise removal
- Strong: Goes after noise in a more dramatic way
- Disable: Turns the filter off

Although noise reduction is a great thing in theory, both filters have a few disadvantages. First, they're applied after you take the picture, when the camera processes the image data and records it to your memory card, which slows your shooting speed. In fact, using the Strong setting for High ISO noise removal reduces the maximum frame rate (shots per second) that you can click off.

Second, noise-reduction filters work primarily by applying a slight blur to the image. Don't expect this process to eliminate noise entirely, and do expect some resulting image softness. You may be able to get better results by using the blur tools or noise-removal filters found in many photo editors because then you can blur just the parts of the image where noise is most noticeable — usually in areas of flat color or little detail, such as skies.

0:Stan	dard		
1:Low			
2:Stro	ng		
3:Disa	ble		

In Auto ISO mode, the Shooting Settings display and Live View display initially show Auto as the ISO value, as you would expect. But when you press the shutter button halfway, which initiates exposure metering, the value changes to show you the ISO setting the camera has selected. You also see the selected value rather than Auto in the viewfinder. *Note:* When you view shooting data during playback, you may see a value reported that's not on the list of "official" ISO settings — ISO 320, for example. This happens because in Auto mode, the camera can select values all along the available ISO range, whereas if you select a specific ISO setting, you're restricted to specific notches within the range.

Although the camera choosing ISO with a little more precision in Auto mode is a good thing, I still can't recommend Auto ISO. Unless you're shooting in manual exposure (M) mode, in which case Auto ISO means ISO 400, you're allowing the camera to ramp ISO as high as 1600, which can produce significant noise in certain conditions. I want to decide when and if I make that noise tradeoff, so I stick with manual ISO control.

Adjusting aperture and shutter speed

You can adjust aperture and shutter speed only in P, Tv, Av, and M exposure modes. In A-DEP mode, the camera forces you to use its selected exposure settings. (However, you can tweak the exposure by using the Exposure Compensation feature discussed in the next section.)

To see the current exposure settings, start by pressing the shutter button halfway. The following things then take place:

- The exposure meter comes to life. If autofocus is enabled, focus is also set at this point.
- ✓ The aperture and shutter speed appear in the viewfinder or the Shooting Settings display, if you have it enabled. In Live View mode, the settings appear under the image preview on the monitor.
- ✓ In manual exposure (M) mode, the exposure meter also lets you know whether the current settings will expose the image properly. In the other advanced exposure modes — Tv, Av, P, and A-DEP — the camera doesn't indicate an exposure problem by using the meter, but by flashing either the shutter speed or the f-stop value. (See the section "Monitoring Exposure Settings," earlier in this chapter, for details.)

The technique you use to change the exposure settings depends on the exposure mode, as outlined in the following list:

P (programmed auto): In this mode, the camera initially displays its recommended combination of aperture and shutter speed. To select a different combination, rotate the Main dial.

- To select a lower f-stop number (larger aperture) and faster shutter speed, rotate the dial to the right.
- To select a higher f-stop number (smaller aperture) and slower shutter speed, rotate the dial to the left.
- ✓ Tv (shutter-priority autoexposure): Rotate the Main dial to the right for a faster shutter speed; nudge it to the left for a slower speed. When you change the shutter speed, the camera automatically adjusts the aperture as needed to maintain the proper exposure.

Changing the aperture also changes depth of field. So even though you're working in shutter-priority mode, keep an eye on the f-stop, too, if depth of field is important to your photo. *Note:* In extreme lighting conditions, the camera may not be able to adjust the aperture enough to produce a good exposure at the current shutter speed — again, possible aperture settings depend on your lens. So you may need to compromise on shutter speed (or, in dim lighting, raise the ISO).

✓ Av (aperture-priority autoexposure): Rotate the Main dial to the right to stop down the aperture to a higher f-stop number. Rotate the dial to the left to open the aperture to a lower f-stop number. When you do, the camera automatically adjusts the shutter speed to maintain the exposure.

If you're handholding the camera, be careful that the shutter speed doesn't drop so low when you stop down the aperture that you run the risk of camera shake. And if your scene contains moving objects, make sure that when you dial in your preferred f-stop, the shutter speed that the camera selects is fast enough to stop action (or slow enough to blur it, if that's your creative goal).

- M (manual exposure): In this mode, you select both aperture and shutter speed, like so:
 - *To adjust shutter speed:* Rotate the Main dial to the right for a faster shutter speed; rotate left for a slower shutter.
 - *To adjust aperture:* Press and hold the Exposure Compensation button, shown in Figure 5-17, while you rotate the Main dial.

See the Av label next to the button? That's your clue to the aperture-related function of the button — Av stands for *aperture value*.

Rotate the dial to the right for a higher f-stop (smaller aperture); rotate left to select a lower f-stop. Don't let up on the button when you rotate the Main dial — if you do, you instead adjust the shutter speed.

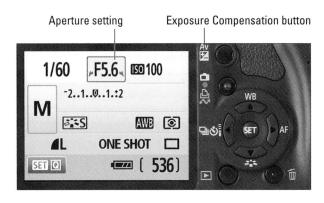

Figure 5-17: To set aperture in M mode, press the Exposure Compensation button while you rotate the Main dial.

In M, Tv, and Av modes, the setting currently available for adjustment appears in the Shooting Settings display in purple, with little arrows at each side. Your camera manual refers to this display as the Main dial pointer, and it's provided as a reminder that you use the Main dial to change the setting. For example, in M mode, the shutter speed appears purple until you hold down the Exposure Compensation button, at which point the marker shifts to the aperture (f-stop) value, as shown in Figure 5-17.

You also can use the Quick Control method of adjusting the settings in the M, Tv, and Av modes. This trick is especially helpful for M mode because you can adjust the f-stop setting without having to remember what button to push to do the job. Try it out. After displaying the Shooting Settings screen, press Set to shift to Quick Control mode and then use the cross keys to highlight the setting you want to change. For example, in Figure 5-18, the aperture setting is highlighted, and a text label offers a helpful reminder with the name of the option at the bottom of the screen. Now, rotate the Main dial

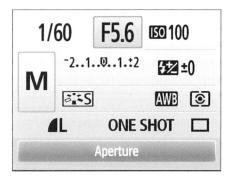

Figure 5-18: You can also use the Quick Control screen to adjust aperture and shutter speed in the M, Tv, and Av exposure modes.

to adjust the setting, press the shutter button halfway, and release it to exit Quick Control mode.

Keep in mind that when you use P, Tv, Av, and A-DEP modes, the settings that the camera selects are based on what it thinks is the proper exposure. If you don't agree with the camera, you have two options. You can switch

to manual exposure (M) mode and simply dial in the aperture and shutter speed that deliver the exposure you want; or if you want to stay in P, Tv, Av, or A-DEP mode, you can tweak the autoexposure settings by using Exposure Compensation, one of the exposure-correction tools described in the next section.

Sorting through Your Camera's Exposure-Correction Tools

In addition to the normal controls over aperture, shutter speed, and ISO, your Rebel offers a collection of tools that enable you to solve tricky exposure problems. The next four sections give you the lowdown on these features.

Overriding autoexposure results with Exposure Compensation

When you set your camera to the P, Tv, Av, or A-DEP exposure modes, you can enjoy the benefits of autoexposure support but retain some control over the final exposure. If you think that the image the camera produced is too dark or too light, you can use a feature known as *Exposure Compensation*, which is sometimes also called *EV Compensation*. (The *EV* stands for *exposure value*.)

Whatever you call it, this feature enables you to tell the camera to produce a darker or lighter exposure than what its autoexposure mechanism thinks is appropriate. Best of all, this feature is probably one of the easiest on the camera to understand. Here's all there is to it:

- Exposure compensation is stated in EV values, as in +2.0 EV. Possible values range from +2.0 EV to -2.0 EV.
- ✓ A setting of EV 0.0 results in no exposure adjustment.
- ✓ For a brighter image, you raise the EV value. The higher you go, the brighter the image becomes.
- ✓ For a darker image, you lower the EV value. The picture becomes progressively darker with each step down the EV scale.

Each full number on the EV scale represents an exposure shift of one *full stop*. In plain English, that means that if you change the Exposure Compensation setting from EV 0.0 to EV -1.0, the camera adjusts either the aperture or the shutter speed to allow half as much light into the camera as you would get at the current setting. If you instead raise the value to EV +1.0, the settings are adjusted to double the light.

By default, the exposure is adjusted in 1/3-stop increments. In other words, you can shift from EV 0.0 to EV +0.3, +0.7, +1.0, and so on. But you can change the adjustment to 1/2-stop increments if you want to shift the exposure in larger jumps — from EV 0.0 to EV +0.5, +1.0, and so on. To do so, display Setup Menu 3, highlight Custom Functions, and press Set. Then select Custom Function 1, press Set, and press the up or down cross key to change the setting. Press Set again to lock in the new setting. If you make this change, the meter will appear slightly different in the Shooting Settings display and Live View display than you see it in this book. (There will be only one intermediate notch between each number on the meter instead of the usual two.) The viewfinder meter does not change, but the exposure indicator bar appears as a double line if you set the Exposure Compensation value to a half-step value (+0.5, +1.5, and so on).

0

Exposure compensation is especially helpful when your subject and background are significantly different in brightness. For example, take a look at the first image in Figure 5-19. Because of the very bright sky in the background, the camera chose an exposure that left the palm tree too dark.

Figure 5-19: For a brighter exposure than the autoexposure mechanism chooses, dial in a positive Exposure Compensation value.

One way to cope with this situation is to adjust the Metering mode setting, as discussed earlier in this chapter. I took the images in Figure 5-19 in Evaluative mode, for example, which meters exposure on the entire frame. Switching to

EV 0.0

EV +1.0

Chapter 5: Getting Creative with Exposure and Lighting

Partial metering might have done the trick, but frankly, I find it easier to use exposure compensation than to fool with metering mode adjustments in most situations. So I left the Metering mode alone and just amped the Exposure Compensation setting to EV +1.0, which produced the brighter exposure on the right.

You can take three roads to applying exposure compensation:

- ✓ Quick Control screen: When the Shooting Settings screen is displayed, press Set to shift to Quick Control mode. Then use the cross keys to highlight the exposure meter, as shown in Figure 5-20, and rotate the Main dial to move the exposure indicator left or right along the meter.
 - Rotate the dial to the left to lower the Exposure Compensation value and produce a darker exposure.
 - Rotate the dial to the right to raise the value and produce a brighter exposure.
 - To return to no adjustment, rotate the dial until the exposure indicator is back at the center position on the meter.

Press the shutter button halfway to exit the Quick Control screen.

Alternately, you can press the Set button while in Quick Control mode to display the screen you see on the right in Figure 5-20. But be careful: Through this screen, you can enable both automatic exposure bracketing (AEB) and exposure compensation. To apply exposure compensation, you must use the left and right cross keys to move the exposure indicator. If you rotate the Main dial, you adjust the AEB setting instead. Press Set to exit the screen after you make your exposure compensation adjustment.

Exposure indicator

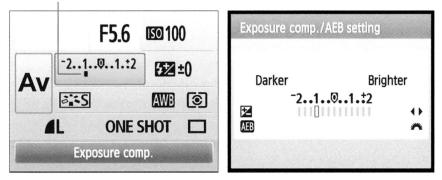

Figure 5-20: You can adjust exposure compensation via the Quick Control screen.

- Exposure Compensation button: You also can press and hold down the button (shown in the margin) while rotating the Main dial to adjust the Exposure Compensation setting.
- Shooting Menu 2: Visit this menu and select the Expo. Comp/AEB option. Press Set to display the same controls you see on the right in Figure 5-20. Use the right and left cross keys to adjust the setting and press Set to exit.

How the camera arrives at the brighter or darker image you request depends on the exposure mode:

- In Av (aperture-priority) mode, the camera adjusts the shutter speed but leaves your selected f-stop in force. Be sure to check the resulting shutter speed to make sure that it isn't so slow that camera shake or blur from moving objects is problematic.
- In Tv (shutter-priority) mode, the opposite occurs: The camera opens or stops down the aperture, leaving your selected shutter speed alone.
- In P (programmed autoexposure) and A-DEP modes, the camera decides whether to adjust aperture, shutter speed, or both to accommodate the Exposure Compensation setting.

These explanations assume that you have a specific ISO setting selected rather than Auto ISO. If you do use Auto ISO, the camera may adjust that value instead.

Keep in mind, too, that the camera can adjust the aperture only so much, according to the aperture range of your lens. The range of shutter speeds is limited by the camera. So if you reach the end of those ranges, you have to compromise on either shutter speed or aperture or adjust ISO.

One final, and critical point about exposure compensation: When you power off the camera, it doesn't return you to a neutral setting (EV 0.0). The setting you last used remains in force for the P, Tv, Av, and A-DEP exposure modes until you change it.

Improving high-contrast shots with Highlight Tone Priority

When a scene contains both very dark and very bright areas, achieving a good exposure can be difficult. If you choose exposure settings that render the shadows properly, the highlights are often overexposed, as in the left image in Figure 5-21. Although the dark lamppost in the foreground looks fine, the white building behind it has become so bright that all detail has been lost. The same thing occurred in the highlight areas of the green church steeple.

Chapter 5: Getting Creative with Exposure and Lighting

Figure 5-21: The Highlight Tone Priority feature can help prevent overexposed highlights.

Your camera offers an option that can help produce a better image in this situation — Highlight Tone Priority — which I used to produce the second image in Figure 5-21. The difference is subtle, but if you look at that white building and steeple, you can see that the effect does make a difference. Now the windows in the building are at least visible, the steeple has regained some of its color, and the sky, too, has a bit more blue.

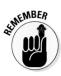

This feature is turned off by default, which may seem like an odd choice after looking at the improvement it made to the scene in Figure 5-21. So what gives? The answer is that to do its thing, Highlight Tone Priority needs to limit your choice of ISO settings. Instead of the ISO 100–12800 range that's possible without Highlight Tone Priority, you're restricted to ISO 200–3200. This occurs because part of the way the camera favors highlights is to actually process the image at an ISO value one step below your selected setting by applying exposure compensation and other adjustments.

Losing the high end of the range is no big deal — the noise levels at those high settings make them pretty unattractive anyway. But in bright light, you may miss the option of lowering the ISO to 100 because you may be forced to

use a smaller aperture or a faster shutter speed than you like. Additionally, you can wind up with slightly more noise in the shadows of your photo when you use Highlight Tone Priority.

If you want to enable the feature, follow these steps:

1. Set the camera Mode dial to one of the advanced exposure modes.

You can take advantage of the Highlight Tone Priority feature only in the P, Tv, Av, M, and A-DEP modes.

- 2. Display Setup Menu 3.
- 3. Highlight Custom Functions, as shown on the left in Figure 5-22, and press Set.

You're taken to command central for accessing custom functions.

4. Press the right or left cross key as needed to display Custom Function 6.

Look for the Custom Function number in the upper-right corner of the screen.

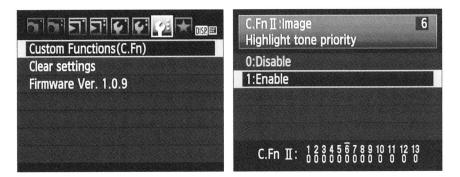

Figure 5-22: Enable Highlight Tone Priority through Custom Function 6 on Setup Menu 3.

5. Press Set and then press the up or down cross key to highlight the Enable option, as shown in Figure 5-22.

6. Press Set.

Highlight Tone Priority is now enabled and remains on until you visit the Custom Functions playground again to turn it off.

As a reminder that Highlight Tone Priority is enabled, a D+ symbol appears near the ISO value in the Shooting Settings display, as shown in Figure 5-23. This same symbol appears with the ISO setting in the viewfinder and in the shooting data that appears onscreen in Live View mode and Playback mode. (See Chapter 4 to find out more about picture playback and Live View.)

Figure 5-23: D+ indicates Highlight Tone Priority is enabled.

Experimenting with Auto Lighting Optimization

When you select a Quality setting that results in a JPEG image file — that is, any setting but Raw — the camera tries to enhance your photo while it's processing the picture. As part of this post-capture work, the camera checks each picture for two potential exposure problems: a too-dark subject and a lack of contrast. If the camera detects either, it applies a subtle corrective tweak that Canon calls Auto Lighting Optimization.

In the fully automatic exposure modes as well as Creative Auto, you have no control over how much adjustment is made. And in manual exposure (M) mode, the feature is not available. But in the other four exposure modes — P, Tv, Av, and A-DEP — you can decide whether to enable Auto Lighting Optimization. You also can request a stronger or lighter application of the effect than the default setting. Figure 5-24 offers an example of the type of impact that each Auto Lighting Optimization setting can make on a low-contrast photo.

Given the level of improvement that the Auto Lighting Optimizer correction made to the photo in Figure 5-24, you may be thinking that you'd be crazy to ever disable the feature. But it's important to note a few points:

- The level of shift that occurs between each Auto Lighting Optimization setting varies dramatically depending on the subject. This particular example shows a fairly noticeable difference between the Strong and Off settings. But you won't always get this much impact from the filter. Even in this example, it's difficult to detect much difference between Off and Low.
- Although the filter improved this particular scene, there are times when you may not find it beneficial. For example, maybe you're purposely trying to shoot a backlit subject in silhouette or produce a low-contrast image. Either way, you don't want the camera to insert its opinions on the exposure or contrast you're trying to achieve.

- Because the filter is applied after you capture the photo, while the camera is writing the data to the memory card, it can slow your shooting rate, just like the Highlight Tone Priority feature.
- ✓ In some lighting conditions, the Auto Lighting Optimizer can produce an increase in image noise.

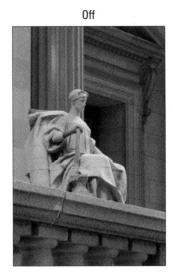

Standard

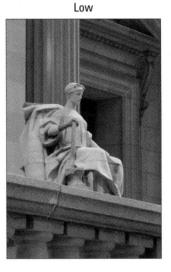

Strong

Figure 5-24: For this image, Auto Lighting Optimization provided a beneficial boost in contrast.

Chapter 5: Getting Creative with Exposure and Lighting

- The corrective action taken by Auto Lighting Optimization can make some other exposure-adjustment features less effective. So turn it off if you don't get the results you expect when you're using the following features:
 - Exposure compensation, discussed earlier in this chapter
 - Flash compensation, discussed later in this chapter
 - · Automatic exposure bracketing, also discussed later in this chapter

By default, the camera applies Auto Lighting Optimization at the Standard level. If you want to experiment with other settings, visit Setup Menu 3, select Custom Functions, and press Set. Then press the right or left cross keys to hunt down Custom Function 7, and press Set. You have four choices, as shown in Figure 5-25: Standard, which is the default level of correction, Strong, Low, and Disable. Highlight your preference and press Set again to lock the setting. The adjustment remains in force until you revisit the Custom Functions menu to change the setting. Again, you have this

C.Fn II : Auto Li				Dt	ot	in	1İ	ZE	31					
0:Stand 1:Low 2:Stron 3:Disab	g													
C.Fn	II:	1 0	2 0	30	40	50	60	70	80	90	10 0	11 0	12 0	13 0

Figure 5-25: Set the level of Auto Lighting Optimization through Custom Function 7.

control only in P, Tv, Av, and A-DEP modes; in the fully automatic exposure modes, the filter is always applied at the Standard level.

If you're not sure what level of Auto Lighting Optimization might work best or you're concerned about the other drawbacks of enabling the filter, consider shooting the picture in the Raw file format. For Raw pictures, the camera applies no post-capture tweaking, regardless of whether this or any other filter is enabled. Then, by using Canon Digital Photo Professional, the software provided free with the camera, you could apply the Auto Lighting Optimization effect when you convert your Raw images to a standard file format. (See Chapter 8 for details about processing Raw files.)

Correcting lens vignetting with Peripheral Illumination Correction

Because of some optical science principles that are too boring and too deadly to explore, some lenses produce pictures that appear darker around the edges of the frame than in the center, even when the lighting is consistent throughout. This phenomenon goes by several names, but the two heard most often are *vignetting* and *light fall-off*. How much vignetting occurs depends on the lens, your aperture setting, and the lens focal length. (Chapter 6 explains focal length.)

The Rebel T1i/500D offers a feature called Peripheral Illumination Correction that's designed to compensate for vignetting by adjusting the light around the edges of the frame. Figure 5-26 shows an example. In the left image, there's just a slight amount of light fall-off at the corners, most noticeable at the top of the image. The right image shows the same scene with Peripheral Illumination Correction enabled.

WHE WHE

Figure 5-26: Peripheral Illumination Correction tries to correct the corner darkening that can occur with some lenses.

I should point out that my "before" example hardly exhibits serious vignetting — I'm betting that most people wouldn't even notice if it weren't shown next to the "after" example. And, in my experience, you're not likely to notice significant vignetting with the 18-55mm kit lens bundled with the camera, either. But if your lens suffers from stronger vignetting, it's worth trying the Peripheral Illumination Correction filter.

Peripheral Illumination Correction off

Peripheral Illumination Correction is available in all your camera's exposure modes, including all the fully automatic modes. But a few factoids need spelling out, however:

- ✓ The correction is available only for photos captured in the JPEG file format. For Raw photos, you can choose to apply the correction and vary its strength if you use Canon Digital Photo Professional to process your Raw images. Chapter 8 talks more about Raw processing. Space limitations prevent me from covering this software fully, but you can find details in the software manual (provided in electronic form on the CD that ships with the camera).
- ✓ For the camera to apply the proper correction, data about the specific lens has to be included in the camera's *firmware*, which is the internal software that runs the digital part of the show. You can determine whether your lens is supported by opening Shooting Menu 1 and selecting the Peripheral Illumination Correction option, as shown on the right in Figure 5-27. Press Set to display the right screen in the figure. If the screen reports that correction data is available, as in the figure, the feature is enabled by default.

If your lens is not supported, you may be able to add its information to the camera; Canon calls this step *registering your lens*. You do this by cabling the camera to your computer and then using some tools included with the free EOS Utility software, also provided with your camera. (You use this same software when you choose to download photos by cabling the camera to the computer instead of using a memory-card reader.) Again, I must refer you to the manual for help on this bit of business because of the limited number of words that can fit in these pages.

✓ If you're using a third-party lens rather than a Canon lens, Canon recommends that you not enable Peripheral Illumination Correction even if the camera reports that correction data is available. (You can still apply the correction in Digital Photo Professional when you shoot in the Raw format.) To turn off the feature, select the Disable setting from the screen shown on the right in Figure 5-27.

✓ In some circumstances, you may see increased noise at the corners of the photo because of the correction. (The exposure adjustment can make noise more apparent.) Also, at high ISO settings, the camera applies the filter at a lesser strength — presumably to avoid adding even more noise to the picture. (See the first part of this chapter for an understanding of noise and its relationship to ISO.)

	Peripheral illumin. correct.					
Quality AL Beep On	Attached lens EF-S18-55mm f/3.5-5.6 IS					
Release shutter without card Review time 2 sec.	Correction data available					
Peripheral illumin. correct.	Correction					
Red-eye On/Off Off	Enable					
Flash control	Disable					

Figure 5-27: If the camera has information about your lens, you can enable the feature.

Locking Autoexposure Settings

To help ensure a proper exposure, your camera continually meters the light until the moment you press the shutter button fully to shoot the picture. In autoexposure modes — that is, any mode but M — it also keeps adjusting exposure settings as needed.

For most situations, this approach works great, resulting in the right settings for the light that's striking your subject when you capture the image. But on occasion, you may want to lock in a certain combination of exposure settings. Here's one such scenario: Suppose that you're shooting several images of a large landscape that you want to join into a panorama in your photo editor. Unless the lighting is even across the entire landscape, the camera's autoexposure brain will select different exposure settings for each shot, depending on which part of the scene is currently in the frame. That can lead to weird breaks in the brightness and contrast of the image when you seam the image together. And if it's the f-stop that's adjusted, which is what could happen in P or Tv exposure modes, you may notice shifts in depth of field as well because the aperture setting affects that aspect of your pictures.

The easiest way to lock in exposure settings is to switch to M (manual exposure) mode and use the same f-stop, shutter speed, and ISO settings for each shot. In manual exposure mode, the camera never overrides your exposure decisions; they're locked until you change them.

But if you prefer to stay in P, Tv, or Av mode, you can lock the current autoexposure settings. Here's how to do it for still photography; Chapter 4 details how to use the feature during Live View shooting:

1. Press the shutter button halfway.

If you're using autofocusing, focus is locked at this point.

2. Press the AE Lock button, shown in Figure 5-28.

AE stands for autoexposure, in case you weren't sure.

Exposure is now locked and remains locked for four seconds, even if you release the AE Lock button and the shutter button. To remind you that AE Lock is in force, the camera displays a little asterisk in the viewfinder. If you need to relock exposure, just press the AE Lock button again.

Note: If your goal is to use the same exposure settings for multiple shots, you must keep the AE Lock button pressed during the entire series of pictures. Every time you let up on the button and press it again, you lock exposure anew based on the light currently in the frame.

One other critical point to remember about using AE Lock: The camera establishes and locks exposure differently depending on the metering mode, the focusing mode (automatic or manual), and on an autofocusing setting called AF Point Selection mode. (Chapter 6 explains this option thoroughly.) Here's the scoop:

- Evaluative metering and automatic AF Point Selection: Exposure is locked on the focusing point that achieved focus.
- Evaluative metering and manual AF Point Selection: Exposure is locked on the selected autofocus point.
- All other metering modes: Exposure is based on the center autofocus point, regardless of the AF Point Selection mode.
- Manual focusing: Exposure is based on the center autofocus point.

Again, if this focusing lingo just sounded like gibberish, check out Chapter 6 to get a full explanation.

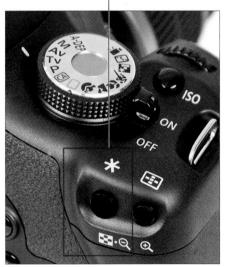

Figure 5-28: You can lock autoexposure settings by pressing this button.

AE Lock button

By combining autoexposure lock with Spot metering, you can ensure a good exposure for photographs in which you want your subject to be off-center, and that subject is significantly darker or lighter than the background. Imagine, for example, a dark statue set against a light blue sky. First, select Spot metering, so that the camera only considers the object located in the very center of the frame. Frame the scene initially so that your statue is located in the center of the viewfinder. Press and hold the shutter button halfway to establish focus and then lock exposure by pressing the AE Lock button. Now reframe the shot to your desired composition and take the picture. (See Chapter 6 for details on selecting an autofocus point.)

These bits of advice assume that you haven't altered the function of the AE Lock button, which you can do via a Custom Function. You can swap the tasks of the shutter button and AE Lock button, for example, so that pressing the shutter button halfway locks exposure and pressing the AE Lock button locks focus. Chapter 11 offers details on the relevant Custom Function.

Bracketing Exposures Automatically

One of my favorite exposure features on the Rebel T1i/500D is *automatic exposure bracketing*, or AEB for short. This feature makes it easy to *bracket exposures* — which simply means to take the same shot using several exposure settings to up the odds that you come away with a perfectly exposed image.

When you enable AEB, your first shot is recorded at the current exposure settings; the second, with settings that produce a darker image; and the third, with settings that produce a brighter image. You can specify how much change in exposure you want in the three images when you turn on the feature.

You can take advantage of AEB in any of the advanced exposure modes. However, the feature isn't available when you use flash. If you want to bracket exposures when using flash, you have to do it, either by using exposure compensation or, in manual exposure mode, by changing the aperture and shutter speed directly.

Speaking of exposure compensation, you can combine that feature with AEB if you want. The camera simply applies the compensation amount when it calculates the exposure for the three bracketed images.

One feature you may want to disable when you use AEB, however, is the Auto Lighting Optimizer option. Because that feature is designed to automatically adjust images that are underexposed or lacking in contrast, it can render AEB ineffective. See the section "Experimenting with Auto Lighting Optimization," earlier in this chapter, for information on where to find and turn off the feature. With that preamble out of the way, the following steps show you how to turn on AEB via Shooting Menu 2. (More about another option for enabling the feature momentarily.)

1. Display Shooting Menu 2 and highlight Expo. Comp./AEB, as shown on the left in Figure 5-29.

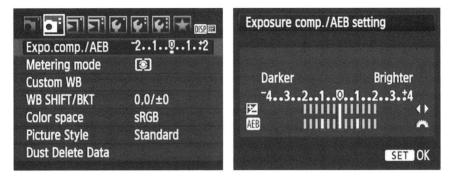

Figure 5-29: Auto exposure bracketing records your image at three exposure settings.

2. Press Set.

You see a screen similar to the one shown on the right in Figure 5-29. This is the same dual-natured screen that appears when you apply exposure compensation through the menu, as explained earlier in the chapter. When the screen first appears, it's in Exposure Compensation mode, so the meter reflects the possible settings for that feature, -2 to +2.

3. Rotate the Main dial to establish the amount of exposure change you want between images.

As soon as you rotate the dial, the meter expands, giving you a broader range of adjustment than the Exposure Compensation feature.

In addition to the extra stops on the meter, you see three red exposure indicators under the meter. These indicators show you the amount of exposure shift that will occur in the three shots the camera will record.

Each whole number represents one stop. For example, if you use the setting shown in Figure 5-29, the camera shoots one image at the actual exposure settings, and it then takes the second image one stop down (using settings that allow half as much light into the camera). The third image is recorded one stop brighter (using settings that allow twice as much light).

Keep rotating the dial until you get the exposure indicators to reflect the amount of adjustment you want between each bracketed shot.

Be careful not to try to use the cross keys instead of the Main dial to set the AEB amount. If you do, you enable the Exposure Compensation feature. You're probably more careful, but I've done this on more than one occasion.

4. Press Set.

AEB is now enabled. To remind you of that fact, the exposure meter in the Shooting Settings display shows the three exposure indicators to represent the exposure shift you established in Step 3, as shown in Figure 5-30. You see the same markers in the viewfinder.

If you prefer, you can also enable AEB through the Quick Control screen. With the Shooting Settings screen displayed, press Set and then use the cross keys to highlight the exposure meter. Press Set again to display a screen that works Auto Exposure Bracketing indicators

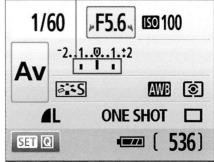

Figure 5-30: The three bars under the meter remind you that automatic exposure bracketing is enabled.

just like the one you get through the menus. Again, rotate the Main dial to set the bracketing amount and then press Set to wrap things up.

How you actually record your trio of exposures depends on whether you set the Drive mode to Single or Continuous. The Drive mode, which I introduce in Chapter 2, determines whether the camera records a single image or multiple images with each press of the shutter button. (Press the left cross key to access the screen that enables you to change this setting.)

AEB in Single mode: You take each exposure separately, pressing the shutter button fully three times to record your trio of images.

If you forget which exposure you're taking, look at the exposure meter. After you press the shutter button halfway to lock focus, the meter shows just a single indicator bar instead of three. If the bar is at 0, you're ready to take the first capture. If it's to the left of 0, you're on capture two, which creates the darker exposure. If it's to the right of 0, you're on capture three, which produces the brightest image. This assumes that you haven't also applied exposure compensation, in which case your starting point will be at a notch other than zero. (Whew, I'm getting a headache just contemplating all the possibilities.)

- ✓ AEB in Continuous mode: The camera records all three exposures with one press of the shutter button. To record another series, release and then press the shutter button again. In other words, when AEB is turned on, the camera doesn't keep recording images until you release the shutter button as it normally does in Continuous mode — you can take only three images with one press of the shutter button.
- Self-Timer/Remote modes: All three exposures are recorded with a single press of the shutter button, as with Continuous mode.

To turn off auto exposure bracketing, just revisit Shooting Menu 2 or the Quick Control screen and use the Main dial to change the AEB setting back to 0.

AEB is also turned off when you power down the camera, enable the flash, replace the camera battery, or replace the memory card. You also can't use the feature in manual exposure (M) mode if you set the shutter speed to the Bulb option. (At that setting, the camera keeps the shutter open as long as you press the shutter button.)

Using Flash in Advanced Exposure Modes

Sometimes, no amount of fiddling with aperture, shutter speed, and ISO produces a bright enough exposure — in which case, you simply have to add more light. The built-in flash on your camera offers the most convenient solution.

In the automatic exposure modes covered in Chapter 2, the camera decides when flash is needed. In Creative Auto mode, also discussed in Chapter 2, you can either let the camera retain flash control or set the flash to always fire or never fire. (You make that selection via the Quick Control screen.)

The advanced exposure modes leave the flash decisions entirely up to you; no Auto mode will hand the reins over to the camera. Instead, when you want to use flash, just press the Flash button on the side of the camera, highlighted in Figure 5-31. The flash pops up and fires on your next shot. To turn off the flash, just press down on the flash assembly to close it.

As you can in the fully automatic modes, you also can set the flash to Red-Eye Reduction mode. Just display Shooting Menu 1 and turn the Red-Eye option on or off. When you take a picture with the feature enabled, the camera lights the Red-Eye Reduction lamp on the front of the camera for a brief time before the flash goes off in an effort to constrict the subject's pupils and thereby lessen the chances of red-eye.

The next section goes into a little background detail about how the camera calculates the flash power that's needed to expose the image. This stuff is a little technical, but it will help you to better understand how to get the results you want because the flash performance varies depending on the exposure mode.

Following that discussion, the rest of the chapter covers advanced flash features, including flash exposure compensation and flash exposure lock (FE Lock). You'll find some tips on getting better results in your flash pictures as well. For details on using Red-Eye Reduction flash, flip to Chapter 2, which spells everything out. Be sure also to visit Chapter 7, where you can find additional flash

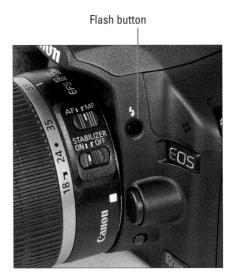

Figure 5-31: Want flash? Just press the Flash button, and you're set to go.

and lighting tips related to specific types of photographs.

Understanding your camera's approach to flash

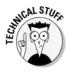

When you use flash, your camera automatically calculates the flash power needed to illuminate the subject. This process is sometimes referred to as *flash metering*. Your Rebel T1i/500D uses a flash-metering system that Canon calls E-TTL II. The *E* stands for *evaluative*, *TTL* stands for *through the lens*, and *II* refers to the fact that this system is an update to the first version of the system.

It isn't important that you remember what the initials stand for or even the flash system's official name. But what is helpful to keep in mind is how the system is designed to work.

First, you need to know that a flash can be used in two basic ways: as the primary light source or as a *fill flash*. When flash is the primary light source, both the subject and background are lit by the flash. In dim lighting, this typically results in a brightly lit subject and a dark background, as shown on the left in Figure 5-32.

With fill flash, the background is exposed primarily by ambient light, and the flash adds a little extra illumination to the subject. Fill flash typically produces brighter backgrounds and, often, softer lighting of the subject because not as much flash power is needed. The downside is that if the ambient light is dim, as in my nighttime photo, you need a slow shutter speed to properly

172

Chapter 5: Getting Creative with Exposure and Lighting

expose the image, and both the camera and the subject must remain very still to avoid blurring. The shutter speed for my fill-flash image, shown on the right in Figure 5-32, was 1/30 second, for example. Fortunately, I had a tripod. and the deer didn't seem inclined to move.

Figure 5-32: Fill flash produces brighter backgrounds.

Neither choice is necessarily right or wrong. Whether you want a dark background depends on the scene and your artistic interpretation. If you want to diminish the background, you may prefer the darker background you get when you use flash as your primary light source. But if the background is important to the context of the shot, allowing the camera to absorb more ambient light and adding just a small bit of fill flash may be more to your liking.

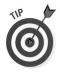

One more note on flash: Although most people think of flash as a tool for nighttime and low-light photography, most outdoor daytime pictures, especially portraits, also benefit from a little fill flash. Figure 5-33 shows you the same scene, shot at a farmer's market on a sunny morning, captured with and without fill flash, for example.

Fill flash

Figure 5-33: Flash often improves daytime pictures outdoors.

Using a flash in bright sunlight also produces a slight warming effect, as Figure 5-33 illustrates, giving colors a subtle reddish-yellowish tint. This color shift occurs because when you enable the flash, the camera's white balancing mechanism warms color slightly to compensate for the bluish light of a flash. But because your scene is actually lit primarily by sunlight, which is *not* as cool as flash light, the white balance adjustment takes the image colors a step warmer than neutral. If you don't want this warming effect, see Chapter 6 to find out how to make a manual white balance adjustment.

So how does this little flash lesson relate to your camera? Well, the exposure mode you use (P, Tv, Av, M, or A-DEP) determines whether the flash operates as a fill flash or as the primary light source. The exposure mode also controls the extent to which the camera adjusts the aperture and shutter speed in response to the ambient light in the scene.

In all modes, the camera analyzes the light both in the background and on the subject. Then it calculates the exposure and flash output as follows:

P: In this mode, the shutter speed is automatically set between 1/60 and 1/200 second. If the ambient light is sufficient, the flash output is geared to providing fill-flash lighting. Otherwise, the flash is determined to be

174

✓ Tv: In this mode, the flash defaults to fill-flash behavior. After you select a shutter speed, the camera determines the proper aperture to expose the background with ambient light. Then it sets the flash power to provide fill-flash lighting to the subject.

You can select a shutter speed between 30 seconds and 1/200 second. If the aperture (f-stop) setting blinks, the camera can't expose the background properly at the shutter speed you selected. You can adjust either the shutter speed or ISO to correct the problem.

✓ Av: Again, the flash is designed to serve as fill-flash lighting. After you set the f-stop, the camera selects the shutter speed needed to expose the background using only ambient light. The flash power is then geared to fill in shadows on the subject.

Depending on the ambient light and your selected f-stop, the camera sets the shutter speed at anywhere from 30 seconds to 1/200 second. So be sure to note the shutter speed before you shoot — at slow shutter speeds, you may need a tripod to avoid camera shake. Your subject also must stay very still to avoid blurring.

If you want to avoid the possibility of a slow shutter altogether, you can. Display Setup Menu 3, select Custom Functions, and press Set. Then select Custom Function 3. as shown in Figure 5-34. At the default setting, the camera operates as just described. If you instead select the second option, the camera sticks with a shutter-speed range of 1/60 to 1/200 second. And with the third option, the shutter speed is always set to 1/200 second when you use flash.

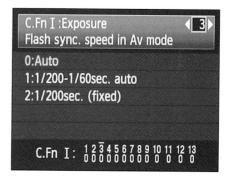

Figure 5-34: You can limit the camera to a fast shutter when using Av mode with flash.

The latter two options both ensure that you can handhold the camera without blur, but obviously, in dim lighting, it can result in a dark background because the camera doesn't have time to soak up much ambient light. At the 1/60 to 1/200 setting, the backgrounds are usually brighter than the 1/200 fixed setting, of course, because the camera at least has the latitude to slow the shutter to 1/60 second.

M: In this mode, the shutter speed, aperture, and ISO setting you select determine how brightly the background will be exposed. The camera takes care of illuminating the subject with fill flash. The maximum shutter speed you can select is 1/200 second; the slowest normal shutter speed is 1/30 second.

You also can set the shutter speed to the Bulb setting — which keeps the shutter open as long as you keep the shutter button pressed, however. In Bulb mode, the flash fires at the beginning of the exposure if the Shutter Sync setting is set to the 1st Curtain setting; with the 2nd Curtain setting, the flash fires at the beginning of the exposure and again at the end. See the upcoming section "Exploring more flash options" for details about the Shutter Sync setting.

A-DEP: You can use flash in this mode, but doing so disables the automatic depth-of-field feature. The flash and exposure systems then operate as described for P mode. However, you can't choose from multiple combinations of aperture and shutter speed as you can in that mode; you're stuck with the combination that the camera selects.

If the flash output in any mode isn't to your liking, you can adjust it by using flash exposure compensation, explained next. Also check out the upcoming section "Locking the flash exposure" for another trick to manipulate flash results. In any auto-exposure mode, you can also use exposure compensation, discussed earlier, to tweak the ambient exposure — that is, the brightness of your background. So you have multiple points of control: exposure compensation to manipulate the background brightness, and flash compensation and flash exposure lock to adjust the flash output.

One final point: These guidelines apply to the camera's built-in-flash. If you use certain Canon external flash units, you not only have more flash control, but can select a faster shutter speed than the built-in flash permits.

Adjusting flash power with Flash Exposure Compensation

When you shoot with your built-in flash, the camera attempts to adjust the flash output as needed to produce a good exposure in the current lighting conditions. On some occasions, you may find that you want a little more or less light than the camera thinks is appropriate.

You can adjust the flash output by using a feature called *Flash Exposure Compensation*. Similar to exposure compensation, discussed earlier in this chapter, flash exposure compensation affects the output level of the flash unit, whereas exposure compensation affects the brightness of the background in your flash photos. As with exposure compensation, flash exposure compensation is stated in terms of EV (*exposure value*) numbers. A setting of 0.0 indicates no flash adjustment; you can increase the flash power to +2.0 or decrease it to -2.0.

Chapter 5: Getting Creative with Exposure and Lighting

Figure 5-35 shows an example of the benefit of this feature — again, available only when you shoot in the advanced exposure modes. I snapped these tomatoes during bright daylight, but a tent awning shaded them. The first image shows you a flash-free shot. Clearly, I needed a little more light, but at normal flash power, the flash was too strong, blowing out the highlights in some areas, as shown in the middle image. By reducing the flash power to EV -1.3, I got a softer flash that straddled the line perfectly between no flash and too much flash.

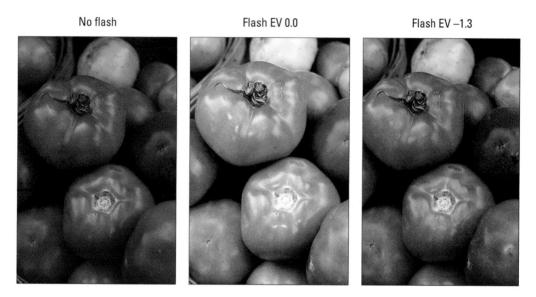

Figure 5-35: When normal flash output is too strong, lower your flash exposure compensation.

As for boosting the flash output, well, you may find it necessary on some occasions, but don't expect the built-in flash to work miracles even at a flash exposure compensation of +2.0. Any built-in flash has a limited range, and you simply can't expect the flash light to reach faraway objects. In other words, don't even try taking flash pictures of a darkened recital hall from your seat in the balcony — all you'll wind up doing is annoying everyone.

Whichever direction you want to go with flash power, you have two ways to do so:

Quick Control screen: This path is by far the easiest way to travel. After displaying the Shooting Settings screen, press Set to shift to the Quick Control display. Then use the cross keys to highlight the Flash Exposure

177

Compensation value, as shown on the left in Figure 5-36. Rotate the Main dial to raise or lower the amount of flash adjustment. Or, if you need more help, press Set to display the second screen in the figure, which reminds you that the setting has no impact when you use an external flash. (You set the flash power on the external flash unit instead.) You can use the Main dial or cross keys to adjust the flash power on this screen; press Set when you finish.

✓ Shooting Menu 2: The menu route to flash power is a little more tedious. Display Shooting Menu 1, select Flash Control, and press Set. You then see the left screen in Figure 5-37. Highlight the Built-in Flash Func. Setting and press Set to display the right screen. Now highlight Flash Exp. Comp. and press Set again. The little flash power meter becomes activated, and you can then use the right or left cross keys to adjust the setting. Press Set when you finish. (In other words, learn the Quick Control method and save yourself a bunch of button presses!)

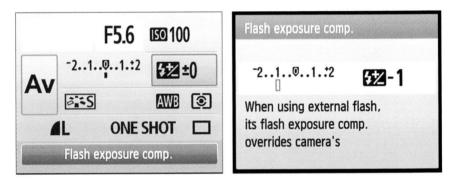

Figure 5-36: The quickest way to adjust flash power is via the Quick Control screen.

Flash control	Built-in flash func.	Built-in flash func. setting	
Flash firingEnableBuilt-in flash func. settingExternal flash func. settingExternal flash C.Fn settingClear ext. flash C.Fn set.	Flash mode Shutter sync. Flash exp. comp E-TTL II	E-TTL II 1st curtain -21º1.:2 Evaluative	
MENU 5		MENU •	

Figure 5-37: You can also change flash power with the menus, but it's a tedious task.

178

Chapter 5: Getting Creative with Exposure and Lighting

You also have the option of customizing the Set button so that it displays the flash-power screen you see in Figure 5-36. (Chapter 11 shows you how.) The problem is that you then lose access to the Quick Control method of changing other camera settings because the Set button normally shifts the Shooting Settings display to the Quick Control display. So I don't recommend that option.

When flash compensation is in effect, the value appears in the Shooting Settings screen, as shown in Figure 5-38. You see the same plus/minus flash symbol in the viewfinder and Live View display, although in both cases without the actual Flash Exposure Compensation value. If you change the Flash Exposure Compensation value to zero, the flashpower icon disappears from all the displays.

As with exposure compensation, any flash-power adjustment you make remains in force until you reset the control, even if you turn off the camera.

Figure 5-38: The flash value appears only when flash compensation is in effect.

So be sure to check the setting before using your flash. Additionally, the Auto Lighting Optimizer feature, covered earlier in this chapter, can interfere with the effect produced by flash exposure compensation, so you may want to disable it.

Locking the flash exposure

You might never notice it, but when you press the shutter button to take a picture with flash enabled, the camera emits a very brief *preflash* before the actual flash. This preflash is used to determine the proper flash power needed to expose the image.

Occasionally, the information that the camera collects from the preflash can be off-target because of the assumptions the system makes about what area of the frame is likely to contain your subject. To address this problem, your camera has a feature called *Flash Exposure Lock*, or FE Lock. This tool enables you to set the flash power based on only the center of the frame.

Unfortunately, FE Lock is not available in Live View mode. So if you want to use this feature, you must abandon Live View and use the viewfinder to frame your images.

Follow these steps to use FE Lock:

1. Frame your photo so that your subject falls under the center autofocus point.

You want your subject smack in the middle of the frame. You can reframe the shot after locking the flash exposure if you want.

2. Press the shutter button halfway.

The camera meters the light in the scene. If you're using autofocusing, focus is set on your subject, and the green focus confirmation dot appears in the viewfinder. (If focus is set at another spot in the frame, see Chapter 6 to find out how to select the center autofocus point.) You can now lift your finger off the shutter button if you want. If you're using autofocusing, focus is set on your subject, and the green focus confirmation dot appears in the viewfinder. You can now lift your finger off the shutter button if you reference off the shutter button if you want.

3. While the subject is still under the center autofocus point, press and release the AE Lock button.

You can see the button in the margin here. The camera emits the preflash, and the letters FEL display for a second in the viewfinder. (FEL stands for *flash exposure lock.*) You also see the asterisk symbol — the one that appears above the AE Lock button on the camera body — next to the flash icon in the viewfinder.

4. If needed, re-establish focus on your subject.

In autofocus mode, press and hold the shutter button halfway. (You need to take this step only if you released the shutter button after Step 2.) In manual focus mode, twist the focusing ring on the lens to establish focus.

5. Reframe the image to your desired composition.

While you do, keep the shutter button pressed halfway to maintain focus if you're using autofocusing.

6. Press the shutter button the rest of the way to take the picture.

The image is captured using the flash output setting you established in Step 3.

Flash exposure lock is also helpful when you're shooting portraits. The preflash sometimes causes people to blink, which means that with normal flash shooting, in which the actual flash and exposure occur immediately after the preflash, their eyes are closed at the exact moment of the exposure. With flash exposure lock, you can fire the preflash and then wait a second or two for the subject's eyes to recover before you take the actual picture.

Better yet, the flash exposure setting remains in force for about 16 seconds, meaning that you can shoot a series of images using the same flash setting without firing another preflash at all.

180

Exploring more flash options

When you set the Mode dial to P, Tv, Av, M, or A-DEP, Shooting Menu 1 offers an option called Flash Control. Through this menu item, you can adjust flash power, as explained a couple of sections ago (although using the Quick Control screen is easier). The Flash Control option also enables you to customize a few other aspects of the built-in flash as well as an external flash head.

To explore your options, highlight Flash Control, as shown on the left in Figure 5-39, and press Set. You then see the screen shown on the right in the figure. Here's the rundown of the available options:

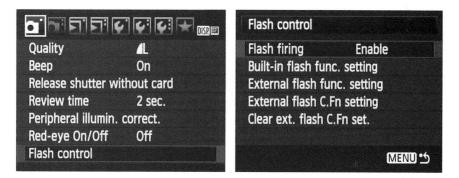

Figure 5-39: You can customize additional flash options via Setup Menu 1.

Flash Firing: Normally, this option is set to Enable. If you want to disable the flash, you can choose Disable instead. However, you don't have to take this step in most cases — just close the pop-up flash head on top of the camera if you don't want to use flash.

What's the point of this option, then? Well, if you use autofocusing in dim lighting, the camera may need some help finding its target. To that end, it sometimes emits an *AF-assist beam* from the flash head — the beam is actually a series of rapid pulses of light. If you want the benefit of the AF-assist beam but you don't want the flash to actually fire, you can disable flash firing. Remember that you do have to pop up the flash unit to expose the lamp that emits the beam. You also can take advantage of this option when you attach an external flash head.

Built-In Flash Function Setting: If you highlight this option and press Set, you display the screen shown in Figure 5-40. The first option is unavailable for the built-in flash. The other three affect the flash as follows:

 Shutter Sync: By default, the flash fires at the beginning of the exposure. This flash timing, known as *1st curtain* sync, is the best choice for most subjects. However, if you use a very slow shutter speed and you're photographing a moving object, *1st* curtain sync causes the blur that results from the motion to appear in front of the object, which doesn't make much visual sense.

Built-in flash func	. setting	
Flash mode	E-TTL II	
Shutter sync.	1st curtain	
Flash exp. comp	⁻ 21 <u>0</u> 1.:2	
E-TTL II	Evaluative	
	MENU *5	

Figure 5-40: These advanced flash options affect only the built-in flash.

To solve this problem, you can change the Shutter Sync option to *2nd curtain sync*, also known as *rear-curtain sync*. In this flash mode, the motion trails appear behind the moving object. The flash actually fires twice in this mode: once when you press the shutter button and again at the end of the exposure.

- *Flash Exposure Compensation:* This setting adjusts the power of the built-in flash; again, see the earlier section "Adjusting flash power with Flash Exposure Compensation" for details.
- *E-TTL II:* This option enables you to switch from the default flash metering approach, called Evaluative. In this mode, the camera operates as described in the earlier section, "Understanding your camera's approach to flash." That is, it exposes the background using ambient light when possible and then sets the flash power to serve as fill light on the subject.

If you instead select the Average option, the flash is used as the primary light source, meaning that the flash power is set to expose the entire scene without relying on ambient light. Typically, this results in a more powerful (and possibly harsh) flash lighting and dark backgrounds.

External Flash controls: The final three options on the Flash Control list (refer to the right screen in Figure 5-39) relate to external flash heads; they don't affect the performance of the built-in flash. However, they apply only to Canon EX-series Speedlites that enable you to control the flash through the camera. If you own such a flash, refer to the flash manual for details.

You can probably discern from these descriptions that most of these features are designed for photographers schooled in flash photography who want to mess around with advanced flash options. If that doesn't describe you, don't

182

worry about it. The default settings selected by Canon will serve you well in most every situation — the exception being flash exposure compensation, which you can just as easily adjust via Shooting Menu 2.

Using an external flash unit

In addition to its built-in flash, your camera has a *hot shoe*, which is photogeek terminology for a connection that enables you to add an external flash head like the one shown in Figure 5-41. The figure features the Canon Speedlite 580EX II, which currently retails for right around \$350.

Although certainly not the cheapest of camera accessories, an external flash may be a worthwhile investment if you do a lot of flash photography, especially portraits. For one thing, an external flash offers greater power, enabling you to illuminate a larger area than you can with a built-in flash. And with flash units like the one in Figure 5-41, you can rotate the flash head so that the flash light bounces off a wall or ceiling instead of hitting your subject directly. This results in softer lighting and can eliminate the harsh shadows often caused by the strong, narrowly focused light of a built-in flash. (Chapter 7 offers an example of the difference this lighting technique can make in portraits.) Additionally, certain Canon flash units permit you to use a shutter speed faster than the 1/200-second limit imposed by the built-in flash.

Whether the investment in an external flash

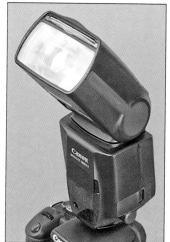

Figure 5-41: An external flash with a rotating head offers greater lighting flexibility.

will be worthwhile depends on the kind of photography you want to do. If you decide to purchase an external flash, I strongly recommend that you shop at a reputable camera store where the personnel can help you match the flash unit to your shooting needs. You don't have to buy a Canon flash, but be aware that non-Canon flash units do not operate in Live View mode.

You may also want to dig into some of the many books that concentrate solely on flash photography. There's a lot more to that game than you may imagine, and you'll no doubt discover some great ideas about lighting your pictures with flash. You can start with Chapter 7, which provides some specific examples of how to get better flash results when you shoot portraits, whether you go with the built-in flash, an external flash, or, my favorite, no flash.

(6)

Manipulating Focus and Color

In This Chapter

- > Controlling the camera's autofocusing performance
- Choosing an autofocus mode
- » Autofocusing in Live View and Movie mode

- > Understanding focal lengths, depth of field, and other focus factors
- > Exploring white balance and other color options

To many people, the word *focus* has just one interpretation when applied to a photograph: Either the subject is in focus or it's blurry. But an artful photographer knows that there's more to focus than simply getting a sharp image of a subject. You also need to consider *depth of field*, or the distance over which objects remain sharply focused. This chapter explains all the ways to control depth of field and also discusses how to use your Rebel's advanced autofocus options.

In addition, this chapter dives into the topic of color, explaining such concepts as *White Balance* (a feature that compensates for the varying color casts created by different light sources), and *color space* (an option that determines the spectrum of colors your camera can capture).

Reviewing Focus Basics

I touch on various focus issues in Chapters 1, 2, and 5. But just in case you're not reading this book from front to back, the following steps provide a recap of the basic process of focusing with your Rebel T1i/500D.

These steps relate only to regular, still photography. You can find details on autofocusing in Live View mode and Movie mode later in this chapter and get a thorough introduction to those modes in Chapter 4.

1. If you haven't already done so, adjust the viewfinder to your eyesight.

Chapter 1 explains how to take this critical step.

2. Set the focusing switch on the lens to manual or automatic focusing.

To focus manually, set the switch Auto/Manual Focus switch to the MF position. For autofocusing, set the switch to the AF position, as in Figure 6-1. (These directions are specific to the kit lens sold with the Rebel T1i/500D, as shown in the figure. If you use another lens, the switch may look or operate differently, so check the product manual.)

3. For handheld shooting, turn on Image Stabilization.

For sharper handheld shots, set the Stabilizer switch on the kit lens to On, as shown in Figure 6-1. If you use another lens that offers image stabilization (it may go by a different name, depending upon the manufacturer), check the lens Figure 6-1: Select AF for autofocus or MF manual to find out how to turn on for manual focus. the feature.

Image Stabilizer switch

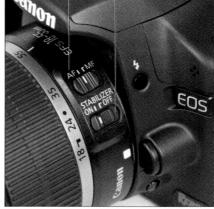

For tripod-mounted shooting with a non-Canon lens, the manufacturer may suggest turning stabilization off, so again, check the lens manual. You don't need to turn the feature off for most Canon IS lenses, but you can save battery power by doing so.

4. Set your focus:

• For autofocusing: Frame your subject so that it appears under one of the nine autofocus points. Then press and hold the shutter button halfway down.

In Portrait, Landscape, Close Up, Night Portrait, and A-DEP modes, the focus lamp in the viewfinder lights, and one or more of the autofocus points turns red, as shown in Figure 6-2. A red dot indicates an active autofocus point and tells you that the area under the dot is in focus. Focus is maintained as long as you continue to hold the shutter button down halfway.

If you shoot in Sports mode, the focus indicators don't appear. Instead, focus is continuously adjusted as needed to track a moving subject until you snap the picture. The same thing occurs in Full Auto, Flash Off, and Creative Auto modes if the camera senses motion in front of the lens; otherwise focus is locked and you see the indicator lights.

In P, Tv, Av, and M modes, you can choose which autofocusing behavior you prefer and also select which of the nine autofocus you want to use when establishing autofocus. See the next section for the complete scoop on autofocusing options.

• For manual focus: Twist the focusing ring on the lens.

Even in manual mode, you can confirm focus by pressing the shutter button halfway. The autofocus point or points that achieved focus flash for a second or two, and the viewfinder's focus lamp lights up.

Never twist the lens focusing ring on the kit lens without first setting the lens switch to the MF position. You can damage the lens by doing so! If you use another lens, check your lens manual for advice. Some lenses enable you to set focus initially using autofocus and then fine-tune focus by twisting the focusing ring without officially setting the lens to manual-focusing mode.

-. • • 100 9.0-2..1......1.12 ISO INN Focus indicator

AF (autofocus) points

Figure 6-2: The viewfinder offers these focusing aids.

Shutter speed and blurry photos

A poorly focused photo isn't always related to the issues discussed in this chapter. Any movement of the camera or subject can also cause blur. Both of these problems are actually related

to shutter speed, an exposure control that I cover in Chapter 5. Be sure to also visit Chapter 7, which provides some additional tips for capturing moving objects without blur.

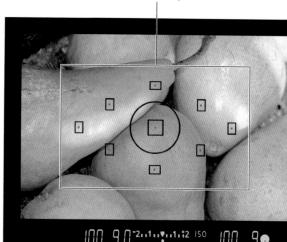

Adjusting Autofocus Performance

You can adjust two aspects of your Rebel T1i/500D's autofocusing system: which autofocus points are used to establish focus, and the AF (autofocus) mode. The next two sections explain these features.

Selecting an autofocus point

When you shoot in any of the fully automatic exposure modes (Full Auto, Portrait, Landscape, and so on) as well as in Creative Auto and A-DEP mode, all nine of your camera's autofocus points are active. That means that the camera's autofocusing system looks at all the points when trying to establish focus. Typically, the camera sets focus on the point that falls over the object closest to the lens. If that focusing decision doesn't suit your needs, you have two options:

- Focus manually.
- Set the camera to P, Tv, Av, or M exposure mode. In those modes, you can tell the camera to base focus on a specific autofocus point.

Chapter 1 explains how to adjust focus manually. If you want to use autofocusing and specify an autofocus point, the following steps spell out the process.

Again, these steps assume that you are not shooting in Live View mode or recording a movie. I explain the intricacies of Live View and Movie mode autofocusing a little later in this chapter, in the section cleverly named "Autofocusing in Live View and Movie Modes." However, some of the autofocusing concepts involved in normal shooting also come into play for Live View and movie autofocusing, so familiarize yourself with these steps before you jump to that discussion.

1. Set the Mode dial to P, Tv, Av, or M.

Again, you can specify an autofocus point only in these exposure modes.

2. Press and release the AF Point Selection button, highlighted in Figure 6-3.

When you do, you see the AF Point Selection screen on the monitor. In Automatic AF Point Selection mode, all the autofocus points appear in color, as shown in Figure 6-4. In Manual AF Point Selection mode, only one point is selected and appears in color, as shown in Figure 6-5. In the figure, the center AF point is selected.

You can check the current mode by looking through the viewfinder, too. When you press and release the AF Point Selection button, all nine autofocus points turn red if you're in Automatic AF Point Selection mode. A single point turns red if you're in Manual AF Point Selection mode.

3. To choose a single autofocus point, set the camera to **Manual AF Point Selection** mode.

You can do this in two ways:

- Rotate the Main dial. This option is easiest when your eye is up to the viewfinder.
- Press the Set button. Pressing the button toggles you between Automatic AF Point Selection and Manual AF Point Selection with the center point activated.

4. Specify which AF Point you want to use.

You can either rotate the Main dial or press the cross keys to select a point. When all autofocus points again turn red, you've cycled back to automatic AF Point Selection mode. Rotate the dial or press a cross key to switch back to single-point selection.

AF Point Selection button

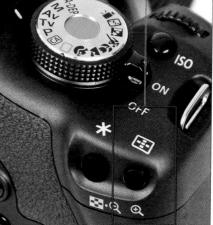

Figure 6-3: Press and release the AF Point Selection button to select an autofocus point.

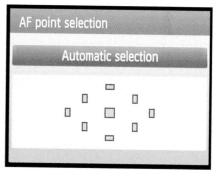

Figure 6-4: In Automatic mode, all nine autofocus points are active.

That's all there is to it. After you select the autofocus point, just frame your shot so that your subject falls under that point and then press the shutter button halfway to focus.

rest of the way.

If you want the benefits of autofocus but find it bothersome to have to worry about selecting an autofocus point, try this approach: Set the camera to Manual AF Point Selection and select the center point as the active point. Now the camera will always set focus based on whatever is at the center of the frame. If you want your subject to appear off-center, you still can: Just frame the picture initially so that the subject is centered, press

the shutter button halfway to establish Figure 6-5: You also can base autofocus focus, and then reframe the image before pressing the shutter button the

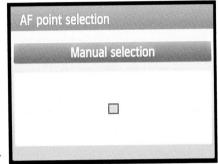

on a single point; here, the center point is selected.

Do be careful about exposure if you use this technique, however. If the exposure metering mode is set to Partial, Spot, or Center-Weighted Average metering and you reframe the image so that your subject isn't at the center of the frame, exposure may be off. To compensate, you may need to lock exposure (using the AE Lock button) before you reframe. In Evaluative metering mode, this issue shouldn't be a big problem because exposure is based on the entire frame. Chapter 5 provides details about metering modes, autoexposure lock, and other exposure issues.

Changing the AF (autofocus) mode

Your camera offers three different autofocusing schemes, which you select through a control called AF mode. The three choices work like so:

- One-Shot: In this mode, which is geared to shooting stationary subjects, the camera locks focus when you press the shutter button halfway. Focus remains locked as long as you hold the shutter button at that halfway position.
- ✓ AI Servo: In this mode, the camera adjusts focus continually as needed from when you press the shutter button halfway to the time you take the picture. This mode is designed to make focusing on moving objects easier.

For AI Servo to work properly, you must reframe as needed to keep your subject under the active autofocus point if you're working in Manual AF Point Selection mode. If the camera is set to Automatic AF Point Selection, the camera initially bases focus on the center focus point. If the subject moves away from that point, focus should still be okay as long as you keep the subject within the area covered by one of the other autofocus points. (The preceding section explains these two modes.)

In either case, the green focus dot in the viewfinder blinks rapidly if the camera isn't tracking focus successfully. If all is going well, the focus dot doesn't light up at all, nor do you hear the beep that normally sounds when focus is achieved. (You can hear the autofocus motor whirring a little when the camera adjusts focus.)

✓ AI Focus: This mode automatically switches the camera from One-Shot to AI Servo as needed. When you first press the shutter button halfway, focus is locked on the active autofocus point (or points), as usual in One-Shot mode. But if the subject moves, the camera shifts into AI Servo mode and adjusts focus as it thinks is warranted.

Which of these three autofocus modes are available to you, however, depends on the exposure mode, as follows:

- P, Tv, Av, and M modes: You can select any of the three AF mode options.
- A-DEP, Portrait, Landscape, Night Portrait, and Close-Up modes: The camera restricts you to One-Shot mode.
- Sports mode: The camera always uses AI Servo autofocus.
- Full Auto, Creative Auto, and No Flash modes: These modes always use AI Focus.
 - AI stands for *artificial intelligence*, if that helps.

So, assuming that you're using an exposure mode that enables you to choose from all three AF modes, which one is best? Here's my take: One-Shot mode works best for shooting still subjects, and AI Servo is the right choice for moving subjects. But frankly, AI Focus does a good job in most cases of making that shift for you and saves you the trouble of having to change the mode each time you go from shooting still to moving subjects. So, in my mind, there's no real reason to fiddle with the setting unless you're shooting moving objects and want to be able to lock focus at a specific position — in which case, my recommendation would be to simply switch to manual focusing anyway.

Whatever your decision, you can set the AF mode in two ways:

Quick Control screen: Display the Shooting Settings screen (just press the shutter button halfway and release it). Then press Set and use the cross keys to highlight the icon shown in Figure 6-6. The selected AF mode setting appears at the bottom of the screen. Rotate the Main dial to cycle through the three mode options.

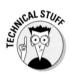

If you prefer, you can press Set after highlighting the AF mode icon to display the screen shown on the right in Figure 6-6, where all the mode choices appear. Then use the cross keys or Main dial to highlight your choice and press Set again.

AF button (right cross key): Press this button to go directly to the screen shown on the right in Figure 6-6. Select your choice and press Set.

AF mode setting

Figure 6-6: Adjust the AF mode through the Quick Control screen or by pressing the AF button (right cross key).

Autofocusing in Live View and Movie Modes

Chapter 4 covers the basics of shooting in Live View mode and Movie mode, both of which require you to compose your shots by using the camera monitor instead of the viewfinder. I mention in that discussion that the simplest and most reliable focusing choice is to do the job manually rather than relying on autofocus, and Chapter 4 explains the steps involved in doing just that.

If you do want to try autofocusing, the next four sections walk you through the process. Before you move on, though, note the following limitations with all the autofocusing methods:

Continuous autofocusing isn't possible. You can set the AF mode to AI Servo, but even if you do, the camera behaves as if you instead selected the One-Shot option. In other words, the camera won't track focus on a moving subject. During movie recording, you might be tempted to reset autofocus if your subject moves. Typically, however, the autofocus system has to "hunt" for the subject a little, causing the shot to go in and out of focus a couple of times before focus is set. Sometimes, the image brightness may change a little as well. So unless this "special effect" is a creative choice that interests you, I recommend focusing manually if you think you'll need to adjust focus during the recording.

Autoexposure and autofocus are set and locked together. When you autofocus in Live View mode, you don't press the shutter button halfway to establish focus as you normally do. Instead, you focus by pressing the AE Lock button — which also locks autoexposure. Chapter 5 covers autoexposure (AE) locking. If you want to lock exposure and focus separately, you have to reset the function of the AE Lock button.

You do this through Custom Function 10, which you can explore fully in Chapter 11. For the purpose of Live View and movie autofocusing, select option 1, AE Lock/AF. After you do, you lock autoexposure by using the shutter button and lock autofocus by pressing the AE Lock button. (Trust me, however, that simply focusing manually is much simpler than this convoluted process. And don't make this change to the button functions while using this book, or things won't work as described.)

Autofocusing isn't possible with remote-control shooting. If you want to control the camera with a remote unit, you must switch to manual focusing.

Choosing the Live View or Movie mode autofocusing method

You can choose from the following three different modes of Live View and movie-recording autofocusing, represented by the symbols you see in the margins:

- AFOUR **Quick mode:** The live preview briefly shuts off after you initiate autofocusing and then reappears when focus is set. As its name implies, this is the fastest option.
- AFLIVE V Live mode: The preview doesn't go dark, and you can see your subject in the monitor during the entire focusing process. However, this is the slowest and least reliable of the three modes.
- AF: Live mode with face detection: This mode works the same as Live mode, but the camera automatically locks focus on a face in the scene if it can find one. When the conditions are just right in terms of lighting, composition, and phase of the moon, this setup works fairly well. However, a number of issues can trip it up. For example, the camera may

mistakenly focus on an object that has a similar shape, color, and contrast to a face. It also won't work if the face isn't just the right size with respect to the background, is tilted at an angle, is too bright or dark, or partly obscured. And, like regular Live mode autofocus, it's slower than Quick mode.

To select the mode you want to use, use either of these techniques:

Quick Control screen: After switching to Live View or Movie mode, press Set to display a stack of control icons on the left side of the screen, as shown on the left in Figure 6-7. The symbol representing the current autofocusing method appears at the top of that stack of icons.

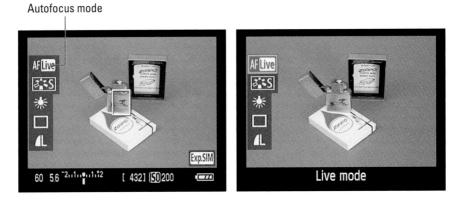

Figure 6-7: During Live View or movie shooting, press Set to enter Quick Control mode and adjust the autofocusing method.

Next, use the cross keys to highlight the autofocus option, as shown on the right in the figure and then rotate the Main dial to change the setting. (If you select Quick mode, you also see nine small autofocus points in the center of the screen; more about that in the next section.) Press the shutter button halfway and release it to exit the Quick Control display.

✓ Setup Menu 2/Movie mode: For Live View shooting, you also can choose the autofocus option through Setup Menu 2. Highlight Live View Function Settings, as shown on the left in Figure 6-8 and then press Set to get to the second screen in the figure. Highlight AF mode, as shown on the right in the figure. Press Set again to display the three autofocus options, highlight your choice, and press Set to exit the menu. In Movie mode, you can access the options through the AF Mode setting on the Movie menu. You could use a slightly different technique to set focus in each mode, so the next three sections spell out the details.

		Live View function settings	
LCD brightness Date/Time Language⊕ Video system Sensor cleaning	※ ⊢	Live View shoot. Grid display Metering timer AF mode	Enable Off 16 sec. Live mode
Live View function	on settings		
			MENU 5

Figure 6-8: You can also change the Live View autofocus setting via Setup Menu 2.

Quick mode autofocusing

As its name implies, Quick mode offers the fastest autofocusing during Live View or movie shooting. Here's how it works:

1. Set the lens switch to the AF position.

Or if you use a lens other than the kit lens, select whatever switch position enables autofocusing.

2. Engage the Live View or Movie display.

• *For Live View:* Set the Mode dial to the P, Tv, Av, M, or A-DEP mode and then press the Live View button, shown in the margin.

• *For Movie recording:* Turn the Mode dial to the little movie-camera icon, and the live preview appears without further ado.

Either way, the camera initially displays a brief text message that reminds you to use the AE Lock button to set focus. You can either wait out the message — it disappears in a few seconds — or move right ahead to Step 3.

3. Press Set, highlight the Autofocus mode icon, and rotate the Main dial to set the mode to Quick.

Rectangles representing the nine autofocus points appear in the center of the screen.

4. Select the autofocus point you want the camera to use to establish focus.

First press the right cross key to highlight the autofocus points, as shown on the left in Figure 6-9. (If the Quick Control screen disappears before you take this step, just press Set to bring it back.) Now you have the same options as when you set the AF Point Selection mode during normal shooting:

- Automatic focus point selection: All nine autofocus points are active, and the camera decides which one to use when setting the focus distance.
- *Manual focus point selection:* You select which of the nine focusing points you want the camera to use.

When all nine points are highlighted, as on the left in Figure 6-9, automatic focus point selection is in force. Rotate the Main dial to shift to manual point selection; keep rotating the dial until the point you want to use is highlighted. In the right screen on Figure 6-9, for example, the center point is active.

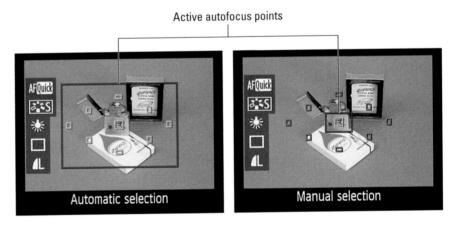

Figure 6-9: In Quick Mode, these small rectangles represent autofocus points.

5. Press the shutter button halfway and release it to return to shooting mode.

Now you see an additional large rectangle along with your single selected point, as shown in Figure 6-10, or with all nine points, if you opted for automatic focus-point selection. That large rectangle is the focusing frame and comes into play later, in Step 9.

6. Frame your shot so that your subject falls under your selected autofocus point.

Or, if you set the camera to automatic focus-point selection (meaning all nine points are active), just make sure that one of the small rectangles falls over your subject.

7. Press and hold the AE Lock button until you hear a beep.

As soon as you press the button, the monitor turns black, and the autofocusing mechanism kicks into gear. Keep pressing the button until the camera beeps. The beep signals you that focus is set.

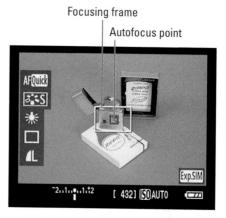

Figure 6-10: You can magnify the area under the focusing frame by pressing the AF Point Selection button.

In P, Tv, Av, or A-DEP mode, the autoexposure system fires up and establishes exposure settings along with focus.

8. When focus is set, release the AE Lock button.

The live preview reappears on the monitor.

9. Verify focus (optional).

You can magnify the display to double-check focus if you want. First press the cross keys to move the large focusing frame (refer to Figure 6-10) over the area of interest. Then press the AF Point Selection button to magnify the area inside the frame. Your first press displays a 5-times magnified view; press again for a 10-times magnification. When you're satisfied with focus, press the AF Point Selection button again to return to the normal display magnification.

If focus is off, you can try reframing the scene and repeating Step 7 — that is, press and hold the AE Lock button until you hear the beep that indicates that focus has been reestablished. You can't, however, select a different AF point without pressing Set to shift back to the Quick Control screen. You then can repeat Step 4 to change the AF point.

After focus is established, press the shutter button all the way to take your picture. Or, to start recording a movie, press the Live View button. See Chapter 4 for all the pertinent details.

Using Live mode autofocusing

Live mode autofocusing enables you to set focus without temporarily losing the monitor preview during Live View or movie shooting. Additionally, you don't have to fiddle with choosing an autofocusing point — instead, you just move a single focusing frame over your subject. In short, this autofocusing method is probably more intuitive to use than Quick mode.

On the very significant downside, however, Live mode autofocusing is noticeably slower than Quick mode, and the camera may have more trouble locking focus than in Quick mode. (The difference is due to the autofocusing system that the camera employs.)

To try it out for yourself, first set the lens switch to the AF position. Then follow these steps:

1. Switch to Live View or Movie mode.

Again, for Live View, you set the Mode dial to P, Tv, Av, M, or A-DEP and then press the Live View button. For movie recording, spin the Mode dial to the Movie setting. In both cases, you see the screen reminding you to use the AE Lock button to focus; give it a few seconds to disappear or just move on to Step 2.

2. Set the autofocus mode to Live.

You can do this by pressing Set, highlighting the autofocus option (refer to Figure 6-7), and then rotating the Main dial to cycle through the three settings. Press the shutter button halfway and release it when you're done.

A rectangular focusing frame appears in the center of the screen, as shown in Figure 6-11.

- 3. Use the cross keys to move the focusing frame over the area on which you want to focus.
- * ● ⊠.@
- 4. Press and hold the AE Lock button.

The camera attempts to establish focus and also sets exposure, if you're using any exposure mode but M (manual).

5. When the focusing frame turns green and you hear a beep, release the AE Lock button.

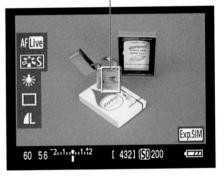

Figure 6-11: In Live mode, put the focusing frame over the subject and then press the AE Lock button to autofocus.

These signals tell you focus has been established — and, in autoexposure modes, that exposure has been set as well.

If the focusing frame instead turns red, the camera can't establish focus. The best option here is to switch to manual focusing.

6. Verify focus (optional).

To zoom in on the area inside the focusing frame and check focus, press the AF Selection Point button. Press once to zoom to a 5-times magnification; press again to display the scene at 10-times magnification. You can press the cross keys to shift the position of the focusing frame to inspect another area.

If focus appears off, you can press the AE Lock button again to restart autofocusing. Again, wait for the beep and green focusing frame indicator to release the button.

When you're happy with focus, press the AF Point Selection button once more to return to normal, non-magnified view.

7. Take the picture or start recording your movie.

Again, see Chapter 4 for help with all other aspects of Live View shooting and movie recording.

Using Live mode autofocus with face detection

In Live Mode with face detection, the camera searches for a face in your scene. If the camera thinks it found a face, it automatically places a focusing frame over the face and sets focus at that spot.

To use this autofocusing option, use the same steps to set up the camera as in the preceding section, but in Step 2, set the autofocus mode to the Face Detection setting.

After you set the autofocus mode, the camera goes to work tracking down possible faces in the scene. If it finds one face, you see the small focusing frame over the person. Figure 6-12 shows how this looks in Movie mode, for example. If the camera detects more than one face, little triangles appear on the left and right side of the focusing frame. That's your cue to use the right or the left cross key to move the frame over the person who is most likely to yell at you if they're out of focus in the picture. Face-detection frame

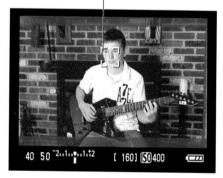

Figure 6-12: The Face Detection mode tries to pick out a face on which to set focus.

If you don't see the little box, the camera can't detect any faces; it's best to switch to either Live or Quick mode to autofocus if that happens. Otherwise, the camera will set focus on the center of the screen, as if you had selected the center autofocus point in Quick mode.

From here on out, things work as spelled out in Steps 4–7 of the Live mode steps.

Manipulating Depth of Field

Getting familiar with the concept of depth of field is one of the biggest steps you can take to becoming a more artful photographer. I introduce you to depth of field in Chapters 2 and 5, but here's a quick recap just to hammer home the lesson. Depth of field simply refers to the distance over which objects in a photograph appear sharply focused.

- With a shallow (small) depth of field: Only your subject and objects very close to it appear sharp. Objects at a distance from the subject appear blurry.
- With a large depth of field: The zone of sharp focus extends to include distant objects.

Which arrangement works best depends entirely upon your creative vision and your subject. In portraits, for example, a classic technique is to use a shallow depth of field, as in Figure 6-13. This approach increases emphasis on the subject while diminishing the impact of the background. But for the photo shown in Figure 6-14, I wanted the historical marker, the lighthouse, and the cottage behind to have equal weight in the scene, so I used settings that produced a large depth of field, keeping them all in sharp focus.

Note, though, that with a shallow depth of field, which part of the scene appears blurry depends on the spot at which you establish focus. In the lighthouse scene, for example, if I had used settings that produced a short depth of field and I set focus on the lighthouse, the

Figure 6-13: A shallow depth of field blurs the background and draws added attention to the subject.

Shallow depth of field

historical marker in the foreground and the cottage in the background both might be outside the zone of sharp focus.

So how do you adjust depth of field? You have three points of control, as follows:

✓ Aperture setting (f-stop): The aperture is one of three exposure settings, all explained fully in Chapter 5. Depth of field increases as you stop down the aperture (by choosing a higher f-stop number). For shallow depth of field, open the aperture (by choosing a lower f-stop number).

Figure 6-15 offers an example. Notice that the trees in the background are much more softly focused in the f/5.6 example than in the f/11 version. Of course, changing the aperture requires adjusting the shutter speed or ISO to maintain the equivalent exposure; for these images, I adjusted shutter speed.

Lens focal length: In lay terms, focal length, which is measured in millimeLarge depth of field

Figure 6-14: A large depth of field keeps both near and far subjects in sharp focus.

ters, determines what the lens "sees." As you increase focal length (use a "longer" lens, in photography speak) the angle of view narrows, objects appear larger in the frame, and — the important point for this discussion — depth of field decreases. Additionally, the spatial relationship of objects changes as you adjust focal length.

For example, Figure 6-16 compares the same scene shot at focal lengths of 138mm and 255mm. I used the same aperture, f/22, for both examples.

Whether you have any focal-length flexibility depends on your lens: If you have a zoom lens, you can adjust the focal length by zooming in or out. (The Rebel T1i/500D kit lens, for example, offers a focal-length range of 18–55mm.) If you don't have a zoom lens and also can't switch to a lens with a different focal length, scratch this means of manipulating depth of field.

For more technical details about focal length and your camera, see the sidebar "Fun facts about focal length."

Camera-to-subject distance: When you move the lens closer to your subject, depth of field decreases. This assumes that you don't zoom in or out to reframe the picture, thereby changing the focal length. If you do, depth of field is affected by both the camera position and focal length.

Figure 6-15: Raising the f-stop value increases depth of field.

138mm, f/22

255mm, f/22

Figure 6-16: Using a longer focal length also reduces depth of field.

The extent to which background focus shifts as you adjust depth of field also is affected by the distance between the subject and the background. For increased background blurring, move the subject farther in front of the background.

Together, these three factors determine the maximum and minimum depth of field that you can achieve, as illustrated by my clever artwork in Figure 6-17 and summed up in the following list:

- ✓ To produce the shallowest depth of field: Open the aperture as wide as possible (select the lowest f-stop number), zoom in to the maximum focal length of your lens, and get as close as possible to your subject.
- To produce maximum depth of field: Stop down the aperture to the highest possible f-stop setting, zoom out to the shortest focal length your lens offers, and move farther from your subject.

Greater depth of field: Select higher f-stop Decrease focal length (zoom out) Move farther from subject

Shorter depth of field: Select lower f-stop Increase focal length (zoom in) Move closer to subject

Figure 6-17: Aperture, focal length, and your shooting distance determine depth of field.

Here are a few additional tips and tricks related to depth of field:

Aperture-priority autoexposure (Av) mode: When depth of field is a primary concern, try using aperture-priority autoexposure (Av). In this mode, detailed fully in Chapter 5, you set the f-stop, and then the camera selects the appropriate shutter speed to produce a good exposure. The range of aperture settings you can access depends upon your lens.

- Creative Auto mode: Creative Auto mode also gives you some control over depth of field. In that mode, you can use the Background slider to request a greater or smaller depth of field, as outlined in Chapter 2.
- Fully automatic scene modes: Some of the fully automatic scene modes are also designed with depth of field in mind. Portrait and Close-Up modes produce shortened depth of field; Landscape mode produces a greater depth of field. You can't adjust aperture in these modes, however, so you're limited to the setting the camera chooses. And in certain lighting conditions, the camera may not be able to choose an aperture that produces the depth of field you expect from the selected mode.
- A-DEP mode: The Rebel T1i/500D also offers a special autoexposure mode called A-DEP, which stands for *automatic depth of field*. In this mode, the camera selects the aperture setting that it thinks will keep all objects in the frame within the zone of sharp focus. You can read more about this mode in the next section.

- Depth of field preview: Not sure which aperture setting you need to produce the depth of field you want? Good news: Your camera offers *depth of field preview*, which enables you to see in advance how the aperture affects the focus zone. See the section labeled "Checking depth of field" for details on how to use this feature.
- Shutter speed: If you adjust aperture to affect depth of field, be sure to always keep an eye on shutter speed as well. To maintain the same exposure, shutter speed must change in tandem with aperture, and you may encounter a situation where the shutter speed is too slow to permit hand-holding a camera. Lenses that offer optical image stabilization do enable most people to handhold the camera at slower shutter speeds than nonstabilized lenses, but double-check your results just to be sure. You can also consider raising the ISO setting to make the image sensor more reactive to light, but remember that higher ISO settings can produce noise. (Chapter 5 has details.)

Fun facts about focal length

Every lens can be characterized by its *focal length*, or in the case of a zoom lens, the range of focal lengths it offers. Measured in millimeters, focal length determines the camera's angle of view, the apparent size and distance of objects in the scene, and depth of field. According to photography tradition, a focal length of about 50mm is a "normal" lens. Most point-and-shoot cameras feature this focal length, which is a medium-range lens that works well for the type of snapshots that users of those kinds of cameras are likely to shoot.

A lens with a focal length less than 35mm is typically known as a *wide angle* lens because at that focal length, the camera has a wide angle of view and produces a long depth of field, making it good for landscape photography. A short focal length also has the effect of making objects seem smaller and farther away. At the other end of the spectrum, a lens with a focal length longer than about 80mm is considered a *telephoto* lens (often referred to as a *long lens*). With a long lens, angle of view narrows, depth of field decreases, and faraway subjects appear closer and larger, which is ideal for wildlife and sports photographers.

Note, however, that the focal lengths stated here and elsewhere in the book are so-called "35mm equivalent" focal lengths. Here's the deal: For reasons that aren't really important, when you put a standard lens on most digital cameras, including your Rebel T1i/500D, the available frame area is reduced, as if you took a picture on a camera that uses 35mm film (the kind you've probably been using for years) and then cropped it.

This so-called *crop factor* (sometimes called the *magnification factor*) varies depending on the digital camera, which is why the photo industry adopted the 35mm-equivalent measuring stick as a standard. With your camera, the cropping factor is roughly 1.6. So the 18–55mm kit lens sold with the Rebel T1i/500D, for example, actually captures the approximate area you

would get from a 27–82mm lens on a 35mm film camera. In the figure here, for example, the red outline indicates the image area that results from the 1.6 crop factor.

Note that although the area the lens can capture changes when you move a lens from a 35mm film camera to a digital body, depth of field isn't affected, nor are the spatial relationships between objects in the frame. So when lens shopping, you gauge those two characteristics of the lens by looking at the stated focal length — no digital-to-film conversion math is required.

Using A-DEP mode

In addition to the four advanced exposure modes found on most digital SLR cameras, your Rebel T1i/500D offers a fifth mode called A-DEP, as shown in Figure 6-18. The initials stand for *automatic depth of field*.

This mode is designed to assist you in producing photos that have a depth of field sufficient to keep all objects in the frame in sharp focus. The camera accomplishes this by analyzing the lens-to-subject distance for all those objects and then selecting the aperture that results in the appropriate depth of field. After choosing the aperture, the camera then selects the necessary shutter speed to properly expose the image at the selected f-stop. A-DEP mode isn't a surefire bet, however, and it does have some restrictions that may make it unsuitable for your subject. Here's what you need to know:

In very dim lighting, the shutter speed the camera selects may be too slow to allow you to handhold the camera without risking camera shake. So check the shutter speed in the viewfinder after you press the shutter button halfway to meter and focus the image.

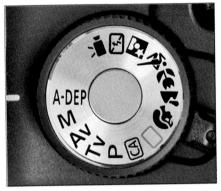

Figure 6-18: A-DEP stands for automatic depth of field.

- ✓ If the aperture value blinks in the viewfinder, the camera can't set the f-stop so that you get both a good exposure and the depth of field necessary to keep all objects in the frame in sharp focus. In this situation, the camera assumes that your primary goal is a good exposure and adjusts the aperture as needed based on the available light.
- If the shutter speed blinks in the viewfinder, the light is either too bright or too dim for the camera to properly expose the image at any combination of aperture and shutter speed. In bright light, you can lower the ISO, if it isn't already at 100, or reposition or shade your subject. In dim lighting, raise the ISO or add artificial light.
- ✓ You can use flash with A-DEP mode, but the minute you turn on the flash, the camera no longer does its automatic depth of field calculation. The same thing occurs if you switch to Live View shooting. In either case, the camera simply presents you with a fixed combination of aperture and shutter speed that will properly expose the image. The depth of field may or may not be what you want.

Given these limitations, my recommendation is that as soon as you fully understand the impact of aperture on depth of field, politely decline the option of using A-DEP mode and work in aperture-priority autoexposure mode (Av) instead. Then you can simply match the f-stop to the depth of field you have in mind, without giving up the option of using flash or Live View shooting.

Checking depth of field

When you look through your viewfinder and press the shutter button halfway, you can get only a partial indication of the depth of field that your current camera settings will produce. You can see the effect of focal length and the camera-to-subject distance, but because the aperture doesn't actually open to your selected f-stop until you take the picture, the viewfinder doesn't show you how that setting will affect depth of field.

By using the Depth-of-Field Preview button on your camera, however, you can do just that when you shoot in the advanced exposure modes. Almost hidden away on the front of your camera, the button is labeled in Figure 6-19.

To use this feature, just press and hold the shutter button halfway down and then press and hold the Depth-of-Field Preview button with the other hand. Depending on the selected f-stop, the scene in the viewfinder may then get darker. Or in Live View mode, the same thing happens in the monitor preview. Either way, this effect doesn't mean that your picture will be darker; it's just a function of how the preview works.

Note that the preview doesn't engage in P, Tv, Av, or A-DEP mode if your aperture and shutter speed aren't adequate to expose the image properly. You have to solve the exposure issue before you can use the preview.

Depth-of-Field Preview button

Controlling Color

Compared with understanding some resolution, aperture, shutter speed, depth of field, and so on - making sense of your camera's color options is easy-breezy. First, color problems aren't all that common, and when they are, they're usually simple to fix with a quick shift of your camera's White Balance control. Second, getting a grip on color requires learning only a couple of new terms, an unusual state of affairs for an endeavor that often seems more like high-tech science than art.

Figure 6-19: Press this button to see how the aperture setting will affect depth of field.

The rest of this chapter explains the White Balance control, plus a couple of other options that enable you to fine-tune the way your camera renders colors. For information on how to alter colors of existing pictures by using the software that shipped with your camera, see Chapter 10.

Correcting colors with white balance

Every light source emits a particular color cast. The old-fashioned fluorescent lights found in most public restrooms, for example, put out a bluishgreenish light, which is why our reflections in the mirrors in those restrooms always look so sickly. And if you think that your beloved looks especially attractive by candlelight, you aren't imagining things: Candlelight casts a warm, yellow-red glow that's flattering to the skin.

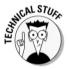

Science-y types measure the color of light, officially known as *color temperature*, on the Kelvin scale, which is named after its creator. You can see an illustration of the Kelvin scale in Figure 6-20.

When photographers talk about "warm light" and "cool light," though, they aren't referring to the position on the Kelvin scale — or at least not in the way we usually think of temperatures, with a higher number meaning hotter. Instead, the terms describe the visual appearance of the light. Warm light, produced by candles and incandescent lights, falls in the red-yellow spectrum you see at the bottom of the Kelvin scale in Figure 6-20; cool light, in the blue-green spectrum, appears at the top of the scale.

At any rate, most of us don't notice these fluctuating colors of light because our eyes automatically compensate for them. Except in very extreme lighting conditions, a white tablecloth appears white to us no matter whether we view it by candlelight, fluorescent light, or regular houselights.

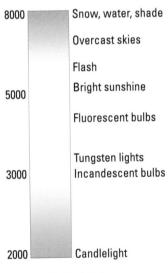

Figure 6-20: Each light source emits a specific color.

Similarly, a digital camera compensates for different colors of light through a feature known as *white balancing*. Simply put, white balancing neutralizes light so that whites are always white, which in turn ensures that other colors are rendered accurately. If the camera senses warm light, it shifts colors slightly to the cool side of the color spectrum; in cool light, the camera shifts colors the opposite direction. The good news is that your camera's Automatic White Balance setting, which carries the label AWB, tackles this process remarkably well in most situations. In some lighting conditions, though, the AWB adjustment doesn't quite do the trick, resulting in an unwanted color cast like the one you see in the left image in Figure 6-21.

Figure 6-21: Multiple light sources can result in a color cast in Auto White Balance mode (left); try switching to manual White Balance control to solve the problem (right).

Serious AWB problems most often occur when your subject is lit by a variety of light sources. For example, I shot the figurine in Figure 6-21 in my home studio, where I use a couple of high-powered photo lights that use tungsten bulbs, which produce light with a color temperature similar to regular house-hold incandescent bulbs. The problem is that the windows in that room also permit some pretty strong daylight to filter through. In Automatic White Balance mode (left), the camera reacted to that daylight — which has a cool color cast — and applied too much warming, giving my original image a yellow tint. No problem: I just switched the white balance mode from AWB to the Tungsten Light setting. The right image in Figure 6-21 shows the corrected colors.

Unfortunately, you can't make this kind of manual white balance selection if you shoot in the fully automatic exposure modes. So, if you spy color problems in your camera monitor, you need to switch to either P, Tv, Av, M, or A-DEP mode. (Chapter 5 details all five exposure modes.) You also can select White Balance setting in Movie mode.

The next section explains precisely how to make a simple white balance correction; following that, you can explore some advanced white balance features.

Changing the white balance setting

You can select a specific white balance setting only in the advance exposure modes (P, Tv, Av, M, and A-DEP). To adjust the setting, you can use either of the following two methods:

Quick Control screen: From the Shooting Settings screen, press Set to bring up the Quick Control screen. Then highlight the White Balance icon, found at the spot shown in Figure 6-22. The selected setting appears at the bottom of the screen, and you can then rotate the Main dial to cycle through the various options.

If you want to see all the settings at once, press Set again instead of rotating the Main dial. Then you see the screen shown on the right in Figure 6-22, and you can use the Main dial or cross keys to select your choice.

On this screen, as in the Shooting Settings and Quick Control displays, the various White Balance settings are represented by the icons listed in Table 6-1. You really don't need to memorize them, however, because as you scroll through the list of options, the name of the selected setting appears on the screen. For some settings, the camera also displays the approximate Kelvin temperature (K) of the selected light source, as shown in the figure. (Refer to Figure 6-20 for a look at the Kelvin scale.) Press Set once more after you select the option you want to use.

If the scene is lit by several sources, choose the setting that corresponds to the strongest one. The Tungsten Light setting is usually best for regular incandescent household bulbs, by the way. Selecting the right setting for the new energy-saving CFL (compact fluorescent) bulbs can be a little tricky because the color temperature varies depending on the bulb you buy. If you have trouble, your best bet is to create a custom White Balance setting that's precisely tuned to the light. See the next section for details.

✓ WB button (top cross key): Give the WB button a press to go directly to the screen shown on the right in Figure 6-22. Then highlight the setting you want to use and press Set.

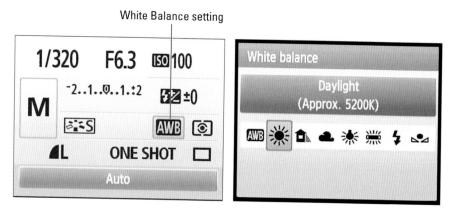

Figure 6-22: You can adjust the White Balance setting through the Quick Control screen or by pressing the WB button (top cross key).

Your selected White Balance setting remains in force for the P, Tv, Av, M, and A-DEP exposure modes until you change it again. To avoid accidentally using an incorrect setting later, you may want to get in the habit of resetting the option to the automatic setting (AWB) after you finish shooting whatever subject it was that caused you to switch to manual White Balance mode.

Table 6-1	White Balance Settings	
Symbol	Setting	
AWB	Auto	
☀	Daylight	
	Shade	
2	Cloudy	
*	Tungsten	
	White Fluorescent	
4 ⊳⊿	Flash	
⊾2	Custom	

Creating a custom white balance setting

If none of the preset white balance options produces the right amount of color correction, you can create your own custom setting. To use this technique, you need a piece of card stock that's either neutral gray or absolute white — not eggshell white, sand white, or any other close-but-not-perfect white. (You can buy reference cards made just for this purpose in many camera stores for under \$20.)

Position the reference card so that it receives the same lighting you'll use for your photo. Then follow these steps:

1. Set the camera to the P, Tv, Av, M, or A-DEP exposure mode.

You can't create a custom setting in any of the fully automatic modes. You can, however, select the custom setting you create when you record movies.

2. Set the white balance setting to Auto.

The preceding section shows you how.

3. Set the camera to manual focusing and then focus on your reference card.

Chapter 1 has details on manual focusing if you need help.

4. Frame the shot so that your reference card fills the center area of the viewfinder.

In other words, make sure that at least the center autofocus point and the six surrounding points fall over the reference card.

5. Make sure that the exposure settings are correct.

Just press the shutter button halfway to check exposure. In M mode, make sure that the exposure indicator is at the midway point of the exposure meter. In other modes, a blinking aperture or shutter speed value indicates an exposure problem. If necessary, adjust ISO, aperture, or shutter speed to fix the problem; Chapter 5 explains how.

6. Take the picture of your reference card.

The camera will use this picture to establish your custom white balance setting.

7. Display Shooting Menu 2 and highlight Custom WB, as shown on the left in Figure 6-23.

8. Press Set.

Now you see the screen shown on the right in Figure 6-23. The image you just captured should appear in the display. (The figure shows the picture I took of a gray reference card.) If not, press the right or left cross key to scroll to the image.

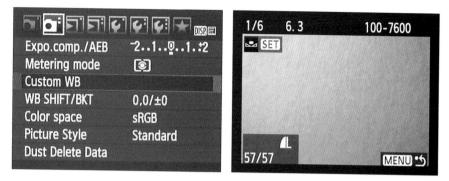

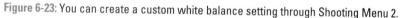

9. Press Set to select the displayed image as the basis for your custom white balance reference.

You see the message shown on the left in Figure 6-24, asking you to confirm that you want the camera to use the image to create the custom white balance setting.

10. Press the right or left cross key to highlight OK and then press Set.

Now you see the screen shown on the right in Figure 6-24. This message tells you that the White Balance setting is now stored. The little icon in the message area represents the custom setting.

11. Press Set one more time to finalize the custom setting.

Your custom white balance setting remains stored until the next time you work your way through these steps. Anytime you're shooting in the same lighting conditions and want to apply the same white balance correction, just press the WB button or use the Quick Control screen to access the White Balance settings and then select the Custom option.

Figure 6-24: This message indicates that your White Balance setting is stored.

Fine-tuning white balance settings

As yet another alternative for manipulating colors, your Rebel T1i/500D enables you to tweak white balancing in a way that shifts all colors toward a particular part of the color spectrum. The end result is similar to applying a traditional color filter to your lens.

To access this option, called White Balance Correction, follow these steps:

1. Set the Mode dial to P, Tv, Av, M, or A-DEP exposure mode.

You can take advantage of White Balance Correction only in these modes.

- 2. Display Shooting Menu 2 and highlight WB Shift/Bkt, as shown on the left in Figure 6-25.
- 3. Press Set to display the screen you see on the right in Figure 6-25.

The screen contains a grid that is oriented around two main color pairs: green and magenta (represented by the G and M labels) and blue and amber (represented by B and A). The little white square indicates the amount of white balance correction, or shift. When the square is dead center in the grid, as in the figure, no shift is applied.

Figure 6-25: White Balance Correction offers one more way to control colors.

4. Use the cross keys to move the square marker in the direction of the shift you want to achieve.

As you do, the Shift area of the display tells the amount of color bias that you've selected. For example, in Figure 6-26, I shifted three levels toward amber and one toward magenta.

If you're familiar with traditional lens filters, you may know that the density of a filter, which determines the degree of color correction it provides, is measured in *mireds* (pronounced *my-redds*). The white balance grid is designed around this system: Moving the marker one level is the equivalent of adding a filter with a density of 5 mireds.

5. Press Set to apply the change and return to the menu.

After you apply white balance correction, a +/– sign appears

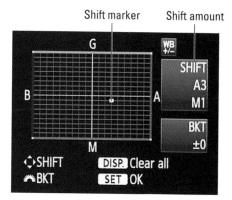

Figure 6-26: Press the cross keys to move the marker and shift white balance.

next to the White Balance symbol in the Shooting Settings display, as shown on the left in Figure 6-27. That's your reminder that white balance shift is being applied. The same symbol appears in the viewfinder, right next to the ISO value.

You can see the exact shift values in Shooting Menu 2, as shown on the right in Figure 6-27, and also in the Camera Settings display. (Remember, to activate that display, first display any menu and then press the DISP button. Chapter 1 provides more details.)

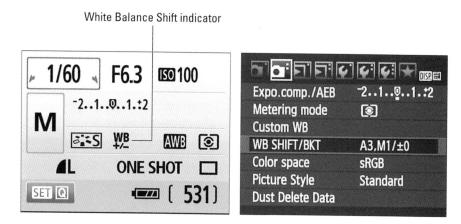

Figure 6-27: The +/- symbol lets you know that White Balance Shift is being applied.

Your adjustment remains in force for all the advanced exposure modes until you change it. And the correction is applied no matter what White Balance setting you choose. Check the monitor or viewfinder before your next shoot; otherwise, you may forget to adjust the white balance for the current light.

6. To cancel White Balance Correction, repeat Steps 1–3, set the marker back to the center of the grid, and then press Set.

Use the cross keys to move the marker back to the center of the grid. Be sure that values in the Shift area of the display are both set to 0.

As an alternative, you can press the DISP button after you get to the grid display. However, doing so also cancels white balance bracketing, which I explain in the next section. After you press DISP, be sure to press Set to lock in your decision.

Many film photography enthusiasts place colored filters on their lenses to either warm or cool their images. Portrait photographers, for example, often add a warming filter to give skin tones a healthy, golden glow. You can mimic the effects of such filters by simply fine-tuning your camera's White Balance settings as just described. Experiment with shifting the white balance a tad toward amber and magenta for a warming effect or toward blue and green for a cooling effect.

Bracketing shots with white balance

Chapter 5 introduces you to your camera's automatic exposure bracketing, which enables you to easily record the same image at three different exposure settings. Similarly, you can take advantage of automatic White Balance Bracketing. With this feature, the camera records the same image three times, using a slightly different white balance adjustment for each.

This feature is especially helpful when you're shooting in varying light sources — for example, a mix of fluorescent light, daylight, and flash. Bracketing the shots increases the odds that the color renditions of at least one of the shots will be to your liking.

Note a couple of things about this feature:

Because the camera records three images each time you press the shutter button, white balance bracketing reduces the maximum capture speed that is possible when you use the Continuous shooting mode. See Chapter 2 for more about Continuous mode. Of course, recording three images instead of one also eats up more space on your memory card.

- The White Balance Bracketing feature is designed around the same grid used for White Balance Correction, explained in the preceding section. As a reminder, the grid is based on two color pairs: green/magenta and blue/amber.
- ✓ When White Balance Bracketing is enabled, the camera always records the first of the three bracketed shots using a neutral white balance setting — or, at least, what it considers to be neutral, given its own measurement of the light. The second and third shots are then recorded using the specified shift along either the green/magenta or blue/amber axis of the color grid.

If all that is as clear as mud, just take a look at Figure 6-28 for an example. I captured these images using a single tungsten studio light and the candlelight. I set up White Balance Bracketing to work along the blue/amber color axis. The camera recorded the first image at neutral, the second with a slightly blue color bias, and the third with an amber bias.

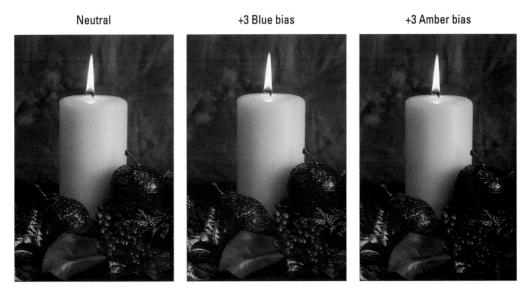

Figure 6-28: I captured one neutral image, one with a blue bias, and one with an amber bias.

To enable White Balance Bracketing, follow these steps:

- 1. Set the Mode dial to an advanced exposure mode (P, Tv, Av, M, or A-DEP).
- 2. Display Shooting Menu 2 and highlight WB/Shift Bkt.

3. Press Set to display the grid shown in Figure 6-29.

The screen is the same one you see when you use the White Balance Correction feature, explained in the preceding section.

4. Rotate the Main dial to set the amount and direction of the bracketing shift.

Rotate the dial as follows to specify whether you want the bracketing to be applied across the horizontal axis (blue to amber) or the vertical axis (green to magenta).

- Blue to amber bracketing: Rotate the dial right.
- Green to magenta bracketing: Rotate the dial left.

As you rotate the dial, three markers appear on the grid, indicating the amount of shift that will be applied to your trio of bracketed images. You can apply a maximum shift of plus or minus three levels of adjustment.

The BKT area of the screen also indicates the shift; for example, in Figure 6-29, the display shows a bracketing amount of plus and minus three levels on the blue/ amber axis. I used the settings shown in Figure 6-29 to record the example images in Figure 6-28. As you can see, even at the maximum shift (+/-3), the difference to the colors is subtle.

If you want to get really fancy, you can combine White Balance Bracketing with White Balance Shift. To set the amount of White Balance Shift, press the cross keys to move the square markers around the grid. Then use the Main dial to adjust the bracketing setting.

5. Press Set to apply your changes and return to the menu.

The bracketing symbol shown in Figure 6-30 appears in the Shooting Settings display. The Camera Settings display, which you bring up by pressing DISP when any menu is visible, also reports the bracketing setting.

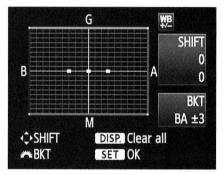

Figure 6-29: I used these settings to capture the bracketed candle images.

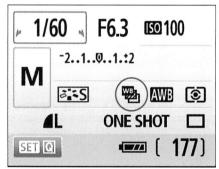

Figure 6-30: This symbol indicates that White Balance Bracketing is turned on.

Your bracketing setting remains in effect until you turn off the camera. You can also cancel bracketing by revisiting the grid screen shown in Figure 6-29 and either rotating the Main dial until you see only a single grid marker or pressing the DISP button. Either way, press Set to officially turn off bracketing.

Choosing a Color Space: sRGB vs. Adobe RGB

Normally, your camera captures images using the *sRGB color mode*, which simply refers to an industry-standard spectrum of colors. (The *s* is for *stan-dard*, and RGB is for Red, Green, Blue, which are the primary colors in the digital imaging color world.) This color mode was created to help ensure color consistency as an image moves from camera (or scanner) to monitor and printer; the idea was to create a spectrum of colors that all of these devices can reproduce.

However, the sRGB color spectrum leaves out some colors that *can* be reproduced in print and onscreen, at least by some devices. So as an alternative, your camera also enables you to shoot in the Adobe RGB color mode, which includes a larger *gamut* (spectrum) of colors. Figure 6-31 offers an illustration of the two spectrums.

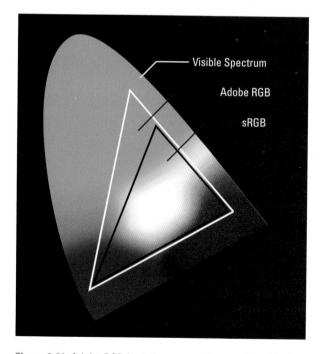

Figure 6-31: Adobe RGB includes some colors not found in the sRGB spectrum.

Which option is right for you depends on what you plan to do with your photos. If you're going to print your pictures without doing any editing to them, sRGB is probably the best choice because it typically results in the "punchy" colors that most people like. Some Internet printing services also request sRGB images.

On the other hand, if you're a color purist, will be editing your photos, making your own prints, or all three, experiment with Adobe RGB. For the record, this is the route that I go because I see no reason to limit myself to a smaller spectrum from the get-go. However, do note that some colors in Adobe RGB can't be reproduced in print; the printer substitutes the closest available color when necessary. Additionally, you'll need photo software that offers support for Adobe RGB as well as some basic *color management controls*, which ensure that your image colors are properly handled when you open, print, edit, and save your files. You should plan to spend a little time educating yourself about color management, too, because you can muck up the works if you don't set all the color-management options correctly. Long story short: If you're brand new to digital imaging, this option may be one you explore after you get more comfortable with the whole topic.

If you do want to capture images in Adobe RGB instead of sRGB, visit Shooting Menu 2 and highlight the Color Space option, as shown on the left in Figure 6-32. Press Set to display the screen shown on the right in the figure. Press the up or down cross key to highlight Adobe RGB and press Set again.

Remember that this color mode choice applies only when you shoot in the advanced exposure modes: P, Tv, Av, M, and A-DEP. In all other modes, the camera automatically selects sRGB as the color space.

After you transfer pictures to your computer, you can tell whether you captured an image in the Adobe RGB color space by looking at its filename: Adobe RGB images start with an underscore, as in _MG_0627.jpg. Pictures captured in the sRGB color space start with the letter *I*, as in IMG_0627.jpg.

		יפופיסומ	
Expo.comp./AEB	⁻21 <u>0</u> 1. : 2 (©]		
Metering mode		and the second stand and the second	
Custom WB		n de la deservación de la construcción de la construcción de la construcción de la construcción de la construc Esta de la construcción de la const	
WB SHIFT/BKT	0,0/±0	ng dia dia 400 km manjarahasi ing Panga Panganakan karang manjarahasi ing Panga	
Color space	sRGB	Color space	sRGB
Picture Style	Standard		Adobe RGB
Dust Delete Data	n an		
	公司的现在分词 网络拉斯斯斯		

Figure 6-32: Choose Adobe RGB for a broader color spectrum.

Taking a Quick Look at Picture Styles

In addition to all the focus and color features already covered in this chapter, your Rebel T1i/500D offers *Picture Styles*. Through Picture Styles, you can further tweak color as well as saturation, contrast, and image sharpening.

Sharpening is a software process that adjusts contrast in a way that creates the illusion of slightly sharper focus. I explain sharpening fully in Chapter 10, but the important thing to note for now is that sharpening cannot remedy poor focus, but instead produces a subtle tweak to this aspect of your pictures.

The camera offers the following six basic Picture Styles:

- Standard: The default setting, this option captures the image using the characteristics that Canon offers as suitable for the majority of subjects.
- Portrait: This mode reduces sharpening slightly from the amount that's applied in Standard mode, with the goal of keeping skin texture soft. Color saturation, on the other hand, is slightly increased. If you shoot in the Portrait autoexposure mode, the camera automatically applies this Picture Style for you.
- Landscape: In a nod to traditions of landscape photography, this Picture Style emphasizes greens and blues and amps up color saturation and sharpness, resulting in bolder images. The camera automatically applies this Picture Style if you set the Mode dial to the Landscape autoexposure mode.
- Neutral: This setting reduces saturation and contrast slightly compared to how the camera renders images when the Standard option is selected.
- ✓ Faithful: The Faithful style is designed to render colors as closely as possible to how your eye perceives them.
- Monochrome: This setting produces black-and-white photos, or, to be more precise, grayscale images. Technically speaking, a true black-andwhite image contains only black and white, with no shades of gray.

If you set the Quality option on Shooting Menu 1 to Raw (or Raw + Large/ Fine), the camera displays your image on the monitor in black and white during playback. But during the Raw converter process, you can either choose to go with your grayscale version or view and save a full-color version. Or, even better, you can process and save the image once as a grayscale photo and again as a color image.

If you *don't* capture the image in the Raw format, you can't access the original image colors later.

The extent to which Picture Controls affect your image depends on the subject as well as the exposure settings you choose and the lighting conditions. But Figure 6-33 offers a test subject shot at each setting to give you a general idea of what to expect. As you can see, the differences are pretty subtle, with the exception of the Monochrome option, of course.

Figure 6-33: Each Picture Control produces a slightly different take on the scene.

The level of control you have over Picture Styles, like most other settings in this chapter, depends on your exposure mode:

- In Full Auto and the six automatic scene modes (Portrait, Landscape, and so on): The camera sets the Picture Style for you. (See the preceding list to find out which scene mode gets which Picture Style.)
- In Creative Auto mode: You can select from four styles: Standard, Portrait, Landscape, and Monochrome.
- In the advanced exposure modes (P, Tv, Av, M, and A-DEP): You not only can select any of the six preset Picture Styles but also tweak each style to your liking and create up to three of your very own, customized styles.
- ✓ Movie mode: You can select any Picture Style, including any custom styles you create. (Want to shoot a black-and-white movie? Set the Picture Style to Monochrome before you start recording.)

For still photography you can select a Picture Style in three ways:

Quick Control screen: Press Set to shift from the regular Shooting Settings display to the Quick Control screen and then highlight the Picture Style icon, as shown on the left in Figure 6-34. Rotate the Main dial to cycle through the available styles.

The numbers you see along with the style name at the bottom of the screen represent the four characteristics applied by the style: Sharpness, Contrast, Saturation, and Color Tone. Sharpness values range from 0 to 7; the higher the value, the more sharpening is applied. At 0, no sharpening is applied. The other values, however, are all set to 0, which represents the default setting for the selected Picture Style. (Through some advanced options, you can adjust all four settings; more on that momentarily.)

If you want to see all the available styles, just press Set to display the screen you see on the right in Figure 6-34. Highlight the style you want to use, and the four style values appear along with the style name, as shown in the figure. Press Set to finish up.

- Picture Style button (bottom cross key): Press the key to display the same screen shown on the right in Figure 6-34. Again, just highlight your choice and press Set.
- Shooting Menu 2: Select the Picture Style option and press Set to display a menu full of all the styles. Highlight your choice and press Set again.

For movie recording, you can select a Picture Style either through Shooting Menu 2 or by using the Quick Control method. See Chapter 4 for help with the second option; it works a little differently than when you're shooting still photos.

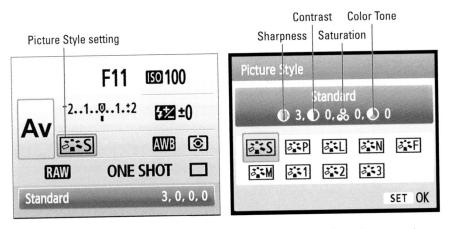

Figure 6-34: You can quickly select a Picture Style through the Quick Control screen or by pressing the bottom cross key.

This discussion of Picture Styles touches on just the very basics. Your camera also enables you to modify each style, varying the amount of sharpness, contrast, saturation, and color tone adjustment that results from each style. And you can create three of your own Picture Style presets if you like.

Frankly, however, I recommend that you stick with the default Picture Style, Standard, and be done with it. First off, you have way more important camera settings to worry about — aperture, shutter speed, autofocus, and all the rest. Why add one more setting to your list, especially when the impact of changing it is minimal? Second, if you really want to mess with the characteristics that the Picture Style options affect, you're much better off shooting in the Raw (CR2) format and then making those adjustments on a picture-by-picture basis in your Raw converter. In Canon Digital Photo Professional, which comes free with the camera, you can even assign any of the existing Picture Styles to your Raw files and then compare how each one affects the image. The camera does tag your Raw file with whatever Picture Style is active at the time you take the shot, but the image adjustments are in no way set in stone or even in sand you can tweak your photo at will. (The selected Picture Style does affect the JPEG preview that's used to display the Raw image thumbnails in Digital Photo Professional and other photo software.)

For these reasons, I'm opting in this book to present you with just this brief introduction to Picture Styles so that I can go into more detail about functions that I see as more useful (such as the white balance customization options presented earlier). But if you're intrigued, the camera manual walks you step by step through all the various Picture Style options.

Putting It All Together

In This Chapter

- Reviewing the best all-around picture-taking settings
- Adjusting the camera for portrait photography
- Discovering the keys to super action shots
- Dialing in the right settings to capture landscapes and other scenic vistas

- Capturing close-up views of your subject
- Shooting through glass, capturing fireworks, and conquering other special challenges

Farlier chapters of this book break down each and every picture-taking feature on your Rebel T1i/500D, describing in detail how the various controls affect exposure, picture quality, focus, color, and the like. This chapter pulls all that information together to help you set up your camera for specific types of photography.

The first few pages offer a quick summary of critical picture-taking settings that should serve you well no matter what your subject. Following that, I offer my advice on which settings to use for portraits, action shots, landscapes, and close-ups. To wrap things up, the end of the chapter includes some miscellaneous tips for dealing with special shooting situations and subjects.

Keep in mind that although I present specific recommendations here, there are no hard and fast rules as to the "right way" to shoot a portrait, a landscape, or whatever. So don't be afraid to wander off on your own, tweaking this exposure setting or adjusting that focus control, to discover your own creative vision. Experimentation is part of the fun of photography, after all — and thanks to your camera monitor and the Erase button, it's an easy, completely free proposition.

Recapping Basic Picture Settings

Your subject, creative goals, and lighting conditions determine which settings you should use for some picture-taking options, such as aperture and shutter speed. I offer my take on those options throughout this chapter. But for the many basic options, I recommend the same settings for almost every shooting scenario. Table 7-1 shows you those recommendations and lists the chapter where you can find details about each setting.

Whether you get any say-so over these settings depends on your chosen exposure mode. You must use P, Tv, Av, M, or A-DEP mode if you want to change the White Balance setting, for example. You can find details about which modes let you do what in the chapters that explain each function.

Table 7-1	All-Purpose Picture-Taking Settings		
Option	Recommended Setting	Chapter	
Image	Large/Fine (JPEG), Medium/Fine (JPEG), or Raw (CR2)	3	
White Balance	Auto	6	
ISO	100 or 200	5	
AF mode	AI Focus	6	
Drive mode	Action photos: Continuous; all others: Single	2	
AF Point Selection	Auto	6	
Metering	Evaluative	5	
Picture Style	Standard	6	
Live View	Disabled	4	

Setting Up for Specific Scenes

For the most part, the settings detailed in the preceding section fall into the "set 'em and forget 'em" category. That leaves you free to concentrate on a handful of other camera options, such as aperture and shutter speed that you can manipulate to achieve a specific photographic goal.

The next four sections explain which of these additional options typically produce the best results when you're shooting portraits, action shots, land-scapes, and close-ups. I offer a few compositional and creative tips along the way — but again, remember that beauty is in the eye of the beholder, and for every so-called rule, plenty of great images prove the exception.

Shooting still portraits

By "still portrait," I mean that your subject isn't moving. For subjects who aren't keen on sitting still long enough to have their picture taken — children, pets, and even some teenagers I know — skip ahead to the next section and use the techniques given for action photography instead.

Assuming that you do have a subject willing to pose, the classic portraiture approach is to keep the subject sharply focused while throwing the back-ground into soft focus, as shown in the examples in this section. This artistic choice emphasizes the subject and helps diminish the impact of any distract-ing background objects in cases where you can't control the setting. The following steps show you how to achieve this look:

1. Set the Mode dial to Av (aperture-priority autoexposure) and then select the lowest f-stop value possible.

As Chapter 5 explains, a low f-stop number opens the aperture, which shortens depth of field, or the range of sharp focus. So dialing in a low f-stop value is the first step in softening your portrait background. (The f-stop range available to you depends on your lens.) Also keep in mind that the farther your subject is from the background, the more background blurring you can achieve.

I recommend aperture-priority autoexposure when depth of field is a primary concern because you can control the f-stop while relying on the camera to select the shutter speed that will properly expose the image. Just rotate the Main dial to select your desired f-stop. But if you aren't comfortable with this advanced exposure mode, give Creative Auto a whirl and follow the steps in Chapter 2 to request a soft-focus background. (You do this through the top slider that appears on the Shooting Settings display in Creative Auto mode.) Portrait mode also results in a more open aperture, although the exact f-stop setting is out of your control and lighting conditions will dictate how wide an aperture the camera will use. Chapter 2 details Portrait mode.

Whichever mode you choose, you can monitor the current aperture and shutter speed both in the Shooting Settings display, as shown on the left in Figure 7-1, and in the viewfinder display, as shown on the right.

2. To further soften the background, zoom in, get closer, or both.

As covered in Chapter 6, zooming in to a longer focal length also reduces depth of field, as does moving physically closer to your subject.

Avoid using a lens with a short focal length (a wide-angle lens) for portraits. They can cause features to appear distorted — sort of like how people look when you view them through a security peephole in a door.

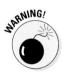

Part II: Taking Creative Control

228

Figure 7-1: You can view exposure settings in the Shooting Settings display or viewfinder.

3. For indoor portraits, shoot flash-free if possible.

Shooting by available light rather than flash produces softer illumination and avoids the problem of red-eye. To get enough light to go flashfree, turn on room lights or, during daylight, pose your subject next to a sunny window.

In the Av exposure mode, simply keeping the built-in flash unit closed disables the flash. In Creative Auto mode, choose the Flash Off setting. (Chapter 2 shows you how.) With Portrait mode, unfortunately, you can't disable the flash if the camera thinks more light is needed. Your only option is to change the exposure mode to No Flash, in which case the camera may or may not choose an aperture setting that throws the background into soft focus.

If flash is unavoidable, see my list of flash tips at the end of the steps to get better results.

4. For outdoor portraits, use a flash.

Even in bright daylight, a flash adds a beneficial pop of light to subjects' faces, as discussed in Chapter 5 and illustrated here in Figure 7-2.

Unfortunately, the camera doesn't let you use flash in Portrait mode if the light is very bright. In the Av exposure mode, just press the Flash button on the side of the camera to enable the flash. In Creative Auto mode, set the flash to the Flash On (fill flash) setting; again, see Chapter 2 for a reminder of how to do so.

Chapter 7: Putting It All Together

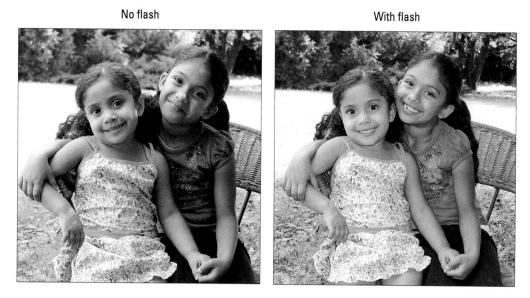

Figure 7-2: To properly illuminate the face in outdoor portraits, use fill flash.

In dim lighting, the camera may select a shutter speed as slow as 30 seconds when you enable the built-in flash in Av mode, so keep an eye on that value and use a tripod if necessary to avoid blurring from camera shake. On the flip side of the coin, the fastest shutter speed you can use with the built-in flash is 1/200 second, and in extremely bright conditions, that may be too slow to avoid overexposing the image. If necessary, move your subject into the shade. (With some external Canon flashes, you can select a faster shutter speed than 1/200 second; see your flash manual for details.)

5. Press and hold the shutter button halfway to engage exposure metering and, in autofocus mode, to lock in focus.

Make sure that an active autofocus point falls over your subject. (In the viewfinder, active autofocus points turn red.) For best results, try to set focus on your subject's eyes.

Chapter 6 explains more about using autofocus, but if you have trouble, simply set your lens to manual focus mode and then twist the focusing ring to set focus.

6. Press the shutter button the rest of the way to capture the image.

Again, these steps just give you a starting point for taking better portraits. A few other tips can also improve your people pics:

- Before pressing the shutter button, do a quick background check. Scan the entire frame looking for intrusive objects that may distract the eye from the subject. If necessary, reposition the subject against a more flattering backdrop if possible. Inside, a softly textured wall works well; outdoors, trees and shrubs can provide nice backdrops as long as they aren't so ornate or colorful that they diminish the subject (for example, a magnolia tree laden with blooms).
- Frame the subject loosely to allow for later cropping to a variety of frame sizes. Your camera produces images that have an aspect ratio of 3:2. That means that your portrait perfectly fits a 4-x-6-inch print size but will require cropping to print at any other proportions, such as 5 x 7 or 8 x 10. Chapter 9 talks more about this issue.
- ✓ Pay attention to white balance if your subject is lit by both flash and ambient light. If you set the White Balance setting to automatic (AWB), as I recommend in Table 7-1, enabling flash tells the camera to warm colors to compensate for the cool light of a flash. If your subject is also lit by room lights or daylight, the result may be colors that are slightly warmer than neutral. This warming effect typically looks nice in portraits, giving the skin a subtle glow. But if you aren't happy with the result or want even more warming, see Chapter 6 to find out how to finetune white balance. Again, you can make this adjustment only in P, Tv, Av, M, or A-DEP exposure mode.
- When flash is unavoidable, try these tricks to produce better results. The following techniques can help solve flash-related issues:
 - *Indoors, turn on as many room lights as possible.* With more ambient light, you reduce the flash power that's needed to expose the picture. This step also causes the pupils to constrict, further reducing the chances of red-eye. (Pay heed to my white balance warning, however.)
 - *Try setting the flash to Red-Eye Reduction mode for nighttime and indoor portraits.* Warn your subject to expect both a light coming from the Red-Eye Reduction lamp, which constricts pupils, and the actual flash. See Chapter 2 for details about using this flash mode, which you enable through Shooting Menu 1.
 - For nighttime pictures, try Night Portrait mode. In this autoexposure mode, the camera automatically selects a slower shutter speed than normal. This enables the camera to soak up more ambient light, producing a brighter background and reducing the flash power that's needed to light the subject. A slow shutter, however, means that you need to use a tripod to avoid camera shake, which can blur the photo. You also need to warn your subjects to remain very still during the exposure.

230

- For professional results, use an external flash with a rotating flash head. Then aim the flash head upward so that the flash light bounces off the ceiling and falls softly down onto the subject. An external flash isn't cheap, but the results make the purchase worthwhile if you shoot lots of portraits. Compare the two portraits in Figure 7-3 for an illustration. In the first example, the built-in flash resulted in strong shadowing behind the subject and harsh, concentrated light. To produce the better result on the right, I used the Canon Speedlite 580EX II and bounced the light off the ceiling.
- *To reduce shadowing from the flash, move your subject farther from the background.* I took this extra step for the right image in Figure 7-3. The increased distance not only reduced shadowing but also softened the focus of the wall a bit (because of the short depth of field resulting from my f-stop and focal length).

A good general rule is to position your subjects far enough from the background that they can't touch it. If that isn't possible, though, try going the other direction: If the person's head is smack up against the background, any shadow will be smaller and less noticeable. For example, you get less shadowing when a subject's head is resting against a sofa cushion than if that person is sitting upright, with the head a foot or so away from the cushion.

Direct flash

Bounce flash

Figure 7-3: To eliminate harsh lighting and strong shadows (left), I used bounce flash and moved the subject farther from the background (right).

Part II: Taking Creative Control

For the maximum control over aperture, shutter speed, and flash power, try working in Manual exposure mode and make friends with the Flash Compensation and FE Lock (flash exposure lock) features.

Capturing action

A fast shutter speed is the key to capturing a blur-free shot of any moving subject, whether it's a spinning Ferris wheel, a butterfly flitting from flower to flower, or in the case of Figures 7-4 and 7-5, a hockey-playing teen. In the first image, a shutter speed of 1/125 second was too slow to catch the subject without blur. For this subject, who was moving at a fairly rapid speed, I needed to bump the shutter speed all the way up to 1/1000 second to freeze the action cleanly, as shown in Figure 7-5.

Figure 7-4: A too-slow shutter speed (1/125 second) causes the skater to appear blurry.

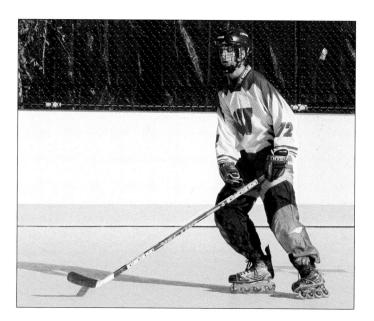

Figure 7-5: Raising the shutter speed to 1/1000 second "froze" the action.

Along with the basic capture settings outlined in Table 7-1, I use the techniques in the following steps to photograph a subject in motion:

1. Set the Mode dial to Tv (shutter-priority autoexposure).

In this mode, you control the shutter speed, and the camera takes care of choosing an aperture setting that will produce a good exposure.

If you aren't ready to step up to this advanced autoexposure mode, explained in Chapter 5, try using Sports mode, detailed in Chapter 2. But be aware that you have no control over any other aspects of your picture (such as white balance, flash, and so on) in that mode.

2. Rotate the Main dial to select the shutter speed.

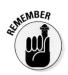

In the Shooting Settings display, the option that appears highlighted, with the little arrow pointers at each side, is the one that you can adjust with the Main dial. In Tv mode, the shutter speed is the active option. After you select the shutter speed, the camera selects the aperture (f-stop) necessary to produce a good exposure.

What shutter speed you need depends on how fast your subject is moving, so some experimentation is needed. But generally speaking, 1/500 second should be plenty for all but the fastest subjects — speed-ing hockey players like my subject, race cars, boats, and so on. For slower subjects, you can even go as low as 1/250 or 1/125 second.

Part II: Taking Creative Control

If the aperture value blinks after you set the shutter speed, the camera can't select an f-stop that will properly expose the photo at that shutter speed. See Chapter 5 for more details about how the camera notifies you of potential exposure problems.

3. Raise the ISO setting or add flash to produce a brighter exposure if needed.

In dim lighting, you may not be able to get a good exposure at your chosen shutter speed without taking this step. Raising the ISO does increase the possibility of noise, but a noisy shot is better than a blurry shot. (The current ISO setting appears in the upper right corner of the Shooting Settings display, as shown in Figure 7-6; press the ISO button or use the Quick Control screen to adjust the setting.)

Note that in Sports mode, the camera automatically overrides your ISO setting if it deems necessary, but it can go only as high as ISO 1600. If you stick with Tv mode and raise the ISO above 800 or so, you may want to enable High ISO Speed Noise Reduction to help alleviate noise. However, doing so can slow down the speed at which you can capture images, so it's a bit of a tradeoff. For more on all these ISO issues, see Chapter 5.

Adding flash is a bit tricky for action shots, unfortunately. First, the flash needs time to recycle between shots, so try to go without if you want to capture images at a fast pace. Second, the built-in flash has limited range — so don't waste your time if your subject isn't close by. And third, remember that the fastest possible shutter speed when you enable the built-in flash is 1/200 second, which may not be fast enough to capture a quickly moving subject without blur. (You can use a faster shutter speed with some Canon external flash units.) For more on this issue, check out Chapter 5.

If you do decide to use flash, you must bail out of Sports mode; it doesn't permit you to use flash.

4. For rapid-fire shooting, set the Drive mode to Continuous.

In this mode, you can take a little more than three pictures per second. The camera continues to record images as long as the shutter button is pressed. You can switch the Drive mode by pressing the left cross key or using the Quick Control screen. The icon representing the current mode appears in the Shooting Settings display, as labeled in Figure 7-6.

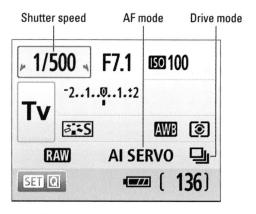

Figure 7-6: Changing the Drive mode to Continuous allows rapid-fire shooting.

234

235

5. For fastest shooting, switch to manual focusing.

You then eliminate the time the camera needs to lock focus in autofocus mode. Chapter 1 shows you how to focus manually, if you need help.

If you do use autofocus, try these two autofocus settings for best performance:

- Set the AF Point Selection mode to Automatic. Press the button shown in the margin to adjust this setting.
- Set the AF (autofocus) mode to AI Servo (continuous-servo autofocus). Press the right cross key or use the Quick Control screen to access this setting. The name of the current setting in the Shooting Settings screen appears, as shown in Figure 7-6.

Chapter 6 details these autofocus options.

6. Turn off automatic image review to speed up the camera even more.

You do this via the Review Time option on Shooting Menu 1. Turning the option off can help speed up the time your camera needs to recover between shots.

7. Compose the subject to allow for movement across the frame.

You can always crop the photo later to a tighter composition. (I did so for my example images, which originally contained quite a bit more background than you see in the book.) Chapter 10 shows you how to crop pictures.

8. Lock in autofocus (if used) in advance.

Press the shutter button halfway to do so. Now when the action occurs, just press the shutter button the rest of the way. Your image-capture time is faster because the camera has already done the work of establishing focus. Remember that in AI Servo mode, you must keep the subject under the active autofocus point (or points) for the camera to maintain focus. Again, Chapter 6 details this feature.

Using these techniques should give you a better chance of capturing any fastmoving subject. But action-shooting strategies also are helpful for shooting candid portraits of kids and pets. Even if they aren't currently running, leaping, or otherwise cavorting, snapping a shot before they do move or change positions is often tough. So if an interaction or scene catches your eye, set your camera into action mode and then just fire off a series of shots as fast as you can.

Part II: Taking Creative Control

Capturing scenic vistas

Providing specific capture settings for landscape photography is tricky because there's no single best approach to capturing a beautiful stretch of countryside, a city skyline, or other vast subject. Take depth of field, for example: One person's idea of a super cityscape might be to keep all buildings in the scene sharply focused. But another photographer might prefer to shoot the same scene so that a foreground building is sharply focused while the others are less so, thus drawing the eye to that first building.

That said, I can offer a few tips to help you photograph a landscape the way *you* see it:

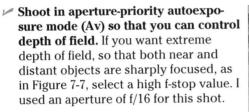

As an alternative to Av mode, you can try Creative Auto mode and then use the slider on the Quick Control screen to request an aperture that will produce a larger depth of field. Landscape mode also tries to produce a large depth of field by selecting a high f-stop number, but you have no control over the exact value (or any other picturetaking settings).

Of course, if the light is dim, the camera may be forced to open the aperture in either Creative Auto or Landscape mode, reducing depth of field, to properly expose the image. (Don't confuse Landscape autoexposure mode with the Landscape Picture

Figure 7-7: Use a high f-stop value (or Landscape mode) to keep foreground and background sharply focused.

Style, by the way; the Landscape exposure mode you want is the one you select from the Mode dial on top of the camera. See Chapter 6 for more details about Picture Styles.)

236

- ✓ If the exposure requires a slow shutter, use a tripod to avoid blurring. The downside to a high f-stop is that you need a slower shutter speed to produce a good exposure. If the shutter speed drops below what you can comfortably handhold, use a tripod to avoid picture-blurring camera shake. No tripod handy? Look for any solid surface on which you can steady the camera. You can always increase the ISO setting to increase light sensitivity, which in turn allows a faster shutter speed, too, but that option brings with it the chances of increased image noise. See Chapter 5 for details. Also see Chapter 1 for details about image stabilization, which can help you get sharper handheld shots at slow shutter speeds.
- For dramatic waterfall and fountain shots, consider using a slow shutter to create that "misty" look. The slow shutter blurs the water, giving it a soft, romantic appearance. Figure 7-8 shows a close-up of this effect. Again, use a tripod to ensure that the rest of the scene doesn't also blur due to camera shake.
- At sunrise or sunset, base exposure on the sky. The foreground will be dark, but you can usually brighten it in a photo editor if needed. If you base exposure on the foreground, on the other hand, the sky will become so bright that all the color will be washed out — a problem you usually can't fix after the fact.

This tip doesn't apply, of course, if your sunrise or sunset is merely serving as a gorgeous backdrop for a portrait. In that case, you should enable your flash and expose for the subject.

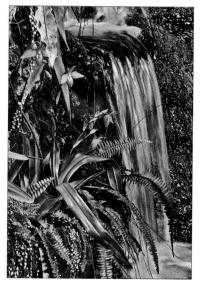

Figure 7-8: For misty waterfalls, use a slow shutter speed (and tripod).

In the advanced exposure modes, you also can experiment with enabling the Highlight Tone Priority option, which you do via Custom Function 6, on Setup Menu 3. This feature can help you retain some additional shadow detail without blowing out highlights. Chapter 5 offers more information.

Part II: Taking Creative Control

✓ For cool nighttime city pics, experiment with slow shutter. Assuming cars or other vehicles are moving through the scene, the result is neon trails of light like those you see in Figure 7-9. Shutter speed for this image was 10 seconds. The longer your shutter speed, the blurrier the motion trails become.

Instead of changing the shutter speed manually between each shot, try setting the speed to Bulb. Available only in M (manual) exposure mode, this option records an image for as long as you hold down the shutter button. So just take a series of images, holding the button down for different lengths of time for each shot. In Bulb mode, you also can exceed the minimum (slowest) shutter speed of 30 seconds. Note that in Bulb mode, the camera displays the elapsed capture time on the monitor. (The viewfinder is dark while the shutter is open.)

Figure 7-9: A slow shutter also creates neon light trails in city-street scenes.

Because long exposures can produce image noise, you also may want to enable the Long Exposure Noise

Reduction feature. You access this option via the Custom Function option on Setup Menu 3; select Custom Function 4 and change the setting from Off to Auto or On. Chapter 5 discusses this option in more detail.

✓ For the best lighting, shoot during the "magic hours." That's the term photographers use for early morning and late afternoon, when the light cast by the sun is soft and warm, giving everything that beautiful, gently warmed look.

Can't wait for the perfect light? Tweak your camera's white balance setting, using the instructions laid out in Chapter 6, to simulate magic-hour light.

✓ In tricky light, bracket shots. Bracketing simply means to take the same picture at several different exposures to increase the odds that at least one of them captures the scene the way you envision. Bracketing is especially a good idea in difficult lighting situations such as sunrise and sunset.

239

Your camera offers automatic exposure bracketing when you shoot in the advanced exposure modes. See Chapter 5 to find out how to take advantage of this feature.

Also experiment with the Auto Lighting Optimizer and Highlight Tone Priority options; capture some images with the features enabled and then take the same shots with the features turned off. You control both options through the Custom Functions options on Setup Menu 3; see Chapter 5 for details.

Capturing dynamic close-ups

For great close-up shots, start with the basic capture settings outlined in Table 7-1. Then try the following additional settings and techniques:

- Check your owner's manual to find out the minimum close-focusing distance of your lens. How "up close and personal" you can get to your subject depends on your lens, not the camera body.
- Take control over depth of field by setting the camera mode to Av (aperture-priority autoexposure) mode. Whether you want a shallow, medium, or extreme depth of field depends on the point of your photo. For the romantic scene shown in Figure 7-10, for example, I wanted to blur the background to help the subjects stand out more. so I set the aperture to f/5.6. But if you want the viewer to clearly see all details throughout the frame for example, if you're shooting a product shot for your company's sales catalog — you need to go the other direction, stopping down the aperture as far as possible.

Not ready for the advanced exposure modes yet? Try Creative Auto mode and follow the directions in Chapter 2 to set the Background slider to the "blurry" end of the scale. You also can try the Close-Up scene mode instead. (It's the one

Figure 7-10: Shallow depth of field helps set the subject apart from the similarly colored background.

marked with the little flower on your Mode dial.) In this mode, the camera automatically opens the aperture to achieve a short depth of field and bases focus on the center of the frame. Creative Auto, however, enables you to control a few aspects of your photo that you can't adjust in Close-Up mode, the most important of which is whether the flash fires.

Part II: Taking Creative Control

- Remember that both zooming in and getting close to your subject decreases depth of field. So back to that product shot: If you need depth of field beyond what you can achieve with the aperture setting, you may need to back away, zoom out, or both. (You can always crop your image to show just the parts of the subject that you want to feature.)
- ✓ When shooting flowers and other nature scenes outdoors, pay attention to shutter speed, too. Even a slight breeze may cause your subject to move, causing blurring at slow shutter speeds. (Chapter 5 offers some examples that illustrate this issue.)
- ✓ Use fill flash for better outdoor lighting. Just as with portraits, a tiny bit of flash typically improves close-ups when the sun is your primary light source. You may need to reduce the flash output slightly, via the camera's Flash Exposure Compensation control. Chapter 5 offers details about using flash.

Also keep in mind that the maximum shutter speed possible when you use the built-in flash is 1/200 second. So in very bright light, you may need to use a high f-stop setting to avoid overexposing the picture. You also can lower the ISO speed setting, if it's not already all the way down to ISO 100.

You can't control whether the flash fires in Close-Up mode, so if flash is an issue, use either Av or Creative Auto mode.

✓ When shooting indoors, try not to use flash as your primary light source. Because you'll be shooting at close range, the light from your flash may be too harsh even at a low Flash Exposure Compensation setting. If flash is inevitable, turn on as many room lights as possible to reduce the flash power that's needed — even a hardware store shop light can do in a pinch as a lighting source. (Remember that if you have multiple light sources, though, you may need to tweak the white balance setting.)

Again, if you don't want to use one of the advanced exposure modes, Creative Auto lets you determine whether the flash fires. See Chapter 2 for the lowdown.

To really get close to your subject, invest in a macro lens or a set of diopters. A true macro lens, which enables you to get really, really close to your subjects, is an expensive proposition; expect to pay around \$200 or more. But if you enjoy capturing the tiny details in life, it's worth the investment.

For a less expensive way to go, you can spend about \$40 for a set of *diopters*, which are sort of like reading glasses that you screw onto your existing lens. Diopters come in several strengths — +1, +2, +4, and so on — with a higher number indicating a greater magnifying power. I took this approach to capture the rose in Figure 7-11. The left image shows you the closest I could get to the subject with my regular lens; to produce the right image, I attached a +6 diopter. The downfall of diopters, sadly, is that they typically produce images that are very soft around the edges, as in Figure 7-11 — a problem that doesn't occur with a good macro lens.

Chapter 7: Putting It All Together

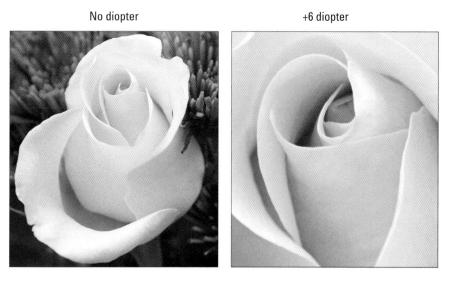

Figure 7-11: To extend your lens's close-focus ability, you can add magnifying diopters.

Coping with Special Situations

A few subjects and shooting situations pose some additional challenges not already covered in earlier sections. So to wrap up this chapter, here's a quick list of ideas for tackling a variety of common "tough-shot" photos:

- ✓ Shooting through glass: To capture subjects that are behind glass, try putting your lens flat against the glass. Use manual focusing; the glass barrier can give the autofocus mechanism fits. Disable your flash to avoid creating any unwanted reflections, too. I used this technique to capture the image of the turtle sticking his neck out in Figure 7-12.
- Shooting out a car window: Set the camera to shutterpriority autoexposure or manual mode and dial in a fast shutter speed to compensate

Figure 7-12: To shoot through glass, place your lens flat against the glass.

for the movement of the car. Oh, and keep a tight grip on your camera.

Part II: Taking Creative Control

✓ Shooting in strong backlighting: When the light behind your subject is very strong and illuminating the subject with flash isn't an option, you can expose the image with the subject in mind, in which case the background may be overexposed. (Turning on Highlight Tone Priority, an advanced exposure option discussed in Chapter 5, may enable you to keep some highlights from blowing out, however.)

As an alternative, you can expose for the background, and purposely underexpose the subject to create a silhouette effect. I opted for this technique when capturing the image in Figure 7-13, which shows a young friend standing mesmerized in front of an aquarium. Be sure to disable your flash, Highlight Tone Priority, and Auto Lighting Optimizer when trying to shoot silhouettes. (You need to shoot in an advanced mode to control these options.)

Figure 7-13: Experiment with shooting backlit subjects in silhouette.

✓ Shooting fireworks: First off, use a tripod; fireworks require a long exposure, and trying to handhold your camera simply isn't going to work. If using a zoom lens, zoom out to the shortest focal length. Switch to manual focusing and set focus at infinity (the farthest focus point possible on your lens). Set the exposure mode to manual, choose a relatively high f-stop setting — say, f/16 or so — and start with a shutter speed of 1 to 3 seconds. From there, it's simply a matter of experimenting with different shutter speeds.

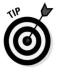

Be especially gentle when you press the shutter button — with a very slow shutter, you can easily create enough camera movement to blur the image. If you purchased the accessory remote control for your camera, this is a good situation in which to use it. You also may want to enable your camera's Long Exposure Noise Reduction feature because a long exposure also increases the chances of noise defects. See Chapter 5 for details. (Keep the ISO setting low to further dampen noise.)

✓ Shooting reflective surfaces: In outdoor shots taken in bright sun, you can reduce glare from reflective surfaces such as glass and metal by using a *circular polarizing filter*, which you can buy for about \$60. A polarizing filter can also help when you're shooting through glass.

But know that for the filter to work, the sun, your subject, and your camera lens must be precisely positioned. Your lens must be at a certain angle from the sun, for example, and the light source must also reflect off the surface at a certain angle and direction. In addition, a polarizing filter also intensifies blue skies in some scenarios, which may or may not be to your liking. In other words, a polarizing filter isn't a surefire cure-all.

A more reliable option for shooting small reflective objects is to invest in a light cube or light tent, such as the ones shown in Figure 7-14, from Cloud Dome (www.clouddome.com) and Lastolite (www.lastolite.com), respectively. You place the reflective object inside the tent or cube and then position your lights around the outside. The cube or tent acts as a light diffuser, reducing reflections. Prices range from about \$50 to \$200, depending on size and features.

Cloud Dome, Inc. Lastolite Limited Figure 7-14: Investing in a light cube or tent makes photographing reflective objects much easier.

Part II: Taking Creative Control _____

244

Part III Working with Picture Files

In this part ou have a memory card full of pictures. Now what? Now you turn to the first chapter in this part, which explains how to get those pictures out of your camera and onto your computer and, just as important, how to safeguard them from future digital destruction. After downloading your files, head for Chapter 9, which offers step-by-step guidance on printing your pictures, sharing them online, and even viewing them on your television.

Downloading, Organizing, and Archiving Your Photos

In This Chapter

- >> Transferring pictures to your computer
- Using the free Canon software to download and organize photos
- Processing Raw (CR2) files
- ▶ Keeping your picture files safe from harm

or many novice digital photographers (and even some experienced ones), the task of moving pictures to the computer and then keeping track of all those image files is one of the more confusing aspects of the art form. In fact, students in my classes have more questions about this subject than just about anything else.

Frankly, writing about the download and organizing process isn't all that easy, either. (I know, poor me!) The problem is that providing you with detailed instructions is pretty much impossible because the steps you need to take vary widely depending upon what software you have installed on your computer and whether you use a Windows or Macintosh operating system.

To give you as much help as possible, however, this chapter shows you how to transfer and organize pictures using the free software that came with your camera. After exploring these discussions, you should be able to adapt the steps to any other photo program you may prefer.

This chapter also covers a few other aspects of handling your picture files, including converting pictures taken in the Raw format to a standard image format. Finally — and perhaps most importantly — this chapter explains how to ensure that your digital images stay safe after they leave the camera.

Sending Pictures to the Computer

You can take two approaches to moving pictures from your camera memory card to your computer:

✓ Connect the camera directly to the computer. For this option, you need to dig out the USB cable that came with your camera. (Your camera manual refers to this cable as the *inter-face cable*.) The cable has a regular USB plug like the one shown in Figure 8-1 at one end and a tiny, camera-specific plug at the other. Your computer must also have a free USB slot, or *port*, in techie talk. If you aren't sure what these gadgets look like, Figure 8-1 gives you a look.

The little three-pronged icon you see on the plug and to the left of the two ports in Figure 8-1 is the universal symbol for USB. USB symbol

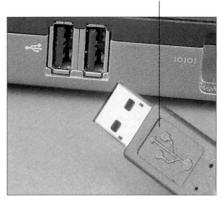

Figure 8-1: Connect the camera to the computer with the supplied USB cable.

Be sure to check for this symbol because a different type of slot — a FireWire slot — looks very similar to a USB slot, and your USB cable can even seem to fit (sort of) into a FireWire slot.

✓ Transfer images via memory card reader. Many computers now also have built-in memory card readers. If yours has one that accepts a Secure Digital (SD) card, you can simply pop the memory card out of your camera and into the card reader instead of hooking the camera up to the computer. *Note:* If you're using the new SDHC (high capacity) cards, the reader must specifically support that type.

As another option, you can buy stand-alone card readers, such as the SanDisk model shown in Figure 8-2. Card readers range anywhere from \$5 to \$35, depending on whether they accept only a single type of card or, as with this SanDisk model, a variety of memory cards. Check your photo printer, too; many printers now have card readers that accept the most popular types of memory cards.

I prefer to use a card reader instead of via the camera, for three reasons:

- ✓ With a card reader, I don't waste camera battery power. (For camera transfers, the camera must be powered up during the entire download process.)
- I don't have to keep track of that elusive USB camera cable.

Chapter 8: Downloading, Organizing, and Archiving Your Photos

I don't have to get down on all fours to plug the camera cable into the computer's USB slot, which is (of course) located in the least convenient spot possible.

The card reader, by contrast, stays perched on my desk, connected to my computer at all times, so there's very little physical activity involved in transferring pictures, which is how I prefer to live my life.

If you want to transfer directly from the camera, however, the next section explains some important steps you need to take to make that option work. If you choose to use a card reader, skip ahead to the section "Starting the transfer process" for an overview of what happens after you insert the card into the reader.

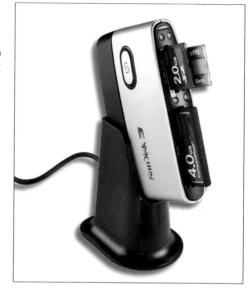

Courtesy SanDisk Corporation Figure 8-2: A card reader offers a more convenient method of image transfer.

Connecting camera and computer

You need to follow a specific set of steps when connecting the camera to your computer. Otherwise, you can damage the camera or the memory card.

Also note that for the process to work smoothly, Canon suggests that your computer is running one of the following operating systems:

- 🛩 Windows Vista
- Windows XP with Service Pack 2 (SP2)
- Mac OS X 10.4 and higher

If you use another OS (operating system, in case you're a non-geek), check the support pages on the Canon Web site (www.canon.com) for the latest news about any updates to system compatibility. You can always simply transfer images with a card reader, too. With that preamble out of the way, the next steps show you how to get your camera to talk to your computer:

1. Assess the level of the camera battery.

Just look at the little battery-status indicator at the bottom of the Shooting Settings display. If the battery is low, charge it before continuing. Running out of battery power during the transfer process can cause problems, including lost picture data. Alternatively, if you have an optional AC adapter, use that to power the camera during picture transfers.

- 2. If your computer isn't already on, turn it on and give it time to finish its normal startup routine.
- 3. Make sure that the camera is turned off.
- 4. Insert the smaller of the two plugs on the USB cable into the A/V Out/Digital port on the side of the camera.

This port is hidden under a little rubber door, just around the corner from the buttons that flank the left side of the monitor, as shown in Figure 8-3. Gently pry open the little door and insert the cable end into the slot.

5. Plug the other end of the cable into the computer's USB port.

It's best to plug the cable into a port that's actually built into the computer, as opposed to one that's on your keyboard or part of an external USB hub. Those accessory-type connections can sometimes foul up the transfer process.

6. Set the Mode dial on top of the camera to any exposure mode but Movie mode.

This step is essential; otherwise, the download process won't work.

7. Turn on the camera.

Connect USB cable here

Figure 8-3: Connect the smaller end of the USB cable here to download pictures.

Chapter 8: Downloading, Organizing, and Archiving Your Photos

The Shooting Settings screen appears briefly on the camera monitor, displaying a "Busy" message. Then the monitor goes black, and the card access lamp (just to the right of the Erase button) begins flickering, letting you know that the camera is communicating with the computer. After a few moments, a Direct Transfer screen appears on the camera monitor (you can just ignore it) and the center of the Print/Share light, better known as the Live View button, glows blue.

For details about the next step in the downloading routine, move on to the next section.

The options you see on the Direct Transfer screen relate to a method of image downloading that requires you to handle everything through the camera menus. I don't cover this download technique because I think most people will find the alternative methods I discuss here easier and more userfriendly. Nor do I cover the Transfer Order item on the Playback menu, which is related to the process. Your camera manual also includes specifics about the other download technique.

Starting the transfer process

After you connect the camera to the computer (be sure to carefully follow the steps in the preceding section) or insert a memory card into your card

reader, your next step depends, again, on the software installed on your computer and the OS (operating system) it runs.

Here are the most common possibilities and how to move forward:

✓ On a Windows-based computer, a Windows dialog box (like the one in Figure 8-4) appears. (The figure features the Windows Vista version of the dialog box.) This dialog box suggests different programs that you can use to download your picture files. Which programs appear depends upon what you have installed on your system; if you installed the Canon software, for example, one or more of those programs should appear in the list. To proceed, just click the transfer program that you want to use.

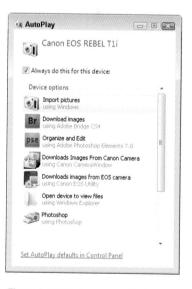

Figure 8-4: Windows may display this initial boxful of transfer options.

Safeguarding your digital photo files

To make sure that your digital photos enjoy a long, healthy life, follow these storage guidelines:

- Don't rely on your computer's hard drive for long-term, archival storage. Hard drives occasionally fail, wiping out all files in the process. This warning applies to both internal and external hard drives. At the very least, having a dual-drive backup is in order — you might keep one copy of your photos on your computer's internal drive and another on an external drive. If one breaks, you still have all your goodies on the other one. Also try to use that second drive only for image storage; assuming that you're not accessing the files every day, this minimizes the run time of the hard drive, which should translate to a longer life span (although it's not guaranteed). Don't forget that if your computer is a portable one, you have to consider the extra risk of theft of vour images as well.
- Camera memory cards, flash memory keys, and other portable storage devices are similarly risky. All are easily damaged if dropped or otherwise mishandled. And being of diminutive stature, these portable storage options also are easily lost.
- The best way to store important files is to copy them to nonrewritable CDs. (The label should say CD-R, not CD-RW.) Look for brand-name CDs that have a gold coating and are advertised as archival quality, which offers a higher level of security than other coatings.

- Recordable DVDs offer the advantage of holding lots more data than a CD. However, as of today, the industry still hasn't settled on a single, standard DVD format, and the archival-level gold coating isn't available for all those formats. For those reasons, I'm not quite as comfortable with DVDs as I am with CDs. So I use DVDs only for noncritical images; precious family photos go on CDs.
- For a double backup, you may want to check into online storage services, such as Mozy (www.mozy.com) and IDrive (www.idrive. com). You pay a monthly subscription fee to back up your important files to the site's servers.

Note, though, the critical phrase here: double backup. Online storage sites have a troubling history of closing down suddenly, taking all their customers' data with them. (One extremely alarming case in point was the closure of a photography-oriented storage site called Digital Railroad, which gave clients a mere 24-hours notice before destroying their files.) So anything you store online should be also stored on DVD or CD and kept in your home or office. Also note that photo-sharing sites such as Shutterfly, Kodak Gallery, and the like aren't designed to be long-term storage tanks for your images. Usually, you get access to only a small amount of file storage space, and the site may require you to purchase prints or other photo products periodically to maintain your account.

If you want to use the same program for all your transfers, select the Always Do This for This Device check box, as I did in Figure 8-4. (The check box has a slightly different name in other versions of Windows.) The next time you connect your camera or insert a memory card,

✓ An installed photo program automatically displays a photo-download wizard. For example, if you installed the Canon software, the EOS Utility window or MemoryCard Utility window may leap to the forefront. Or, if you installed some other program, such as Photoshop Elements, its downloader may pop up instead. On a Mac, the built-in iPhoto software may display its auto downloader. (Apple's Web site, www.apple.com, offers excellent video tutorials on using iPhoto, by the way.)

Usually, the downloader that appears is associated with the software that you most recently installed. Each new program that you add to your system tries to wrestle control over your image downloads away from the previous program.

If you don't want a program's auto downloader to launch whenever you insert a memory card or connect your camera, you should be able to turn off that feature. Check the software manual to find out how to disable the auto launch.

✓ Nothing happens. Don't panic; assuming that your card reader or camera is properly connected, all is probably well. Someone — maybe even you — simply may have disabled all the automatic downloaders on your system. Just launch your photo software and then transfer your pictures using whatever command starts that process. (I show you how to do it with the Canon software tools later in the chapter; for other programs, consult the software manual.)

As another option, you can use Windows Explorer or the Mac Finder to simply drag and drop files from your memory card to your computer's hard drive. The process is exactly the same as when you move any other file from a CD, DVD, or other storage device onto your hard drive.

As I say in the introduction to this chapter, it's impossible to give step-bystep instructions for using all the various photo downloaders that may be sprinkled over your hard drive. So in the next sections, I provide details on using Canon software to download and organize your files.

If you use some other software, the concepts are the same, but check your program manual to get the small details. In most programs, you also can find lots of information by simply opening the Help menu.

0

Downloading images with Canon tools

The software CD that shipped with your Rebel T1i/500D includes several programs for transferring, organizing, and editing your photos. For downloading images, I suggest that you use the tools discussed in the next two sections.

Before you try the download steps, however, you may want to visit the Canon Web site and download the latest versions of the software in the suite. Even if you recently bought your camera, the shipping CD may be a little out of date. Just go to www.canon.com and follow the links to locate the software for your camera. (You can also download updated manuals.)

In this book, the steps relate to version 2.6.1 of the EOS Utility and version 6.3 for ZoomBrowser EX (Windows) and ImageBrowser (Mac). As I write this, those versions are the most recent available.

After taking care of the software download and installation chores, see the next two sections for details on how to transfer your images.

Using EOS Utility to transfer images from your camera

Follow these steps to transfer images directly from your camera to the computer using the Canon EOS Utility software:

1. Connect your camera (turned off) to the computer.

See the first part of this chapter for specifics.

2. Turn on the camera.

After a few moments, the EOS Utility window should appear automatically. If it doesn't, just launch the program as you would any other on your system. Figure 8-5 shows the Windows Vista version of the screen; the Mac version looks pretty much the same.

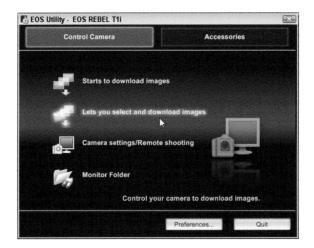

Figure 8-5: EOS Utility is designed for sending pictures from the camera to the computer.

3. Click the Lets You Select and Download Images option, as shown in the figure.

With this option, you can specify which pictures you want to download from the camera. After you click the option, you see a browser window that looks similar to the one in Figure 8-6, with thumbnails of the images currently on your card. The figure shows the Windows version, but the Mac version contains the same components. Click the magnifying glass icons in the lower-right corner of the window to enlarge or reduce the thumbnail size.

4. Select the images that you want to copy to the computer.

In Windows, each thumbnail contains a check box in its lower-left corner. To select an image for downloading, click the box to put a check mark in it. On the Mac, there are no check boxes; instead, click the image thumbnail to highlight it.

For a quick way to select all images, press Ctrl+A (Windows) or #+A (Mac). Or choose Edit=>Select Image=>Select All.

5. Click the Download button at the bottom of the window.

A screen appears that tells you where the program wants to store your downloaded pictures. Figure 8-7 shows the Windows version of this notice; the Mac version contains the same options.

 E EOS UNINY - EOS REBEL T1!

 File
 Edit
 Vinew
 Window
 Heig

 State
 Stat

Figure 8-6: Select the thumbnails of the images you want to transfer.

Figure 8-7: You can specify where you want to store the photos.

By default, pictures are stored in the Pictures or My Pictures folder in Windows (depending on the version of Windows you use) and in the Pictures folder on a Mac. You can put your images anywhere you like; however, most photo editing programs look first for photos in those folders, so sticking with this universally accepted setup makes some sense.

6. Verify or change the storage location for your pictures.

If you want to put the pictures in a location different from what the program suggests, click the Destination Folder button and specify the storage location and folder name you prefer. You also can choose to have the picture files renamed when they're copied; click the File Name button to access the renaming options.

7. Click OK to begin the download.

A progress window appears, showing you the status of the download.

8. When the download is complete, turn off the camera.

You can safely remove the cable connecting it to the computer.

That's the basic process, but I need to share a couple of fine points:

Setting download preferences: While the camera is still connected and turned on, you can click the Preferences button at the bottom of the EOS Utility browser (refer to Figure 8-6) to open a dialog box where you can specify many aspects of how the transfer program works. Figure 8-8 shows the Windows version; Figure 8-9, the Mac version.

In Windows, click the tabs at the top of the Preferences dialog box to reveal all your options. (You may need to use the scroll arrows at the right side of the tabs to access hidden tabs.) On a Mac, display the various panels by choosing them from the drop-down list at the top of the dialog box.

Startup Action Show main window Show [Lets you select and download images] screen Show [Camera settings/Remote shooting] screen Execute [Starts to download images] Start EOS Utility automatically when the camera is connected Auto power off (except when using an AC power supply)	Basic Settings	Destination Folder	File Name	Download Images	Remote Shooting	Lot
Show [Lets you select and download images] screen Show [Camera settings/Remote shooting] screen Execute [Starts to download images] Start EOS Utility automatically when the camera is connected	Startup Ac	tion				
Show [Camera settings/Remote shooting] screen Execute [Starts to download images] Start EOS Utility automatically when the camera is connected	Sh	ow main window				
Execute [Starts to download images] Start EOS Utility automatically when the camera is connected	🔿 Sh	ow (Lets you select a	and download	d images] screen		
☑ Start EOS Utility automatically when the camera is connected	🔘 Sh	ow (Camera settings	Remote she	ooting] screen		
) Ex	ecute (Starts to down	load images]		
Auto power off (except when using an AC power supply)	🖉 Start E	DS Utility automatical	ly when the c	amera is connected		
	🔄 Auto po	wer off (except when	using an AC	power supply)		
Add WFT Pairing Software to the Startup folder	🗌 Add WF	T Pairing Software to	the Startup t	older		

Figure 8-8: In Windows, click the tabs at the top of the window to access download options.

Hell	Preferences
Basi	: Settings
	Startup Action
	Show main window
	O Show [Lets you select and download images] screen
	Show [Camera settings/Remote shooting] screen
	Execute [Starts to download images]
	Auto power off (except when using an AC power supply)
	Register WFT Pairing Software in Login Options
	Cancel

Figure 8-9: On a Mac, select a panel of options from the drop-down list at the top of the dialog box.

Auto-launching the other Canon programs: After the download is complete, the EOS Utility may automatically launch Canon Digital Photo Professional or ZoomBrowser EX (Windows) or ImageBrowser (Mac) so that you can immediately start working with your pictures. (You must have installed the programs for this to occur.)

If you want to change the program that's launched, visit the Linked Software panel of the EOS Utility's Preferences dialog box. You then can select the program that you want to use or choose None to disable autolaunch altogether.

Closing the EOS Utility: The utility browser window doesn't close automatically after the download is complete. So you must return to it and click the Quit button to shut it down. (Refer to Figure 8-6.)

Using MemoryCard Utility for card-to-computer transfers

Transferring images from a memory card reader involves a different Canon tool, MemoryCard Utility. This tool is actually a component of ZoomBrowser EX (Windows) and ImageBrowser (Mac). To try it out, take these steps:

1. Put your card in your card reader.

If all the planets are aligned — meaning that the Canon software was the last photo software you installed, and some other program doesn't try to handle the job for you — the MemoryCard Utility window shown in Figure 8-10 appears automatically when you put your memory card into the card reader. The figure shows the Windows version of the window; the Mac version is identical except that the top of the window refers to ImageBrowser, which is the Mac version of ZoomBrowser EX.

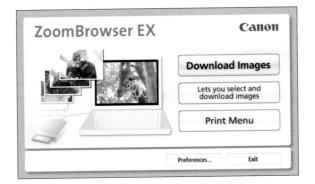

Figure 8-10: MemoryCard Utility enables you to transfer pictures using a card reader.

If the window doesn't appear, you can access it as follows:

- *Windows:* Open the program called ZoomBrowser EX MemoryCard Utility, using the steps you usually take to start a program.
- *Mac:* Start the program called Canon Camera Window. The program should detect your memory card and display the MemoryCard Utility window.

2. Click the Lets You Select and Download Images option.

You then see the browser window shown in Figure 8-11. The figure shows the Windows version; the Mac version contains the same basic components but follows conventional Mac design rules. Either way, thumbnails of the images on your memory card are displayed in the window.

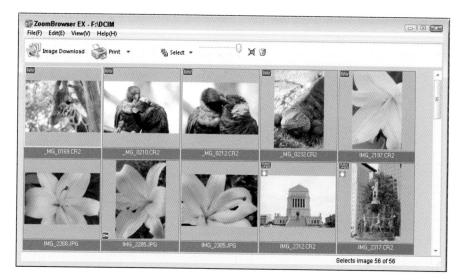

Figure 8-11: Select images to download from the browser window.

3. Select the images that you want to download.

- To select the first photo, click its thumbnail.
- *To select additional pictures,* Ctrl+click (Windows) or **#**+click (Mac) their thumbnails.
- *To quickly select all images*, press Ctrl+A in Windows or **#**+A on a Mac. Or, depending on your OS, do the following:

Windows: Choose Select All from the Select drop-down list, located on the toolbar near the top of the window.

Mac: Choose Select All from the Select Image list, located at the bottom of the window.

4. Click the Image Download button.

In Windows, the button is near the top-left corner of the browser window. On a Mac, it's in the bottom-left corner (and for whatever reason, named Download Images instead of Image Download).

Either way, a new window appears to show you where the downloader wants to put your files and the name it plans to assign the storage folder, as shown in Figure 8-12.

If you're not happy with the program's choices, click the Change Settings button to open a dialog box where you can select a different storage location. In the same dialog box, you can also choose to have the files renamed when they're copied. Click OK to close the Change Settings dialog box when you finish.

Most programs look first for photos stored in the location suggested initially by the downloader. In Windows, that folder is either Pictures or My Pictures, depending on what version of Windows you use. On a Mac, the folder is Pictures. Sticking with these

Figure 8-12: Click the Change Settings button to specify a different download folder.

default storage locations can simplify your life down the road, but of course, you're free to set up whatever image-organization system works best for you.

5. Click the Starts Download button.

Your files start making their way to your computer. When the download is finished, the MemoryCard Utility window closes, and either ZoomBrowser EX (Windows) or ImageBrowser (Mac) appears, displaying your downloaded files. See the next section for details on using that program.

Using ZoomBrowser EX/ImageBrowser

In addition to the aforementioned software tools, your Canon CD contains two additional programs: ZoomBrowser EX (Windows) or ImageBrowser (Mac), plus Digital Photo Professional. In this section, you find out how to organize your photos using the ZoomBrowser EX/ImageBrowser tool. The upcoming section, "Processing Raw (CR2) Files," introduces you to Digital Photo Professional, which you can use to process photos you shoot in the Raw format. You can also browse and organize your photos in that program if you prefer. However, I think that most beginners will find ZoomBrowser and ImageBrowser easier to use. These programs also offer the simple photo-editing tools that I cover in Chapter 10.

The next sections give you the most basic of introductions to ZoomBrowser EX/ImageBrowser, which, in the interest of saving type, I may refer to from

here on in as just "the browser." If you want more details, the CD that ships with the program offers a very good online manual.

Before you move on, though, I want to clear up one common point of confusion: You can use Canon's software to download and organize your photos and still use any photo editing software you prefer. And to do your editing, you don't need to re-download photos — after you transfer photos to your computer, you can access them from any program, just as you can any file that you put on your system.

Getting acquainted with the program

Figure 8-13 offers a look at the ZoomBrowser EX window; Figure 8-14 shows the ImageBrowser window. As you can see, both windows contain most of the same basic components although the Mac version of the browser is lacking the row of task buttons found in the upper-left corner of the Windows version. The two versions also offer a different set of image-viewing modes — Zoom, Scroll, and Preview modes in Windows; Preview and List modes on the Mac.

Figure 8-13: Click a folder in the Explore panel to display its images.

262

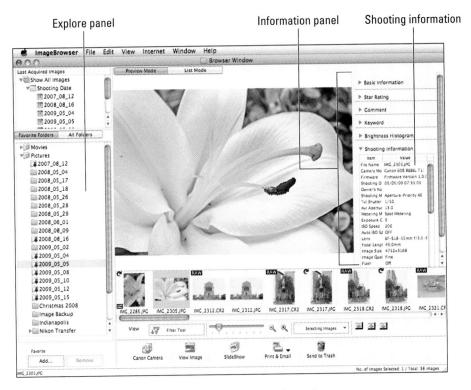

Figure 8-14: Click a thumbnail to view that image in the main preview area.

Whichever version you use, you can customize the window layout via the View menu. The arrangement you see in the figures is the Preview mode setup. I prefer this mode because it provides easy access not just to your images, but also to details about the camera settings you used to shoot the picture. Note that in Windows, you can display and hide the Explore and Information panels by clicking the little vertical buttons that border the preview area (the "Information panel" label in Figure 8-13 points to one of the little guys). On a Mac, choose View Settings to display a submenu where you can toggle the panels on and off.

Here's a quick guide to viewing your photos in Preview mode:

Select the folder you want to view. Click the folder's icon in the Explore panel, found on the left side of the window and labeled in Figures 8-13 and 8-14. If you click the Favorite Folders tab, you see only the Pictures or My Pictures folders (Windows) or Pictures folder (Mac) along with any custom Favorites folders that you create, a topic that you can visit in the upcoming section "Organizing your photos." By default, picture files that you transfer from your camera or memory card using the Canon software go into these folders. To view all folders on your computer, click the All Folders button.

Preview the images in the selected folder. In Preview mode, the current image appears at a large size in the middle of the window, as shown in the figures, and a filmstrip of smaller thumbnails appears beneath.

To view the next image in the filmstrip, click its thumbnail. On a Mac, you then can press the right- and left-arrow keys on your keyboard to view your photos one by one. In Windows, the same technique works on some keyboards; if not, click the Next and Previous buttons (under the large preview) instead. Drag the scroll bar under the thumbnails to scroll the thumbnail display as needed.

- ✓ View an image in full-screen mode. For a larger view of a photo, doubleclick its thumbnail. (You must double-click the thumbnail, not the larger preview image.) Doing so opens the image in its own browser window, displaying the image as large as possible to fit the available screen space. This full-screen window is the Viewer window. The next section explains more about the controls therein. To exit the Viewer window and return to the main browser, just click the window's Close button.
- ✓ View shooting information. Check out the Information panel, located on the right side of the window. If you click the Shooting Information button, you display all the settings that you used to capture the selected image, as shown in Figures 8-13 and 8-14. Reviewing this data — known as *metadata* — is a great way to better understand what settings work best for different types of pictures, especially when you're just getting up to speed with aperture, shutter speed, white balance, and all the other digital photography basics. *Note:* You may need to scroll the Information panel display to access the Shooting Information button, depending on the size of the program window.

Those are the basics of navigating through your images. In the next section, you can find some hints about viewing your photos in full-screen mode, inside the Viewer window. After that, the section "Organizing your photos" explains how to customize the folder setup that the Canon software creates for you.

Viewing photos in full-screen mode

Double-clicking a thumbnail in the main browser window displays the image inside the Viewer window. Figure 8-15 shows the Windows version of the Viewer window; Figure 8-16 shows the Mac alternative.

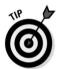

Previous/Next

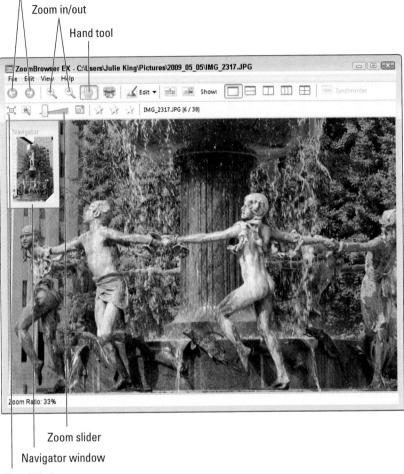

Fit to Window

Figure 8-15: To display an image in the Viewer window, double-click its thumbnail.

After opening an image in the Viewer window, use these tricks to inspect it more closely:

- Magnify the image. You can zoom in on your image for a closer look by using these techniques:
 - *In ZoomBrowser EX (Windows):* Drag the Zoom slider or click the preview with the Zoom In tool, both labeled in Figure 8-15.
 - *In ImageBrowser (Mac):* Choose a specific magnification level from the Display Size drop-down list, labeled in Figure 8-16.

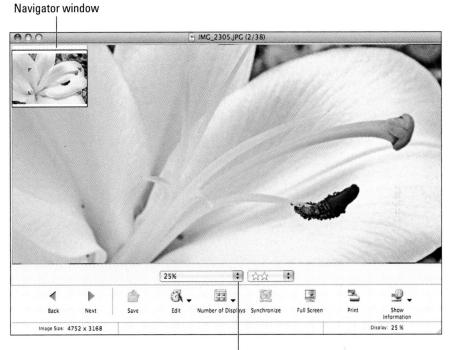

Display size list

Figure 8-16: The Mac version of the Viewer window looks like this.

✓ Scroll a magnified image. After you magnify the photo, a tiny Navigator window appears in the top-left corner of the screen, as shown in the figures. The little red triangles in the Navigator window indicate the area that you're viewing in the main preview. To scroll the display to see another portion of the image, put your cursor in the Navigator window, within the area bounded by those little red triangles, and drag.

In Windows, you also can click the Hand tool, labeled in Figure 8-15, and drag in the preview. On a Mac, just drag in the preview; your cursor automatically sets itself to Hand-tool mode as soon as you enlarge the image display.

Reduce the view size. In Windows, click the preview with the Zoom Out tool or use the Zoom slider. (Refer to Figure 8-15.) On a Mac, choose a smaller zoom size from the Display Size drop-down list.

To zoom out so that you can see the entire image, click the Fit to Window button in Windows. (Refer to Figure 8-15.) On a Mac, choose Fit to Window from the Display Size list instead.

- View the next image in the folder. If you want to inspect more images in the Viewer window, just click the Previous and Next buttons, labeled in Figure 8-15, if you use Windows. On a Mac, click the Back or Next button located under the preview.
- Edit the photo. To use the editing tools provided with the program, open the Edit drop-down list, found above the preview in Windows and beneath it on a Mac. Then select the editing task you want to perform. Chapter 10 provides more details about shifting into Editing mode and using the available tools.

Keep in mind that the preceding tidbits just give you the basics of using the Viewer window; for additional tips, check out the program manual.

Organizing your photos

By default, the Canon download software puts your picture files into either the Pictures or My Pictures folder in Windows or in the Pictures folder on a Mac. Within that folder, the downloading tools organize the images by their shooting dates, creating a new folder for each date found on the memory card, as shown in Figure 8-17. Each folder contains only the images shot on that particular day.

If you don't like this organizational structure, you can change it. For example, maybe you prefer to organize photos according to the date you downloaded them to your computer. Or you may want to organize images by category family, travel, work, and so on. I took this approach to customize my folder collection in Figure 8-17.

To keep things simple, I suggest that you add these custom folders within the

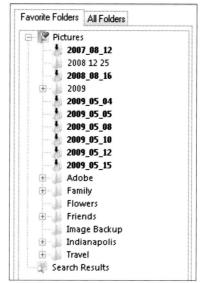

Pictures or My Pictures folder (Windows) or Pictures folder (Mac). That way, you'll always know where to look for images on your computer's hard drive. And programs that default to looking to those folders for photos will be able to find them as well. The next two sections show you the basics you need to create custom folders and then organize images in them.

Creating custom folders

Take these steps to add a folder to the My Pictures or Pictures list. Again, which folder is the default image-storage tank depends on your computer's OS (operating system).

- 1. Click the Favorite Folders tab of the Explore panel, if it isn't already visible.
- 2. Click My Pictures or Pictures.

The folder should appear highlighted.

3. Choose File New Folder.

The New Folder dialog box appears.

4. Type the name of the folder in the text box and then click OK.

Your folder appears as a subfolder under the My Pictures or Pictures folder.

To create a subfolder within your new folder, follow the same process, but click the new folder in Step 2.

Managing your image collection

After you create your folders, you can place images into them in two ways:

- ✓ Move an image from one folder to another. Display the image thumbnail and then drag it to the desired folder. The program moves the image file to the new folder and removes it from the old one.
- Download new images directly to your desired folder. You can specify a custom folder as the download destination when you use the EOS Utility and MemoryCard Utility software to transfer images. See the earlier sections of this chapter for details.

Use these techniques to maintain and further organize your image collection:

✓ Delete a folder. First, click the folder name to select it. Then, in Windows, choose File⇒Delete. On a Mac, choose File⇒Send to Trash. In both cases, when the program displays a message asking you to confirm that you want to get rid of the folder, click Yes to proceed.

Be careful: This step deletes both the folder and all images inside it!

- ✓ Rename a folder. Click the folder and choose File⇒Rename. In the dialog box that appears, type the new folder name and then click OK.
- Rename a picture file. Click the image thumbnail and choose Filet? Rename. Type the new name in the dialog box that appears and then click OK. *Note:* Do not type the three-letter file extension (.jpg or .CR2) at the end of the new filename. The program adds that data automatically to the filename for you.

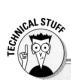

Using your mouse as a shutter button

Along with providing a convenient way for you to download images, the EOS Utility software enables you to use your computer to actually shoot pictures.

While your camera is connected to your computer, clicking the Camera Settings/Remote Shooting button in the main EOS Utility window displays a panel containing clickable controls for adjusting the major camera settings, such as aperture, white balance, ISO, and metering mode. After you establish those settings, you click another button to record whatever scene is in front of your camera lens. What's the point? Well, this feature is great in scenarios that make having a live photographer close to the subject either difficult or dangerous — for example, trying to get a shot of a chemical reaction in a science lab or capture an image of an animal that's shy around humans. Additionally, the software enables easy time-lapse photography, enabling you to set the camera to take pictures automatically at specified intervals over a period of minutes, hours, or even days.

✓ Delete a picture. Click the image thumbnail to select it. Then, in Windows, choose Filet⇒Delete; on a Mac, choose Filet⇒Send to Trash. Like with deleting a folder, you're presented with a dialog box asking you whether you really, really want to dump that image. Respond in the affirmative to do so.

Processing Raw (CR2) Files

Chapter 3 introduces you to the Camera Raw file format, which enables you to capture images as raw data. One advantage of capturing Raw files, which are called CR2 files on your Rebel T1i/500D, is that you make the decisions about how to translate the raw data into an actual photograph. You can specify attributes such as color intensity, image sharpening, contrast, and so on — all of which are handled automatically by the camera if you use its other file format, JPEG.

The bad news: You have to specify attributes, such as color intensity, image sharpening, contrast, and so on before you can do anything with your pictures. Although you can print them immediately if you use the Canon software, you can't take them to a photo lab for printing, share them online, or edit them in your photo software until you process them using a tool known as a raw converter. At the end of the process, you save the finished file in a standard file format, such as JPEG or TIFF. If you decide to shoot in the Raw format, you can process your images with the free Canon software provided with your camera. For this task, you can start the job in ZoomBrowser (Windows) or ImageBrowser (Mac). But to actually process your files, you must call on a second program, Digital Photo Professional, from within the browser program. Follow these steps:

- 1. Click the image thumbnail in the ZoomBrowser or ImageBrowser window.
- 2. In Windows, choose Tools Process RAW Images by Digital Photo Professional. On a Mac, choose File Process RAW Images by Digital Photo Professional.

Be sure to choose this specific command and not Processing RAW Image. That feature doesn't work with Raw files produced by your camera.

The Digital Photo Professional window appears, displaying thumbnails of your photos.

3. Inside Digital Photo Professional, click your image thumbnail and then choose View=>Edit in Edit Image Window.

Now your photo appears inside an editing window, as shown in Figure 8-18. The exact appearance of the window may vary depending on your program settings. If you don't see the tool palette on the right side of the window, choose View=? Tool Palette to display it. (Other View menu options enable you to customize the window display.)

The Tool Palette offers three tabs full of controls for adjusting your photo. You can find complete details in the program's Help system, but I want to highlight a couple of the available options:

• *Raw tab*: On this tab, shown in Figure 8-18, you find controls for tweaking exposure, white balance, and color. For white balance, you can choose a specific setting, as shown in the figure (I selected Cloudy), or click the little eyedropper and then click an area of the image that should be white, black, or gray to remove any color cast.

Through the Picture Style option, you can actually apply one of the camera's Picture Style options to the photo. Or you can customize the style by dragging the Sharpness, Contrast, Color Saturation, and Color Tone sliders. (If you select Monochrome as the Picture Style, the Color Saturation and Color Tone sliders are replaced by the Filter Effect and Toning Effect sliders.) Chapter 6 talks about Picture Styles.

• *RGB tab:* This tab enables you to adjust exposure further by using a Tone Curve adjustment similar to the one that I cover in Chapter 10. You can make additional color and sharpness adjustments here as well, but it's best to make those changes using the controls on the Raw tab instead. (The RGB tab options are provided primarily for manipulating JPEG and TIFF photos and not for Raw conversion).

270 Part III: Working with Picture Files

Figure 8-18: You can convert Raw images using Digital Photo Professional.

• *NR/Lens/ALO tab:* On this tab, shown in Figure 8-19, you can apply noise removal and correct certain lens distortion problems. You can even apply Peripheral Illumination Correction and the Auto Lighting Optimizer effects here instead of through the in-camera correction (which I cover in Chapter 5). Click the Tune button to access the lens correction options.

At any time, you can revert the image to the original settings by choosing Adjustment — Revert to Shot Settings.

4. Choose File Convert and Save.

You see the standard file-saving dialog box with a few additional controls, as shown in Figure 8-20. The figure features the Windows Vista version of the dialog box, but the critical controls are the same no matter what type of computer you use.

5. Set the save options.

Here's the rundown of the critical options:

• *File Type:* Choose EXIF-Tiff (8 bits/channel). This saves your image in the TIFF file format, which preserves all image data. Don't choose the JPEG format; doing so is destructive to the photo because of the lossy compression that is applied. Chapter 3 has details.

A bit is a unit of computer data; the more bits you have, the more colors your image can contain. Many photo editing programs can't open 16-bit files, or they limit you to a few editing tools, so I suggest you stick with the standard, 8-bit image option unless you know your software can handle the higher bit depth. If you do prefer 16-bit files, you can select TIFF 16bit as your file type.

- Output Resolution: This option does not adjust the pixel count of your image, as you might imagine. It only sets the default output resolution that will be used if you send the photo to a printer. Most photoediting programs enable you to adjust this value before printing. The Canon software does not, however, so if you plan to print through the browser, I suggest you set this value to 300. Chapter 9 talks more about printing.
- *Embed ICC Profile in Image:* On your Rebel T1i/500D, you can shoot in either the sRGB or Adobe RGB color

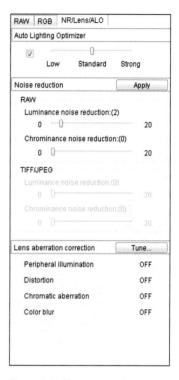

Figure 8-19: You can apply Peripheral Illumination Correction here as well as in the camera.

space; Chapter 6 has details. Select this check box when saving your processed Raw file to include the color-space data in the file. If you then open the photo in a program that supports color profiles, the colors are rendered more accurately. (*ICC* refers to the International Color Consortium, the group that created color-space standards.)

• *Resize*: Uncheck this box so that your processed file contains all its original pixels.

6. Enter a filename, select the folder and browse where you want to store the image, and then click Save.

A progress box appears, letting you know that the conversion and filesaving is going forward. Click the Exit button (Windows) or the Terminate button (Mac) to close the progress box when the process is complete.

7. Close the Edit window to return to the Digital Photo Professional browser.

271

8. Close Digital Photo Professional.

You see a dialog box that tells you that your Raw file was edited and asks whether you want to save the changes.

9. Click Yes to store your raw-processing "recipe" with the Raw file.

The Raw settings you used are then kept with the original image so that you can create additional copies of the Raw file easily without having to make all your adjustments again.

Again, these steps give you only a basic overview of the process. If you regularly shoot in the Raw format, take the time to explore the Digital Photo Professional Help system so that you can take advantage of its other features. If you prefer, you can choose to use that program to do your photo downloading and organizing as well instead of ZoomBrowser or ImageBrowser.

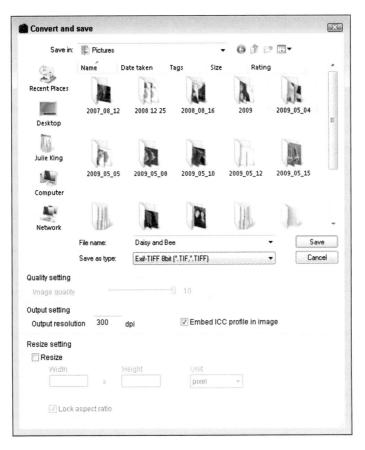

Figure 8-20: Always save your processed files in the TIFF format.

Printing and Sharing Your Photos

In This Chapter

- Setting the stage for great prints
- Looking at retail printing options
- >> Printing with the Canon software
- >> Preparing a picture for the Web
- Creating a slide show
- Viewing images on TV

hen my first digital photography book was published, way back in the 1990s, consumer digital cameras didn't offer the resolution needed to produce good prints at anything more than postage-stamp size — and even then, the operative word was *good*, not *great*. Making a print was a pretty much a do-it-yourself proposition unless you paid skyhigh prices at a professional imaging lab. In those days, retail photo labs didn't offer digital printing, and online printing services hadn't arrived yet, either.

Well, time and technology march on, and, at least in the case of digital photo printing, to a very good outcome. Your Rebel T1i/500D can help you produce dynamic prints even at large sizes, and getting those prints made is easy and economical, thanks to an abundance of digital printing services now in stores and online. For home printing, today's printers are better and less expensive than ever, too.

Part III: Working with Picture Files

That said, getting the best prints from your picture files still requires a little bit of knowledge and prep work on your part. To that end, this chapter tells you exactly how to ensure that your pictures will look as good on paper as they do in your camera monitor.

In addition, this chapter shows you how to prepare your picture for e-mail sharing — an important step if you don't want to annoy friends and family by cluttering their inboxes with ginormous, too-large-to-view photos. Following that, you can find out how to create a digital slide show, view your pictures on a television, and more.

Avoiding Printing Problems

Although digital printing has come a long way in the past couple of years, a few issues still can cause hiccups in the process. Before you print your photos, whether on your own printer or through a lab, read through the next three sections, which show you how to avoid the most common trouble spots.

Check the pixel count before you print

Resolution — the number of pixels in your digital image — plays a huge role in how large you can print your photos and still maintain good picture quality. You can get the complete story on resolution in Chapter 3, but here's a quick recap as it relates to printing:

Choose the right resolution before you shoot: On your Rebel T1i/500D, you set picture resolution via the Quality option, found on Shooting Menu 1, or through the Quick Control display.

You must select this option *before* you capture an image, which means that you need some idea of your ultimate print size before you shoot. And remember that if you crop your image, you eliminate some pixels, so take that factor into account when you do the resolution math.

✓ Aim for a minimum of 200 pixels per inch (ppi): For good print quality, the *minimum* pixel count (in my experience, anyway) is 200 pixels per linear inch, or 200 ppi. That means that if you want a 4-x-6-inch print, you need at least 800 x 1200 pixels.

Depending on your printer, you may get even better results at 200+ ppi. Some printers do their best work when fed 300 ppi, and a few (notably, Epson) request 360 ppi as the optimum resolution. However, going higher than that typically doesn't produce any better prints.

274

Unfortunately, because most printer manuals don't bother to tell you what image resolution produces the best results, finding the right pixel level is a matter of experimentation. (Don't confuse the manual's statements related to the printer's dpi with ppi. Dots per inch (dpi) refers to how many dots of color the printer can lay down per inch; many printers use multiple dots to reproduce one image pixel.)

If you're printing your photos at a retail kiosk or at an online site, the software that you use to order your prints should determine the resolution of your files and then suggest appropriate print sizes. If you're printing on a home printer, though, you need to be the resolution cop.

So what do you do if you find that you don't have enough pixels for the print size you have in mind? You just have to decide what's more important print size or print quality.

If your print size exceeds your pixel supply, you have the following two choices, neither of which provides a good outcome:

Keep the existing pixel count and accept lowered photo quality. In this case, your pixels simply grow in size to fill the requested print size. When pixels get too large, you get a defect known as pixelation. The picture starts to appear jagged, or stairstepped, along curved or digital lines. Or at worst, your eye can actually make out the individual pixels, and your photo begins to look more like a mosaic than, well, a photograph.

Add more pixels and accept lowered photo quality. In some photo programs, you can add pixels to an existing image, a process called resampling. Some other photo programs even resample the photo automatically for you, depending on the print settings you choose.

Although this option might sound good, it really doesn't solve your problem. You're asking the software to make up photo information out of thin air, and the resulting image usually looks worse than the original. You don't get pixelation, but details turn muddy, giving the image a blurry, poorly rendered appearance.

Just to hammer home the point and remind you one more time of the impact of resolution picture quality, Figures 9-1 and 9-2 show you the same image as it appears at 300 ppi (the resolution required by the publisher of this book), at 50 ppi, and then resampled from 50 ppi to 300 ppi. As you can see, there's just no way around the rule: If you want the best-quality prints, you need the right pixel count from the get-go.

276

Figure 9-1: A high-quality print depends on a high-resolution original.

Allow for different print proportions

Unlike many digital cameras, yours produces images that have an aspect ratio of 3:2. That is, images are 3 units wide by 2 units tall — just like 35mm film — which means that they translate perfectly to the standard 4-x-6-inch print size. (Most digital cameras produce 4:3 images, which means the pictures must be cropped to fit a 4-x-6-inch piece of paper.)

If you want to print your digital original at other standard sizes — $5 \ge 7$, $8 \ge 10$, $11 \ge 14$, and so on — you need to crop the photo to match those proportions. Alternatively, you can reduce the photo size slightly and leave an empty margin along the edges of the print as needed.

Chapter 9: Printing and Sharing Your Photos

50 ppi resampled to 300 ppi

Figure 9-2: Adding pixels in a photo editor doesn't rescue a low-resolution original.

As a point of reference, both images in Figure 9-3 are original, 3:2 images. The blue outlines indicate how much of the original can fit within a 5-x-7-inch frame and an 8-x-10-inch frame, respectively.

Chapter 10 shows you how to crop your image using the free Canon software that ships with your camera. You also can usually crop your photo using the software provided at online printing sites and at retail print kiosks. If you plan to simply drop off your memory card for printing at a lab, be sure to find out whether the printer automatically crops the image without your input. If so, use your photo software to crop the photo, save the cropped image to your memory card, and deliver that version of the file to the printer.

To allow yourself printing flexibility, leave at least a little margin of background around your subject when you shoot, as I did for the example in Figure 9-3. That way, you don't clip off the edges of the subject no matter what print size you choose. (Some people refer to this margin padding as *head room*, especially when describing portrait composition.)

8 x 10 frame area

5 x 7 frame area

Figure 9-3: Composing your shots with a little head room enables you to crop to different frame sizes.

Get print and monitor colors in sync

Ah, your photo colors look perfect on your computer monitor. But when you print the picture, the image is too red, or too green, or has some other nasty color tint. This problem, which is probably the most prevalent printing issue, can occur because of any or all of the following factors:

✓ Your monitor needs to be calibrated. When print colors don't match what you see on your monitor, the most likely culprit is actually the monitor, not the printer. If the monitor isn't accurately calibrated, the colors it displays aren't a true reflection of your image colors. The same caveat applies with regard to monitor brightness: You can't accurately gauge the exposure of a photo if the brightness of the monitor is cranked way up or down. To ensure that your monitor is displaying photos on a neutral canvas, you can start with a software-based calibration utility, which is just a small program that guides you through the process of adjusting your monitor. The program displays various color swatches and other graphics and then asks you to provide feedback about what you see onscreen.

If you use a Mac, its operating software (or OS) offers a built-in calibration utility, the Display Calibrator Assistant; Figure 9-4 shows the welcome screen that appears when you run the program. (Access it by opening the System Preferences dialog box, clicking the Displays icon, clicking the Color button, and then clicking the Calibrate button.) You also can find free calibration software for both Mac and Windows systems online; just enter the term *free monitor calibration software* into your favorite search engine.

00	Display Calibrator Assistant
	Introduction
 Introduction Set Up Native Gamma Target Gamma Target White Point Admin Name Conclusion 	Welcome to the Apple Display Calibrator Assistant! This assistant will help you calibrate your display and create a custom Colorsync profile. With a properly calibrated display, the system and other software that uses ColorSync can better display images in their intended colors. Image: Software that uses ColorSync can better display images in their intended colors. Image: Software that uses ColorSync can better display images in their intended colors. Image: Software that uses ColorSync can better display images in their intended colors. Image: Software that uses ColorSync can better display images in their intended colors. Image: Software that uses ColorSync can better display images in their intended colors. Image: Software that uses ColorSync can better display's brightness and contrast. Image: Software that uses ColorSync can better display's native luminance consons curve. Image: Software the display's brightness and contrast. Image: Software the display's native point (warmth or coloress of white) Image: Expert Mode - This turns on extra options. Click the Continue button below to begin.
	Go Back Continue

Figure 9-4: Mac users can take advantage of the operating system's built-in calibration tool.

Software-based tools, though, depend on your eyes to make decisions during the calibration process. For a more reliable calibration, you may want to invest in a hardware solution, such as the Pantone Huey (\$90, www.pantone.com) or the ColorVision Spyder2express (\$80, www. datacolor.com). These products use a device known as a *colorimeter* to accurately measure your display colors.

Whichever route you go, the calibration process produces a monitor *profile*, which is simply a data file that tells your computer how to adjust the display to compensate for any monitor color casts. Your Windows or Mac operating system loads this file automatically when you start your computer. Your only responsibility is to perform the calibration every month or so because monitor colors do drift over time.

✓ One of your printer cartridges is empty or clogged. If your prints look great one day but are way off the next, the number-one suspect is an empty ink cartridge or a clogged print nozzle or head. Check your manual to find out how to perform the necessary maintenance to keep the nozzles or print heads in good shape.

If black-and-white prints have a color tint, a logical assumption is that your black ink cartridge is to blame, if your printer has one. But the truth is that a printer that doesn't use multiple black or gray cartridges will always have a slight color tint. Why? Because in order to create gray, the printer instead has to mix yellow, magenta, and cyan in perfectly equal amounts, and that's a difficult feat for the typical inkjet printer to pull off. If your black-and-white prints have a strong color tint, however, it could be that one of your color cartridges is empty, and replacing it may help somewhat. Long story short: Unless you have a printer that's marketed for producing good black-and-white prints, you'll probably save yourself some grief by simply having your black-andwhites printed at a retail lab.

When you buy replacement ink, by the way, keep in mind that thirdparty brands (although may be cheaper) may not deliver the performance you get from cartridges from your printer manufacturer. A lot of science goes into getting ink formulas to mesh with the printer's inkdelivery system, and the printer manufacturer obviously knows most about that delivery system.

- ✓ You chose the wrong paper setting in your printer software. When you set up your print job, be sure to select the right setting from the paper type option glossy, matte, and so on. This setting affects how the printer lays down ink on the paper.
- ✓ Your photo paper is low quality. Sad but true: Cheap, store-brand photo papers usually don't render colors as well as the higher-priced, name-brand papers. For best results, try papers from your printer manufacturer; again, those papers are engineered to provide top performance with the printer's specific inks and ink-delivery system.
- ✓ Your printer and photo software are fighting over color management duties. Some photo programs offer *color management* tools, which enable you to control how colors are handled as an image passes from camera to monitor to printer. Most printer software also offers color management features. The problem is, if you enable color management controls both in your photo software and your printer software, you can

create conflicts that lead to wacky colors. Check your photo software and printer manuals to find out what color management options are available and how to turn them on and off.

Even if all the aforementioned issues are resolved, however, don't expect perfect color matching between printer and monitor. Printers simply can't reproduce the entire spectrum of colors that a monitor can display. In addition, monitor colors always appear brighter because they are, after all, generated with light.

Finally, be sure to evaluate your print colors and monitor colors in the same ambient light — daylight, office light, whatever — because that light source has its own influence on the colors you see. Also allow your prints to dry for 15 minutes or so before you make any final judgments.

Printing Online or In-Store

Normally, I'm a do-it-yourself type of gal. I mow my own lawn, check my own tire pressure, and hang my own screen doors. I am woman; hear me roar. Unless, that is, I discover that I can have someone else do the job in less time and for less money than I can — which just happens to be the case for digital photo printing. Although I occasionally make my own prints for fine art images I plan to sell or exhibit, I have everyday snapshots made at my local retail photo lab.

Unless you're already very comfortable with computers and photo printing, I suggest that you do the same. Compare the cost of retail digital printing with the cost of using a home or office photo printer — remember to factor in the required ink, paper, and your precious time — and you'll no doubt come out ahead if you delegate the job.

You can choose from a variety of retail printing options:

- ✓ Drop-off printing services: Just like you used to leave a roll of film at the photo lab of your corner drugstore or camera store, you can drop off your memory card, order your prints, and then pick them up in as little as an hour.
- Self-serve print kiosks: Many photo labs, big-box stores, and other retail outlets also offer self-serve print kiosks. You insert your memory card into the appropriate slot, follow the onscreen directions, and wait for your prints to slide out the print chute.
- Online with mail-order delivery: You can upload your photo files to online printing sites and have prints mailed directly to your house. Photo-sharing sites such as Shutterfly, Kodak Gallery, and Snapfish are well-known players in this market. Many national retail chains (Ritz Camera, Wal-Mart, and others) also offer this service.

Online with local pickup: Here's my favorite option. Many national chains enable you to upload your picture files for easy ordering, and then you can pick up your prints locally.

282

This service is a great way to share prints with friends and family who don't live nearby. I can upload and order prints from my desk in Indianapolis, for example, and have them printed at a store located a few miles from my parents' home in Texas.

Printing from ZoomBrowser EX/ImageBrowser

If you prefer to print your own pictures on a home or office printer, the process is much the same as printing anything from your computer: You open the picture file in your photo software of choice; choose File Print; and specify the print size, paper size, paper type, and so on, as usual.

The following steps show you how to get the job done using Canon ZoomBrowser EX (Windows) or ImageBrowser (Mac). Chapter 8 introduces you to this free software, so you may want to pop over to that chapter to find out how to browse your images using the program, if you haven't already done so. Then walk this way:

1. Click the thumbnail for the image that you want to print.

2. Choose File Print Photo Print.

Your image then appears inside the Photo Print window, as shown in Figure 9-5. The figure shows the Windows Vista version of the Photo Print features. If you're a Mac user, your window lacks the gray task panel that appears on the left in Windows, but don't fret: The critical printing settings remain the same, albeit with a slightly different look.

3. Select a printer.

In Windows, choose the printer from the Name drop-down list. On a Mac, select your printer from the Printer drop-down list.

4. Specify your printer settings.

- Windows: Click the Properties button.
- Mac: Click the Page Setup button.

Either way, you're taken to the standard print-setup dialog box for your printer. The options therein depend on your printer, so check your manual for guidance. But be sure to specify the following settings:

- Paper size
- Paper type (glossy, plain paper, and so on)
- Borderless printing on or off (if your printer offers this feature)

Chapter 9: Printing and Sharing Your Photos

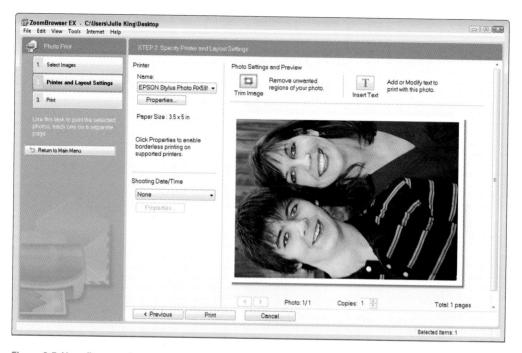

Figure 9-5: Your first step is to select a printer and paper size.

The browser software automatically chooses the print orientation (portrait or landscape) that best fits the image on the page. Even though you can select an orientation option in your printer setup dialog box, the program overrides you later if it deems necessary.

When you finish establishing the printer settings, click OK to return to the Photo Print window.

5. Adjust the image cropping as necessary.

By default, the browser automatically enlarges and/or crops your image to fit your chosen paper size if necessary. To see exactly what has been cropped in Windows, click the Trim Image button. On a Mac, click the Remove Unwanted Regions of Your Photo button.

In both cases, your image opens in the Trim Image editing window, as shown in Figure 9-6, which contains some of the controls that you see when you use the program's editing functions.

284

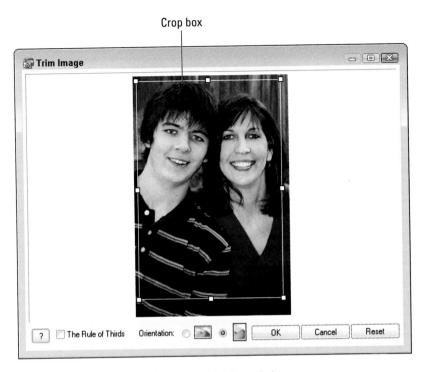

Figure 9-6: You can adjust the image cropping if needed.

Chapter 10 details the Trim Image editing controls, but here's the short story:

- The box with the little white squares around it indicates the crop box. Anything outside the box isn't printed.
- Drag any of those squares to adjust the size of the crop box. You're limited to setting the box to the same proportions as your selected paper size.
- Drag inside the box to move it over a different part of the photo.
- Click the Orientation icons (Windows) or Trimming Frame buttons (Mac) if you want to change the layout of the cropping box (horizontal or vertical).
- Click OK to apply the new cropping and return to the Photo Print window.

If you don't want your photo to be cropped or enlarged, you need to exit the printing process and adjust a program preference. See the end of these steps for details.

6. Add the shooting date/time (optional).

You can print the date and time when the photo was taken by choosing an option from the Shooting Date/Time drop-down list in the Photo Print window (refer to Figure 9-5). The program determines the date and time from data in the image file.

If you choose to print the date and time, click the Properties button that appears underneath the Shooting Date/Time drop-down list to set the font, size, and placement of the type.

7. Add a caption to the photo (optional).

To add a caption to your photo, click the Insert Text button (Windows, upper-right corner of the screen) or the Add or Modify Text to Print with This Photo button (Mac). Either way, you're taken to the Insert Text window, which offers most of the same text tools as the regular Insert Text window, which I cover at the end of Chapter 10. If you add text, click OK to close the Insert Text window and return to the Photo Print window when you're finished.

8. Click the Print button.

Your photo file is shipped to the printer.

As I mention in Step 5, you can choose to turn off the automatic cropping that occurs by default. First, close the Photo Print window if it's open. Then take these steps:

- ✓ Windows: Choose Tools⇒Preferences to open the Preferences dialog box. Click the Printing tab and select the Do Not Allow Trimming of the Image option. Click OK to close the dialog box.
- ✓ Mac: Choose ImageBrowser →Preferences. Select Photo Print from the drop-down list at the top of the dialog box that appears. Then select Do Not Trim and click OK.

If you take this step, the Trim function inside the Photo Print dialog box becomes disabled, so you must do any cropping before you print.

Although it's fine for casual printing, Photo Print lacks some features that are typically found in most photo editors and even in the software that ships with most photo printers. You can't print multiple images on the same page, for example, or even multiple copies of the same photo. So if you own other software, you may find it more convenient than using the browser's print functions.

STHICAL STUR

286

Whatever software you use, be sure to follow the resolution guidelines set out near the beginning of this chapter. And note that the Photo Print window doesn't warn you if your image doesn't contain enough pixels to produce a good print at the size you select. So before you begin printing, check that pixel count by displaying the Shooting Information panel in the main browser window. The Image Size listing, highlighted in Figure 9-7, shows you the pixel count.

Your Rebel T1i/500D offers two features that enable you to print directly from your camera or memory card — without using the computer as middle-machine — assuming that your printer offers the required options.

The first of these features is DPOF (Digital Print Order Format). With this option, accessed via the Print Order option on your camera's Playback menu, you select the pictures on your memory card that you want to print, and you specify how many copies you want of each image. Then, if your photo printer has a Secure Digital (SD) memory card slot (or SDHC slot, if you use these new high-capacity cards) and supports DPOF, you just pop the memory card into that slot. The printer reads your "print order" and outputs just the requested copies of your selected images. (You use the printer's own controls to set paper size, print orientation, and other print settings.)

A second direct-printing feature, PictBridge, works a little differently. If you have a PictBridge-enabled photo printer, you can connect the camera to the printer using the USB cable supplied with your camera. A PictBridge interface appears on the camera monitor, and you use the camera controls to select the pictures you want to print. With PictBridge, you specify additional print options, such as page size and whether you want to print a border around the photo, from the camera.

Both DPOF and PictBridge are especially useful when you need fast printing. For example, if you shoot pictures at a party and want to deliver prints to guests before they go home, DPOF offers a quicker option than firing up your computer, downloading pictures, and so on. And if you invest in one of the tiny portable photo printers on the market today, you can easily make prints away from your home or office you can take both your portable printer and camera along to your regional sales meeting, for example.

For the record, I prefer DPOF to PictBridge because with PictBridge, you have to deal with cabling the printer and camera together. Also, the camera must be turned on for the whole printing process, wasting battery power. If you're interested in exploring either printing feature, your camera manual provides complete details.

Chapter 9: Printing and Sharing Your Photos

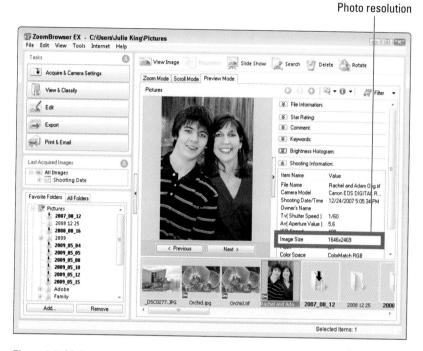

Figure 9-7: Make sure that the pixel count is adequate for the print size.

Preparing Pictures for E-Mail and Online Sharing

How many times have you received an e-mail message that looks like the one in Figure 9-8? Some well-meaning friend or relative sent you a digital photo that's so large you can't to view the whole thing on your monitor.

The problem is that computer monitors can display only a limited number of pixels. The exact number depends on the monitor's resolution setting and the capabilities of the computer's video card, but suffice it to say that the average photo from one of today's digital cameras has a pixel count in excess of what the monitor can handle.

In general, a good rule is to limit a photo to no more than 450 pixels at its longest dimension. That ensures that people can view your entire picture without scrolling, as in Figure 9-9. This image measures 450 x 300 pixels.

288

This recommendation means that even if you shoot at your camera's lowest-resolution setting (2352×1568) , you need to dump pixels from your images before sending them to the cyber post office. If you're posting to an online photo sharing site, you may be able to upload all your original pixels, but many sites do have resolution limits.

Figure 9-8: The attached image has too many pixels to be viewed without scrolling.

In addition to resizing your originals, you also need to check their file type; if the photos are in the Raw (CR2) or TIFF format, you need to create a JPEG copy for online use. Web browsers and e-mail programs can't display Raw or TIFF files.

Fortunately, you can tackle both bits of photo prep pretty easily in ZoomBrowser or ImageBrowser. Click this way:

1. For Raw files, follow the steps in Chapter 8 to convert the photo to the TIFF format.

You use Canon Digital Photo Professional to do the conversion. After you finish the process, close that program and return to ZoomBrowser (Windows) or ImageBrowser (Mac).

Given that you then need to make a JPEG copy of your TIFF file for online sharing, why not just save your converted raw files as JPEG images at the processing stage? Because JPEG is a destructive format, eliminating some image data as a tradeoff for producing smaller file sizes. You want to create the original Raw conversion in the TIFF format, which retains top image quality.

Figure 9-9: Keep e-mail pictures to no larger than 450 pixels wide or tall.

2. In the image browser, click the thumbnail of the photo you want to e-mail.

The photo can be in JPEG or TIFF format.

3. Choose File⇔Export⇔Export Still Images (Windows) or File⇔Export Image (Mac).

Export is the geekspeak way of saying "save this file in a different format."

In Windows, you next see a window that contains the file-saving options, as shown in Figure 9-10. On a Mac, you see the Write a Still Image box instead; click Edit and Save Image and then click the Next button to get to the file-saving options. They're arranged a little differently on the Mac than in Figure 9-10, but the basic controls are the same.

	STEP 2. Specify the export settings	
1. Select Images	Image Settings	You can reduce the amount of memory your files use by
Specify Export Settings	Long side:	resizing the images to a smaller size.
3. Finish	400 pixels	
Ise this task to create copies of our photos. You can change the use quality, and image type of he exported photos without	Short side:	
iffecting the originals		
Return to Main Menu		When exporting images as JPEGs, you can also reduce file sizes by using a lower Quality setting which compresses the
	Original File Size: 5.1 MB Modified File Size: 146.2 KB Calculate	image more. The images won't look as sharp but the file sizes will be smaller.
	File Name Settings	ARC: ARC: 3
	abc 🖻 Add a prefix MG_	
	Save to Folder	High quality Low quality
	Current Folder Pictures Specify Folder Browse	
	•	
	Selected terms: 1	

Figure 9-10: Use the Export command to create a JPEG copy of a TIFF photo.

4. Set the image size.

To keep the original pixel count, deselect the Resize Images During Export check box (Windows) or Resize the Image box (Mac). If you want to resample the image (trim the pixel count), select the box, as shown in the figure. Then click the Long Side option (Windows) or Specify the Length Dimension (Mac) and type a value in the neighboring box. The value you enter determines the number of pixels the image contains along its longest side. The program automatically sets the pixel count of the shortest side to retain the original image proportions.

For e-mail images, I suggest setting the long side of the image to 450 pixels or less. This ensures that the recipient can view the entire image without scrolling the e-mail window. If you're posting to an online photo sharing site, check the site guidelines about picture dimensions. Some sites enable you to upload high-resolution photos so that people who

view them can order prints. Usually, the main photo page contains small thumbnails that people can click to view the larger version of the image.

5. Select the Change Image Type check box.

For JPEG originals, you aren't actually changing the file type, but you need to check the box anyway to be able to access the file-saving option used later, in Step 7.

6. Select the JPEG format from the drop-down list under the check box.

This setting should already be selected for you if your original is a JPEG file.

7. Use the Quality (Windows) or Image Quality (Mac) slider to set the desired image quality.

At the highest Quality setting, the program applies the least amount of *JPEG compression*, which is the process that reduces file sizes by dumping image data. For the best image quality, set the slider to either Highest or High. (Your file size is already pretty small because of the reduced pixel count.)

By clicking the Calculate button, you can see the approximate file size of your JPEG copy, which is determined by the dimensions (pixel count) and quality level you choose. If you're sending the photo to someone who is forced to still use a dial-up Internet connection, you may want to notch the quality level down a bit so the picture can download faster.

8. Specify a filename.

You have two options:

• Accept the program's filename. If you deselect the Add a Prefix check box (Windows) or the Rename the File box (Mac), the program gives your JPEG copy the same name as the original — for example, IMG_7813.TIF becomes IMG_7813.JPG. For JPEG photos, the program tags a number onto the end of the filename so that you don't overwrite your original file. IMG_7813.jpg becomes IMG_7813_2.jpg, for example.

• *Create a new filename:* You also can assign a new filename to your e-mail-sized copy. First, select the Add a Prefix check box (Windows) or the Rename the File box (Mac). Then type the text in the adjacent text box. Note that the program automatically appends the numbers 0001 to whatever text you enter. For example, if you type **Web** in the box, the filename of your JPEG copy will be Web0001.jpg.

Online photo sharing: Read the fine print

If you want to share more than a couple of photos, consider posting your images at an online photo album site instead of attaching them to e-mail messages. Photo sharing sites (such as Shutterfly, Kodak Gallery, and Picasa) all allow you to create digital photo albums and then invite friends and family to view your pictures and order prints of their favorites.

At most sites, picture sharing is free, but your albums and images are deleted if you don't order prints or make some other purchase from the site within a specified amount of time. Additionally, although many free sites enable you to upload high-resolution files for printing, they don't let you retrieve those files from the site. (In other words, don't think of album sites as archival storage solutions.) And here's another little bit of fine print to investigate: The membership agreement at some sites states that you agree to let the site use your photos, for free, for any purpose that it sees fit. I never use this type of site, but it's up to you to decide what you think is safe and fair.

9. Choose the folder where you want to store the JPEG file.

• *Windows:* You specify the folder by using the Save to Folder option. Click Current Folder to put the copy in the same folder as the original. Click Pictures (or My Pictures, depending on the version of Windows you use) to put the copy in that folder instead, or click Browse to select another folder.

Depending on the size of the program window, you may need to scroll the window display to be able to see the Save to Folder option.

• *Mac*: On a Mac, the current folder destination appears at the bottom of the dialog box; click the Browse button to select a different storage bin.

10. Click Finish to save the copy.

After creating your Web-ready image, you can attach it to an e-mail message just as you do any file.

If you need to prepare a photograph for use on a Web page, you can use these same steps. Just ask the Web site designer what dimensions to use in Step 4. Also find out whether the site has any maximum file size limits and, if so, adjust the quality level in Step 7 until you get the picture file within those guidelines. (Click the Calculate button after each adjustment to see the new file size.)

292

Creating an In-Camera Slide Show

Many photo editing and cataloging programs offer a tool for creating digital slide shows that can be viewed on a computer or (if copied to DVD) on a DVD player. You can even add music, special transition effects, and the like to jazz up your presentations.

If you just want a simple slide show — that is, one that just displays all the photos on the camera memory card one by one — you don't need a computer or any photo software. You can create and run the slide show right on your camera. And by connecting your camera to a television, as outlined in the next section, you can present your show to a whole roomful of people.

Follow these steps:

1. Display Playback Menu 2 and highlight Slide Show, as shown on the left in Figure 9-11.

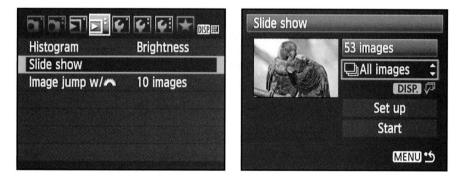

Figure 9-11: Choose Slide Show and then use the options to customize a few aspects of the playback.

2. Press Set.

You see the screen shown on the right in the figure. The thumbnail shows the first image that will appear in the slide show.

In the neighboring box, you see the total number of images currently slated for inclusion in the show. On your first trip to this menu screen, all images on the card are selected for the show.

3. Select which files you want to include in the slide show.

To do this, highlight the second box to the right of the thumbnail — it says All Images in Figure 9-11. Then press Set to activate the option box, as shown in the figure. (The little up and down arrows indicate the option's active and ready to be adjusted.)

Now use the up and down cross keys to scroll through your four playback options and select your choice, as follows:

- *All Images*: Choose this setting and then press Set to include all files, whether they're still photos or movies.
- *Date:* With this option, you can play only pictures or movies taken on a single date. As soon as you select the option, the screen changes to show you the thumbnail of the first photo you took on the most recent shooting data, along with the number of pictures taken on the same day (see the figure on the left in Figure 9-12). To select a different date, press the DISP button to bring up a screen similar to the one shown on the right in Figure 9-12. The list on the left shows you the shooting dates of all the files on the memory card. Use the up and down cross keys to scroll to the date you want to use and then press Set.

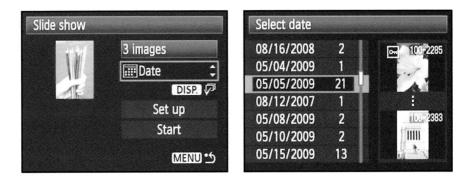

Figure 9-12: With the Date option, you can limit the show to photos or movies shot on a specific day.

- *Movies:* Select this option and press Set to include only movies in your show.
- *Stills:* Select this option and press Set to include only still photos in the show.
- 4. Highlight Set Up, as shown on the left in Figure 9-13, and press Set.

You cruise to the right screen in the figure.

5. Set the still photo playback time.

By default, all still photos appear for one second. If you want a longer display time, highlight the Play Time option, as shown on the right in the figure, and press Set. You're presented with a menu that offers four timing options, ranging from one second to five seconds. Highlight your choice and press Set.

294

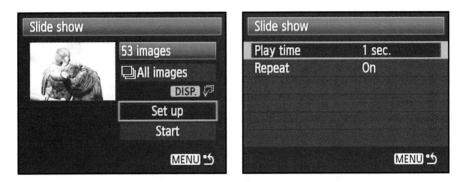

Movies are played in their entirety, regardless of the option you choose here.

6. Specify whether you want the slide show to "loop" continuously.

That is, do you want the camera to cease playback when it reaches the last photo (not loop) or movie or start the show over again (loop)? Here's how to make the call:

- a. Highlight the Repeat option on the Slide Show screen (right image in Figure 9-13).
- b. Press Set to activate the option.
- c. Highlight On for continuous looping, or highlight Off for a one-time playback.
- d. Press Set again.
- 7. Press Menu to return to the main Slide Show screen.

This is the one shown on the left in Figure 9-13.

8. Highlight Start and press Set.

Your slide show begins playing.

During the show, you can control the display as follows:

- Pause playback. Press the Set button. While the show is paused, you can press the right or left cross key to view the next or previous photo. Press Set again to restart playback.
- Change the information display style. Press the DISP button. (See Chapter 4 for details about the available display styles.)
- Adjust sound volume for movies. Rotate the Main dial.
- Exit the slide show. Press the Menu button twice to return to Playback Menu 2. Or press the Playback button to return to normal photo playback.

Viewing Your Photos on a Television

Your camera is equipped with a feature that allows you to play your pictures and movies on a television screen. In fact, you get two playback options:

- HDTV playback: If you have a high-definition television, you can set the camera to high-def playback. However, you need to purchase an HDMI cable to connect the camera and television; the Canon part number you need is HDMI Cable HTC-100.
- Regular video playback: Haven't made the leap yet to HDTV? (Join the crowd or, at least, join me.) No worries: You can set the camera to send a regular, standard definition audio and video signal to the TV. And for this option, no added cable investment is needed because the cable you need is included with the camera. It's the one that has two plugs (one yellow and one black) at one end.

With the right cable in hand and the camera turned off, open the little rubber door on the left side of the camera. There you find two ports (connection slots): one for a standard audio/video (A/V) signal and one for the HDMI signal. The A/V port is the same one you use to connect the camera via USB for picture download, as explained in Chapter 9. Figure 9-14 labels the two ports.

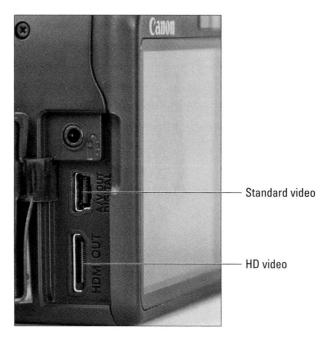

Figure 9-14: You can connect your camera to a television, VCR, or DVD player.

296

The smaller plug on the cable attaches to the camera. For A/V playback, your cable has two plugs at the other end: The yellow one goes into your TV's video jack; the black one goes into the audio jack. For HDMI playback, there's just a single plug that goes to the TV.

At this point, I need to point you to your specific TV manual to find out exactly which jacks to use to connect your camera. You also need to consult your manual to find out what channel to select for playback of signals from auxiliary input devices.

After you sort out that issue, turn on your camera to send the signal to the TV set. You can control playback using the same camera controls as you normally do to view pictures on your camera monitor. (See Chapter 4 for help.) You can also run a slide show by following the steps outlined in the preceding section.

Note that you may need to adjust one camera setting, Video System, which is found on Setup Menu 2. You get just two options here: NTSC and PAL. Select the video mode that's used by your part of the world. (In the United States, Canada, and Mexico, NTSC is the standard.)

Part IV The Part of Tens

In this part ...

n time-honored *For Dummies* tradition, this part of the book contains additional tidbits of information presented in the always popular "Top Ten" list format.

Chapter 10 shows you how to do some minor picture touchups, such as cropping and adjusting exposure, by using the free software that shipped with your camera. Following that, Chapter 11 introduces you to ten camera functions that I consider specialty tools — bonus options that, while not at the top of the list of the features I suggest you study, are nonetheless interesting to explore when you have a free moment or two.

Ten Fast Photo-Editing Tricks

very photographer produces a clunker image now and then. When it happens to you, don't be too quick to reach for the Erase button on your camera. Many common problems are surprisingly easy to fix using the tools found in most photo-editing programs.

In fact, you can perform many common retouching tasks using one of the free programs provided with your camera. Called ZoomBrowser EX in Windows and ImageBrowser on the Mac, this software offers tools for removing redeye, adjusting exposure, tweaking colors, sharpening focus, and more.

Chapter 8 introduces you to these programs, showing you how to use them to download, view, and organize your pictures. This chapter lays out the step-by-step instructions for using the editing tools to repair and enhance your photos.

A few other notes before you start:

- If you shot your pictures using the Raw file format, you must process them using the raw-conversion instructions laid out in Chapter 8 before you can edit them.
- Although the tools provided in the free software are pretty good, they don't allow selective editing. That is, you can't apply them just to the part of your photo that needs help. For that kind of retouching work, you need a more sophisticated photo editor. One inexpensive pick to consider is Adobe Photoshop Elements (www.adobe.com), which retails for under \$100 and contains all the tools most digital photographers need.
- Most figures in this chapter feature the Windows versions of the Canon software. Although the Mac version looks different, the retouching steps are the same unless I state otherwise.
- ✓ For simplicity's sake, I refer to ZoomBrowser EX and ImageBrowser generically in the instructions here as just "the browser."

Finally, Canon occasionally posts updates to its software on its Web site (www.canon.com). So if you've owned your camera for a while, check the Web site to make sure that you're using the most current versions of the available programs. This book features version 6.3.1 of ZoomBrowser EX and ImageBrowser.

Removing Red-Eye

From my experience, red-eye is not a major problem with the Rebel T1i/500D. But if you spot red-eye in your flash pictures, take these steps to fix the problem:

1. In the main browser window, double-click the image thumbnail.

Again, Chapter 8 shows you how to get your images into the browser and keep track of your picture files.

After you double-click a thumbnail, the picture opens in its own Viewer window. Figure 10-1 offers a look at how the window appears in Windows; Figure 10-2 shows the Mac version.

2. Open the Edit drop-down list, as shown in Figures 10-1 and 10-2.

Figure 10-1: In Windows, click the Edit list above the preview to access retouching tools.

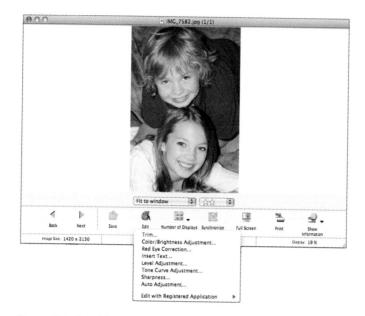

Figure 10-2: On a Mac, the Edit list appears at the bottom of the window.

3. Choose Red Eye Correction from the Edit list.

Your photo appears in the Red Eye Correction retouching window. Figure 10-3 shows the Windows version; Figure 10-4, the Mac version.

4. Zoom in on your photo so that you can get a good view of the eyes.

- *In Windows:* Zoom and scroll the display using the controls labeled in Figure 10-3, which work the same way as they do when you view your photo in the initial Viewer window. Chapter 8 details all the controls, but here's a quick reminder: The fastest way to zoom in and out is to drag the Zoom slider; to scroll the display, just drag in the Navigator window, which appears whenever the entire image isn't visible at the current preview size. Or click the Hand tool, labeled in Figure 10-3, and drag in the preview.
- *On a Mac:* Zoom by choosing a magnification level from the Display Size drop-down list, labeled in Figure 10-4, or by clicking the Zoom In and Zoom Out buttons. The Mac version of the retouching window does not sport a Navigator window instead, you use the scroll bars to scroll the display.

5. Click the Manual Mode option.

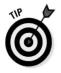

In Auto mode, the red-eye correction tool can sometimes trip up, "correcting" red pixels that aren't actually in the eye, so stick with Manual mode, which enables you to specify exactly where you want the program to do its retouching work.

304 Part IV: The Part of Tens _____

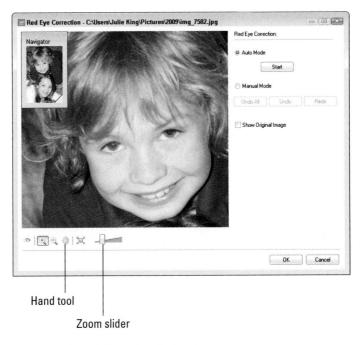

Figure 10-3: Zoom in for a close look at the eyes.

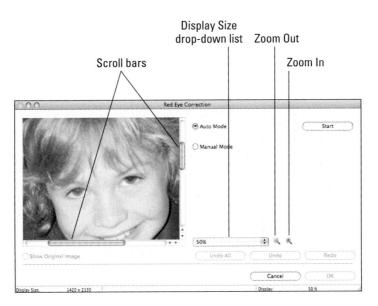

Figure 10-4: On a Mac, use these controls to adjust the preview size.

6. In Windows, select the Red Eye tool, labeled in Figure 10-5.

The tool is ready to go if it appears highlighted, as in the figure. If not, click the tool icon. Mac users can ignore this step.

7. Position your mouse cursor over one of the red eyes.

If the program detects fixable red pixels, a green circle appears, as shown in Figure 10-5. The circle indicates the area that the tool will try to correct. As you move your cursor around the eye, the circle may change size as the program searches for pixels that meet its red-eye criteria.

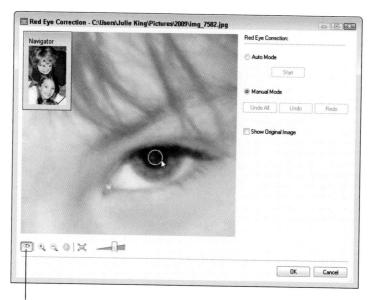

Red Eye tool

Figure 10-5: The little green circle indicates the eye area that will be replaced.

8. Click to initiate the repair.

If you like what you see, move on to the next eye. Or click Undo to get rid of the correction and then try again.

9. After you finish all eye repairs, click OK.

The Red Eye Correction window closes, and your repaired photo appears in the Viewer window.

10. Save your picture in the TIFF file format.

The last section of this chapter provides details.

Like most red-eye removal tools, the Canon version can do a good job in the right circumstances. But if the eyes are very bright, the tool may not be able to make the repair. In addition, no red-eye remover works on animal eyes; red-eye tools detect and replace only red-eye pixels, and animal eyes typically turn yellow, white, or green in response to a flash. The best solution is to simply paint in the correct eye colors.

Cropping Your Photo

To *crop* a photo simply means to trim away some of its perimeter. Removing excess background can often improve an image, as illustrated by my original frog scene, shown on the left in Figure 10-6, and its cropped cousin, shown on the right. In the original image, there's just too much going on — the eye has a hard time figuring out what's important. Eliminating all but a little of the surrounding foliage returned emphasis to the subject and created a stronger composition.

Figure 10-6: Cropping creates a better composition, eliminating background clutter.

You may also want to crop an image so that it fits a specific frame size. As Chapter 8 explains, the original images from your camera fit perfectly in 4-x-6inch frames, but if you want a $5 \ge 7, 8 \ge 10$, or other standard print size, you need to crop your image to those new proportions. (If you don't, the photo printer software or retail print lab will crop for you, and the result may not be the composition that you'd choose.) Follow these steps to get the job done:

1. In the main browser window, double-click the image thumbnail.

Your photo appears all by its lonesome in a new Viewer window.

2. Choose Trim from the Edit drop-down list.

Refer to Figures 10-1 and 10-2, in the preceding section, if you need help finding the list. Your image appears in the Trim Image retouching window, and a dotted outline, called a *crop box*, appears around your photo, as shown in Figure 10-7.

3. Click the Advanced Options button to display all the crop-size controls.

Figure 10-7 labels the button and shows the controls that appear when you click it. (On a Mac, the panel that contains the controls pops out of the side of the dialog box instead of appearing within it.)

Trim button

Figure 10-7: You can specify a crop size via the Advanced Options controls.

Part IV: The Part of Tens .

4. Choose an option from the Aspect Ratio drop-down list.

Your selection determines the proportions of the cropped image. You can go in three directions:

- *Manual:* This option enables you to crop the image to any proportions. I chose this setting for my frog photo.
- *Maintain Original:* The program restricts you to cropping to the same proportions as your original, which is 3:2.
- *Specific Aspect Ratios:* You also can select from six specific aspect ratios: 2:3, 3:2, 3:4, 4:3, 9:16, and 16:9. The first number in the pair indicates the width, and the second indicates the height.
- 5. In Windows, make sure that the Trim button is selected (refer to Figure 10-7).

It should be selected already unless you used the adjacent controls to zoom or scroll the preview. Just click the button to select it if needed. Mac users can skip this step.

6. Adjust the size and position of the crop box as needed.

Use these techniques:

- *Move the crop box*. Drag inside the box.
- *Resize the crop box.* Drag any of the *handles* those little squares around the perimeter of the crop box. I labeled one of the handles in Figure 10-7.

As you drag the handles, the W and H boxes in the Size of Trimming Area portion of the dialog box reflect the new dimensions of the crop box, with the measurement shown in pixels. Keep in mind that pixel count is critical to print quality. Chapters 3 and 9 provide details, but the short story is that you need roughly 200 to 300 pixels per linear inch of your print. So if you have a finished print size in mind, monitor the W and H values as you adjust the crop box size to make sure that you aren't clipping away too many pixels.

• *Set a specific crop size.* You also can enter specific pixel dimensions in the W and H boxes. The crop box automatically adjusts to the dimensions you enter.

Using the third option is the easiest way to crop your photo to a size that doesn't mesh with any of the specific aspect ratio choices. Say that you want to produce a 5-x-7-inch print from your cropped photo, and you want an image resolution of 300 pixels per inch. Just multiply the print dimensions by the desired resolution and then enter those values into the W and H boxes. For the 5 x 7 at 300 ppi example, the W and H values are 1500 and 2100, respectively. If the resulting crop boundary encompasses too much or too little of your photo, just keep adjusting the W and H values, making sure to always keep the two at the same proportions you originally entered.

7. Turn on the Use the Rule of Thirds gridlines (optional).

A classic composition rule is to imagine that your image is divided into thirds vertically and horizontally and then position the subject at a spot where two dividing lines intersect. To help you visualize that concept, the Trim box can display those horizontal and vertical grid lines, as shown in Figure 10-8. Just click the Use the Rule of Thirds check box to toggle the grid on and off.

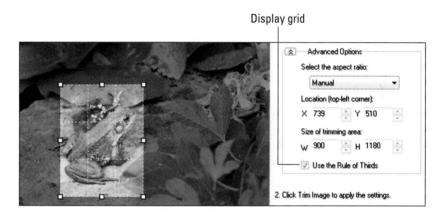

Figure 10-8: The Rule of Thirds gridlines offer a compositional guide.

8. When you're happy with the crop box, click the Trim Image button.

The cropped photo appears in the preview. If you don't like the results, click the Undo button and try again.

- 9. Click OK to close the retouching window.
- 10. Choose File Save As to save your cropped image.

The last section of this chapter has details.

Adjusting Color Saturation

Saturation refers to the intensity and purity of color. A fully saturated color contains no black, white, or gray. In other words, saturated colors are deep, rich, and bold.

On occasion, an image can benefit from a little saturation bump. Figure 10-9 offers an example. I was drawn to this scene by the mix of colors, and the original photo, shown on the left, seemed a little lackluster in that regard. So I increased the saturation ever so slightly to produce the image shown on the right.

310 Part IV: The Part of Tens

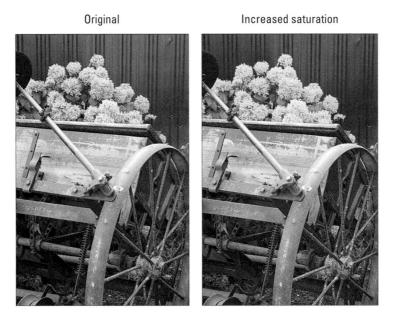

Figure 10-9: I slightly increased saturation to make the colors pop a little more.

Follow these steps to adjust saturation:

1. In the main browser window, double-click the image thumbnail.

Your photo opens inside its own Viewer window.

2. Click the Edit drop-down list.

The list appears above the image preview in Windows; it appears below the preview on a Mac.

3. Choose Color/Brightness Adjustment from the list.

Your image appears in the Color/Brightness Adjustment retouching window. The window contents vary depending whether you're using the Windows or Mac version of the program; Figures 10-10 and 10-11 show you both versions.

4. Set the Retouching mode to Color Adjustment.

- In Windows: Select Color Adjustment from the drop-down list at the top of the window (refer to Figure 10-10). After you do so, the window offers three sliders: Brightness, Saturation, and Contrast.
- On a Mac: Click the Color Adjustment tab. The Mac version of the tool offers just Saturation and Brightness sliders.

	AND DESCRIPTION PROPERTY AND	Please select adjustment option:	
	Color Adjustment	annaannan an	
	Brightness:	0	
	Saturation:		
	Contrast:	0	
1			
15- march 1			
1/4			
	1		
A BAR AND			
	6		
	Undo All U	ndo Aedo	

Figure 10-10: In Windows, select Color Adjustment from the top drop-down list.

	Color/Brightness Adjustment
	RGB Adjustment Color Adjustment
	Saturation 12
	Brightness 0
Show Original Image	Undo All Undo Redo
	Cancel
Display Size: 1420 x 2130	

Figure 10-11: On a Mac, click the Color Adjustment tab to display these options.

One note about the Brightness and Contrast controls: These tools aren't the best options for adjusting exposure and contrast. You can get much better results by using the Level Adjustment and Tone Curve Adjustment tools, both explained later in this chapter.

5. Drag the Saturation slider to adjust the image as desired.

Be careful about increasing saturation too much. Doing so actually can destroy picture detail because areas that previously contained a range of saturation levels all shift to the fully saturated state, giving you a solid blob of color.

- 6. Click OK to apply the change and close the retouching window.
- 7. Save the edited image, following the steps provided at the end of this chapter.

Tweaking Color Balance

Chapter 6 explains how to use your camera's White Balance and Picture Style controls to manipulate the colors in your pictures. If you can't get the results you want by using those features, you may be able to do the job using the RGB Adjustment filter offered by the Canon browser. In Figure 10-12, for example, I used the filter to tone down the amount of blue in the image and bring out the warm yellow tones of the building instead.

Figure 10-12: I warmed colors to emphasize the buildings rather than the sky.

Follow these steps to use the filter:

1. Open the image in its own Viewer window.

You do this by double-clicking the image thumbnail in the main browser window.

2. Choose Color/Brightness Adjustment from the Edit drop-down list.

Look for the list above the image preview if you're a Windows user; on a Mac, the list is below the preview. After you choose the command, your photo appears in a retouching window. Figure 10-13 shows you both the Windows and Mac versions of the window.

3. Choose RGB Adjustment.

In Windows, choose the option from the drop-down list at the top of the window, as shown in the top image in Figure 10-13. On a Mac, just click the RGB Adjustment tab, as shown in the lower image. Either way, you gain access to three sliders: Red, Green, and Blue.

4. Drag the sliders to adjust image colors.

The filter is based on three color pairs: red-cyan; green-magenta; and blue-yellow. (Those six colors happen to be the primary and secondary colors of the RGB color world, which is the one in which all digital images reside.) When you move the sliders, you affect both the primary color and its secondary opposite, as follows:

- *Red slider:* As you drag the slider to the right, you increase red and decrease cyan. Drag the slider to the left to diminish reds and embolden cyans.
- *Green slider*: Drag this slider to the right to add green and reduce magenta. Drag to the left to produce the opposite result.
- *Blue slider:* Drag this slider to the right to increase the amount of blue and reduce the amount of yellow. Drag left to increase yellow and tone down blues.

In imaging lingo, tools of this type are *color balancing* filters because they shift the balance between the two opposite colors.

I used the slider settings shown in the figure for my photo.

- 5. Click OK to apply the change and close the retouching window.
- 6. Save your work in the TIFF format, as explained in the last section of this chapter.

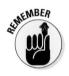

Part IV: The Part of Tens

Figure 10-13: Select RGB Adjustment to tweak color balance.

Adjusting Exposure

Getting exposure just right is one of the trickiest aspects of photography. Fortunately, the Canon software gives you several tools for tweaking exposure. The next sections introduce the two most capable: the Level Adjustment filter and the Tone Curve Adjustment filter.

Stay away from the exposure options that appear when you open the Color Adjustment filter (shown in Figures 10-10 and 10-11). In Windows, the filter offers a Brightness and Contrast slider; on a Mac, you get just the Brightness slider. The problem is that both sliders affect all pixels in your image; you can't brighten just the shadows, for example, without also brightening the *midtones* (areas of medium brightness) and highlights. For that reason, these sliders rarely produce good results.

Three-point exposure control with the Level Adjustment filter

With the Level Adjustment filter, you can adjust shadows, midtones, and highlights individually. Figure 10-14 shows the filter as it appears in Windows; the Mac version contains the same options in a slightly different layout.

Figure 10-14: The Level Adjustment tool isn't nearly as difficult to use as it appears.

Now, I know what you're thinking: "Wow, that looks *way* too complicated for me." Trust me, though, that this filter is actually pretty easy to use. First, ignore everything but the graph in the middle of the box, known as a *histogram*, and the three sliders underneath, labeled Shadows, Midtones, and Highlights in Figure 10-15. See? Easier already.

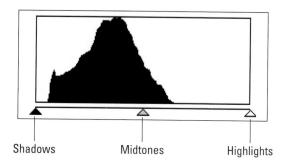

Figure 10-15: All you need to worry about are these three sliders.

The histogram works just like the Brightness histogram that you can display while reviewing your images on your camera monitor, a topic that I discuss in Chapter 4. The horizontal axis of the graph represents the possible brightness values in an image, ranging from black on the left side to white on the right. The vertical axis shows how many pixels fall at a particular brightness value. So if you have a tall spike, you have lots of pixels at that brightness value.

To adjust exposure, drag the three sliders underneath the histogram, depending on whether you want to shift shadows, midtones, or highlights. Follow these steps to try it out:

- 1. In the main browser window, double-click the image thumbnail to open it in a new Viewer window.
- 2. Open the Level Adjustment retouching window.
 - *In Windows:* Choose Color/Brightness Adjustment from the Edit drop-down list, found above the image preview. Then select Level Adjustment from the drop-down list at the top of the retouching window, as shown in Figure 10-14.
 - *On a Mac:* Choose Level Adjustment from the Edit drop-down list, which appears underneath the image preview.

3. Set the Channel option to RGB.

On a Mac, the option is unlabeled; it's the pop-up list above the histogram.

- 4. Drag the sliders underneath the histogram to adjust exposure.
 - To darken shadows: Drag the Shadows slider to the right.
 - *To adjust midtones:* Drag the middle slider to the right to darken midtones; drag it to the left to brighten them.
 - *To brighten highlights:* Drag the Highlights slider to the left.

When you drag the Shadows or Highlights slider, the Midtones slider moves in tandem. So you may need to readjust that slider after you set the other two.

You can compare your original image with the adjusted one by toggling the dialog box preview on and off. In Windows, click the Show Original Image box to turn off the preview; click again to return to the preview. On a Mac, click the Preview box.

I dragged the sliders to the positions shown in Figure 10-16 to produce the results you see in the preview.

- 5. Click OK to accept the changes and close the dialog box.
- 6. Save your image in the TIFF file format.

See the last section of this chapter to find out how.

	Please select adjustment option:	
CANCE TO BE	Level Adjustment 💌	
1 Social States	Auto Levels ?	
A A	Channet: RGB -	
	Input Levels: 13 1.48 180	
	Output Levels: 0 255	
T. A / A		
VET	Use Last Applied Settings	
Electra Albert	🖾 Show Original Image	
1 A A SKI	Undo All Undo Reda	

Figure 10-16: I brightened highlights and midtones but darkened shadows slightly.

Gaining more control with the Tone Curve Adjustment filter

With the Level Adjustment filter, you get three points of exposure-correction control — highlights, shadows, and midtones. The Tone Curve Adjustment filter takes things a step further, enabling you to manipulate specific values along the entire brightness spectrum.

Figure 10-17 offers a look at the Windows version of the Tone Curve Adjustment retouching window. The Mac version is slightly different in appearance, but it contains the same main components.

Again, the controls inside the window seem mighty perplexing at first. But here's all you need to know to take advantage of the filter:

- ✓ See that line that runs diagonally through the white grid? That's just another representation of the possible brightness values in a digital image. Black falls at the lower end of the line; white, at the top. (The shaded bars that run alongside the left and lower edges of the grid remind you of that orientation.) Medium brightness falls dead center on the line.
- ✓ To adjust exposure, click and drag at the spot on the line that corresponds to the brightness value you want to change. Drag up to brighten the image; drag down to darken it. For example, in Figure 10-18, I dragged the center of the line up. The resulting curve *tone curve*, in imaging parlance produced the exposure change shown in the preview.

318 Part IV: The Part of Tens _____

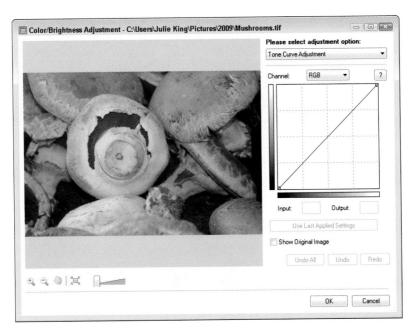

Figure 10-17: With the Tone Curve Adjustment filter, you get even greater exposure control.

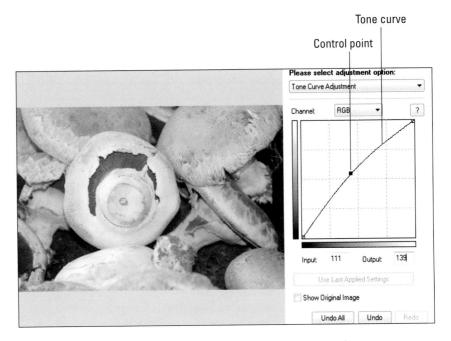

Figure 10-18: Drag upward to brighten the image; drag down to darken it.

- ✓ After a drag, a control point appears at the spot on the line you dragged to anchor that part of the tone curve, as shown in Figure 10-18.
- ✓ You can bend the tone curve as much as you want, in any direction you want. Just keep clicking and dragging to add control points. But be careful extreme curves or curves with tons of points can produce really ugly results and odd breaks in color and brightness. I usually aim for a gentle curve that has no more than six points, including the ones that are provided automatically at the black and white ends of the curve.
- ✓ To increase contrast, create an s-shaped curve; to decrease contrast, create a reverse-s shape. I used the gentle s-shaped curve, shown in Figure 10-19, to produce the finished mushroom photo that you see in the preview. The curve resulted in a slight bump in exposure to medium and medium bright pixels and a slight darkening of medium dark and dark pixels. The white and black areas of the image remain unchanged.

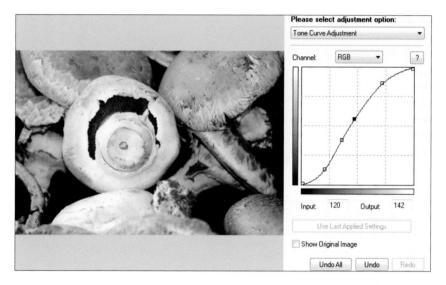

The best way to understand this filter is to try it. So take these steps:

1. Open the image in its own Viewer window.

You know the drill: Just double-click the thumbnail in the main browser window. (See Chapter 8 if you need help.)

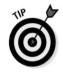

2. Open the Tone Curve Adjustment retouching window.

- *In Windows:* Click the Edit drop-down list at the top of the browser window and choose Adjust Color/Brightness. When the retouching window appears, select Tone Curve Adjustment from the drop-down list at the top.
- *On a Mac:* Click the Edit drop-down list underneath the image preview and choose Tone Curve Adjustment.
- 3. Set the Channel option to RGB.

On a Mac, the option is the unlabeled pop-up list just above the grid.

4. Bend the tone curve by adding and dragging control points.

See the preceding list for details on this step. If you need to delete a point, click it to select it and then press Delete. (The selected control point appears black.)

of INEMBER

If your image doesn't appear to change in the preview, check the status of the Show Original Image box. Deselect the box to turn on the dialog box preview.

- 5. Click OK to apply the adjustment and close the retouching window.
- 6. Save your image in the TIFF file format, following the steps at the end of this chapter.

Sharpening Focus (Sort Of)

Have you ever seen one of those spy-movie thrillers where the good guys capture a photo of the villain's face — only the picture is so blurry that it could just as easily be a picture of pudding? The heroes ask the photo-lab experts to enhance the picture, and within seconds, it's transformed into an image so clear you can make out individual hairs in the villain's mustache.

It is with heavy heart that I tell you that this kind of image rescue is pure Hollywood fantasy. You simply can't take a blurry image and turn it into a sharply focused photo, even with the most sophisticated photo software on the market. There is, however, a digital process called *sharpening* that can *slightly* improve the apparent focus of pictures that are *slightly* blurry, as illustrated by the before and after images in Figure 10-20. Notice that I say "apparent" focus: Sharpening doesn't really adjust focus but instead creates the *illusion* of sharper focus by increasing contrast in a special way.

Here's how it works: Wherever pixels of different colors come together, the sharpening process boosts contrast along the border between them. The light side of the border gets lighter; the dark side gets darker. Photography experts refer to those light and dark strips as *sharpening halos*. You can get a close-up look at the halos in the right, sharpened example in Figure 10-21,

which shows a tiny portion of the pencil image from Figure 10-20. Notice that in the sharpened example, the yellow side of the boundary between the pencils received a light halo, and the blue side received a dark halo.

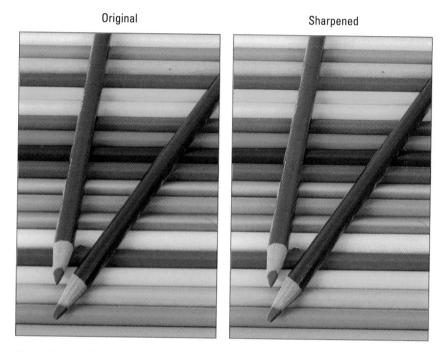

Figure 10-20: A slightly blurry image (left) can benefit from a sharpening filter (right).

Original

Sharpened

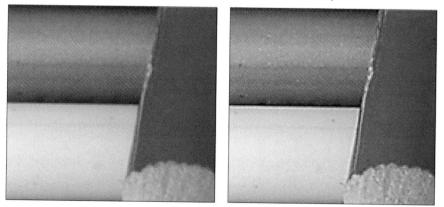

Figure 10-21: Sharpening adds light and dark halos along color boundaries.

Part IV: The Part of Tens

A little sharpening can go a long way toward improving a slightly soft image. But too much sharpening does more damage than good. The halos become so strong that they're clearly visible, and the image takes on a sandpaper-like texture. And again, no amount of sharpening can repair a truly out-of-focus image, so all you do when you crank up sharpening is make matters worse.

Both the Windows and Mac versions of the Canon software offer a simple Sharpening tool, but the Windows version offers a second sharpening filter as well. First, the rudimentary sharpener, shown in its Mac incarnation in Figure 10-22. To use this tool, just follow the usual steps: Double-click the image thumbnail to open it in its own Viewer window and then choose Sharpness from the Edit drop-down list. (See Figures 10-1 and 10-2 if you have trouble finding the list.) Drag the slider to the right to add sharpening and then click OK to finish the job.

	Sharpness
	Sharpness
and Second	
	Undo All Undo Redo
Show Original Image	Cancel OK
Display Size: 1420 x 2130	

Figure 10-22: The Mac version of the browser offers only a simple sharpening slider.

Windows users, however, have the option of using a more flexible sharpening tool, an Unsharp Mask filter. To switch to this filter, just click the Unsharp Mask tab at the top of the Sharpness retouching window, as shown in Figure 10-23.

The three sliders provided for the Unsharp Mask filter enable you to control where and how the sharpening halos are applied, as follows:

Amount: This slider adjusts the intensity of the sharpening halos.

Radius: This slider adjusts the width of the halos. Don't go too high, or else the sharpening halos will become very noticeable. ✓ Threshold: With this slider, you can limit the sharpening effect just to high-contrast color boundaries. Try raising the value a few notches up from 0 when sharpening portraits to sharpen the image without adding unwanted texture to the skin. I used this technique to keep the surface of the pencils smooth in my photo while sharpening the edges between them.

Whichever sharpening filter you use, don't forget to save the altered image in the TIFF file format. The last section of this chapter explains this critical part of the retouching process.

Sharpness - C:\Users\Julie King\Pictures\2009\Pencils original.tif	
	Sharpen Unsharp Mask
	2
	Amount: 73 🗼 %
	Radius: 1.0 📺 pixels
and the second	Threshold: 2 2 levels
and the second frances of the second	
and the second s	
and the second s	
and the first for the second s	
and the second s	Undo Ali Undo Redo
	Undo Ali Undo Redo
	OK Cancel
	11 P

Figure 10-23: The Unsharp Mask filter provides three levels of sharpening control.

Shifting to AutoPilot

You may have noticed as you explored the Edit drop-down list the Auto Adjustment option. If you select this option, the program opens your image in a retouching window, as usual. Figure 10-24 shows the Windows flavor of the window; the Mac version is virtually identical. After the window opens, click the Auto Adjust Image button and sit back and wait. The program analyzes your image and then makes whatever changes it deems necessary. You can compare the "before" and "after" views of your photo by clicking the Show Original Image box on and off.

Figure 10-24: Click Auto Adjust Image to see what changes the program thinks are needed.

As a rule, I don't recommend this type of automatic image correction tool because it so often doesn't produce results as good as what you can do by using the manual filter controls. That said, if you aren't working on important images or you just don't have the time or interest in using the more sophisticated tools, go ahead and give that Auto Adjust Image button a click. If you don't like what you see, click the Cancel button and do the job yourself, using the tricks laid out elsewhere in this chapter.

Adding Text

You know that saying, "A picture is worth a thousand words." Well, you can increase that count by adding text to your photo. You can do so as follows:

- 1. Open your photo in its own Viewer window by double-clicking the image thumbnail in the main browser window.
- 2. Choose Insert Text from the Edit drop-down list.

Look for the list at the top of the window if you use the Windows version of the program and at the bottom if you're a Mac user. Either way, you see your photo in the Insert Text retouching window. Figure 10-25 gives you a look at the Windows version of the window. (Again, the Mac version is virtually identical.)

	Insert Text.	
	Fort Name: Palatino Linotype Fort Size: 36 • Test Color: 18 7 11 @ Antiolate: 18 7 11 Test. Come on in	
	the water's fine! Import Comment	
Come on in the water's fine!	Import Shooting Date/Time	
the water's fine!	Undo All Undo Redo	

Figure 10-25: You can add captions and other text information.

3. Click in the preview at the spot you want to add the text.

In Windows, be sure that the Text tool, located under the preview, next to the Zoom tools, is selected before you click. After you click, a text box appears, as shown in the figure. At any time, you can resize the box as needed by dragging the little boxes that appear around its perimeter. To move the box (and any text inside), just drag inside the box.

4. Type your text.

The text appears both in the image preview and in the Text area on the right side of the window.

To add the date and time you shot the picture, click the Import Shooting Date/Time button. Similarly, if you added comment text when organizing your pictures, clicking the Import Comment button enters that text for you. (You can add comments via the Comment pane that appears when you browse images in Preview display mode. Chapter 8 explains the basics of browsing images.)

You can specify a font (type design), size, and color and add bold, underline, or italic formatting. The Antialias option smoothes the jagged edges that can occur when letters contain diagonal or curved lines. As a rule, keeping this option enabled is a good idea.

5. Click OK and save your edited photo as explained in the next section.

Saving Your Edited Files

Whatever retouching task you do, the last step is to save your edited picture file. After you click OK to close the retouching window and return to the Viewer window, choose File Save. You then see the standard Windows or Mac file-saving dialog box that appears when you save any type of file.

You need to take two critical steps inside the dialog box:

Select TIFF as the file type. TIFF is an image file format that produces the best picture quality for saved images.

Do *not* use JPEG as the file type. Every time you edit and save a picture in the JPEG format, you damage the picture quality slightly. Chapter 3 has details on this issue. Should you need a JPEG version of your edited photo for online use, save it first as a TIFF file and then follow the steps provided in Chapter 9 to create a copy in the JPEG format.

✓ Type a name for the picture in the File Name box (Windows) or the Save As box (Mac). The filename of the original image appears automatically in the box. You don't have to change the filename — you won't overwrite the original file when you save because you aren't saving it in the JPEG format (and you can't save in the Raw format). But I like to add a tag to the filename that indicates the status of the image — for example, IMG_7582 retouched, or PencilsSharpened, or the like.

After taking care of those two pieces of business, specify where you want to store the file as you usually do. Then click the Save button to save the file and close the dialog box.

Ten Special-Purpose Features to Explore on a Rainy Day

11 X

Consider this chapter the literary equivalent of the end of one of those late-night infomercial offers — the part where the host exclaims, "But wait! There's more!"

The ten features covered in these pages fit the category of "interesting bonus." They aren't the sort of features that drive people to choose one camera over another, and they may come in handy only for certain users, on certain occasions. Still, they're included at no extra charge with your camera, so check 'em out when you have a few spare moments. Who knows; you may discover that one of these bonus features is actually a hidden gem that provides just the solution you need for one of your photography problems.

Many of the features I discuss here involve Custom Functions, a group of 13 advanced options that you access via Setup Menu 3. If you're not familiar with how to navigate the Custom Functions, the next section spells things out.

Changing the Function of the Set Button

Normally, the Set button serves a couple of functions on the Rebel T1i/D500:

- When a menu is displayed, you press the button to lock in menu selections.
- When the Shooting Settings screen is displayed, you press Set to shift to the Quick Control screen, where you can quickly adjust certain critical picture-taking settings. (See Chapter 1 for details on that technique.)

This setup makes the most sense to me, but I would be remiss if I didn't tell you that you do have the option to use the Set button for something other than accessing the Quick Control screen. You can use it to display the Quality settings, for example, or the Flash Exposure Compensation setting.

To customize the button, take these steps:

1. Set your camera to one of the advanced exposure modes (P, Tv, Av, M, or A-DEP).

You can't adjust the performance of the Set button in the fully automatic exposure modes. Nor does the button perform whatever alternative function you may assign when the camera is set to those modes.

2. Display Setup Menu 3 and highlight Custom Functions, as shown on the left in Figure 11-1.

This menu item enables you to customize 13 aspects of the camera's performance.

3. Press Set.

The screen should look something like the one on the right in Figure 11-1, at least along the bottom of the screen. What appears in the rest of the screen depends on which Custom Function is selected.

The Custom Functions are grouped into four categories. The category number and name appear in the top-left corner of the screen; the number of the selected function appears in the top-right corner and is marked with a bar at the bottom of the screen. And the blue text indicates the current setting of the selected Custom Function. You also can see the number of the option that's selected at the bottom of the screen, underneath the Custom Function number. A zero represents the default setting.

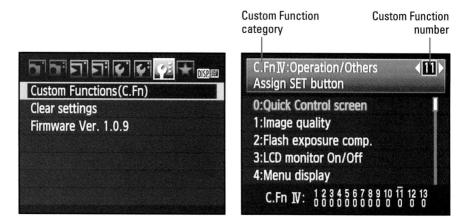

Figure 11-1: The Custom Function menu item provides access to 13 customization options.

328

4. If needed, press the right or left cross key to display Custom Function 11.

Now you should definitely see the options shown on the right in Figure 11-1.

5. Press the Set button.

Now the list of options for Custom Function 11 becomes accessible, and a yellow highlight box appears around one of the options, as shown in Figure 11-2. Again, the option that appears in blue is the selected setting; 0 represents the default setting.

If you select option 1, pressing the Set button whisks you to the screen where you can change the

Image Quality setting. Option 2 enables you to access the Flash Exposure Compensation screen instead. If you choose option 3, pressing Set turns the monitor off. Option 4 enables the Set button to display menus and option 5 disables the Set button altogether when no menus are active — but again, only for the advanced exposure modes.

6. Press the up or down cross keys to highlight your choice.

I highlighted the Flash Exposure Compensation option in Figure 11-2.

0:Quick Control screen 1:Image quality 2:Flash exposure comp. 3:LCD monitor On/Off 4:Menu display C.Fn IV: 12345678910111213

11

C.Fn IV: Operation/Others

Assign SET button

Figure 11-2: You can use the Set button to access Flash Exposure Compensation settings — but I'm not sure why you would.

7. Press the Set button.

Now whenever you shoot in the advanced exposure modes and press Set while no menus are displayed, the button takes on the function you just assigned to it. To go back to the default setting, repeat these steps, and select option 0 in Step 6. The button then reverts to its original purpose, which is to bring up the Quick Control screen when the Shooting Settings screen is displayed.

In case I didn't already make my opinion clear of which setting to use, I want to stress that if you choose any Set button function except the default, lots of instructions in this book aren't going to work correctly.

Part IV: The Part of Tens

Customizing Exposure and Focus Lock Options

By default, pressing your shutter button halfway establishes and locks focus when you use autofocusing. When you shoot in the advanced autoexposure modes, you also can lock in the exposure settings the camera selects by pressing and holding the AE (autoexposure) Lock button, labeled in Figure 11-3.

You can customize the locking behaviors of the two buttons via Custom Function 10. Here's how:

1. Set the Mode dial to an advanced exposure setting.

As with all Custom Functions, you can take advantage of this option only in the P, Tv, Av, M, or A-DEP exposure mode. Additionally, the locking setup you specify applies only to those modes.

2. Display Setup Menu 3, highlight Custom Functions, and press Set.

3. Select Custom Function 10.

Press the right or left cross key to scroll through the Custom Functions.

4. Press Set to activate the list of settings, as shown in Figure 11-4.

A highlight box appears, as shown in the figure. The option that appears in blue text is the current setting; option 0 represents the default setting. AE Lock button

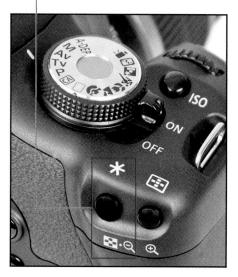

Figure 11-3: By default, pressing the AE Lock button locks the autoexposure setting.

C.FnIV:Operation/Others Shutter/AE lock button	10
0:AF/AE lock	
1:AE lock/AF	
2:AF/AF lock, no AE lock	
3:AE/AF, no AE lock	
C.Fn IV: 123456789101112	13 0

Figure 11-4: Adjust autoexposure/autofocus lock behavior via Custom Function 10.

5. Press the up and down cross keys to highlight the option you want to use.

You have the following four choices. (The first part of the setting name indicates what happens with a half-press of the shutter button; the second part indicates the function of the AE Lock button.)

- *AF/AE Lock:* This is the default setting. Pressing the shutter button halfway establishes and locks autofocus; pressing the AE Lock button locks autoexposure.
- *AE Lock/AF:* With this option, pressing the shutter button halfway locks autoexposure instead of focus. To initiate autofocusing, you instead press the AE Lock button. In other words, this mode is the exact opposite of the default setup.

If you want to lock exposure when shooting in Live View mode, this is the only way to make it possible. During Live View shooting, the AE Lock button is normally used to autofocus, disabling the normal exposure-lock function. With this setting selected, you can press the shutter button to lock exposure and use the AE Lock button to set focus.

• *AF/AF Lock, no AE Lock:* This mode is designed to prevent focusing mishaps when you use AI Servo autofocusing, explained in Chapter 6. Here's the deal: In the AI Servo mode, the autofocus motor continually adjusts focus from the time you press the shutter button halfway until the time you actually take the image. This feature helps you keep moving objects sharply focused. But if something moves in front of your subject, the camera may mistakenly focus on that object, which may leave your subject blurry.

To cope with that possibility, this locking option enables you to initiate autofocusing as usual, by pressing the shutter button halfway. But at any time before you take the picture, you can press the AE Lock button to temporarily stop the autofocusing motor from adjusting focus if an intruder moves into the frame. When you release the button, the autofocusing mechanism starts up again.

If you choose this option, autoexposure is set when you press the shutter button all the way. You can't lock autoexposure.

• *AE/AF, no AE Lock:* Similar to the preceding mode, this one also is designed to help you capture moving subjects in the AI Servo mode. Pressing the shutter button halfway initiates autoexposure metering, which is adjusted continuously as needed until the time you snap the picture. Pressing the AE Lock button starts the autofocusing servo system; releasing the button stops it. You cannot lock autoexposure in this mode.

6. Press the Set button to finalize your choice.

Now when you shoot in an advanced exposure mode, the camera locks focus and exposure according to the option you selected. In the fully automatic modes, the settings have no effect; you still press the shutter button halfway to focus, and you can't lock autoexposure.

Disabling the AF-Assist Beam

In dim lighting, your camera may emit an AF (autofocus)-assist beam from the built-in flash when you press the shutter button halfway — assuming that the flash unit is open, of course. This pulse of light helps the camera "see" its target better, improving the performance of the autofocusing system.

If you're shooting in a situation where the AF-assist beam may be distracting to your subject or to others in the room, you can disable it. Take these steps to control this aspect of your camera:

1. Set the Mode dial to P, Tv, Av, M, or A-DEP.

As with the other customization options discussed in preceding sections, this one is available only in these advanced exposure modes.

2. Display Setup Menu 3, highlight Custom Functions, and press Set.

You're taken to the main launching pad for adjusting all the Custom Functions.

3. Press the right or left cross key as needed to select Custom Function 8.

4. Press the Set button.

Now the options shown in Figure 11-5 become accessible.

5. Press the up or down cross key to highlight your desired setting.

Setting 1 disables the AF-assist beam of both the built-in flash and compatible Canon EX-series Speedlite external flash units. Setting 2 disables the beam of the built-in flash while allowing the beam of a compatible EX-series Speedlite to function normally.

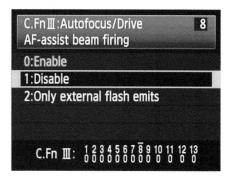

Figure 11-5: You can disable the autofocusassist beam.

6. Press the Set button.

Your chosen setting affects all the advanced exposure modes. In fully automatic modes, the autofocus assist beam continues to light from the built-in flash when the camera deems it necessary.

Without the aid of the assist beam, the camera may have trouble autofocusing in dim lighting. The easiest solution is to simply focus manually; Chapter 1 shows you how.

332

Enabling Mirror Lockup

One of the components involved in the optical system of an SLR camera is a tiny mirror that moves when you press the shutter button. The small vibration caused by the movement of the mirror can result in slight blurring of the image when you use a very slow shutter speed, shoot with a long telephoto lens, or take extreme close-up shots. To eliminate the possibility, your camera offers a feature called *mirror lockup*. When you enable this feature, the mirror movement is completed well before the shot is recorded, thus preventing any camera shake.

To try out this feature, take these steps:

1. Set the Mode dial to an advanced exposure mode.

Mirror lockup isn't available in the fully automatic exposure modes. So set that dial to P, Tv, Av, M, or A-DEP.

- 2. Display Setup Menu 3, highlight Custom Functions, and press Set.
- 3. Press the right or left cross key to scroll to Custom Function 9.
- 4. Press Set to access the options shown in Figure 11-6.
- 5. Press the up or down cross key to highlight the Enable option, as shown in the figure.

C.FnⅢ:Aut Mirror lock		ve	9
0:Disable			
1:Enable			
C.Fn Ⅲ:	123456	7 8 9 10 11 0 0 0 0 0	12 13 0 0

Figure 11-6: Mirror lockup prevents camera shake caused by the movement of the optical system's mirror.

After you enable mirror lockup, you take a slightly different approach to picture-taking than usual. Use this technique:

1. Frame your shot.

6. Press the Set button.

2. If you're using autofocus, press and hold the shutter button halfway to lock focus.

Or, if you prefer manual focusing, twist the focusing ring as needed to focus the image.

3. Press the shutter button all the way down to lock up the mirror. Then release the button.

Part IV: The Part of Tens

At this point, you can no longer see anything through the viewfinder. Don't panic — that's normal. The mirror's function is to enable you to see in the viewfinder the scene that the lens will capture, and mirror lockup prevents it from serving that purpose.

4. Press the shutter button all the way again.

The camera then takes the picture.

Using a tripod or other support is critical to getting a shake-free shot in situations that call for mirror lockup. For even more protection, set your camera to the 2-second self-timer mode, introduced in Chapter 2, and take your hands completely off the camera after you press the shutter button in Step 3. The picture is taken two seconds after the mirror lockup occurs. If you purchased the remote-control unit for your camera, you instead can trigger the shutter button using it.

Adding Cleaning Instructions to Images

You've no doubt noticed that your camera displays a message that says "Sensor Cleaning" every time you turn off the camera. And when you turn on the camera, a little "cleaning" icon flickers in the lower-right corner of the Shooting Settings display. These alerts tell you that the camera is performing a self-maintenance step that is designed to remove from the sensor any dust particles that may have made their way into the camera interior.

If you don't see these alerts, open Setup Menu 2, choose the Sensor Cleaning option, and then press Set. Next, set the Auto Cleaning option to Enable. (There's really no reason to disable this feature, although Canon gives you the choice to do so.)

The automated sensor cleaning normally is all that's necessary to keep the sensor dust-free. But if you notice that small spots are appearing consistently on your images, you may need to step in and take action on your own.

The best solution, of course, is to take your camera to a good repair shop and have the sensor professionally cleaned. I *do not* recommend that you take on this job yourself; it's a delicate procedure, and you can easily ruin your camera.

Until you can have the camera cleaned, however, you can use a feature on Shooting Menu 2 to create a custom dust-removal filter that you can apply in Digital Photo Professional, which is one of the free programs that ships with your camera. The first step in creating the filter is to record a data file that maps the location of the dust spots on the sensor. To do this, you need a white piece of paper or other white surface and a lens that can achieve a focal length of 55mm or greater. (The kit lens sold with your camera qualifies.) Then take these steps:

1. Set the lens focal length at 55mm or longer.

If you own the kit lens, just zoom in as far as possible, which sets the focal length at 55mm.

2. Switch the camera to manual focusing.

On the kit lens, move the focus switch on the lens from AF to MF.

3. Set focus at infinity.

Some lenses have a marking that indicates the infinity position — the symbol looks like a number 8 lying on its side. If your lens doesn't have the marking, hold the camera so that the lens is facing you and then turn the lens focusing ring clockwise until it stops.

4. Set the camera to one of the advanced exposure modes (P, Tv, Av, M, or A-DEP).

You can create the dust data file only in these modes.

- 5. Display Shooting Menu 2 and highlight Dust Delete Data, as shown on the left in Figure 11-7.
- 6. Press the Set button.

Now you see the Dust Delete Data message shown on the right in Figure 11-7.

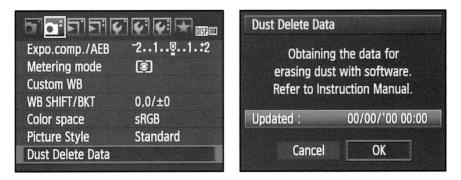

Figure 11-7: You can record dust-removal data that can be read by Digital Photo Professional.

7. Press the right cross key to highlight OK and then press Set.

Part IV: The Part of Tens

The camera performs its normal automatic sensor-cleaning ritual, which takes a second or two. Then you see the instruction screen shown on the left in Figure 11-8.

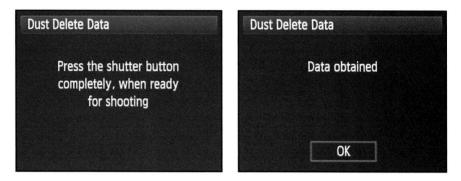

Figure 11-8: The Dust Delete Data is recorded when you press the shutter button all the way.

8. Position the camera so that it's about 8 to 12 inches from your white card or piece of paper.

Your card or paper needs to be large enough to completely fill the viewfinder at this distance.

9. Press the shutter button all the way to record the Dust Delete Data.

No picture is taken; the camera just records the Dust Delete Data in its internal memory. If the process was successful, you see the message shown on the right in Figure 11-8.

If the camera tells you that it couldn't record the data, the lighting conditions are likely to blame. Make sure that the lighting is even across the entire surface of your white card or paper and that the paper is sufficiently illuminated and then try again.

10. Press the Set button.

The current date now appears on the initial Dust Delete Data screen (shown on the right in Figure 11-7).

After you create your Dust Delete Data file, the camera attaches the data to every subsequent image, regardless of whether you shoot in the fully automatic or advanced exposure modes.

To clean a photo, open it in Digital Photo Professional and choose Tools Start Stamp Tool. Your photo then appears in an editing window; click the Apply Dust Delete Data button to start the automated dust-busting feature. The program's manual and Help system offer details about this process; look for the Help entry related to using the Copy Stamp tool.

337

Turning Off the Shooting Settings Screen

When you turn on your camera, the monitor automatically turns on and displays the Shooting Settings screen. At least, it does if you stick with the default setting selected for Custom Function 12, which bears the lengthy name LCD Display When Power On.

You can prevent the monitor from displaying the screen every time you power up the camera, if you choose. The monitor is one of the biggest drains on the camera battery, so limiting it to displaying information only when you need it can extend the time between battery charges.

As with other Custom Functions, this option works only when the camera is set to one of the advanced exposure modes — in other modes, the screen still appears automatically. Still, any battery savings can be helpful when you're running low on juice.

To take advantage of this feature, take these steps:

- 1. Set the camera to P, Tv, Av, M, or A-DEP mode.
- 2. Display Setup Menu 3, highlight Custom Functions, and press Set.
- 3. Use the cross keys to select Custom Function 12 and then press Set.

You see the screen shown in Figure 11-9.

4. Press the up or down cross key to highlight Retain Power OFF Status.

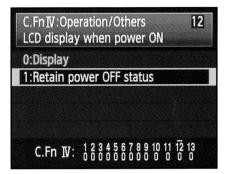

Figure 11-9: You can prevent the monitor from turning on automatically when you power up the camera.

- 5. Press Set.
- 6. Press the shutter button halfway and release it to temporarily display the Shooting Settings screen.
- 7. Press the DISP button to turn off the monitor.
- 8. Turn off the camera.

When you turn on the camera again, the monitor doesn't automatically display the Shooting Settings screen — as long as the Mode dial is set to an advanced shooting mode, that is. To view the screen, press the DISP button; press the button again to return to monitor-off status.

Part IV: The Part of Tens

Note that if you turn off the camera while the Shooting Settings screen is displayed, it appears again automatically the next time you power up the camera. So if you really want the monitor to retain its "power off status," be sure to press DISP to shut off the monitor before you turn off the camera.

Adding Original Decision Data

Now that photo editing has gone mainstream, determining whether a digital photo has been altered from its original state is difficult. However, through Custom Function 13, you now have a way to prove that a picture file hasn't been edited.

If you enable this Custom Function, as shown in Figure 11-10, the camera adds to the image file a tag that verifies the photo as original. There's a catch, though: To make use of that tag when the file is opened on your computer, you must use a special piece of software, the Original Data

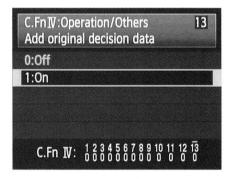

Figure 11-10: This Custom Function is relevant only if you buy a \$650 accessory software kit.

Decision Security Kit OSK-E3. You can buy that product for about \$650.

If you want to know more about the whole issue, visit the Canon Web site.

Creating Your Very Own Camera Menu

Canon does a good job of making it easy to change the most commonly used camera settings. You can access many critical options by pressing the buttons on the camera body, and others require only a quick trip to the camera menus.

To make things even simpler for you, the Rebel T1i/500D enables you to create your own custom menu containing up to six items from the camera's other six menus. For example, I created a custom menu that contains the options shown in Figure 11-11. (The last item, My Menu Settings, is always on the menu; more about that later.) Logically enough, the custom menu goes by the name My Menu and is represented by the green star icon, as shown in the figure.

To create your menu, take these steps:

1. Set the camera Mode dial to an advanced exposure mode.

Sadly, you can create and order from your custom menu only in P, Tv, Av, M, and A-DEP exposure modes.

2. Press the Menu button and display the My Menu screen.

Initially, your screen shows only a single item, as shown on the left in Figure 11-12.

3. Highlight My Menu Settings and press Set.

Now you see the right screen in Figure 11-12.

Figure 11-11: Group your favorite menu items together with the My Menu feature.

Figure 11-12: To add items to your menu, select Register and press Set.

4. Highlight Register and press Set.

You're presented with a scrolling list that contains each and every item found on the camera's other six menus, as shown on the left in Figure 11-13.

5. Highlight the first item that you want to include on your custom menu.

If you want to add a specific Custom Function to your menu, scroll *past* the item named Custom Functions to find and highlight the individual function. (The item named Custom Functions simply puts the Custom Functions menu item on your menu, and you still have to wade through the multiple levels of steps to get to your function.)

Part IV: The Part of Tens

Figure 11-13: Highlight an item to put on your menu and press Set.

6. Press Set.

You see a confirmation screen like the one shown on the right in Figure 11-13.

7. Highlight OK and press Set.

You return to the list of menu options. The option you just added to your menu is dimmed in the list.

8. Repeat Steps 5 through 7 to add up to five additional items to your menu.

9. Press the Menu button.

You then see the My Menu screen, where the items you added to the menu should appear.

After creating your menu, you can further customize and manage it as follows:

- Give your menu priority. You can tell the camera that you want it to automatically display your menu anytime you press the Menu button. To do so, select My Menu Settings on the main My Menu screen and then press Set. You see the screen shown on the right in Figure 11-12. Highlight Display from My Menu and press Set. Highlight Enable and press Set again.
- Change the order of the list of menu items. Once again, highlight My Menu Settings and press Set. Then highlight the Sort option (refer to the right screen in Figure 11-12) and press Set. Highlight a menu item, press Set, and then use the up or down cross keys to move the item up or down in the list. Press Set to glue the menu item in its new position. Press Menu to return to the My Menu Settings screen; press Menu again to return to your custom menu.

340

✓ Delete menu items. Display your menu, highlight My Menu Settings, and press Set. Then, to delete a single item, highlight Delete and press Set. Highlight the menu item you want to remove and press Set again. Highlight OK and press Set again to confirm your decision. To remove all items from your custom menu, choose Delete All Items (on the screen shown on the right in Figure 11-12), press Set, highlight OK, and press Set again.

Tagging Files with Your Copyright Claim

By using the EOS Utility software that ships with your camera, you can load your personal copyright data into the camera's brain. Then, whenever you shoot a picture, your copyright information is recorded as part of the file's *metadata* — the extra data that records information about your picture-taking settings, the date, time, and so on. Chapter 8 shows you how to view metadata for pictures in Canon ZoomBrowser (Windows) and ImageBrowser (Mac); Figure 11-14 shows you where to look for the copyright information.

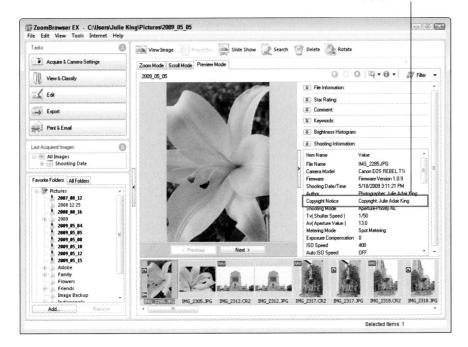

Figure 11-14: Tagging your files with your copyright notice lets people know who owns the rights to the picture.

Copyright information

Part IV: The Part of Tens

What's the point, exactly? Well, including a copyright notice is a reasonable first step to take if you want to prevent anyone from using your pictures without your permission. Anyone who views your picture in a program that can display metadata will see your copyright notice and know who owns the rights to the picture. Obviously, that won't be enough to completely prevent unauthorized use of your images. And technically speaking, you hold the copyright to your photo whether you take any steps to mark it with your name. But if you ever come to the point of pressing legal action against the perpetrator, you can at least show that you did your due diligence in letting people know that you hold the copyright.

The process of creating and downloading your copyright data from the EOS Utility software to your camera isn't complicated, but it does involve more steps than I have room to cover here. So if you're intrigued, dig through your camera box and dig out the CD titled "EOS Digital Software Instruction Manual" and then pop it into your computer's CD or DVD drive. The CD contains electronic versions of the manuals for all the programs shipped with your camera; look for the file that begins with the letters "EU2." After opening that file, navigate to the manual's Chapter 2 for information about the copyright function. (The manuals are provided in the PDF format; if you don't already have a PDF viewer on your computer, you can download a free one, Adobe Acrobat Reader, from www.adobe.com.)

If you tag your files with copyright data, you can later disable the tagging, if necessary, through the Clear Settings option on Setup Menu 3. Your camera manual has details on that part of the process.

Getting Free Help and Creative Ideas

Okay, so this last tip is a bit of a cheat: It isn't actually found on your camera, but it will help you better understand the features that are. I speak of the Canon Web site, which you can access at www.canon.com.

If you haven't yet visited the site, I encourage you to do so. In the Support section of the site, you can get free technical support for camera problems and even download an electronic copy of your camera manual, should you happen to misplace the one that came with your camera. Most importantly, check periodically to make sure that your camera is running the latest *firmware*, which is the geekspeak term for the camera's internal software.

Be sure to also check out the Learning Center section of the site. There, you can find loads of tutorials and other great instructional offerings not only about your camera but also about the software that ships with it

342

Index

• Symbols and Numerics •

1 Image option, 89 2-Second Self-Timer mode, 61 3:2 ratio, 276 10 Images option, 89 100 Images option, 89

• A •

action photography, 232-235 active autofocus point, 186 A-DEP (automatic depth of field) mode adjusting aperture and shutter speed, 152 calculating exposure and flash output, 174 depth of field and, 204 explanation of, 205-206 flash and, 45 overview, 108, 133, 144 Adobe RGB color mode, 219-220 advanced exposure modes. See also aperture; ISO: shutter speed bracketing exposures automatically, 168 - 170choosing exposure metering mode, 144 - 148exposure-correction tools, 155–165 locking Autoexposure Settings, 166–167 monitoring exposure settings, 142-144 overview, 131-133 using flash in, 170-183 Advanced Options button, 307 AE lock. See autoexposure (AE) lock AE Lock/AF mode, 331 AE Lock/FE Lock/Index/Reduce button, 22 AE/AF, no AE Lock mode, 331 AEB (automatic exposure bracketing), 115 AF button, 192 AF Point Selection option, 88, 226 AF Point Selection/Magnify button, 22 AF/AE Lock mode, 331

AF/AF Lock, no AE Lock mode, 331 AF-assist beam, 41, 180, 332 AF/MF switch, 14 AI (artificial intelligence), 43 Al Focus mode, 191 AI Servo mode, 190-191 alignment grid, 117 All Images setting, 294 Amount slider, Unsharp Mask filter, 322 Antialias option, 325 anti-shake, 14 aperture balancing with ISO and shutter speed, 141 controlling, 152-155 defined, 134 exposure-setting side effects, 136–140 overview, 133-135 aperture setting (f-stop), 22, 44, 59, 134, 139, 201 Aperture/Exposure Compensation button, 22 aperture-priority autoexposure mode. See Av mode archiving photos processing Raw (CR2) files, 268-272 using ZoomBrowser EX/ImageBrowser, 260-268 artificial intelligence (AI), 43 Aspect Ratio drop-down list, 308 attaching lens, 10-12 Auto Adjust Image button, 324 Auto Adjustment option, ZoomBrowser EX/ImageBrowser, 323-324 Auto Cleaning option, 36 Auto flash, 45 Auto Lighting Optimization, 107–108, 161 - 163Auto Power Off option, Setup Menu 1, 33 Auto Reset option, 33 Auto Rotate feature, Setup Menu 1, 34, 91 Auto White Balance (AWB), 114 autoexposure (AE) lock, 108, 166-167, 330-331 Live View, 115 movie recording, 126

autoexposure meter, 41 autofocus (AF) mode. See also autofocusing changing, 190-192 Close-Up mode, 54 Full Auto mode, 48 Landscape mode, 52 Movie menu, 123 Night Portrait mode, 56 One-Shot, 51 Picture-Taking Settings, 226 Portrait mode, 51 Sports mode, 55 autofocus points, 15, 41, 188-190 autofocusing. See also autofocus (AF) mode adjusting, 188-192 in Live View, 192-200 in Movie mode, 192-200 setting locks, 330-331 shifting to manual focus from, 14-15 Auto/Manual Focus switch, 13, 40 automated sensor cleaning, 334 automatic depth of field (A-DEP) mode. See A-DEP mode automatic exposure bracketing (AEB), 115 automatic exposure modes Creative Auto mode, 56-60 Drive mode, 60-63 flash options, 45-46 Full Auto mode, 48-49 fully automatic scene modes, 49-56 overview, 39-40, 47 picture-taking technique, 40-44 Red-Eye Reduction flash, 46-47 Automatic focus point selection, 196 Av (aperture-priority autoexposure) mode, 133, 144 adjusting aperture and shutter speed, 153 calculating exposure and flash output, 174 depth of field and, 203, 236 flash and, 45 still portraits, 227 AWB (Auto White Balance), 114

• B •

background, Creative Auto mode, 58 backlighting, shooting in, 242

back-of-body controls, 20-23 banding, 80 Basic Zone, 19 battery, monitor usage and, 109 Beep option, Shooting Menu 1, 38 bit, defined, 272 bit depth, 80 blown highlights, 96, 99 blue label indicator on camera, 21 Blue slider, color balance, 313 blue to amber bracketing, 218 blurring, 187, 237 Bounce flash, 231 bracket exposures, 168 bracketing exposures, 168-170, 238 Bracketing, White Balance, 216-219 brightness histogram, 99-100, 116 buffer, 126 Built-In Flash Function Setting, 181 burst mode, 61 Busy signal, 46

• () •

camera, connecting to computer, 249-251 camera controls. See controls, camera camera settings. See settings, camera Camera Settings display, 31-32 camera shake, 334 camera-to-subject distance, 201-203 candlelight, 208 Canon Digital Photo Professional, 163, 224, 257, 272 Canon EOS Rebel T1i/500D, overview of, 1 - 5Canon EOS Utility, 5, 254–258 Canon ImageBrowser. See ImageBrowser Canon MemoryCard Utility, 258-260 Canon Speedlite 580EX II, 182 Canon Web site, 342 Canon ZoomBrowser EX. See ZoomBrowser EX caption, adding to photo, 285 car window, shooting out, 241 card-to-computer transfers, 258-260 Center-Weighted Average metering, 145 challenging photography, 241-243 Change Settings button, 260 channels, color, 80, 100 circular polarizing filter, 243

Clean Manually option, 36 Clean Now option, 36 cleaning filter, 334-336 Clear Settings option, Setup Menu 3, 37 clipped highlights, 96, 99 Close-Up mode, 45, 53-54 close-up photography, 239–241 Cloud Dome, 243 color. 280 Adobe RGB color mode, 219–220 balance adjustments, ZoomBrowser EX/ ImageBrowser, 312-314 Full Auto mode, 49 fully automatic scene modes, 50 overview, 207-208 Picture Styles, 221–224 and printer, 278-281 saturation adjustments, ZoomBrowser EX/ImageBrowser, 309–312 sRGB (standard red, green, blue) color mode, 219-220 tools for managing, 220 White Balance settings, 208–219 Color Adjustment tab, 311 color cast, 66-67 color channels, 80, 100 color space, 32, 98, 185, 270 color temperature, 208 colorimeter, 279 compression, JPEG, 69 computer, connecting to camera, 249–251 computerless printing, 287 connecting camera and computer, 249-251 Continuous capture mode, 30 Continuous mode, AEB, 170 Continuous option, 33, 61 Continuous shooting mode, 108, 216 control strip, movie playback, 128 controls, camera back-of-body, 20-23 front-left buttons, 24 overview, 18 topside, 18-20 Conversion Target option, 271 Copy Stamp tool, 336 copyright notice, tagging files with, 341-342 CR2 format, 79-82, 268-272 Creative Auto mode depth of field and, 204

explanation of, 56-60

flash and, 45 f-stop and, 44 Creative Zone, 19 creativity, 2-3 crop box, 284, 307 crop factor (magnification factor), 205 cropping, ZoomBrowser EX/ImageBrowser, 306-309 cross keys, 22-23, 87 **Custom Functions** Custom Function 1, 156 Custom Function 2, 149, 150 Custom Function 3, 174 Custom Function 4, 150, 238 Custom Function 5, 151 **Custom Function 6, 160, 237** Custom Function 7, 107, 163 Custom Function 8, 332 Custom Function 9, 109, 333 Custom Function 10, 108, 145, 193, 330 Custom Function 11, 329 Custom Function 12, 337 Custom Function 13, 338 **ISO Expansion**, 149 overview, 37, 328 custom menu, 338-341 custom white balance settings, 212–213

D+ symbol, 160 data-restoration software, 102 Date option, 294 Date/Time option, Setup Menu 2, 36 default Movie display, 120 default Playback mode, 87 deleting photos all images on memory card, 102–103 overview, 101 selected images, 103–105 single images, 102 depth of field, 44 A-DEP mode, 205-206 Close-Up mode, 53 Landscape mode, 52 overview, 200-205 previewing, 24, 204, 207 Destination Folder button, 256 detaching lens, 12

Index 345

Canon EOS Rebel T1i/500D For Dummies

Digital Exposure Compensation control, Image Quality Adjustment panel, 270 digital noise, 66-67 digital photo files, safeguarding, 252 Digital Photo Professional, 163, 224, 257, 272 Digital Print Order Format (DPOF), 287 digital-image defects, 66 dim lighting, 206 diopters, 240 dioptric adjustment control, 15 Direct flash, 231 Direct Transfer screen, 251 DISP button, 23 Display Off sensor, 15 Display the first/last frame of the movie control, 128 Display the next frame control, 128 Display the previous frame control, 128 dots per inch (dpi), 72, 275 downloading process Canon tools, 253-260 connecting camera and computer, 249 - 251overview, 247-249 starting transfer process, 251-253 dpi (dots per inch), 72, 275 DPOF (Digital Print Order Format), 287 Drive mode changing, 43, 61-63 Close-Up mode, 54 Creative Auto mode, 60 Full Auto mode, 48 Landscape mode, 52 Night Portrait mode, 56 Picture-Taking Settings, 226 Portrait mode, 51 Sports mode, 54-55 Drive mode icon, Live View, 115 drop-off printing service, 281 Dust Delete Data message, 335–336 dust-removal filter, 334-336

• E •

Edit drop-down list, 266, 302–303 editing photo adding text, 324–326 adjusting color balance, 312–314

adjusting color saturation, 309–312 adjusting exposure, 314-320 Auto Adjustment option, 323–324 cropping, 306-309 overview, 301-302 removing red-eye, 302-306 saving edited files, 326 sharpening, 320-323 EF (electro focus) design, 10 e-mail, preparing photos for, 286-292 EOS Rebel T1i/500D, overview of, 1-5 EOS Utility, 5, 254-258 Erase button, 23 Erase Images screen, 103 E-series dioptric adjustment lens, 16 E-TTL (evaluative through the lens) II, 172, 181 EV (Exposure) Compensation, 22, 94, 143, 155-158 EV (exposure value) numbers, 176 evaluative metering, 145, 167 evaluative through the lens (E-TTL) II, 172, 181 Exit movie playback control, 128 Explore panel ImageBrowser window, 262 ZoomBrowser EX window, 261 exposure Creative Auto mode, 60 Full Auto mode, 49 fully automatic scene modes, 50 Live View, 119 Live View shooting and, 145 Exposure (EV) Compensation, 22, 94, 143, 155-158 exposure adjustments, ZoomBrowser EX/ ImageBrowser Level Adjustment filter, 314–317 overview, 314 Tone Curve Adjustment filter, 317–320 exposure lock, 330-331 exposure meter, 121, 142 exposure modes. See also advanced exposure modes; automatic exposure modes; flash exposure simulation (Exp.SIM), 116 Exposure Simulation icon, 121 exposure value (EV) numbers, 176

Index

exposure-correction tools, 155–165 Auto Lighting Optimization, 161–163 Exposure Compensation, 155–158 Highlight Tone Priority, 158-160 Peripheral Illumination Correction, 163 - 165exposure-setting side effects, 136-140 Exp.SIM (exposure simulation), 116 external camera controls back-of-body controls, 20-23 front-left buttons, 24 overview, 18 topside controls, 18-20 external flash controls, 182 external flash units, 183 eyepiece adapter, 16

• F •

Faithful Picture Style, 221-222 Fast forward control, 128 FE Lock (Flash Exposure Lock), 108, 179 FEB (flash exposure bracketing), 115 FEL display, 179 file formats defined. 76 Fine versus RAW, 82-83 JPEG, 76-79 overview, 76 Raw (CR2), 79-82, 268-272 File Numbering option, Setup Menu 1, 33 file size, 97, 118 filename, accepting or creating new, 291 fill flash, 45, 172, 240 filter, cleaning, 334-336 Fine settings, 77-78, 82-83 fireworks, shooting, 242 firmware, 4, 165, 342 Firmware Ver. screen, Setup Menu 3, 37 1st-curtain sync, 181 Fit to Window, ZoomBrowser EX, 264 flash options, 45-46 using in advanced exposure modes, 170 - 182Flash button, 24 Flash Compensation amount symbol, 96 Flash Control option, 180

flash exposure bracketing (FEB), 115 Flash Exposure Compensation, 176-178, 181 Flash Exposure Lock (FE Lock), 108, 179 flash metering, 171 Flash Off exposure mode, 45 Flash Off mode, 56 Flash On symbol, 46 Flash Recycling, 46 flash status, Live View, 115 fluorescent lighting, 208 focal length, 15, 201, 204-205 Focal length marker, 13 focusing. See also autofocusing adjusting viewfinder, 15-16 depth of field, 200-207 manual focus, 14-15 overview, 185-187 focusing frame, 113 Focusing ring, 13 focusing screen, 16 folders, ZoomBrowser EX/ImageBrowser, 266 - 268force flash, 45 Format option, Setup Menu 1, 34 formatting card, 17 versus deleting, 105 frame rate, 118 free monitor calibration software, 277 Freespace value, 32 front-left buttons, 24 f-stop (aperture setting), 22, 44, 59, 134, 139, 201 Full Auto mode, 40, 45, 48-49 Full High-Definition; 1280 x 720, 118 full stop, 155 full-data display mode, Live View, 125 full-frame view, 93 full-screen mode, ZoomBrowser EX/ ImageBrowser, 263-266 fully automatic exposure modes, 19 fully automatic scene modes Close-Up mode, 53-54 depth of field and, 204 Flash Off mode, 56 Landscape mode, 51–52 Night Portrait mode, 55-56

fully automatic scene modes *(continued)* overview, 49–50 Portrait mode, 50–51 Sports mode, 54–55

• G •

glass, shooting through, 241 grain, 138 Green slider, color balance, 313 green to magenta bracketing, 218 grid, alignment, 117 Grid display option, Movie menu, 123

• H •

Hand tool, ZoomBrowser EX, 264 handheld shooting, 186 handles, 308 HDMI playback, 296 HDTV playback, 296 head room, 277 high-capacity SD (SDHC) card, 17 high-contrast shots, 158-160 Highlight Tone Priority, 97, 158–160 highlights, 96, 99, 316 histogram, 36, 95, 315-316 Histogram display mode Brightness histogram, 99-100 overview, 99 RGB histogram, 100-101 Hold option, instant review, 86 hot shoe. 182

•]•

IDrive, 252
image number value, 94–95, 98
Image Quality option, Picture-Taking Settings, 226
image sensor, dirty, 83
image stabilizer (IS) lens, 13–14
Image Stabilizer switch, 13, 40, 186
Image Type setting, 271
Image Zone modes
Close-Up mode, 53–54
Flash Off mode, 56
Landscape mode, 51–52

Night Portrait mode, 55–56 overview, 49-50 Portrait mode, 50-51 Sports mode, 54–55 ImageBrowser adding text, 324-326 adjusting color balance, 312-314 adjusting color saturation, 309-312 adjusting exposure, 314-320 Auto Adjustment option, 323-324 cropping, 306-309 folder collections, 266-268 overview, 260-263, 301-302 printing from, 282–286 removing red-eye, 302-306 saving edited files, 326 sharpening, 320-323 viewing photos in full-screen mode, 263 - 266image-exposure formula, 135 Images to Save option, 271 Import Shooting Date/Time button, 325 in-camera slide show, 293-295 Index display mode, 88 Index mode, movies and, 127 indoor portraits, 228 information display changing with Movie mode, 120-122 modes, 94-95 Information panel ImageBrowser window, 262 ZoomBrowser EX window, 261 ink, 280 interface cable, 248 internal menus, 25 internal temperature, 127 IS (image stabilizer) lens, 13-14 ISO balancing with shutter speed and aperture, 141 controlling, 148-152 defined, 135 exposure-setting side effects, 136-140 overview, 133-135 ISO button, 20 ISO Expansion custom function, 149 ISO option, Picture-Taking Settings, 226 ISO speed option, 97

___ Index

•] •

JPEG artifacts, 66–67 JPEG compression, 69, 291 JPEG format, 76–79, 82–83 JPEG Normal setting, 83 jump bar, 90 Jump feature, 88–89 jumping through images, 88–90

• K •

Kelvin scale, 208 Kodak Gallery, 252

• [•

L (Large) resolution setting, 71 Landscape mode, 45, 51-52 landscape orientation, 91 landscape photography, 236-239 Landscape Picture Style, 221-222 Landscape setting, 44 Language option, Setup Menu 2, 36 Large (L) resolution setting, 71 large depth of field, 200 Lastolite, 243 LCD Auto Off option, Setup Menu 1, 34-35 LCD Brightness option, Setup Menu 2,35-36 lens attaching, 10-12 cleaning, 83 correcting vignetting, 163-165 overview, 10 removing, 12 shifting from autofocus to manual focus, 14 - 15using IS (image stabilizer) lens, 13-14 zooming in and out, 15 lens filters, 215 lens release button, 11, 24 lens/sensor dirt, 66-67 Level Adjustment filter, ZoomBrowser EX/ ImageBrowser, 314-317 Lexar Image Rescue, 102 light fall-off, correcting, 163–165

Live mode autofocusing, 198–200 Live View autofocusing in, 192-200 customizing shooting data, 114-116 enabling, 110-111 overview, 107-110 taking shots in, 111–114 using Quick Control screen in, 116-117 Live View Functions, Setup Menu 2, 36 Live View mode exposure and, 145 exposure settings, 142 picture quality and, 109 Picture-Taking Settings, 226 Live View/Movie/Print/Share button, 22 lock autoexposure, 330-331 autofocusing, 330-331 lock switch, 18 locking flash exposure, 179-180 long lens (telephoto lens), 109, 205 looping, slide show, 295 lossy compression, 77 low-level formatting, 34

• M •

M (manual exposure) mode, 45, 133, 143, 153, 174 M (Medium) resolution setting, 71 macro lens, 240 magic hours, 238 magnification factor (crop factor), 205 magnified images, 265 mail-order delivery, 281 Main dial, 20, 88-89, 169 Maintain Original option, cropping, 308 Manual AF Point Selection mode, 189 manual exposure (M) mode, 45, 133, 143, 153, 174 manual focus, 14-15, 234 Manual focus point, 196 Manual Mode option, 303 Manual option, cropping, 308 Manual Reset option, 33 maximum burst frames, 30 MediaRecover, 102

Canon EOS Rebel T1i/500D For Dummies

350

Medium (M) resolution setting, 71 megapixel (MP), 71 memory buffer, 30 memory cards deleting all images on, 102–103 overview, 17-18 picture capacity, 74 MemoryCard Utility, Canon, 258-260 Menu button, 23 menus commands, 4 customizing, 338-341 ordering from, 25–26 metadata, 263, 341 metering mode, 96, 108, 144-148 Metering option, Picture-Taking Settings, 226Metering Timer option, Live View mode, 111 Metering timer option, Movie menu, 122-123 midtones, 99, 314 mireds, 215 mirror lockup, 333-334 Mirror Lock-Up function, 109 Mode dial, 19 modes, autofocusing, 193-195 monitor and battery, 109 deleting photos, 101–105 instant review, 86 overview, 85-86 protecting photos, 105-107 recording movies, 117-127 resolution and, 286 using as viewfinder, 107–117 viewing images in Playback mode, 86–93 viewing picture data, 93-101 Monochrome Picture Style, 221–222 motion blur, 137 mounting index, 11 mouse, using as shutter button, 268 Movie Menu, 25 Movie menu options, 122–123 Movie mode, autofocusing in choosing mode, 193-195 Live mode, 198-199 Live mode with face detection, 199–200 overview, 192-193 Quick mode, 195-197 Movie Rec. Size option, Movie menu, 123 Movie Size/Time Remaining value, 121

movies changing information display, 120–122 overview, 117–119 playing, 127–128 setting recording options, 122–124 shooting, 124–127 Movies option, 89, 294 moving subject, 141 Mozy, 252 MP (megapixel), 71 multiple images, viewing, 87–88 My Menu feature, 25, 38 My Pictures folder, 256, 260

• 1/ •

nature scenes, 240 Navigator window, ZoomBrowser EX, 264 Neutral Picture Style, 221–222 Night Portrait mode, 45, 55–56, 230 nighttime city shot, 238 noise, 109, 138, 150–151, 270 non-moving subject, 141 Normal setting, 77–78

• () •

Off mode, flash, 45 Off option, instant review, 86 On mode, flash, 45 One-Shot mode, 190 online photo sharing, 281–282, 292 online printing sites, 281 On/Off switch, 18-19 organization of photos processing Raw (CR2) files, 268-272 using ZoomBrowser EX/ImageBrowser, 260 - 268orientation, 90-91 Orientation icons, 284 Original Data Decision Security Kit OSK-E3, 338 original decision data, 98, 338 outdoor portraits, 228

• 1 •

P (programmed autoexposure) mode, 45, 132, 144, 152–153, 174 Partial metering, 145

Index 351

Peripheral Illumination Correction, 163 - 165photo paper, 280 photo-download wizard, 253 photography action, 232-235 basic picture settings, 226 close-up, 239-241 landscape, 236-239 overview, 225 scenic, 236-239 setting up for specific scenes, 226-241 special situations, 241-243 photos. See also editing photo; picture data; sharing photos deleting, 101-105 Highlight Tone Priority, 161–163 jumping through, 88–90 organizing in ZoomBrowser EX/ ImageBrowser, 263–268 printing, 273-286 processing Raw (CR2) files, 268–272 protecting, 105–107 quality of, 65–70. See also file formats; resolution rotating vertical pictures, 90–92 sending to computer, 249-260 viewing in Playback mode, 86–93 viewing multiple at the same time, 87–88 zooming in, 92-93 PictBridge, 287 picture data Histogram display mode, 99–101 information display modes, 94-95 overview, 93-94 Shooting Information display, 95–98 picture settings, 226 Picture Style button, 223 Picture Style, Image Quality Adjustment panel, 270 Picture Style option, Picture-Taking Settings, 226 Picture Style setting Close-Up mode, 54 Creative Auto mode, 60 Full Auto mode, 48 Landscape mode, 52 Night Portrait mode, 56 Playback mode, 114 Portrait mode, 51 Sports mode, 54

Picture Styles, 221–224 pictures. See photos picture-taking technique, 40-44 pixel dimension, 71 pixels checking count before printing, 274-276 defined, 71 and file size, 73–74 and print quality, 71-72 resolution recommendations, 75 and screen display size, 72–73 pixels per inch (ppi), 71, 274 Play in slow motion control, 128 Playback button, 23 Playback mode jumping through images, 88–90 overview, 86-87 rotating vertical pictures, 90–92 viewing multiple images at the same time, 87-88 zooming in for closer view, 92-93 Playback 1 menu, 25 Playback 2 menu, 25 playing movies, 127-128 Portrait mode, 45, 50-51 portrait orientation, 91 Portrait Picture Style, 221–222 Portrait setting, 44 portraits FEL and, 180 indoor, 228 outdoor, 228 still, 227-232 posterization, 80 ppi (pixels per inch), 71, 274 Preferences dialog box, 256-257 preflash, 179 previewing depth of field, 207 Previous/next buttons, ZoomBrowser EX, 264print proportions, 276-278 printing allowing for different print proportions, 276 - 278checking pixel count before, 274–276 colors, 278-281 computerless, 287 in-store, 281-282 online, 281-282 overview, 273-274 from ZoomBrowser EX/ImageBrowser, 282 - 286

profile, monitor, 280 programmed autoexposure (P) mode, 45, 132, 144, 152–153, 174 Protect feature, 94 protecting photos, 105–107

• () •

Quality settings, 49, 60, 68–70, 95, 97, 115 Quick Control screen adjusting recording settings, 123–124 adjusting white balance setting, 210 applying exposure compensation, 156 flash and, 177 metering mode, 147 overview, 28–30 selecting Picture Style, 223 setting AF mode, 191–192 setting modes in Live View, 194 using in Live View, 116–117 Quick mode autofocusing, 195–197

• R •

Radius slider, Unsharp Mask filter, 322 Raw (CR2) format, 79-83, 268-272 raw converter, 268 Raw Image Task tool, 269 RAW setting, 82 RAW+Large/Fine setting, 82 read-only status, 106 rear-curtain sync (2nd-curtain sync), 181 recording movies changing information display, 120-122 overview, 117-119 playing movies, 127-128 setting recording options, 123-124 shooting, 124-127 red, green, blue (RGB) histogram, 100-101 red label indicator on camera, 21 Red slider, color balance, 313 Red-Eye Reduction flash, 46-47 Red-Eye Reduction/Self-Timer Lamp, 20 red-eye removal, ZoomBrowser EX/ ImageBrowser, 302-306 reflective surfaces, shooting, 243 registering your lens, 165 Release shutter without card option, Shooting Menu 1, 38 Remote control option, Movie menu, 123

remote-control shooting, 193 removing lens, 12 Rename File option, 271 replacement ink, 280 resampling, 72, 275 Resize Images During Export check box, 290Resize the Image box, 290 resolution defined. 71 monitor and, 286 overview, 70-71 pixels and file size, 73-74 pixels and print quality, 71-72 pixels and screen display size, 72–73 recommendations, 75 Resolution option, 271 Review Time option, 86 rewind control, 128 RGB (red, green, blue) histogram, 100–101 RGB color mode, Adobe, 219-220 rotating vertical pictures, 90-92

• 5 •

S (short back focus) design, 10 S (Small) resolution setting, 71 saturation, 272 Save Folder option, 271 saving files, ZoomBrowser EX/ ImageBrowser, 326 scene modes, fully automatic Close-Up mode, 53–54 Flash Off mode, 56 Landscape mode, 51–52 Night Portrait mode, 55–56 overview, 49-50 Portrait mode, 50-51 Sports mode, 54-55 scenes, setting up for capturing action, 232-235 capturing dynamic close-ups, 239-241 capturing scenic vistas, 236-239 overview, 226 shooting still portraits, 227–232 scenic photography, 236-239 Screen Color option, Setup Menu 1, 35 SD (Secure Digital) card, 17, 248, 287 SD speed class rating, 17 SDHC (high-capacity SD) card, 17

Index

353

2nd-curtain sync (rear-curtain sync), 181 Secure Digital (SD) card, 17, 248, 287 selected images, deleting, 103-105 self-serve print kiosk, 281 Self-Timer Continuous option, 62 Self-Timer/Remote Control mode, 61 Self-Timer/Remote modes, 170 sensor cleaning, 334-336 Sensor Cleaning option, Setup Menu 2, 36 Set button, 22-23, 92, 109, 327-329 settings, camera Camera Settings display, 31–32 ordering from menus, 25–26 overview, 24 Quick Control screen, 28-30 using Shooting Settings display, 27–28 viewfinder data, 30-31 setup options My Menu feature, 38 overview, 33 Setup Menu 1, 33–35 Setup Menu 2, 35–36 Setup Menu 3, 37 Shooting Menu 1, 37–38 Shadows slider, 316 shake, camera, 334 shallow (small) depth of field, 200 sharing photos in-camera slide show, 293-295 overview, 273-274 preparing for e-mail, 286–292 preparing for online sharing, 286–292 viewing on television, 296–297 sharpening, 221 sharpening halos, 320–322 sharpening, ZoomBrowser EX/ ImageBrowser, 320-323 shooting data, customizing in Live View, 114 - 116Shooting information ImageBrowser window, 262 ZoomBrowser EX window, 261 Shooting Information display, 95–98 Shooting Menu 1, 25, 37-38, 69 Shooting Menu 2, 25, 147, 177, 223 Shooting Settings display overview, 27-28 turning off, 337-338

Shooting Settings screen, Creative Auto mode, 57 short back focus (S) design, 10 Shutter button, 20 shutter button, using mouse as, 268 shutter speed balancing with ISO and aperture, 141 controlling, 152–155 defined, 135 depth of field and, 204 exposure-setting side effects, 136–140 motion blur and, 137 overview, 133-135 Sports mode, 54 Shutter Sync option, 181 Shutterfly, 252 shutter-priority autoexposure (Tv) mode, 45, 132, 144, 153, 174 Single mode, AEB, 170 Single setting, 61 single-lens reflex (SLR) lens, 10 slide show, in-camera, 293–295 slow motion playback, 128 SLR (single-lens reflex) lens, 10 Small (S) resolution setting, 71 small (shallow) depth of field, 200 software menu commands, 4 software shown in book. 5 sound recording, 118 Sound Recording option, Movie menu. 123 special situations, 241–243 Specific Aspect Ratios, cropping, 308 speed class rating, SD, 17 Speedlite 580EX II, Canon, 182 Sports mode, 45, 54–55, 234 Spot metering, 145 sRGB (standard red, green, blue) color mode, 219-220 s-shaped curve, 319 Standard Picture Style, 221–222 standard red, green, blue (sRGB) color mode, 219–220 Still picture capture, 119 still portraits, 227–232 Still Quality setting, 121 Stills option, 89, 294 sunrise/sunset shots, 237

• 7 •

tagging files with copyright claims, 341-342 telephoto lens (long lens), 109, 205 television, viewing photos on, 296-297 temperature, internal, 127 text, ZoomBrowser EX/ImageBrowser, 324-326 third-party lens, 165 Threshold slider, Unsharp Mask filter, 323 TIFF file format, 326 tonal range, 99 tone curve, 317 Tone Curve Adjustment filter, ZoomBrowser EX/ImageBrowser, 317 - 320topside controls, 18-20 total images value, 98 total number value, 94-95 transfer process Canon tools, 253-260 connecting camera and computer, 249-251 overview, 247-249 starting, 251-253 Trim Image editing window, 283 Trimming Frame buttons, 284 tripod, 112, 237 Tv (shutter-priority autoexposure) mode, 45, 132, 144, 153, 174

• 11 •

Unsharp Mask filter, 322 Use the Rule of Thirds gridlines, 309

• 1/ •

vertical pictures, rotating, 90–92 vibration compensation, 14 video format, 118–119 video playback, 296 Video System option, Setup Menu 2, 36 Viewer window, 266 viewfinder adjusting focus, 15–16 data in, 30–31 using monitor as, 107–117 Viewfinder adjustment knob, 15 viewing photos on television, 296–297 vignetting, lens, 163–165

• 11 •

warming filter, 216 waterfall shot, 237 WB button, 210–211 White Balance Bracketing, 32, 216–219 White Balance settings changing, 210–211 correcting colors with, 208–210 creating custom, 212–213 fine-tuning, 214–216 White Balance Bracketing, 216–219 white label indicator on camera, 21 wide angle lens, 204

• Z •

zones, 19 Zoom barrel, 13 ZoomBrowser EX adding text, 324-326 adjusting color balance, 312-314 adjusting color saturation, 309-312 adjusting exposure, 314-320 Auto Adjustment option, 323-324 cropping, 306-309 folder collections, 266-268 overview, 260-263, 301-302 printing from, 282-286 removing red-eye, 302-306 saving edited files, 326 sharpening, 320-323 viewing photos in full-screen mode, 263 - 266zooming, 15, 92-93